Art in Renaissance Italy

Oxford History of Art

Evelyn Welch is Lecturer in the School of European
Studies at the University of Sussex. She is the author of
Art and Authority in Renaissance Milan (1995) and
numerous articles on Renaissance topics.

Oxford History of Art

Titles in the Oxford History of Art series are up to date, fully-illustrated introductions to a wide variety of subjects written by leading experts in their field. They will appear regularly, building into an interlocking and comprehensive series. In the list below, published titles appear in bold.

WESTERN ART

Archaic and Classical Greek Art
Robin Osborne

Classical Art from Greece to Rome
Mary Beard & John Henderson

Imperial Rome and Christian Triumph
Jaś Elsner

Early Medieval Art
Lawrence Nees

Late Medieval Art
Veronica Sekules

Art in Renaissance Italy
Evelyn Welch

Northern European Art
Susie Nash

Art in Europe 1500–1750
Nigel Llewellyn

Art in Europe 1700–1830
Matthew Craske

Art in Europe and the United States 1815–70
Ann Bermingham

Modern Art 1851–1929
Richard Brettell

After Modern Art 1945–2000
David Hopkins

WESTERN ARCHITECTURE

Greek Architecture
David Small

Roman Architecture
Janet Delaine

Early Medieval Architecture
Roger Stalley

Medieval Architecture
Nicola Coldstream

Renaissance Architecture
Christy Anderson

Baroque and Rococo Architecture 1600–1750
Hilary Ballon

European Architecture 1750–1890
Barry Bergdoll

Modern Architecture
Alan Colquhoun

Contemporary Architecture
Anthony Vidler

Architecture in the United States
Dell Upton

WORLD ART

Aegean Art and Architecture
Donald Preziosi & Louise Hitchcock

Early Art and Architecture in Africa
Peter Garlake

African Art
John Picton

Contemporary African Art
Olu Oguibe

African-American Art
Sharon F. Patton

Nineteenth-Century American Art
Barbara Groseclose

Twentieth-Century American Art
Erika Doss

Australian Art
Andrew Sayers

Byzantine Art
Robin Cormack

Art in China
Craig Clunas

East European Art
Jeremy Howard

Ancient Egyptian Art
Marianne Eaton-Krauss

Art in India
Partha Mitter

Islamic Art
Irene Bierman

Japanese Art
Karen Brock

Melanesian Art
Michael O'Hanlon

Mesoamerican Art
Cecelia Klein

Native North American Art
Janet Berlo & Ruth Phillips

Polynesian and Micronesian Art
Adrienne Kaeppler

South-East Asian Art
John Guy

WESTERN DESIGN

Twentieth-Century Design
Jonathan M. Woodham

American Design
Jeffrey Meikle

Nineteenth-Century Design
Gillian Naylor

Fashion
Christopher Breward

WESTERN SCULPTURE

Sculpture 1900–1945
Penelope Curtis

Sculpture Since 1945
Andrew Causey

PHOTOGRAPHY

The Photograph
Graham Clarke

Photography in the United States
Miles Orvell

Contemporary Photography

THEMES AND GENRES

Landscape and Western Art
Malcolm Andrews

Portraiture
Shearer West

Art and the New Technology

Art and Film

Art and Science

Women in Art

REFERENCE BOOKS

The Art of Art History: A Critical Anthology
Donald Preziosi (ed.)

Oxford History of Art

Art in Renaissance Italy 1350–1500

Evelyn Welch

OXFORD
UNIVERSITY PRESS

OXFORD
UNIVERSITY PRESS

In memory of Clare

Great Clarendon Street, Oxford OX2 6DP

Oxford New York

Athens Auckland Bangkok Bombay Calcutta
Cape Town Dar es Salaam Delhi Florence Hong Kong Istanbul
Karachi Kuala Lumpur Madras Madrid Melbourne Mexico City Mumbai
Nairobi Paris São Paulo Singapore Taipei Tokyo Toronto Warsaw
and associated companies in Berlin Ibadan

Oxford is a registered trade mark of Oxford University Press
in the UK and in certain other countries

British Library Cataloguing in Publication Data
Data available

Library of Congress Cataloguing in Publication Data
Data available

978-0-19-284279-4
0-19-284279-X

10 9 8 7 6

Picture research by Elisabeth Agate
Design by Esterson Lackersteen

Printed in China on acid-free paper by C&C Offset Printing Co. Ltd.

Contents

Preface

There is no such thing as a neutral textbook. This one takes a particular view of Italian art produced between 1350 and 1500, attempting to integrate it within its original religious, political, and social culture. It does not, therefore, try to provide a comprehensive survey or to illustrate the best-known works from the period. Its purpose, instead, is to raise a series of questions about how art was created, where it was originally seen, and what messages its patrons hoped to convey. The information provided in response to these questions is designed to provide a context, rather than a substitute, for our own careful observation of the works of art themselves.

Thanks are due to my colleagues at the University of Sussex, particularly Dr Craig Clunas, who read much of the manuscript, and to Dr Shayne Mitchell, Dr Kate Lowe, and Dr Amanda Lillie for their advice and assistance.

E. W.

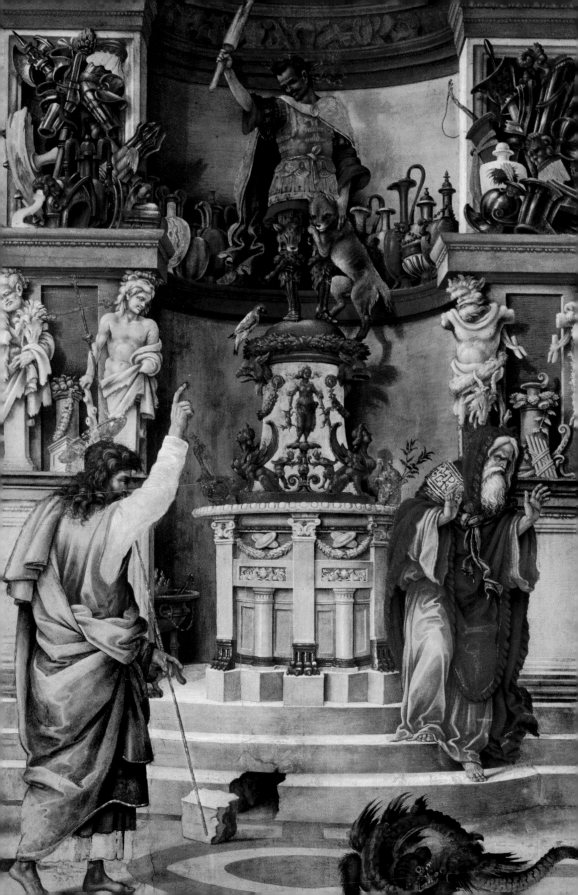

Introduction

1

Italy is a modern phenomenon with streets, squares, and museums dedicated to the memory of the peninsula's political unification, the so-called *Risorgimento*, which took place in the second half of the nineteenth century. In a portrait produced for the city of Siena in 1888 [1], Italy's first king, Vittorio Emanuele II, stands with his hand on a map cleared of any internal political or geographic dividing-lines; the frame bears the arms of the once-separate regions which now made up the new country: Rome, Piedmont, Tuscany, Lombardy, Venice, and the Kingdom of Sicily. The image implies that Italy was a geographic entity whose reunification under Vittorio Emanuele in the early 1860s was its natural, long-awaited destiny.

But did Italy ever exist before the nineteenth century and what did the creation of this new nation mean for writers trying to define its historical past? These questions are worth keeping in mind, for the construction of Italy coincided with the first serious scholarly attempts to classify the period we now call the Renaissance. The term, which means 'rebirth', and originally referred to the revival of classical antiquity, was first used in 1855 by the historian Jules Michelet as the title for a volume on sixteenth-century French history. It was then appropriated by a Swiss historian, Jacob Burckhardt (1818–97), whose highly influential *Civilization of the Renaissance in Italy* first appeared in German in 1860. To these northern European writers, the Italian Renaissance was a fifteenth- and sixteenth-century episode which formed the crucial moment when ideals such as individualism, nationalism, secularism, and capitalist entrepreneurialism were born and then transmitted to the rest of the Western world.

In a letter describing his book, Burckhardt was very explicit about his purpose: 'The Renaissance was to have been portrayed in so far as she was the mother and the source of modern man.'[1] Today, however, we must ask whether this vision of a proto-modern Renaissance was as much a construction as the portrait of Vittorio Emanuele II itself. Few historians and art historians accept Burckhardt's assumptions, which tie Italian culture to a nascent modernity and state-creation, without some reservations. Yet it has proved difficult to disentangle this historical model from those aspects, such as the collecting of Greek and

1 Luigi Mussini

Portrait of Vittorio Emanuele II,
King of Italy, oil-painting on
canvas, 1888, Palazzo
Pubblico, Siena.

Between April 1859 and 1866
the six separate states in the
Italian peninsula and the
northern territories which had
once belonged to the Austrian
Empire were united under
King Vittorio Emanuele II.
With the capture of Rome
in 1870, Italy, as we know
it today, was created. This
commemorative portrait
of the first king of Italy was
painted for the town hall
(Palazzo Pubblico) in Siena.

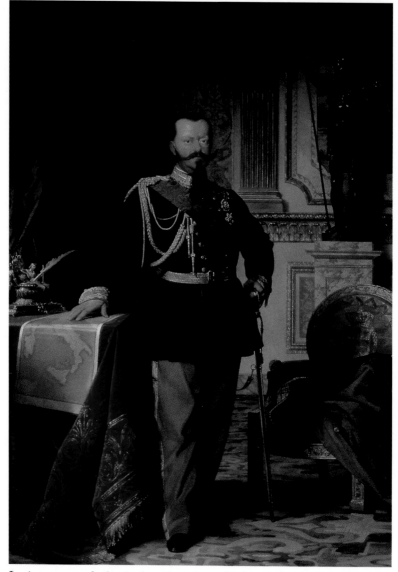

Latin texts and classical antiquities, which can be illustrated in the period itself. Overt references to Roman and Greek monuments or themes, and the development of techniques such as linear perspective, which allowed the construction of geometrically convincing illusions of the natural world, have become the hallmarks of what is traditionally considered this moment's particular 'period style'.

Because of the important, although not unique, role Tuscan artists had played in the dissemination of classical formulas and mathematical interests, traditional discussions of Renaissance art have tended to focus on this geographic area. The typical survey charts the early appearance of classicizing motifs in the Pisan and Sienese sculpture of Nicola Pisano (active 1258–84) and his son Giovanni (active 1265–1319),

and in the work of the Florentine painter Giotto di Bondone (active 1301–37) or the Sienese brothers Ambrogio and Pietro Lorenzetti (active 1319–48). Such a study then moves on to the achievements of early fifteenth-century artists such as Filippo Brunelleschi (1377–1446), Masaccio (active 1401–28), and Donatello (1386–1466) before seeking a culminating moment in the work of later painters and sculptors such as Leonardo da Vinci (1452–1519), Michelangelo Buonarroti (1475–1564), and Raphael Sanzio (1483–1520). From this perspective of triumphant progression, the period covered by this volume forms the 'Early' Renaissance, a time before the 'real' or 'High' Renaissance took place.

This seductive, and by no means completely inaccurate, narrative is not purely a nineteenth-century invention; it is based heavily on the writings of fifteenth-century artists and commentators and on the work of a sixteenth-century artist and writer working in Florence, Giorgio Vasari (1511–74), whose biography-based *Lives of the Artists* proved extremely influential in the development of critical writing on the history of art in general. Yet, as art historians are increasingly aware, Vasari's vision, like Burckhardt's historical model, is problematic. It transforms the earlier centuries of Italian art into ante-rooms for the sixteenth century and disguises as much as it reveals, ignoring both Italy's complexity and diversity.

Continuity and transition

Another way forward is to consider the fourteenth and fifteenth centuries as both periods of tremendous transition and as ones of remarkable continuity. If, for example, we examine two chapels in the Dominican church of Santa Maria Novella in Florence, their stylistic differences are immediately obvious. The first chapel [2, 3], painted by two brothers, Andrea (active c.1343–68) and Nardo di Cione (d. 1365/6), in the late 1350s, has images of damnation and salvation with a dramatic altarpiece dominated by the stiff, frontal figure of Christ passing down Christian law and doctrine to Sts Peter and Thomas Aquinas. The second chapel [4, 5], painted almost a century and a half later by Filippino Lippi (1457–1504), is equal in scale but has reduced the importance of the altarpiece, and concentrated the narrative on single-frame scenes of apostolic miracles. The early Christian story illustrating the victory of St Philip over a demon is set against a triumphal arch and sits securely within *all'antica* grotesque masques and ornaments which jostle for the viewer's attention. The spatial illusion is convincing, the dramatic gestures evocative, and the naturalism is cleverly mixed with antique allusions.

But however dramatic the changes in style, the similarities also deserve our attention. Despite the distance in time, both chapels were commissioned by members of the same renowned Florentine dynasty, the Strozzi. They served the same purpose, acting as burial spots, sites

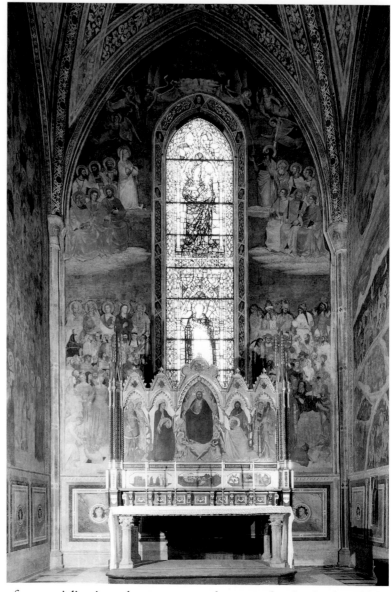

Strozzi chapel, 1354–9,
Santa Maria Novella, Florence.
When the wealthy Florentine
Rosello Strozzi died he asked
that his heirs make restitution
for his sins, and his young son
Tommaso arranged to endow
a family chapel in Santa Maria
Novella. Nardo di Cione was
responsible for the frescos of
the Last Judgement, Paradise,
and Inferno on the walls, while
his brother Orcagna painted
the altarpiece and probably
designed the stained glass
image of the Virgin and Child
and St Thomas Aquinas for
the window above.

of memorialization where masses and prayers for the dead could be provided. Both patrons, Tommaso Strozzi in 1357 and Filippo Strozzi in 1487, insisted on drawing up contracts with their painters specifying the quality of the materials, the time the work would take, and the final cost. Even the technique employed, true fresco in tempera paint with ultramarine blue and gilding laid on, was the same. Finally, the stories they told, of the Last Judgement and of the saints, were drawn from the same Christian tradition.

Thus any story of art which focuses on the appearance and development of a single visual style, such as the reuse and adaptation of classical motifs and of linear perspective, has limitations as well as

3 Andrea di Cione (Orcagna)

Strozzi altarpiece, tempera on panel, 1354–7 (the frame is a nineteenth-century replica), Strozzi chapel, Santa Maria Novella, Florence.

In 1357 Andrea di Cione signed a contract with Rosello Strozzi's son, Tommaso, to provide this altarpiece which depicts Christ between the Virgin and Saint John the Baptist along with Saints Catherine, Lawrence, Michael, and Paul. St Peter and the Dominican father, St Thomas Aquinas, kneel to receive the keys and the laws respectively from Christ. In the predella panel below Orcagna painted small narrative scenes from the lives of these saints such as the mass of St Thomas Aquinas, the miracle of the calming of the sea from the life of St Peter, and the death of King Henry II of Germany whose soul was saved from the devil when St Lawrence placed a gold chalice which the King had once donated into the scales. Note the devil retiring to the far left with the chalice handle which he had wrenched off in his attempt to regain his prey.

advantages. It is told at the expense of works which do not fit into a neat pattern and ignores continuity in favour of change. If, for example, we are always looking for an increased attention to spatial awareness or references to ancient buildings, the work [6] of the mid-fifteenth-century Sienese painter Giovanni di Paolo (active *c*.1420–d. 1483) seems dated compared to the Florentine fresco of the Trinity painted by Masaccio decades earlier [7]. With assistance from his friend and associate, the goldsmith and engineer Filippo Brunelleschi, Masaccio adapted mathematical formulas to suggest a convincing architectural space. Giovanni di Paolo did nothing of the kind. The bed in which St Elizabeth has just given birth to St John the Baptist sits awkwardly in space, while the dizzying play of tiles, a motif taken directly from earlier Sienese traditions, has no geometric logic. However, once we realize that the lines of the bed actually reverse the mathematics of perspective, we can appreciate that Giovanni di Paolo is playing with his viewers' assumptions about space. His style is not defined by ignorance, it was formed as a deliberate contrast to the work produced in the rival town of Florence. In these terms, linear perspective was an important part of Italy's visual culture, but not invariably the most dominant.

To emphasize this point further, it is worth comparing the work of a single sculptor, Niccolò dell'Arca (active 1463–d. 1494). We might be tempted to see one, the terracotta Lamentation over the Body of Christ [8, 9, 10], as more Gothic in style and the other, the marble top of the Arca di San Domenico [11], as a development towards the Tuscan Renaissance. But while the Arca's heavy garlands and putti can be related to works visible in Florence, Siena, Padua, and Rome, the

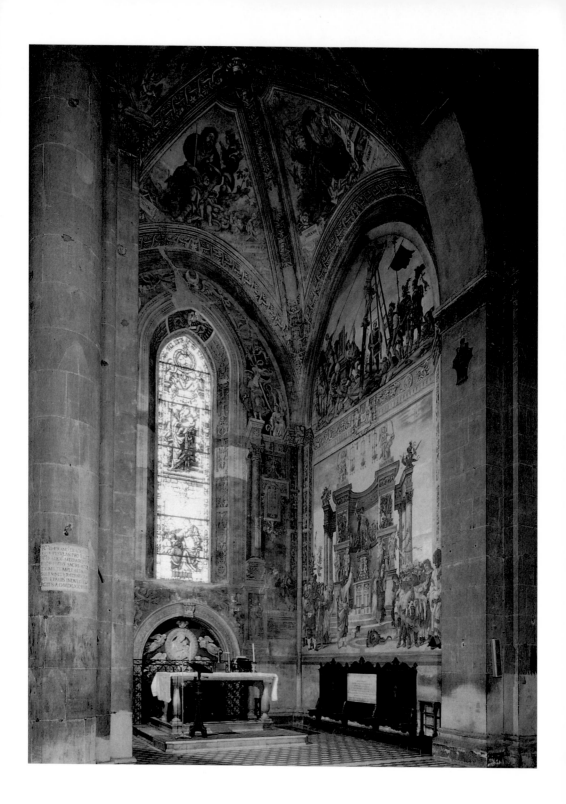

different materials (clay and stone), the different locations (a hospital and a shrine), and the different types of response each work was meant to evoke (empathy, compassion, and guilt in the *Lamentation*; awe and pride in a great Bolognese possession in the shrine) go further towards explaining dell'Arca's shift from high emotion to restrained classicism than a simple theory of stylistic development.

I have laboured these introductory points in order to insist that the two issues at stake, the change in style and a continuity of purpose, need equal consideration. Indeed, I will argue that the two were actually quite closely connected. There were commissions where artists and patrons found it more appropriate to use traditional iconography and styles; at other times it was convenient to startle the viewer, to ask him or her to look again at the Christian stories and images which had become overfamiliar in over a thousand years of telling and retelling. This happened in multiple ways, and in many different places, in a peninsula which was not yet the Italy that we know today.

Italy and abroad

The word *risorgimento* comes from the verb *risorgere*, 'to rise up again', implying that the peninsula had had a prior existence as a single nation.

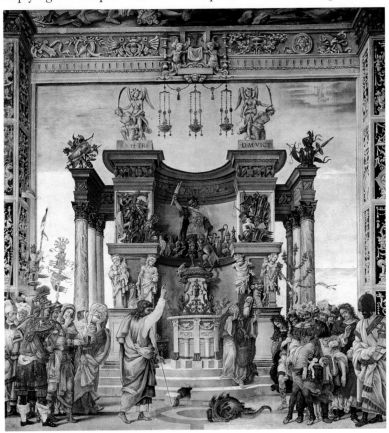

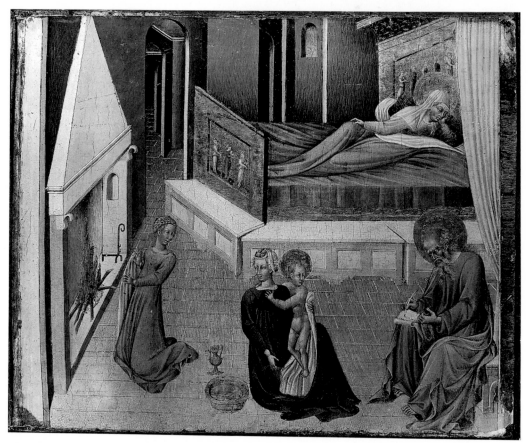

6 Giovanni di Paolo

Birth of St John the Baptist, tempera on wood panel, c.1453.

The son of a painter, Giovanni di Paolo was born in Siena around 1400 and lived until 1482. This is one of five panels from a predella to an altarpiece dedicated to St John the Baptist. In using receding floor tiles to create an illusion of space and depth, the artist was drawing on earlier fourteenth-century Sienese traditions.

Yet, as one historian has put it, 'the truth is "Italy" was nothing more than a sentiment . . . the reality was not unity but a mass of divided cities, lordships and towns, dominated by particularist sentiments and local interests'.[2] Geographically, Italy is divided from northern Europe by the Alps and from North Africa and Greece by the Adriatic and Mediterranean Seas. The mountains of the Apennines create internal barriers. Wide variations in the region, in terms of urbanization, climate, and geographical conditions, ensured different forms of agricultural and maritime development. Thus where we look for cultural cohesion and development, earlier viewers saw separate, and often competing, towns and communities. In areas not much more than a day or two's ride from each other, different dialects were spoken, different legal codes, calendars, and holy days were kept, and different coinage was issued. Architectural measurements and the weights of loaves of bread were calculated with different units from town to town while social customs could vary dramatically. In the court of Savoy, for example, women could be kissed in public; in Florence such an act would have been unheard of.

Diversity was crucial; nevertheless what prevented the peninsula from becoming a series of isolated, independent fragments was the

facility and ease with which men, women, and objects travelled. Thus the particularism, or *campanilismo*, of individual cities and regions has to be balanced with the trade and territorial ambitions which bound the country to the wider problems of Europe, both east and west. Outside central Italy, the divisions between Italy, the German lands, France, and east-central Europe are often quite difficult to define with precision. Around the northern edges, in the region of Savoy and the towns of Trent, Bolzano, or Udine, Italian-, German-, and French-speaking communities coexisted. In the south, Arabic, Jewish, French, Aragonese, Greek, and Catalan influences all had an impact.

Cross-cultural exchanges appear even more dramatically when considering Italy as a series of port-towns (see diagram). It was far easier to move by ship than it was to travel across the Apennines. To the north, merchants and merchandise moved by sea and river from Pisa, Livorno, and Genoa to the great trading centres of Bruges and Ghent. To the west, they landed in Barcelona, Valencia, and Lisbon; to the east they used the port of Venice to reach Alexandria; to the south there was trade with the African coastline. While earlier centuries had undoubtedly seen greater and more dramatic waves of movement, these later trips, as some economic historians are now suggesting, should not be discounted. The records of one wealthy Tuscan businessman alone, Francesco Datini of Prato, listed over 3,000 different ships that he used when trading between 1383 and 1411.[3] The fourteenth and fifteenth centuries saw a steady supply of travellers as pilgrims went to Jerusalem on regular tours and traders continued to move from Venice and Genoa out into the Levant. The journey of three Florentines on a pilgrimage to Egypt, Mount Sinai, and Palestine in 1384–5 shows the relative ease with which such a trip could be undertaken. They left Venice during the September shipping season, and, after stopping off at various Greek islands, arrived in Alexandria three weeks later. To come back in the spring, they made for the port of Beirut and even after a difficult return journey, arrived in Venice forty-two days after they set sail. By the fifteenth century such voyages were so common that many Venetian sailors made their living from the great galleys which took up to two hundred passengers on a round trip from Italy to Jerusalem—where the captain offered a price inclusive of food, tolls, taxes, and transport on sea and land.[4]

Thus while it might seem that the Italian world contracted in the second half of the fourteenth century as the great trading companies of an earlier era lost their prominence abroad and the Ottoman advance threatened to engulf Christian territories in the East, it is important to recognize that for those who aspired to wealth or spiritual fulfilment, no single city was self-contained; however proudly local traditions were praised, merchants and artisans, priests and pilgrims moved widely and came into contact with diverse traditions. This is

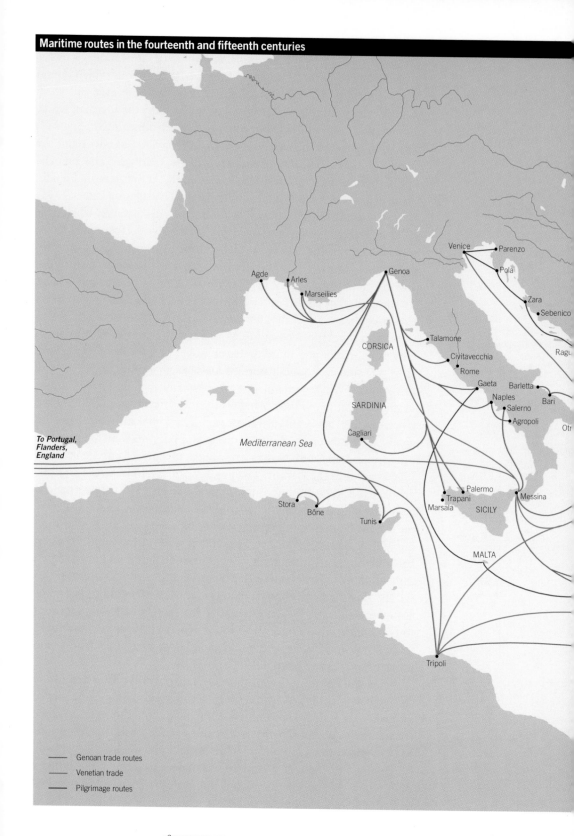

Agde
Arles
Marseilies
Genoa
Venice
Parenzo
Pola
Zara
Sebenico
Ragu.
Talamone
CORSICA
Civitavecchia
Rome
Gaeta
Barletta
Naples
Bari
Salerno
SARDINIA
Agropoli
Otr
Cagliari
To Portugal,
Flanders,
England
Mediterranean Sea
Palermo
Stora
Trapani
Messina
Bône
Marsala
SICILY
Tunis
MALTA
Tripoli

—— Genoan trade routes

—— Venetian trade

—— Pilgrimage routes

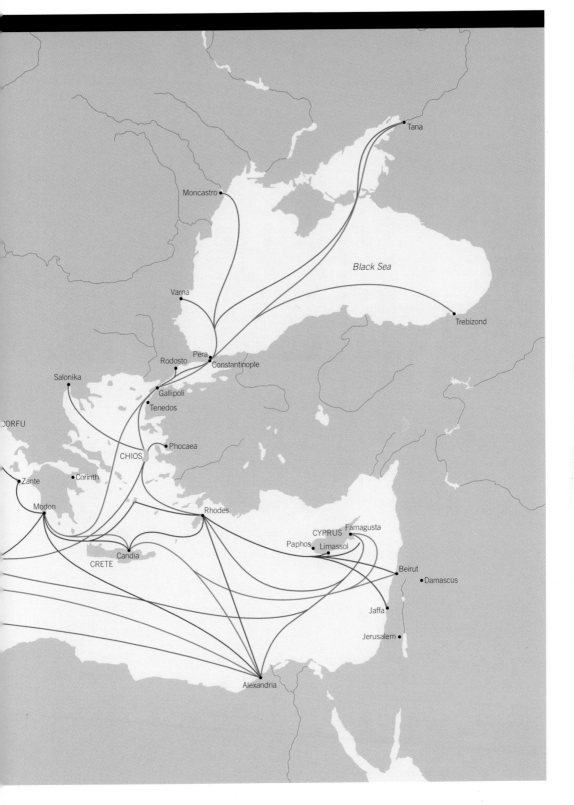

Tana

Moncastro

Black Sea

Varna

Trebizond

Rodosto
Pera
Constantinople

Salonika

Gallipoli

Tenedos

CORFU

Phocaea

CHIOS

Zante

Corinth

Modon

Rhodes

CYPRUS Famagusta

Paphos Limassol

CRETE

Candia

Beirut

Damascus

Jaffa

Jerusalem

Alexandria

7 Masaccio

The Trinity, fresco, *c.*1427,
Santa Maria Novella, Florence.
Painted in twenty-four sections
or, *giornate*, this depicts the
mystery of the unity of the
Father, Son, and Holy Ghost
(the dove). The artist had a
short independent career of
probably no more than six or
eight years before his death in
Rome in 1428.
He is particularly renowned
for his innovative use of
perspective. But while it has
often been assumed that the
Trinity was painted with
mathematical precision,
recent investigation has shown
that Masaccio was willing to
compromise his calculations in
order to achieve visual effects.

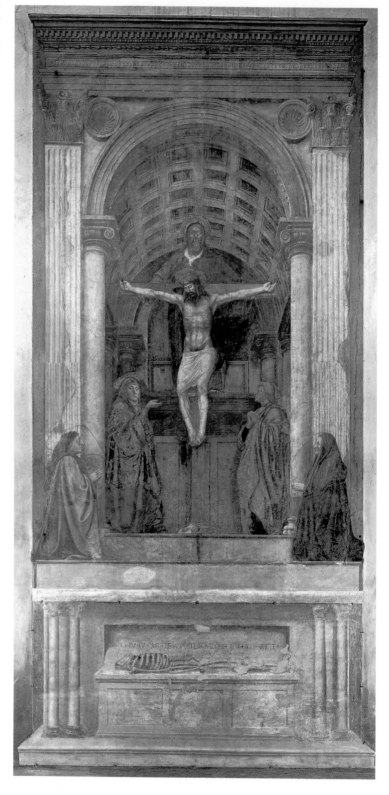

not to suggest that travellers and traders in the fourteenth and fifteenth century were aspiring multicultural idealists; amongst the most popular printed books in the late fifteenth century were anti-Semitic and anti-Muslim tracts, slavery was widespread, and the experience of foreign travel often reinforced prejudicial assumptions. It remains important, however, to realize that transmission across several cultures, whether happily or unhappily, was an integral part of this Renaissance experience.

Such exchanges could be as true for artists as they were for the cloth-trader or the pilgrim. While many patrons and artists never went further than their immediate locality to find employment or employees, it was possible to place orders for tapestries, paintings, goldwork, portraits, dinnerware, and cloth in other parts of Europe and the East and to ship Italian works abroad. In 1499, for example, an Italian trader in the city of Candia on the island of Cyprus (then under Venetian control) ordered seven hundred icons of the Madonna and Child, five hundred of which were to be painted 'in the Latin style' and 'two hundred in the Greek style' which he planned to export.[5] At the higher end of the market, Chinese porcelain was a much-valued import as were Byzantine relics, reliquaries, ivories, textiles, and rare marbles. Italian artists and their reputations proved equally mobile. The duke of Berry, the king of France, and the Holy Roman Emperor were regular customers for novelties such as intarsia work, glass, and cast medals. In the 1350s the painter Tomaso da Modena (c.1325/6-pre-1379), went to the Bohemian court to work for Emperor Charles IV. In 1425 the Florentine artist Masolino (active c.1423–d. 1447) also went east, to Hungary, for three years to work for the Milanese bishop-cardinal Branda Castiglioni, and for a Florentine mercenary soldier, Filippo Scolari, known as Pippo Spano, who held important positions in the Hungarian Church and court respectively; in the late 1460s the Florentine artist Michelozzo di Bartolommeo (1396-1472) went to the Greek island of Chios. This movement of artists and objects went well beyond the immediate confines of western Europe. The Venetian painter Niccolò Brancaleone worked in Ethiopia in the 1480s, where he was partly responsible for institutionalizing Italian iconography amongst the Christian communities in Africa, and Gentile Bellini (1429-1507) acted as court artist to Sultan Mehmed II for a year in 1479-80.[6]

This list could easily be extended but we must be wary about its implications. Again such exchanges do not guarantee lasting cultural contact. Artists can pass through areas without changing their style and can leave little, if any, influence behind them. Nevertheless it is a further reminder that any definition of things 'Italian' as classical and Tuscan will miss much of this interaction in favour of a simpler, but narrower, interpretation of the period and its art.

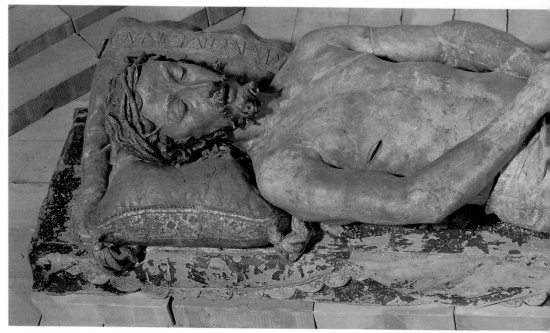

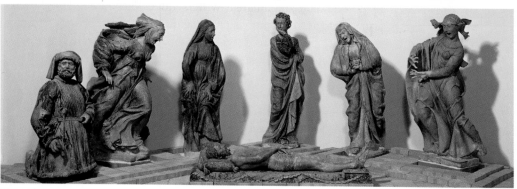

8 Niccolò dell'Arca

Lamentation over the Body of Christ, painted terracotta, 1463, Santa Maria della Vita, Bologna.

The terracotta figures represent the moment when Christ's body was removed from the cross and probably reproduces theatrical scenes produced by confraternities during the Lenten and Easter period. This Lamentation was commissioned by the confraternity responsible for the hospital of Santa Maria della Vita in Bologna and originally stood by the doorway leading into the wards.

The histories of Italy

Whatever their origins, training, and travels, artists had to respond to the needs of their commissioning and viewing public. In the 1970s the influential British art historian Michael Baxandall popularized the concept of the period eye: the immediate social and visual context in which pictures were both created and observed. His typical Italian patron was a merchant, a humanist, or a prince: someone who was able to look at pictures with mathematical or classical training.

This book is very indebted to the idea of the period eye, but I would suggest that we need to multiply our vision, sensitizing our understanding of the many different ways and possibilities of seeing and observing objects which existed in the past. Historically, such multiplicity can be observed through the chroniclers of the period. Different types of narratives, ranging from informal jottings to carefully crafted commentaries, were produced in the fourteenth and fifteenth centuries

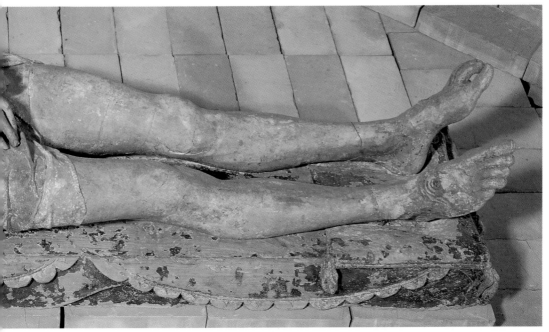

9
As 8; detail of the figure of Christ.

10
As 8; detail of the figure of the Virgin Mary.

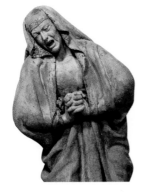

by professional and amateur writers alike. They rarely described the same event in the same way, or for the same purpose. For example, when considering the year 1350, many writers mentioned the Jubilee proclaimed by Pope Clement VI (reigned 1342–52), an important event which promised forgiveness of sins to all visitors who came to Rome. One author, the compiler of a chronicle in Ferrara, noted the date because it had given his entire city the chance to escape from papal excommunication; for a Florentine diarist, however, the Jubilee merely meant the irritation of finding that his wife had left him to look after the children while she went off to Rome.[7]

Both types of events, large and small, civic and domestic, gave meaning to Italy's history. Within the broad sweep the variations proved crucial, for, as the German scholar Aby Warburg (1866–1929) once famously said, 'God lies in the detail'. Even the great disaster of 1348, the Black Death, failed to penetrate everywhere, leaving the city of Milan unscathed. This devastating epidemic, caused by the transmission of a particularly virulent strain of bubonic plague carried by rat-fleas, and by the pneumonic and septicaemic forms carried by humans, arrived in Sicily in late 1347 on galleys trading with Byzantium and the Crimea. It quickly spread to Italy's other port-towns before moving inland, killing between a third and a half of the population of many urban areas. Some communities, like the nuns of San Jacopo di Ripoli in Tuscany, who lost all but three of their one hundred sisters in 1348, were particularly hard hit and the impact was even greater in the countryside where migration caused by heavy taxation, poor crop yields, and warfare, as well as illness, denuded hamlets and villages

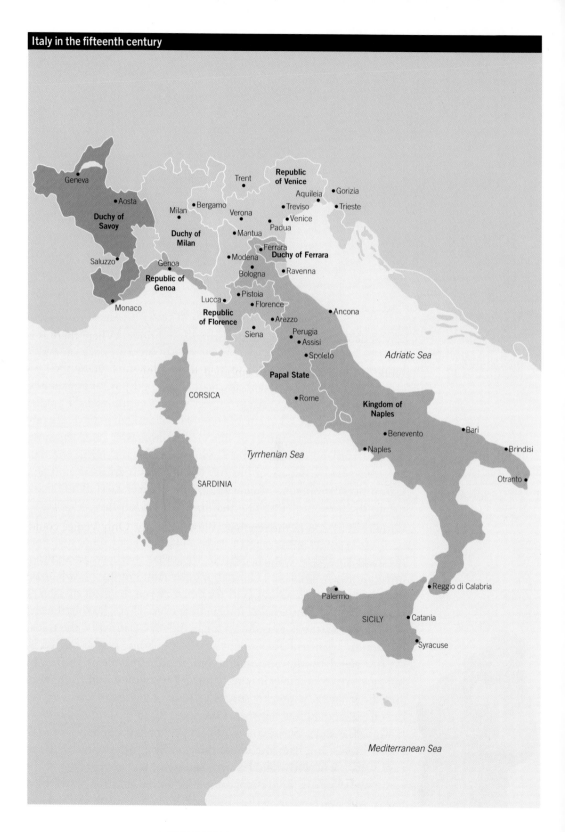

Geneva

• Aosta

**Duchy of
Savoy**

Milan

• Bergamo

Trent

Verona

**Republic
of Venice**

Aquileia • Gorizia

• Treviso • Trieste

• Venice

**Duchy of
Milan**

• Mantua

Padua

Ferrara

• Modena **Duchy of Ferrara**

Saluzzo •

Genoa

**Republic of
Genoa**

Bologna

• Ravenna

Monaco

Lucca •

• Pistoia

• Florence

**Republic
of Florence**

• Arezzo

Siena

• Ancona

Perugia

• Assisi

• Spoleto

Adriatic Sea

Papal State

CORSICA

• Rome

**Kingdom of
Naples**

Tyrrhenian Sea

• Benevento • Bari

• Naples • Brindisi

SARDINIA

Otranto •

• Reggio di Calabria

Palermo

Mediterranean Sea

SICILY • Catania

• Syracuse

alike. Nevertheless, while the Black Death of 1348 was à moment of great drama, recent research has suggested that it was the less dramatic, but more persistent, recurrent cycles of plague which proved influential in the long run. Plague hit Palermo over twelve times between 1362 and 1452. In Florence, there were at least eight major epidemics during the fifteenth century with a particularly severe outbreak in 1478. The dukes of Milan established a stringent system to isolate towns which reported plague since almost every year from 1399 to 1498 saw some area under their jurisdiction hit by a sudden wave of illnesses. From the second half of the fourteenth and throughout the fifteenth century, all Europeans had to seek some form of accommodation with this new threat.

This book begins just after the Black Death, in part because the precise economic, psychological, social, and even artistic consequences of the plague have been the subject of much controversy. There are historians who claim that it inaugurated a period of considerable economic decline; there are others who have argued for a more positive view of economic, trading, and working conditions. Where there is a general consensus, it centres on the fact that, as the population fell, a stable demand for labour, combined with minimal inflation, led to increased wages and wider prosperity across social classes. This did not, however, lead to any idealized society, contributing instead to a sense of social disorder as old élites were attacked by the newly enriched. There were popular revolts in Lucca, Siena, Perugia, Florence, Bologna, and Ferrara in the late fourteenth and early fifteenth century by workers who hoped to gain a greater participation in government or by citizens objecting to heavy taxation. There were regular shifts in rulership in the signorial governments of northern and southern Italy and in the republics of central Italy. Only Venice could boast of apparent stability.

Given the drama of the plague deaths and the ensuing political disorder, art historians have tried to find a link between this great historical change and artistic developments. In 1951 the American scholar Millard Meiss proposed the influential thesis that the Black Death and the disorder which followed had had a distinctive stylistic impact, leading to a rejection of the naturalism devised by Giotto in the early fourteenth century in favour of a return to the more traditional and spiritually iconic images of an earlier period.[8] The Strozzi altarpiece of 1357, with its insistence on doctrine over human empathy, was one of the major pieces of evidence for this argument. More recently, however, another historian, Samuel Cohn, has argued that this increase in conventional pictorial styles could be explained by the expanding market for devotional works of art from social groups who would not have been able or expected to afford them in the past. As demand increased, he persuasively suggests, workshop organization

11

Arca di San Domenico,
Marble, 1265–1536
(lid produced by Niccolò
dell'Arca, 1469–73),
San Domenico, Bologna.

The central casket containing
the body of the founder of the
Dominican order, Saint
Dominic, was carved between
1265 and 1267 by Nicola
Pisano and his assistants.
In 1411 the shrine was placed
in a special chapel which stood
between the lay congregation
and the friar's choir. In 1469
the governors of Bologna
ordered a new systematization
of the area, commissioning
Niccolò dell'Arca to provide
a monumental lid. Only
sixteen of the twenty-one
figures requested for the
shrine's lid had been
completed at Niccolò's death
on 2 March 1494. The 19-year-
old Florentine sculptor
Michelangelo Buonarroti
was then hired by a Bolognese
patrician and member of
government, Gian Francesco
Aldovandi (who had acted
as a government official in
Florence), to complete three
of the missing figures, that of
the Bolognese bishop, Saint
Petronius, Saint Proculus, and
a candelabra-bearing angel.

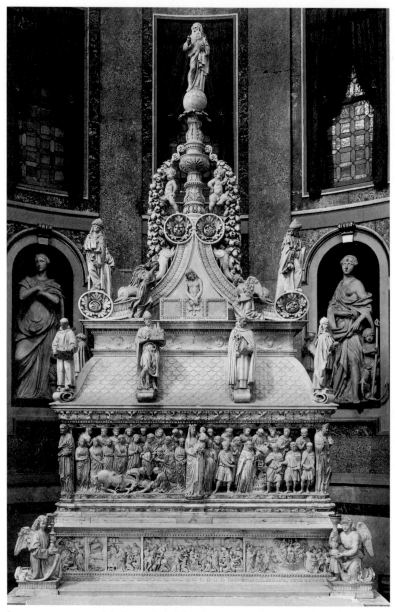

became more sophisticated and both price and quality fell. Only during the first quarter of the quattrocento did a smaller number of more demanding patrons insist on a return to more expensive, and more innovative, works of art.[9]

There is no easy conclusion to this argument, but it is important to note that both studies concentrate on Tuscany, an area which was forced, over the short term, to curtail earlier programmes of urban development. In their tax returns, central Italian artists were quick to point out that warfare and plague did not bring easy profits and that they found it difficult to sustain a living. But as a warning against any

simplistic connection between historical events and visual change, we should note that in the north and in Naples, where Giotto had also worked, this development was not particularly noticeable; and as towns such as Verona, Bologna, Como, and Milan erected new cathedrals in the late trecento, sculptors, goldsmiths, stained-glass-makers, weavers, embroiderers, and painters arrived from across Europe to revitalize their cities' artistic communities and to introduce a remarkable number of alternative styles. Indeed, by the early fifteenth century the Tuscan cities had stabilized to the extent that they too could continue the construction and decoration of their major churches and cathedrals, thereby ensuring more consistent artistic employment.

Cathedrals were traditional civic symbols and much of the impetus for their construction and ornamentation was the need to define urban status at a time when political identification was far from certain. The peninsula's main political allegiances were divided between loyalty to the Holy Roman Emperor (an allegiance defined as Ghibelline) and loyalty to the Papacy (an allegiance defined as Guelph). By the mid-fourteenth century, however, these two central alliances were usually nominal. Although successive Holy Roman Emperors did journey from Germany and Bohemia to Milan and Rome for ceremonial coronations, they were normally looking for cash subsidies rather than directly intervening in peninsular politics. The Papacy was in a difficult position as well. The popes remained outside Italy in the Anjou fiefdom of Avignon (sold to the Papacy by Giovanna of Anjou, queen of the Kingdom of Naples in 1348) until 1377 when the return to Rome of Gregory XI (reigned 1370–8) provoked a split in the Church, the so-called Great Schism. This was caused by the election of two popes in 1378, one created by pro-French cardinals who wished to see a return to France and one by pro-Italian cardinals who encouraged residence in Rome. The conflict, which meant that at times there were as many as three claimants to the throne of St Peter, was not resolved until 1415 and only towards the late 1440s could the popes consider themselves secure in Rome itself.

With the absence of any centralized authority, the period from 1350 to 1450 was one of regular turmoil as towns and individual rulers sought to establish territorial supremacy and create new dominions. Boundaries and allegiances shifted as would-be lords, the so-called *signori*, such as Bernabò (d. 1386) and Gian Galeazzo Visconti (d. 1402) of Milan, hired mercenary captains from across Italy and Europe to expand their rule. Rival republican and oligarchic governments such as Florence and Siena were also interested in territorial expansion. The financial and military strain was tremendous and ensured that by 1450 the small-scale dominions which were once dotted across the peninsula in the previous century were nominally allied to, or under the direct control of, the five larger territorial states which had their

administrative centres in the cities of Milan, Venice, Florence, Rome, and Naples. But if internal fragmentation had disappeared from view, it had not been totally eradicated. The city of Como still resented its domination by Milan, Padua that of Venice, Pisa that of Florence, Palermo that of Naples, and so on. But for a short half-century between 1450 and 1500 the interests of the larger city-states defined the peninsula's economic and political direction.

From the Peace of Lodi to the French invasions, 1454–1500

The most important formal sign of peninsular stability was the signing of the Peace of Lodi in 1454, a treaty which recognized the spheres of influence of these five major powers. The respite came about, in part, because the political and economic stability of all five signatories was uncertain. They could no longer afford to fight each other and the fall of Constantinople in 1453 to the Ottoman Emperor Mehmed II (the Conqueror, ruled 1451–81), had made all Italians aware of their vulnerability. In the Kingdom of Naples, Alfonso of Aragon (1395–1458) had been in full control of his capital city, Naples, for less than a decade and faced both internal opposition and the threat of invasion by rival claimants. In nominally republican Florence, Cosimo de' Medici (1389–1464) was also well aware of the limitations of his recently acquired, and still highly unofficial, political influence. His ally, the new duke of Milan, Francesco Sforza (1401–66) was a mercenary soldier who, having married the daughter of the previous Visconti duke, had taken his title by force in 1450. Of the other two signatories, Pope Nicholas V (reigned 1447–55) wanted to concentrate on recapturing the Papal States in central Italy and to aid Christians threatened by the expanding Ottoman Empire, while the Venetian senate needed to protect both its territorial hinterland, the terraferma, and most importantly its maritime trading-routes and territories.

The respite promised by the Peace of Lodi held while all five participants benefited. The treaty was, of course, quite a different story for those towns, such as Genoa or Rimini, who were subsumed within the agreement. Freed from concerns about larger peninsular conflicts, the five city-states could concentrate on absorbing and subduing the once-independent communities within their permitted horizon. Thus the agreement of 1454 did not bring a stop to war. But for a brief period it did mean that opportunities to seriously redraw the map of Italy were curtailed and that the chances for new mercenary soldiers to acquire lands or to expand their territorial interests were limited.

In 1471 the same powers signed an extension of the treaty, but this time the diplomats were more half-hearted. The fragility of the ruling families' control continued to be amply demonstrated with an uprising against the Sforza of Milan in 1476 when Duke Galeazzo Maria (1444–76) was murdered. An assassination attempt was directed

against the Medici in Florence in 1478, killing Cosimo's grandson Giuliano de' Medici (1453–78) and threatening the latter's brother Lorenzo (1449–92). Ferdinand (Ferrante) of Aragon, king of Naples and southern Italy, who was partly responsible for the attempt on the Medicis' lives, himself faced internal rebellions which culminated in the Barons' War of 1486.

Although only one major conflict, the War of Ferrara which Venice began in 1481, pitted the Italian city-states directly against each other on a major scale, each government continued in its attempts to expand its territorial and economic interests. All were willing to enter into pragmatic alliances with outside powers, including the kings of France, the dukes of Burgundy, the Holy Roman Emperor, the kings of Hungary, rulers in Serbia and Albania, and Sultan Mehmed II and his successor Bayezid II (ruled 1481–1512). While the continued incursions of Ottoman troops and the development of a Turkish naval fleet, which managed landings in Friuli in northern Italy in 1475 and in the heel of Italy in Otranto in 1480, gave rise to further demands for a crusade against the infidel, alliances with the sultan and his representatives were constantly negotiated to protect trading routes and interests.

The capture of Naples by King Charles VIII of France (1470–98) (whose Angevin family had traditional rights to the city) between 1494 and 1495 was undertaken, in part, because of claims that the Aragonese rulers had singularly failed to protect Christians from this Muslim threat. For the French, Naples was meant to be the start of a new crusade which would halt the Ottoman advance. That Charles VIII and his soldiers were content with Italian booty should not disguise the fact that such anti-Muslim crusading rhetoric remained a powerful justification for invasion and conquest in the fifteenth century.

Once they had arrived, the French army (often led and staffed by exiled Italians) proved a catalyst which forced previously disguised tensions and dissension into the open. Although Charles VIII retreated in 1495 and Naples returned to the Aragonese (and then passed by a circuitous route of alliance and treachery to the unified Spanish crown under King Ferdinand of Aragon (1452–1516)), the impact of the invasion remained. In 1494 anti-Medicean factions in Florence, hoping to re-create a genuine republic, took the opportunity to remove the most recent figure of Medicean authority, Piero di Lorenzo (1472–1503), from power. Smaller cities such as Novara and Pisa demanded, and received, independence from their overlords. Most importantly, although he had encouraged Charles VIII to attack Naples, the recently invested duke of Milan, Ludovico Maria Sforza (1451–1508), soon realized that he too was vulnerable. When a new king of France, Louis XII (1482–1515), entered the peninsula in 1499 it was to attack and conquer Milan, an acquisition which would lead to further conflict in the sixteenth century as the French and Spanish kings sought

to bring Italy's lands under their territorial dominion. By the mid-cinquecento the centres of political control were no longer in Italy's many cities and towns but in Europe's expanding international courts.

Beliefs and believing

This briefly sketched historical narrative suggests that Italians remained divided by their diverse loyalties. But if political unity proved problematic, there were other beliefs and assumptions which were shared. Traditional moral virtues—princely, chivalric, and Christian—were not always practised, but they were widely held; the beliefs and rituals of Catholicism had few boundaries. Charismatic preachers, such as St Bernardino of Siena (1380–1444), moved from city to city encouraging and exhorting their listeners on topics which stretched from clothing to political behaviour, a hatred of heretics and witches, as well as promoting changes such as hospital and monastic reform and a new type of banking, the *Monte di Pietà*, which would free the poor from the need to resort to pawnbrokers.

For the wealthy élite, there were further social, intellectual, and economic threads which overcame faction and division, ranging from intermarriage and a belief in patrician nobility and knightly honour, to the languages of chivalric and classical culture. The romances which told of the feats of the knights of King Arthur and other heroes were sung and read in French, Spanish, and Italian across the peninsula in courts and cities alike. Children were given the Arthurian names of Guinevere and Lancelot; young aristocratic men aspired to join knightly societies and held jousts in honour of their beloveds. These youths, and a small number of women, might also learn Latin, the language of communication for university teachers, doctors, lawyers, administrators, priests, and poets throughout Europe. If they were truly enthusiastic, they might go on to study Greek.

The revival of interest in ancient languages and literature has been an important, long-standing focus of Renaissance studies. Access to the language and texts of the Greek philosophers Plato and Aristotle and the Roman writers such as Virgil, Cicero, and Quintilian, was supposed to offer access to their moral and philosophical values and beliefs. For Italian readers this had a special resonance. In northern Europe, Latin and the culture of Rome had been the civilization of an invader. In Italy almost every major city considered itself the daughter of Rome. The evidence of this inheritance was very visible. Examples like the sarcophagus in **12** from the baptistery in Florence could be seen throughout the fourteenth and fifteenth centuries. Such ancient marbles were incorporated into new buildings, old sarcophagi were recarved to provide new tombs, and Roman statues, coins, cameos, and engraved gems were discovered as farmers ploughed or the foundations for new buildings were dug. In Italy, one could argue, there

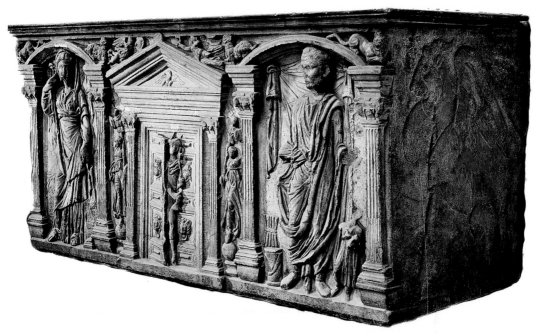

could be no 'rebirth' of classical antiquity for there had never been a proper burial of the corpse of ancient Rome.

12

Mercury Psychopompos Emerging from the Gate of Hades, Roman sarcophagus, third century AD.

This was originally in the baptistery in Florence where it was carefully studied by artists such as Donatello. Nanni di Banco copied the swagged cloth seen in the niche behind the figures in his Quattro Coronati group in Orsanmichele, Florence; and Filarete used the motif of the emerging Mercury peering through the doors in his image of Castel Sant'Angelo on the bronze doors of the basilica of St Peter, Rome.

Humanism and humanists

With an increased interest in defining one's civic or personal heritage, a small, close-knit, although often argumentative, community of scholars found employment in the search for ancient manuscripts in Latin, Greek, and Hebrew, which then required careful philological study and translation. The term by which they are best known, 'the humanists', is another sixteenth-century word which differentiates these scholars from their earlier counterparts by a change in curriculum and mode of teaching. Instead of emphasizing the traditional subjects of academic enquiry, the trivium (grammar, rhetoric, and dialectic) and the quadrivium (arithmetic, geometry, astronomy, and music), these students substituted the *studia humanitatis* which favoured the study of grammar, rhetoric, history, poetry, and moral philosophy.

The type of lifestyle to which such a humanist aspired was that of Francesco Petrarca, known as Petrarch (1304–74), who refused to take up the traditional duties of graduate—those of a notary, lawyer, or doctor—in order to earn his living. He sought, instead, literary patronage at the papal court in Avignon and in the princely courts of Naples and north Italy. With the support of the Papacy in Avignon, the Visconti of Milan and the da Carrara lords of Padua he searched for Latin texts, collected Greek manuscripts (which he could not read), and re-created new genres of laudatory literature based on classical sources. From his various retreats in Provence and northern Italy, Petrarch wrote

letters in Latin to his long-deceased heroes, Cicero and Saint Augustine, to fellow scholars and poets such as Boccaccio, and to Europe's political leaders. Originally enamoured of the Roman citizen, Cola di Rienzo (1313–54), who tried to establish a genuine republic in that city, Petrarch then tried to convince Holy Roman Emperor Charles IV of Luxemburg to unite the peninsula into a new empire, offering him a set of ancient coins with the image of the Roman Emperor Augustus to encourage his emulation of classical achievements.[10]

Petrarch was severely criticized by Florentine compatriots, such as the poet and writer Giovanni Boccaccio (1313–75), for accepting the hospitality of anti-Florentine rulers. But Petrarch made no apologies for his behaviour and the humanists continued to prove politically neutral throughout the fifteenth century. In signorial governments they manned the prince's secretariat and in republics and in the Church they acted as political and spiritual leaders. Others continued to seek work in the universities or in the new printing-presses established in the late 1460s. Such posts made long-term projects feasible. The translation of Plato's *Republic* from Greek to Latin was undertaken by Francesco Filelfo (1398–1481) in the 1440s with the support of Filippo Maria Visconti (1392–1447); Strabo's *Geography* was translated by Guarino da Verona (1374–1460) with the financial aid of Pope Nicholas V (reigned 1447–55) and of the Venetian nobleman Jacopo Antonio Marcello (c.1398–1464) in the 1450s. To obtain assistance for these erudite tasks, humanists wrote poems and epics emphasizing the importance of their work, begging for patronage and funds, praising the new generation of munificent princely rulers, or offering condemnations and invectives against those who proved less forthcoming. When successful, the humanist was rewarded with a job as a tutor to the ruler's children, male and female, ensuring that by the late fifteenth century their classical studies were no longer just the preserve of professional intellectuals but an expected accomplishment of Italy's aristocracy.

By the end of the fifteenth century, therefore, a range of classical references, readings, and motifs were joined to the better established chivalric and Christian themes known to Italy's élite. There were only mild concerns about the appropriateness of such scholarship. A small number of moralists, like the mid-fifteenth-century archbishop of Florence St Antoninus (1389–1459), railed against the nudity found in mythological paintings, and in 1468 Pope Paul II (Pietro Barbo, 1417–71) accused an eccentric group of scholars led by Pomponeo Leto (1428–98), who gave each other classical names and held fanciful dinner parties in Roman dress, of sodomy and heresy and banned their meetings. But these were exceptions and the close integration of Christian belief and humanist philosophy is widely acknowledged by specialists. It is still worth emphasizing again, however, that an appreciation of pagan antiquity was not seen as antagonistic to Catholic

values, certainly not by the humanists themselves. For example, when Giovanni Pico della Mirandola (1463–94), a scholar dedicated to synthesizing different philosophical viewpoints from Neoplatonism to the Jewish cabbala, was condemned by the pope as a heretic, both he and his patron, Lorenzo de' Medici, stoutly defended his Christian lifestyle. Pico himself argued that

It is neither ridiculous nor useless nor unworthy of a philosopher to devote great and unremitting care to holy prayers, rites, vows and hymns jointly sung to God. If this is helpful and proper for the human race, it is especially useful and proper for those who have given themselves up to the study of letters and the life of contemplation.[11]

Thus the beliefs and rituals of Christianity which affected the entire population far overshadowed those experiences which defined the minority of the political and intellectual élite. Because of the importance of religious values and of the place imagery held in the Catholic Church, everyone in Italy, not just the humanists and their élite audiences, needed art.

To explore the works of art that were produced in response to these multiple demands, therefore this book is organized in a different fashion from the traditional exposition of the revival of classical antiquity. It is centred on a series of enquiries rather than a set of answers. We need to ask how works of art were made, by whom, and for what purpose? What messages did artist and patrons hope to communicate and how were they actually perceived by viewers in the past and today? What were the specific contexts in which they were seen and used? The responses are not always obvious but the questions will help to challenge the ease with which the Renaissance and its culture have been categorized and explained.

Part I

Artistic Enterprises

Materials and
Methods

2

The history of art is usually told as the history of artists. 'Anonymous' is an unenticing label and the first question museum visitors usually ask of a Renaissance object is often 'who made it?'

Captions, such as those included in this book, try to satisfy this interest by providing the name of the artist and the date it was made. But while we can find a small number of fifteenth-century patrons proudly listing the artists whose works they possessed, the emphasis on authorship was not always crucial. Instead the question, 'who made it?', was often replaced with 'what was it made from, and how?'

This may not seem an obvious issue today. Renowned late twentieth-century artists often use common everyday materials. Part of their argument is that the individual, whether painter, sculptor, performer, or installation organizer, personally transforms the physically mundane into a higher cultural form. In defining the work as 'art', the conceptual or philosophical idea, the location of the exhibition in a museum or gallery, the artist's individual reputation, and the price the work last sold for, can frequently prove as, if not more important than, the material in which the artist was working.

But in the period we are considering, 1350–1500, materials and artistry were closely linked. The more expensive, rare, or unusual the substance, the more deserving it was of fine craftsmanship and distinguished design. This did not always imply an elaborate narrative and to properly understand the value of works like the tomb of the Medici brothers Piero and Giovanni in the old sacristy in the church of San Lorenzo, Florence, we have to stop looking for the story and examine the workmanship.

At first sight the tomb appears to be quite simple. But the discerning viewer would have noted that it was created by the sculptor Andrea del Verrocchio in three of the most valuable materials of antiquity: marble, porphyry, and bronze [13]. The porphyry discs in the base and centre could only be obtained by cannibalizing ancient Greek and Roman columns and the stone was so hard that just cutting it required enormous technical skill. Bronze, whether for the feet or the grate, which was twisted to resemble heavy silk ropes, also required significant expertise and expense.

Detail of 56

13 Andrea del Verrocchio

Tomb of Piero and Giovanni de' Medici, bronze, porphyry, serpentine, marble, and *pietra serena* surround, 1469–72, old sacristy, San Lorenzo, Florence.

Verrocchio was commissioned by Piero de' Medici to provide a tomb for his father Cosimo between 1465 and 1467. Soon after Piero's own death, Lorenzo turned to Verrocchio to design this tomb which was erected in an arched opening between the family chapel and sacristy of the church of San Lorenzo and the chapel holding the church's most important sacred relics.

The fourteenth-century monumental equestrian image of Bernabò Visconti of Milan attributed to the north Italian sculptor Bonino da Campione (active 1357–d. 1397) would have prompted similar questions about the acquisition and transportation of such a large piece of unbroken marble at a time when quarries were relatively inaccessible. Its size was only one factor; from a poem written in 1385, we know that the appearance of the Visconti statue has changed considerably. Although, by looking closely, traces of paint are still visible, the poet informs us that it was once entirely covered in gold leaf.[1]

This evidence suggests that Bonino da Campione was trying to

imitate a monumental piece of metalwork, creating the illusion of a huge gold statue. It is important to emphasize that this was quite common for in this period the division between what we now call the fine arts and the decorative arts, or, as they are sometimes termed, the major and the minor arts, did not exist. If anything, the former took precedence over the latter. For example, the bright yellow colour of Lorenzo Ghiberti's (c.1378–1455) second set of doors for the Florentine baptistery, popularly termed the 'Gates of Paradise', was designed to suggest the work of a goldsmith (the art in which Ghiberti was trained and continued to practise) [14, 15]. Similarly, the shimmering tones of Donatello's St Louis of Toulouse were meant to imply that this large-scale niche sculpture was made of solid gold.

Any insistence on a firm distinction between artists and artisans, or between high art and craft, will miss such references. We need, therefore, to begin an exploration of 'what is it made from?', by looking at the ways work was categorized in the period itself, a time when the role of the goldsmith was often considered superior to that of the painter.

Precious materials

God and nature, rather than man himself, provided the most precious and valued objects in Italian collections. In the famed fourteenth-century Visconti library in Pavia or in Lorenzo de' Medici's fifteenth-century study, pride of place was given, not to paintings, but to the tusk of the sea-mammal, the narwhal, commonly assumed to be the horn of a unicorn. Ostrich eggs and nautilus shells were similarly conserved and displayed for their rarity and unusual properties. Pearls, diamonds, and other gems, carved or uncarved, were gathered because of their rarity, monetary value, and because of the magical abilities they were thought to possess. For example, coral was thought to ward off evil. It was not widely available and the inscription on the ex-voto gift presented to the baptistery of Florence by Anichino Corsi in Florence [16] indicates that he had obtained the unusually large and splendid piece of coral during a successful campaign against the Ottomans.[2] The guild responsible for the baptistery's decoration then commissioned an elaborate setting where the gilt-silver mount was used to emphasize and enhance the coral's natural shape.

The gilding, such as that used on the coral mount, was a way of using a valuable material sparingly, gaining the effect of gold without the expense. Italy was unusual in medieval Europe in having a reliable source of bullion for goldsmiths and official mints alike. Gold arrived regularly from northern and eastern Africa, from Egypt, and from Hungary, where an important new gold-mine had been established in the 1320s. The Venetian senate, which minted 4,000 kilos of gold ducats and 10,000 kilos of silver coins in 1423 alone, imported bullion from east-central Europe and Germany, as well as sending an annual

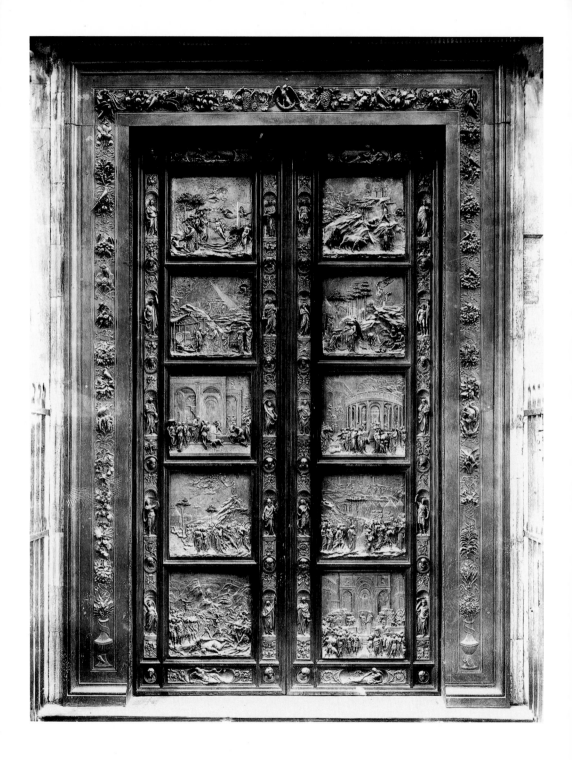

14 Lorenzo Ghiberti

'Gates of Paradise', gilt bronze, 1425–52, doors to the baptistery, Florence.
Ghiberti, who had already completed the first set of bronze doors, was immediately awarded the contract for this second set on 2 January 1425, work he was supposed to execute with the help of Michelozzo di Bartolommeo. Originally designed as twenty-eight scenes, the panels were eventually reduced to ten; work continued until April 1452, when the consuls responsible for commissioning the work agreed that, 'considering their beauty, the doors newly created for the church of San Giovanni should be placed in the doorway in the middle, facing Santa Maria del Fiore'. In lieu of final payment, Ghiberti received the house and shop where he worked on the doors.

convoy of galleys to Alexandria in Egypt during the late summer or autumn to trade, returning with valuable metals and other exotic materials: hippopotamus tusks, perfume oils, pearls, and precious stones. The thin, almost featherweight, gold coins first issued in the mid-thirteenth century—the florins of Florence and the ducats of Venice and Genoa—became the bedrock of the Italian trading system, securing the treasuries of princely and communal states alike.[3]

In state mints (and in the workshops of forgers) gold and other coins were struck by placing the metal between two dies and hitting the piece with a hammer. Thicker pieces, such as medals, were cast, a task which could also be carried out with relative ease. Apart from its ability to take an impression or its function as monetary exchange, gold had many other admirable physical qualities. Unlike silver or bronze whose colour changed radically over the years, it remained stable yet flexible. It could be beaten to microscopic thinness, bonded to wood or to other metals with glue, or stretched into thin threads which were wound around silk for weaving. Although it was expensive it could be made into an alloy with cheaper metals such as brass and copper which gave it a richer colour.

Thanks to its low melting-point it could also be mixed with liquid mercury and made into soft paste. This could then be rubbed on to metals such as silver or bronze which had higher melting-points.

15 Lorenzo Ghiberti

Detail of the Story of Joseph from the 'Gates of Paradise', gilt bronze, 1425–52, the Baptistery, Florence (original panel now in the Museo dell'Opera del Duomo, Florence).

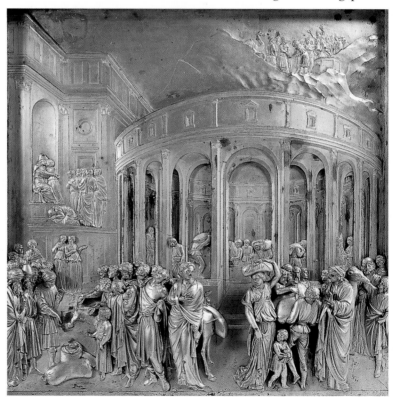

Ex-Voto of Anichino Corsi, coral mounted in partly gilded silver, 1447.

An inscription around the centre of the silver base explains that the coral was the 'spoils of war' which an otherwise unknown Florentine, Anichino Corsi, had obtained during an expedition against the Ottoman Turks and donated to the Florentine baptistery. The mount was commissioned in 1447 by the Calimala guild who were responsible for the baptistery's upkeep.

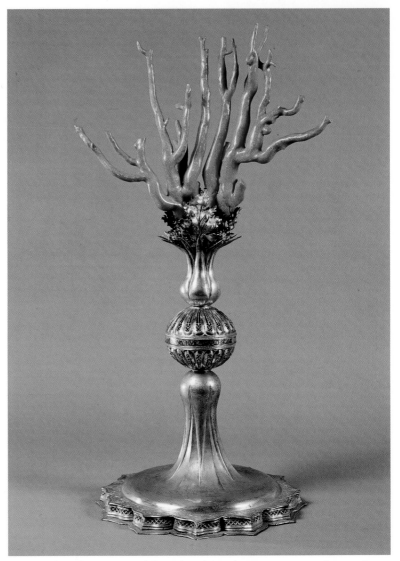

When placed in a special furnace, the mercury evaporated, creating a toxic smoke, and the gold literally merged with the metal underneath. This technique, known as fire-gilding, was used by Donatello on his figure of St Louis of Toulouse, a statue whose carefully crafted and enamelled bishop's crosier and mitre were precisely the types of objects that the goldsmith would have been expected to create in the quattrocento.

A scene from the late fifteenth-century stained-glass window from Milan cathedral dedicated to St Eligius, the patron saint of the goldsmiths' guild, illustrates the basic tools needed for this trade. The scene, as presented by the glazier and painter Niccolò da Varallo (1420–after 1489), represents a contemporary shop [**17**]. Within such an environment an apprentice would have learned both the basics of

17 Niccolò da Varallo

St Eligius is Apprenticed as a Goldsmith, stained glass, 1480–6, cathedral, Milan.

This is one of a number of stained-glass panels commissioned by the Milanese guild of goldsmiths for the window above their altar in the cathedral of Milan. St Eligius, the patron saint of metalworkers and goldsmiths, is shown here arriving to take up his apprenticeship. Note the small furnace, bellows, and tools which were characteristic of this trade.

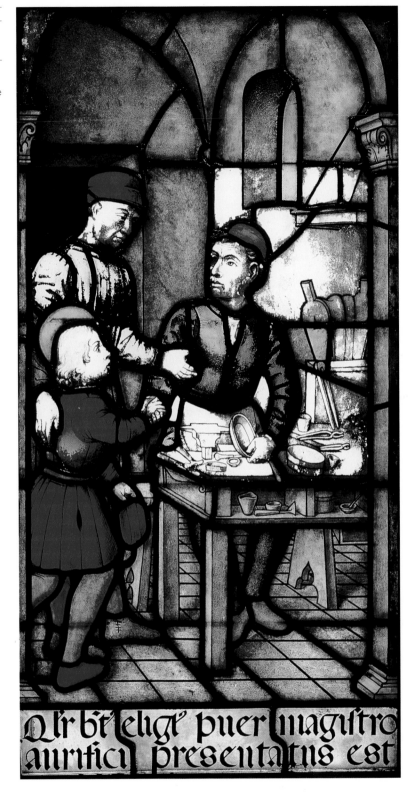

18 Simone di Giovanni di Giovanni Ghini

Golden Rose of Pope Pius II, gold and gilt silver with a sapphire tear-drop, 1458, Palazzo Pubblico, Siena.

Every year the pope delivered a golden rose and a sword to the prince or city who, in his judgement, had done the most to preserve the faith. In the fifteenth century recipients included the duke of Ferrara, Borso d'Este, and the king of England. This particular example was given by Pope Pius II (Aeneas Silvius Piccolomini) to his home town of Siena in 1458.

drawing, and how to acquire, weigh, and value precious metals. He would have also been taught how to operate and regulate the furnace whose bellows can be observed to the rear, to use the small hammers and calipers needed to beat the metal into shape and the punches used for embossing, and to work the chisels and burins required for delicate incisions.

The fragile leaves and stems of the papal golden rose shown in **18** illustrates some of the techniques at their disposal. The rose, along with a jewelled sword, had been given by the pope to secular authorities as a sign of his favour since the beginning of the twelfth century. This one was given by Pope Pius II (reigned 1458–64) to his native city of Siena in 1458. The finest goldsmiths were employed to produce these greatly prized hollow-stemmed flowers, leaves, and thorns. They added jewels, in this case a single sapphire tear suspended from the gold-wire branches, while fragrant perfumes such as balsam were inserted in the stem to ensure that the illusion was complete.

Each papal rose was meant to be preserved by its new owner as a sign of honour as well as a symbol of wealth. Similarly, gold and silver portrait medals were bestowed as signs of friendship or allegiance. The popularity of such commissions and gifts can be readily documented in the fifteenth century. The duke of Milan, Galeazzo Maria Sforza, gave the marquis of Mantua, his chief military officer (to whom he owed considerable back-pay), two large gold portrait medals worth the enormous sum of 10,000 ducats each. The temptation to transform these into ready cash was often too strong to resist and the survival of these fine casts is unusual. One example which is still visible is that of the marchioness of Mantua, Isabella d'Este (1474–1539), whose personal copy of her own medal was set in an elaborate frame of gold, enamelled gold braid, rosettes, and diamonds which spelt out her name. The reverse shows an image of victory standing under the astrological sign of Capricorn, the birth-sign of the Emperor Augustus. The amount of surface-work, cold chasing, punching, and striations on both the medal and the frame indicate that this was a carefully prepared piece which repaid close observation. We know from an inventory of Isabella's rooms, drawn up after her death in 1528, that it was displayed in a special case next to an antique cameo, encouraging comparison between her own image and that of the Romans and between antique craftsmanship and that of modern-day artists such as the medallist and sculptor Gian Cristoforo Romano (1470–1512) [**111**].

If gold was the most superior of the metals, silver was more easily obtainable. It was imported in relatively large quantities from Germany and east-central Europe, and, as we have seen, the goldsmith and his patrons often disguised it with a thin patina of gold to conceal its origins. This is the case with the reliquary head of St Dominic, created by Jacopo Roseto (dates unknown) in 1383 [**19**] which is composed

19 Jacopo Roseto
Reliquary head of St
Dominic, silver, gilt-silver,
and enamel, 1383, San
Domenico, Bologna.

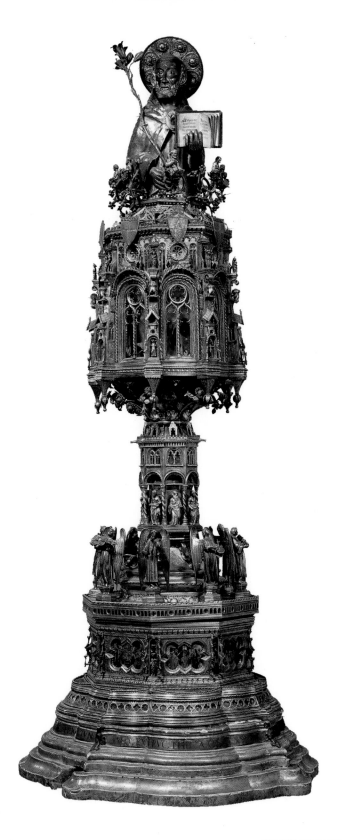

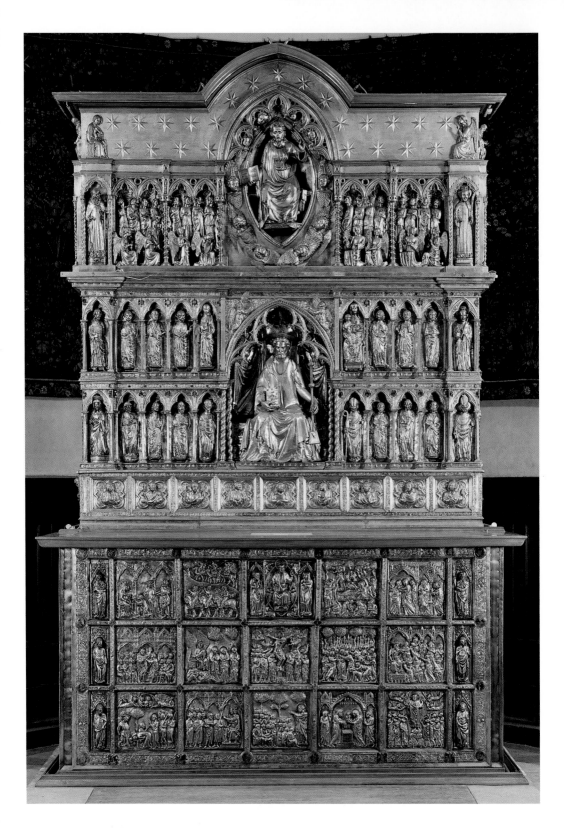

20

Silver altar of San Jacopo, San Jacopo, Pistoia, 1287–1456, silver, gilt-silver, enamel, and jewels.

Although work commenced in 1287, the shrine was primarily designed and produced after 1361 when two Florentine goldsmiths, Francesco Niccolai and Leonardo di ser Giovanni, were employed for a decade on the elaborate reliquary-altar dedicated to St Jacopo. Work was still under way in the fifteenth century when Brunelleschi and possibly Donatello made contributions.

of 2,946 pieces of gilt silver fused together along with forty-eight small statuettes.[4] Silver's natural luminescence was also appreciated in its own right. Two Tuscan works created contemporaneously are elaborate masterpieces of the smith's art, the altar of San Jacopo in Pistoia [**20**] where an earlier initiative was taken forward in 1361 and completed around 1456, and the altar created for festival occasions in the baptistery in Florence, begun in 1367 [**21**]. The central image of St John the Baptist, the patron saint of Florence, was added in 1452 by the sculptor Michelozzo Michelozzi (1396–1472) [**22**], who used the lost-wax method to create a free-standing statuette.

Much of Michelozzo's skill lay not just in the casting and chasing of the metal itself, but also in the subsequent enamelling which coloured the figure and its surroundings. This was an equally complex procedure where the artist created a paste from vitreous materials—sand, red lead, soda, or potash—which were melted together and mixed with metallic oxides for colour. The resulting slab was then ground and spread on to the surface for firing at temperatures which fused the paste without melting the metal. By the fifteenth century the image was often engraved directly on to the metal itself and the special technique known as niello seems to have developed from this process. Here a black metal alloy of silver, sulphur, and lead was placed in hollowed depressions of the engraved base and then fired to create objects which were used as belts, buckles, buttons, or most popularly as paxes—a plaquette which was kissed during the mass when, during the 'Agnus Dei', the priest called out, 'The peace of the Lord be always with you'. The one shown in **23** with the Coronation of the Virgin was commissioned from Maso Finiguerra (1426–64) by the merchants' guild in Florence in 1452 as a donation to the baptistery. This particular piece

21

Silver Paliotto for the altar of St John the Baptist, Baptistery, Florence, silver-gilt and enamel, begun 1367.

The silver altar frontal which depicts the life of Saint John the Baptist was commissioned from Betto di Beri and Leonardo di ser Giovanni on 16 January 1367 by the Calimala guild. A series of artists contributed to the altar which was completed after 1477 when the guild commissioned side panels from Andrea del Verrocchio and Antonio del Pollaiuolo. On the feast day of St John the altar and the relics and other precious objects owned by the baptistery were put on view.

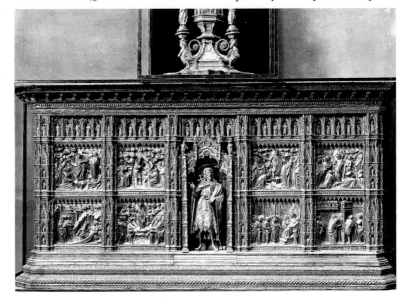

As 21; detail: figure of
St John the Baptist, 1452,
by Michelozzo di Bartolomeo.
This statue of St John, the
patron saint and an important
civic symbol of Florence was
made by Michelozzo, the
architect of the Palazzo
Medici, and a close
collaborator of both Lorenzo
Ghiberti and Donatello.

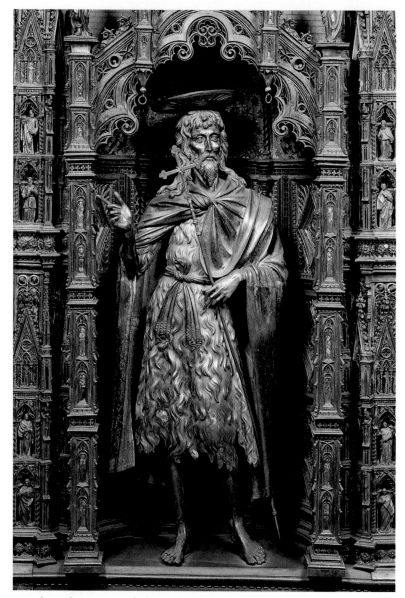

may have been passed through the congregation to be kissed, but it
seems many Italians purchased their own personal pieces in order
to avoid having to share a pax, no matter how splendid, with their
neighbours.

Bronze

Works in gold and silver had one distinct disadvantage: they could be
quickly transformed into cash. Many of the valuable early reliquaries
and liturgical objects from the sacristy of the Florentine cathedral and
of the church of San Lorenzo were destroyed when the city confiscated
such goods to pay their troops in 1529. In 1499 Duke Ludovico Maria

Sforza of Milan similarly appropriated his cathedral's sacristy wealth to pay his army.

Bronze—an alloy of copper and tin—was much cheaper than gold or silver and while it might be melted down to make cannons and other heavy weaponry, there was little point in destroying a statue to make pennies. Yet while its components were easier to obtain than precious metals, getting pure elements whose melting-point and colour would prove consistent was still difficult. Most of the sources for copper were in northern Europe and Italian patrons hoped to avoid the expense of mining and transport by melting down existing copper objects. In Siena, for example, the government collected and stored cauldrons, pots, and pans for the doors they planned for their cathedral in the mid-fifteenth century. In Florence, the committee responsible for that city's duomo also accumulated mortars, brass basins, and other small-scale metal objects to obtain the ingredients needed for its new sacristy doors.

Special long-term bronze-casting projects required special mining provisions. Made over a period of twenty-five years, Ghiberti's Gates

of Paradise have a very high copper content (93.7 per cent) with tin, zinc, and lead making up the alloy.[5] The consistency of his materials was only possible because his copper came from the same mine in Burgundy. It was equally common to turn to neighbouring Germany for supplies and, inevitably, areas which had a well-developed armaments industry stockpiled and distributed the materials needed to create bronze. Thus although a small group of Tuscan artists made their reputations as designers and engineers working in bronze, it was Venice, which had established trading links and a reputation for cannon-founding in its arsenal, which proved to be one of the most reliable suppliers of basic materials.

For small objects, the casting process was quite straightforward, requiring little more than a shallow dish of damp sand and enough heat to melt a limited amount of copper. To create a single-sided medal or a plaquette, a mould would simply be pressed into the sand to create an impression. The hot metal would then be poured and left to cool. After the piece was removed, the rough edges and surface marks were smoothed away and the object was polished. The system was only slightly more difficult for a work such as Isabella d'Este's double-sided medal where both the obverse and the reverse needed to be considered.

For large-scale bronzes, however, the casting procedure, based on the lost-wax process, was as much a question of engineering as of artistic design. Many of Leonardo da Vinci's drawings for his enormous equestrian monument to Francesco Sforza concerned the problems of actually assembling and transporting the huge terracotta model to the site where it was to be cast [109, 110]. In an age without reliable furnaces, generating a consistent high heat and pouring the molten metal were all troublesome procedures which required access to both large quantities of fuel and specific types of expertise. It was, thus, quite common for sculptors like Donatello to turn to expert foundrymen or coppersmiths to carry out the actual casting. It is not surprising as well to find that in Leonardo da Vinci's case, his patron Ludovico Maria Sforza was as concerned with his technical abilities as he was with his ideas.

One solution to the problem of monumental bronze-casting favoured by both Donatello and Leonardo, was to reduce the work to multiple parts which could be cast separately. This was how the figure of St Louis of Toulouse, which was made out of eleven separate pieces, was created. Some sculptors, such as Verrocchio, made moulds directly from the hands, arms, feet, and legs of their assistants and then attached them to the body of the statue. Others, like Lorenzo Ghiberti, made their reputation because of an ability to create figures in as few sections as possible. When in 1401 the Florentine guild responsible for embellishing the city's baptistery had to choose an artist to create a new set of bronze doors [24], Ghiberti's entry in the compe-

tition won, in part, because of the technical sophistication of his offering, a single plate, with only one attached figure, the nude Isaac. His competitor, another goldsmith, Filippo Brunelleschi, had also created an impressive scene, but many more of his figures had been added on to the back-plate, making seven separate sections. Brunelleschi's method had some advantages; if the casting failed on one figure the rest of the work was not affected. But had his design been chosen, it would have required more bronze and taken more time to complete. Patrons continued to have high expectations of Ghiberti's technical abilities. When he signed his contract with the Florentine bankers' guild, the Cambio, for the figure of St Matthew on the shrine of Orsanmichele in 1419, the artist specifically promised to make it in only two pieces, the body and the head. But even exacting clients knew how difficult his work was. When the figure's foot failed to emerge properly from the mould, the Cambio representatives agreed to pay for its recasting without hesitation [**123**].

Stone

By the mid-fifteenth century the statues in the exterior niches of the church of Orsanmichele provided excellent illustrations of the different capabilities and challenges of bronze and marble. While Ghiberti created his three saints exclusively in metal, his colleague and competitor Donatello was experimenting with techniques which allowed extremely shallow carving, so-called *schiacciatto* relief, as well as working in the round on large-scale monumental figures.

Even marble, however, did not have the same prestige as bronze. Stone was too common. Although some rare types like the porphyry used in the Medici tomb were only obtainable by reusing antique

A model is made from wax. Where, as in the case of Verrocchio's figure of Christ for Orsanmichele, the work is complex, a preliminary model may be made in clay or plaster [1] and then a negative plaster cast taken of the model is created [2,3]. A full wax model is then created [4].

Wax spouts, known as runners and risers, are attached to serve as funnels known as pour channels, for the molten metal, and as vents to expel wax, gas, and air. Reinforcing pins keep the work stable. The entire mould is encased in clay and the metal is heated and poured [5]. The bronze fills the cavities left by the melted wax. When cooled, the outer clay case is removed revealing the finished work [6].

The holes made by the reinforcing pins, and the runners and risers, are repaired along with any other damage. The surface is worked with files, fine abrasives, punches, and burins to bring the surface to a sheen and to incise delicate surface work. A patina may be applied to give a consistent colour.

1

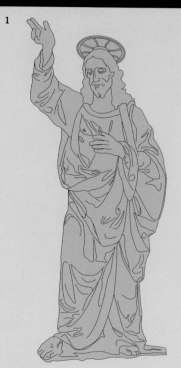

4

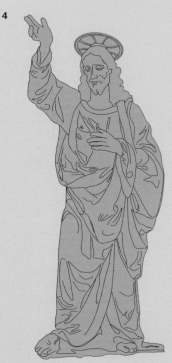

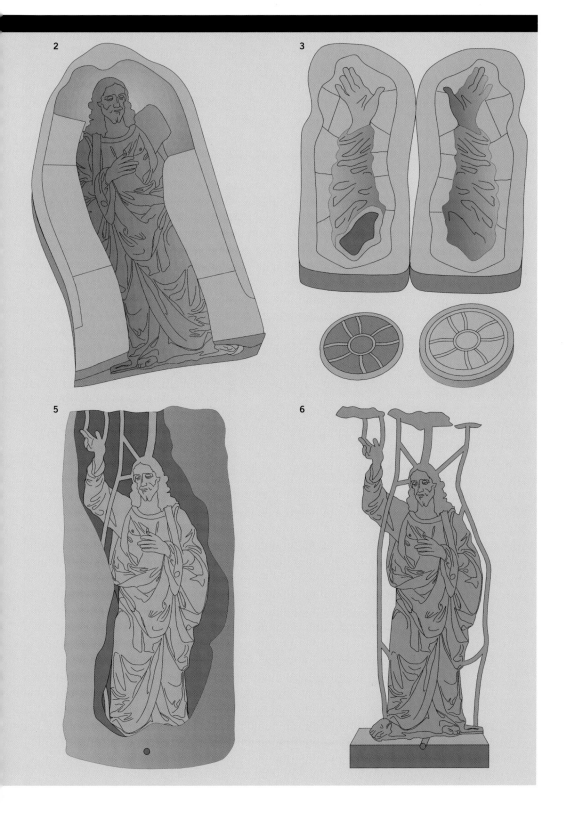

pieces, there was an extraordinary range of hard and soft stones which were readily available throughout the peninsula. Regional quarries provided much of the local buildings and sculpture, stones which gave each Italian town its distinctive coloration. In the north, sources in the lower areas of the Alps provided the coloured marbles: the streaky Candoglia of Lombardy; the reds, whites, and blacks of Verona; the bronze colours of the Botticino marble of Brescia. The white Istrian limestones from the Dalmatian coastline were imported through Venice in considerable quantities by a well-established system of merchants and shippers. Tuscany also had numerous marble, sandstone, and limestone quarries, including the fine-grained white marble of Carrara to the north of Pisa. Further south towards and beyond Rome the local stone was softer, primarily volcanic Tufa and Travertine.

Quarries were often established for specific projects and their long-term survival was only assured when specialist workers were either able to fulfil the needs of a major institutional project such as a cathedral or a reliable demand for domestic objects like door-frames, stairs, balustrades, pestles and mortars, or stone cannon-balls (the demand for which was very high in the late trecento and early quattrocento). The availability of such stone was not an issue; the techniques and manpower needed for excavating the material were more problematic. The cost of the stone was then multiplied several times over by the expense of transportation. Sending Carrarese marble to Milan or Pavia, for example, entailed moving the blocks from the quarry to the port at Pisa and then sailing them around the peninsula to Venice where they then had to be loaded on to barges which went up the canals of the Po Valley into Lombardy.

Given the expense involved, patrons were usually careful to specify the precise type of stone they wanted, a choice which made a tremendous difference to the sculptures design, eventual appearance, and longevity. When the Sienese sculptor Jacopo della Quercia (c.1374–1438) embarked on the portal and façade of the church of San Petronio in Bologna in the 1420s, he was sent north to secure supplies, using quarries near Verona and Valpolicella for red stone and buying white Istrian marble from Venetian warehouses. The selection of these hard-wearing stones meant that his work in San Petronio has lasted relatively well over the centuries [128]. The prime disadvantage of these limestones was that they could not be polished and required a greater use of abrasives and a time-consuming process of carving; for example, we know that it took the Venetian sculptor and architect Bartolomeo Bon (active 1426–d. 1464), 203 days to carve an elaborate limestone well-head between 1427 and 1428.[6] While softer limestones and marbles were easier to manipulate, they did not resist adverse weather conditions well. The fountain della Quercia created in Siena's central square, the Fonte Gaia, was carved in a porous local marble

[120]. This originally permitted crisper edges and sharper three-dimensional figures, but the poor quality of the stone has meant that his panels and figures are almost illegible today.

The most expensive marble came from further away in the mountains above Pisa, in the Carrara region. The stone was much denser and more compact in its crystalline structure. For works which required a clear edge and a high sheen, it was increasingly preferred by sculptors and patrons alike. By the early fifteenth century Carrarese marble, like most other types of stone, could be purchased through specialist merchants and dealers (a number of whom were related by blood or marriage to the sculptors and masons themselves). Although the specialists dealt with the quarries and problems of transportation, this purchasing system should not disguise the continuing difficulties and expense of deciding to commission a stone monument. Nor did it fully relieve the craftsman from the responsibility of selecting his own stones. Niccolò dell'Arca's contract for the San Domenico tomb cover specified that he had to obtain the finest quality marble from Carrara himself [11]. Donatello refused pieces of marble which the cathedral of Florence had procured when the measurements or standards were not to his liking. Michelangelo's first task when he was awarded the contract to design the *Pietà* for a chapel in the basilica of St Peter's in Rome in 1495 was to return to the Tuscan quarries to select the large piece of high-quality marble which was required [117].

Because of the investment in the material itself, sculptures were carefully thought through before work was initiated. Although preliminary models made of clay or wax do not seem to have been common until the second half of the fifteenth century, earlier sculptors' contracts indicate that drawings were normally appended. For the Fonte Gaia in Siena, Jacopo della Quercia was required to draw his plans on a wall within the town hall. To achieve their effects, stonemasons such as della Quercia used large, powerful axes, hammers, chisels, claws and drills, and abrasives, the evidence of which can still be seen on the rear of pieces designed for niches. Having roughed out the work, the artist proceeded to use finer and finer tools and abrasives to finish the work while a final polishing removed the tool-marks of the chisel and claw. A wash with mild acids might remove the evidence of carving to create a finely polished surface, or the sculptor might appreciate the reflections and shadow the marks provided.

Wood and clay

Despite the emphasis on obtaining unflawed stones, marble was often painted or, at the very least, gilded. The fine white simple forms of Francesco Laurana's (*c.*1420–1503) bust of an Aragonese princess in the Kunsthistorisches Museum in Vienna [138] are the invention of a nineteenth-century restorer who stripped away much of the original

pigmentation and wax additions. The gold and paint added considerably to the object's cost and value; materials such as wood and clay were chosen precisely because they were easier to colour. Whatever the hierarchy we now hold, wood—usually poplar, walnut, or chestnut—was not regarded as a particularly cheap or disposable material in the Renaissance, particularly in Tuscany where deforestation was widespread. Italian artists were well known for their techniques of marquetry and intarsia work as well as for their pictorial skill. In 1408, for example, the wealthy duke of Berry was offered the services of the Sienese sculptor who specialized in this type of work, Domenico di Niccolò dei Cori (c.1362–1450): 'there is a worker in mosaic and also in marquetry pictures, so beautiful and well finished in various colours of wood that no man was ever a better worker than he is in this science'.[7] By the fifteenth century the workshops of Giuliano da Maiano (1432–90) in Florence and of the brothers Cristoforo (d. 1491) and Lorenzo (d. 1477) Lendinara in Emilia, were producing inlaid panels with astonishing illusions for clients throughout Italy and abroad [51, 52]. They used a relatively limited range of woods, the most common being the soft poplar, harder pear, and walnut, while the darkest colours were created by bog oak which had been blackened by long soaking. Thin pieces were carefully placed in patterns using glues made from cheese or animal substances. The work had to be created with precision since changes in humidity and temperature might loosen the individual wood fragments, destroying the inlay and the illusionistic effects.

Wood was also valued because of its relative lightness, flexibility, and the way in which broad gestures and outstretched arms, which were difficult to create in marble or bronze, could be created and even moved. The diameter of the tree-trunk fixed the limits of the overall piece but joins could be easily cut and reset for popular figures such as the Angel and Virgin Annunciate. The guilds which sponsored such works often used to dress the figures in garments which matched the liturgical calendar and the holy event taking place. The Annunciation figures from Montalcino [25], signed and dated 1367 and 1370, were put into place on either side of an altarpiece. The two figures were probably a collaborative effort between the carver and a painter who decorated the wood. When Jacopo della Quercia provided the figures for a similar Annunciation arrangement in San Gimignano in 1421 [26], he signed one of the figures while the painter Martino di Bartolomeo (1389–1434) signed and dated the other.

Terracotta figures were similarly painted and grouped in even more complex arrangements. Like wood, clay had the advantage of cheapness, weight, pliability, and easy manipulation. Working in clay was not, however, entirely without its associated costs. There was the need for a kiln, wood for fuel, and high-quality clay as well as the chemical

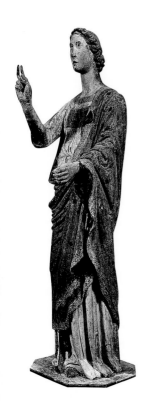

constituents of the glazes. Specialist manufacturers in majolica, the tin-glazed earthenware which graced the tables of most of the élite households in Italy, were both proud of and very secretive concerning the special nature of their techniques, such as those needed to make the lustreware, which had to be fired three times to achieve its special sheen.[8] The process of making Niccolò dell'Arca's figures for the *Lamentation over the Body of Christ* required similar investment [**8**, **9**, **10**]. He needed a large furnace and confronted the problem, common to all work in clay, of shrinkage and cracking during the firings. The figures had to be hollowed out, and cut into pieces—the figure of Christ, for example, was fired in three sections. The work would be reassembled before being gessoed and painted so that any imperfections could be disguised.

The two figures that make up the Florentine sculptor Luca della Robbia's (1399/1400–1482) *Visitation* [**27**], made in around 1445 for the church of San Giovanni Fuorcivitas in Pistoia, were created in a very similar way. The lower section of the two women's bodies was modelled individually but in the upper area, the right hand of the Virgin was shaped and fired on the shoulder of St Elizabeth, indicating that della Robbia had carefully considered the interrelationship between the two figures. Luca della Robbia's technique of tin-glazing, derived from majolica pottery, made his work both durable and colourful, proving popular throughout Tuscany and abroad for every form of artistic production from free-standing statues to altarpieces and heraldry. His works were moulded or modelled in clay then fired in the normal fashion. In the next stage they were treated as if they were enamels and covered with lead and tin oxides and a vitreous material made from potash. This provided a stable white ground on to which a restricted number of coloured glazes could be laid. The piece would be refired and when the pigment and glaze fused the resulting work proved brilliantly coloured, colours that it would retain for centuries to come. As importantly, the work was much quicker to complete than marble-carving and there was no need to import stone or to employ a painter. The glazing formula and process was considered an industrial secret; when Luca della Robbia died, he implied that by leaving the recipe to his nephew Andrea, the young man's fortune was ensured.

Glass
Majolica glazes were closely related to glass production and are extensions of the technical skill and unusual materials which were in evidence in the works on the mainland, but above all on the Venetian island of Murano. To make the translucent pieces which established this glass as a luxury item, traders imported its main ingredient from Syria: high-quality potash which came from calcified plants. The potash provided the ballast for boats returning from the Middle East

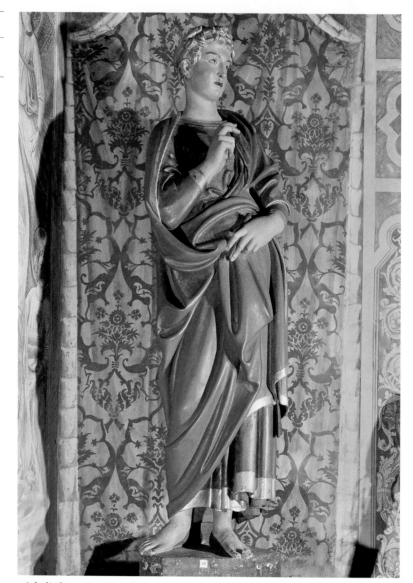

with light cotton and since the thirteenth century the Venetian government had banned its export from the city. These ashes were mixed with the crystal pebbles and sand from the rivers of the Veneto and Lombardy. The clay to make the crucibles in which the glass was fired came from Constantinople. The high investment in quality materials and manufacture, alongside strict government controls over the quantity which could be produced and fierce limits on the export of workers and raw goods, meant that Venetian glass was much sought after in the fourteenth and fifteenth centuries. Coloured glass was created by adding different metals to the mixture and painted enamelling, such as that seen on the amethyst-coloured plate from Trent [**28**], was widely practised by specialists, including a number of women, who usually

worked for the owner of the furnace rather than directly for the client. The amounts which were produced could be prodigious. The inventory of one producer in Verona taken in 1409 listed approximately 40,000 pieces, mainly drinking vessels of one form or another.[9]

More prized than the common coloured glass was clear glass-crystal, created in imitation of the natural but much rarer clear rock-crystal. This was already being made in Murano during the fourteenth century but in the mid-1450s one specialist, Angelo Barovier (d. 1461), has been credited, perhaps apocryphally, with the invention of a new form of purifying the Syrian ashes, making possible the translucency which we now take for granted. His shop, which was inherited by his son and daughter, was later also known for its production of

milky-white pieces [**29**], designed to imitate the Chinese porcelain which Italians were still unable to copy in the fifteenth century.

Drawing and painting

Stained glass is often considered the preserve of the medieval period and its fifteenth-century manifestation, such as the panel by Niccolò da Varallo for the cathedral of Milan, is only now being given the attention it deserves. The creation of stained glass was very much a joint effort between glaziers and painters, who worked closely together. The designs for the windows of the church of Orsanmichele were, for example, provided by the painter Agnolo Gaddi (*c.*1345–96) in the late fourteenth century and by Lorenzo Monaco (1370/1–1425/6) and Lorenzo Ghiberti in the fifteenth century.[10] This work is only one area in which artists who specialized in different crafts and belonged to different guilds collaborated. Lengthy lists could be made of such interchange. Gaddi, for example, also designed sculpture, providing drawings for the allegorical figures on Florence's Loggia dei Lanzi.

The relationship between painters and sculptors can be docu-

27 Luca della Robbia

The Visitation, enamelled terracotta, *c.*1445, San Giovanni Fuorcivitas, Pistoia.
In 1441–2 Luca della Robbia began experimenting with the tin-glazing techniques which would establish his reputation in terracotta. Although much of his work is well documented, the only record relating to the Visitation is a donation (for the perpetual illumination of the figures) made in October 1445 by a female member of one of Pistoia's wealthiest families, Monna Bice, the widow of Jacopo di Neri de' Fioravanti.

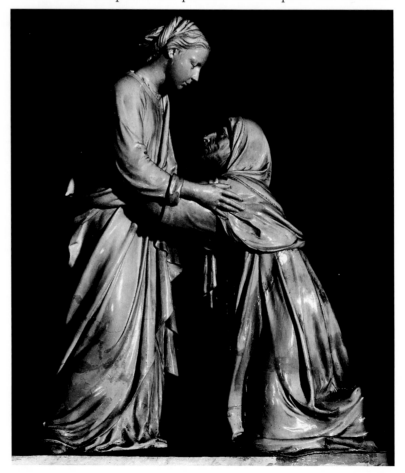

28

Glass plate, mid-fifteenth century.

This survives in unusually good condition and is decorated with grapes and vine-leaves, peacocks and other birds. In the centre, a female figure appears wearing a French-style head-dress popular in the mid-fifteenth century.

mented in almost every town. In 1476, for example, the Venetian sculptor Antonio Rizzo (active 1465–83) promised the Scuola Grande di San Marco in Venice that he would make a pulpit following the designs of the painter Gentile Bellini (active c.1460–d. 1507).[11] Domenico di Niccolò dei Cori provided the designs for the mosaic floor of Siena cathedral; in Padua, Francesco Squarcione (c.1397–1468) provided drawings for the intarsia of the sacristy panels of the Franciscan church of Sant'Antonio, known as the Santo, as did Alesso Baldovinetti (c.1425–99) for the creation of the sacristy panels for the cathedral in Florence. Weavers and embroiderers also relied on the provision of designs such as those Cosmè Tura (1430–95) gave to the French tapestry-maker Robinetto di Francia, which were used for two versions of a *Pietà* for the Este court chapel in 1475 [**147**]. Robinetto was one of the few weavers in Ferrara trusted with such tasks and Tura normally

29 Giovanni Barovier and Giovanni Maria Obizzo (attrib.)

Enamelled white '*lattimo*' drinking-glass, *c.*1495–1505. The heavy white coloration, obtained by mixing lead oxide with the glass silicates, was meant to imitate the Chinese porcelains being imported into Venice. The Barovier family had traditionally employed painters to enamel their works, and Giovanni Barovier is documented working in association with the Venetian painter Giovanni Maria Obizzo between 1490 and 1525.

30 Master Bernardo, embroiderer

Chasuble of Pope Sixtus IV, (based on the designs of Pietro Calzetta), 1477.

The contract for the orphrey attached to the chasuble indicated that Calzetta's designs were paid for by the embroiderer himself. They are based on Sixtus IV's Della Rovere family coat of arms: the oak-tree and acorn.

sent his drawings north to specialist weaving centres in Flanders and France.

Cloth manufacturers also needed the assistance of painters such as Pisanello (before 1395–1455) who provided designs using his patron's particular mottoes and devices [**54**]. In Genoa, the 1423 guild statutes of silk manufacturers tried to prevent unlicensed use of another weaver's drawings and insisted that painters were not to supply the same drawing to multiple clients.[12] Embroidery was a further area of exchange between different specialists as professionals purchased drawings for ecclesiastical and secular garments. An orphrey (the decorative piece at the edge) for a liturgical garment which Pope Sixtus IV (reigned 1471–84) donated to the Santo in Padua in 1477 was embroidered by a Master Bernardo who, we know from his contract, purchased the drawings of saints which he needed from the local artist Pietro Calzetta (1430/40–86) [**30**].[13] Some artists such as Andrea Orcagna (*c.*1308–*c.*1368), who designed the Orsanmichele tabernacle, painted the Strozzi altarpiece of 1357, and provided many of the designs for Florence cathedral, worked simultaneously across different media. In 1358, for example, when he agreed to take on the task of supervising the cathedral in Orvieto, Orcagna was to 'organise the building work and the creation of images, paint with a brush, work in mosaic, and polish figures made of marble'.[14] Antonio Averlino, now known as Filarete (*c.*1400–*c.*1469), boasted in his treatise (*c.*1464) that he was capable of designing glass, medals, statues, buildings, cameos, and cannons. In the late fifteenth century his compatriot Antonio Pollaiuolo

(1431/2–98) was similarly versatile, providing altarpieces and designing embroidered vestments, jousting helmets, and works in gold, silver, and bronze.

Filarete and Pollaiuolo were renowned during their lifetime for their abilities as draughtsmen, *maestri del disegno*, a complex term which alludes to the central skill needed for the painter's multiple occupation and applications. Drawing techniques were emphasized in the early years of training during which the young apprentice might work in the rigorous form of silver-point on prepared coloured paper, or in the more fluid forms of lead-point, charcoal, or pen and ink on plain paper or parchment. Every written source from the period stresses the importance of such practice, which included both the careful observation of nature and the faithful reproduction of the works of recognized masters. During their training, apprentices usually incised their work on a wax tablet for paper, parchment, and even the silver stylus they used were very expensive. When writing out a list of all the items a young apprentice had stolen in the 1490s, for example, Leonardo da Vinci noted with annoyance that the young boy had taken the silver pen of another member of the shop.[15]

Drawings had multiple uses. Presentation pieces, such as the design for the arch of Alfonso of Aragon, attributed to Pisanello [**104**], and the drawing for a fountain in Siena by della Quercia [**118, 119**] were, as we have seen, meant to give the patron a good indication of a large-scale monumental project. Others, like the sketches by Leonardo da Vinci for the Sforza horse, were used by the artist himself to work through problems [**109, 110**]. We know that drawings were carefully listed in artists' inventories and were handed down from father to son, or passed from one shop to another. Nevertheless, despite such contemporary attention, only a tiny percentage of what must have been extensive numbers of drawings remain from the fourteenth and fifteenth centuries. Of these rare survivors, some contain formulaic figures and compositions that the workshop would turn to. Others are more elaborate. Two carefully prepared and bound books, one on paper, and one primarily on parchment, from the shop of the mid-fifteenth-century Venetian painter Jacopo Bellini (active *c*.1424–d. 1470/1) are quite puzzling. Their survival is due to the fact that they were regarded as valued curiosities rather than as working drawings to be copied, pricked, or reused and redrawn. After Jacopo's death in about 1470, the parchment sketchbook was preserved by his widow who passed it to their son Gentile in 1471. He, in turn, took it to Constantinople in 1479 where it seems to have been acquired by Sultan Mehmed II. The book is now in Paris and scholars are able to say a great deal about how it was actually made. For example, Jacopo used whatever parchment was to hand, reusing sections from an earlier fourteenth-century pattern-book which had drawings for silk-

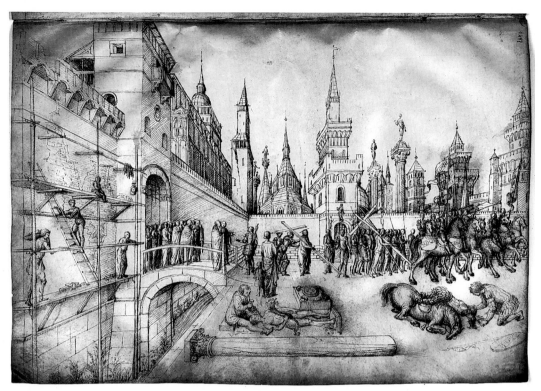

31 Jacopo Bellini

The Bearing of the Cross, silver-point on prepared parchment, c.1430–50.

Many of the carefully prepared drawings in this parchment sketchbook relate to the artist's interest in antiquity and the depiction of perspectival space. Here, he has placed the scene of Christ's March to Calvary against a foreground of artistic endeavour: a sculptor works on a cornucopia-bearing male nude while to the left, artisans repair the city walls. The album remained in the possession of the Bellini family until it was given to Sultan Mehmed II by Jacopo's son Gentile in 1479.

weaving and embroidery. He covered over the support with a fresh ground and then used silver- and lead-point, strengthened with pen and ink, to create elaborate compositions such as the image of *Christ Carrying the Cross* shown in **31**. Yet while scholars have investigated the book's construction in considerable detail there is still no agreement as to why it was created. It is possible that Jacopo Bellini was experimenting with the mathematics needed to create perspectival illusions, or that he was copying works and antiquities which he had seen.

Models and visual ideas such as those created by Bellini were easily transferred from artist to artist, sometimes without their permission. In 1425, for example, Lorenzo Ghiberti complained that he had lent a fellow goldsmith in Siena some drawings of birds which, much to his annoyance, had then been passed on to the specialist wood-sculptor Domenico di Niccolò dei Cori without his knowledge.[16] A design by Antonio Pollaiuolo which had been used in a workshop in Padua was, according to the aggrieved master Francesco Squarcione (1397–1468), stolen by his apprentice Giorgio da Sebenico (d. 1475), who took it back with him to Dalmatia and only returned it, along with seventeen other purloined drawings, much later.[17]

Squarcione had a particularly interesting collection of drawings which he put to multiple uses. Towards the end of his life, for example, we find him loaning a drawing by a deceased colleague to yet another painter, who was going to use it as the model for a chapel dedicated to

the Corpus Christi, the body of Christ (see page 105). The way ideas, iconography, and styles travelled through objects, drawings, and by instruction make it possible to understand how a particular visual style could spread with great rapidity across Italy and abroad to be accepted or rejected at will.

Wall-painting

Today, the Italian Renaissance is firmly associated with fresco painting such as the narrative scenes of the Brancacci chapel in the Carmine in Florence [**92**, **93**, **94**]. But to contemporary viewers these were comparatively inexpensive substitutes for more notable forms of decoration in mosaic or woven hangings. By the mid-fourteenth and certainly by the fifteenth century, however, the once-common techniques of mosaic and the manufacture of glass tesserae were rapidly disappearing. This does not seem to have been due to a lack of demand; merely maintaining and repairing the existing mosaics in prestigious sites such as the basilica of San Marco in Venice strained the available specialists.

Tapestries, woven both abroad in France and Flanders and at home, were acceptable alternatives, as were rich and expensively woven clothes, particularly since their portability meant that they could be used in different places for different occasions. The investment in looms, and the specialist skills needed to translate designs on to the weft and warp of the cloth, were considerable. There were attempts to bring tapestry-weavers into Italy, and the Bolognese government sponsored one weaver who promised to set up an industry in their city. But as we have seen with the case of Cosmè Tura in Ferrara, it often proved simpler to send drawings north and receive tapestries in return.

Fresco-painting was a faster, cheaper, and more durable alternative to cloth and tapestry, whose designs and effects it often imitated. Although less labour-intensive and with lower material costs, it still required considerable skill. The artist had to carefully prepare the wall surface, put up appropriate scaffolding (often one of the most important costs of the project), and ensure that the work proceeded smoothly. There were many variables involved and fresco-painting was highly dependent on the weather. Too cold and wet and the plaster would not dry; too hot and it would dry before the section had been completed. The temptation to find ways of slowing down the pace of true fresco led to experiments with the use of 'fresco secco' or dry fresco, in both tempera and oil. Some pigments, such as the ultramarine blue made from lapis lazuli, always had to be laid on *secco*, while oil-painting was already being used in fresco by Piero della Francesca (*c*.1420–92) in his work in Arezzo in the 1450s. Leonardo da Vinci's famously disastrous experiments with new techniques of using oil for fresco-painting ensured that his painting of the Last Supper for the

Fresco-painting

First a rough layer of plaster, the *arriccio*, was laid. Then an underdrawing, the *sinopia*, was often rapidly sketched in. A fresh patch of fine wet plaster, the *intonaco*, was placed on a small section and the actual work of painting began. In true or *buon* fresco the diluted pigment would be painted directly on to the wet plaster in order to chemically bind with the calcium in the gypsum, creating a fixed, stable surface that could not be erased. This meant that the painter had to work rapidly and efficiently and that only as much plaster

would be laid as he could finish in approximately one day, a section known as a *giornata*. Work always started at the ceiling and the top of the wall and the joins between the plastered areas can often be easily identified. You can see from the *giornate* which have been identified in Masaccio's painting of *Saint Peter's Shadow Healing the Sick* in the Brancacci chapel that the artist first worked rapidly on the upper sections of the fresco but gave a great deal of time to the faces of the central characters.

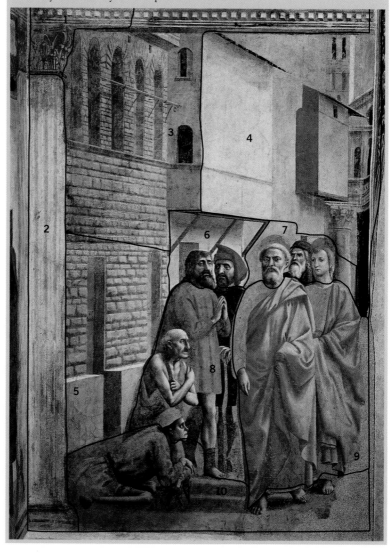

refectory of the monastery of Santa Maria delle Grazie in Milan was already disintegrating a few decades after he had finished his work. Oil painting did not necessarily replace tempera; patrons might prefer true fresco precisely because of its longevity and stability. By 1448 contracts such as that drawn up for the Ovetari chapel in Padua were insisting that the work 'should be painted in fresco and not in oil', while both the Tornabuoni and the Strozzi patrons of the frescoed chapels in Santa Maria Novella in Florence, painted in the 1480s and 1490s, were adamant that their artists work in true fresco, clauses which are useful reminders that not all innovations were seen as progress.[18] [4, 5, 86, 87].

Painting on panel and canvas
Traditional manufacturing techniques were equally important for paintings produced on supports such as cloth, leather, paper, wood, and canvas. In many larger cities painters had become quite specialized by the late fourteenth century. There were painters of playing-cards, painters on wax who decorated candles and votive offerings, painters on leather and paper who produced dog-collars, bridles, and trappings for horses as well as the vast quantities of pennants and shields required for any procession of soldiers, knights, or funeral mourners.[19] These were regular, reliable sources of income and the same artists might be sporadically called upon to provide bigger items such as altarpieces which took longer to produce and a greater investment in time and materials.

Although styles shifted, the actual process for creating a large altarpiece on panel remained fairly consistent between 1350 and 1500. A carpenter usually provided the wooden framework, one which in Italy was typically made from soft poplar wood. This base was one of the most expensive elements and separate contracts and designs were often drawn up to determine the overall shape and format which was occasionally, but not necessarily, made to the painter's design. Vulnerable to woodworm and to changes in temperature and humidity, the panel had to be carefully seasoned. There were numerous details such as buttresses and spiralling finials or pieces of sculpture in either wood or gesso which then had to be attached, painted, and gilded. Although by the mid-fifteenth century the elaborate polyptych altarpiece had gone out of style in Florence, it retained its considerable importance elsewhere. The massive two-storey altarpiece offered by Giuliano della Rovere (1443–1513), the future Pope Julius II, for the cathedral of Savona in 1490 achieved its overall impact from the dramatic wooden frame and sculptural ensemble into which the pictures were inserted [32].

Wood was not the only possible support. Altarpieces were also made out of painted stone or of ivory; stretched and prepared linen canvas was also used. In all cases, there were similarities in terms of preparation. The base needed to be smoothed with gesso and then,

32 Vincenzo Foppa and Lodovico Brea

Della Rovere altarpiece, tempera on panel and polychromed wood frame, 1490, Santa Maria di Castello, Savona.

Originally commissioned for the high altar of the cathedral of Savona, this large multi-tiered polyptych bears the arms of the city and of its greatest family, the Della Rovere. Cardinal Giuliano Della Rovere (the future Pope Julius II) kneels before the Virgin and Child. At the time of its creation, his uncle Francesco Della Rovere was in office as Pope Sixtus IV.

Painting on panel

The carpenter supplied the wooden panel which was then covered in glue size and gesso—gypsum—in increasingly fine layers to create a smooth surface on to which either gold leaf or some other background colour could be laid. An underdrawing in charcoal and ink would then be put in place, and red bole—a greasy red clay—applied to the areas where gold leaf was to be laid. The bole provided a background colour giving a rich hue to the rather thin, meagre gold leaf. This was carefully layered on piece by piece and burnished, a trickier process than might be thought which required considerable professional skill. Once in place it could be figured using punches or, after paint had been applied, revealed through a process known as *sgraffito*, where paint was scratched away to create illusions of rich embroidery or cloth—or by using mordant gilding where powdered gold was glued on to the paint surface.

Detail of 3

however, it is Marcello's turn to pay homage, acknowledging René's royal presence by kneeling to offer his book, which is accepted with a familiar gesture appropriate to a king. Although all three are joined by their mutual admiration and respect for scholarship, their social distinctions are still firmly acknowledged.

Alongside the increasing number of stationers and court scribes who produced manuscripts for the urban patriciate and royal courts, monastic institutions remained important sources of labour and materials. It is in nunneries that we may find the small number of female painters working. We know that one of the reformers of the Dominican order, Giovanni Dominici (1355/6–1419), taught the nuns in the convents in Venice and Pisa under his jurisdiction to paint manuscripts.[24] At the end of the century, another Dominican reformer, Girolamo Savonarola (1452–98), was equally anxious that the Florentine nuns of Santa Caterina should 'foster the fine arts for the honour of God'.[25] Recent research has indicated that these were more than pious hopes. Accounts for the convent of the Poor Clares of Monteluce in Perugia show that these cloistered nuns prepared a wide selection of religious books for a diverse clientele of nuns, friars, and laymen and women. The nunnery of San Jacopo di Ripoli in Florence became particularly renowned for the women's printing-skills. During the 1470s the nuns printed and sold thousands of new books, using travelling preachers and salesmen to distribute their merchandise, selling on one occasion 1,000 copies of the Life of St Margaret to an intinerant street-singer, an order which would have produced a substantial income for the convent itself.[26]

Printing and engraving

As the example of the nunnery of San Jacopo di Ripoli makes clear, traditional centres of book-production were able, with financial support (given in this case by generous benefactors who provided the money needed for the press), to switch over to the new techniques of printing with movable type introduced from Germany into Italy when the first press was installed, in the Benedictine monastery of Subiaco outside Rome, in 1465. There were, however, many who felt threatened by the new technology. In 1472 the scribes of Genoa asked, in a petition which gives a clear indication as to which books were considered to be popular best sellers, to have exclusive rights over 'breviaries, missals, offices of the Virgin, Donatos (basic grammar books), psalters, the rules of grammar . . . the works of Ovid . . . and of Aesop'.[27] But while professional writers may have felt they were losing business, designers were still needed for the decorative borders and illustrations that publishers required and readers expected. In Venice alone there were, it has been estimated, fifty printers at work by 1480, turning out hundreds and later thousands of editions of both high-quality classical texts and

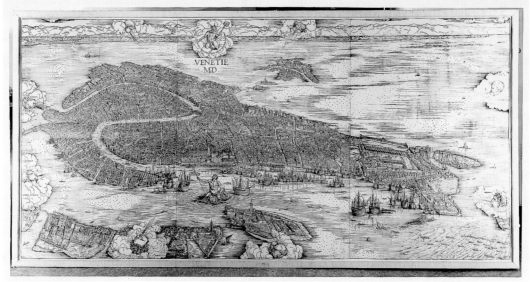

36 Jacopo de' Barbari

View of Venice, woodcut from six blocks, 1500.

Made from six sheets, this bird's-eye view of Venice covers almost four square metres when assembled. Jacopo de' Barbari achieved considerable success following its publication, going on to serve Emperor Maximilian as court portraitist in Nuremberg, probably on the recommendation of his publisher Anton Kolb.

more accessible religious tracts. For most of the late fifteenth century these continued to be hand-coloured and -finished by professional illuminators.

Woodblock-printing had a long history in Italy but the development and refinement of reproductive techniques brought other advantages and became one of the crucial changes of the fifteenth century, enabling a wide distribution of new visual ideas to a broader spectrum of viewers.[28] There were several different ways of creating prints using either the long-standing techniques of block-carving to create woodcuts, or the more recent innovations of printing from incised metal plates to create an engraving. Etching, a technique which uses chemicals to create the design on iron and steel plates, does not seem to have been used until around 1500. Woodcuts and engravings could be purchased independently from booksellers. These single-sheet images seemed to have satisfied a variety of needs; there are indications that they were pasted into books, glued on to linen canvas for display, or placed directly on to the wall. Most were variations on devotional imagery but a significant percentage were secular, including maps, calendars, pattern-books, and increasingly classical stories and motifs. One engraving, *The Mass of St Gregory*, considered to have been made in Florence, is particularly interesting in terms of its subject-matter and purpose. It is an unofficial indulgence image; that is, the inscription informs the owner or viewer that prayers to the Virgin said before it guaranteed remission from purgatory. Dated to between 1460 and 1470, it is an excellent example of how iconography and imagery travelled with even greater rapidity with the introduction of these reproductive techniques. It was adapted almost directly from a German engraving of around the same date, but by the late 1470s was in the Ottoman Empire in the collection of a prince, Yakub Beg, who, it has

been suggested, probably acquired it through Florentine merchants living and working in Constantinople [**71**].[29]

With such rapid transferrals of images from city to city, and country to country, the problem of copyright and profitability became more acute. In 1497, for example, an entrepreneurial German printer, Anton Kolb, arranged for the design and printing of Jacopo de' Barbari's (1440/50–1516) wooden block-cut panoramic view of Venice on six oversized sheets of paper [**36**]. This was an enormous enterprise requiring special paper-mills to create the oversized sheets and great care in both the design and execution of the prints. Three years later Kolb was anxious to protect his investment and petitioned the Venetian government for a patent which would allow him the sole right to reproduce and to export the work. He pointed out that many had not appreciated the difficulties involved:

because of the almost unattainable and incredible skill required to make such an accurate drawing both on account of its size and [the size] of the paper, the like of which was never made before, and also because of the new art of printing a form of such large dimensions and the difficulty of the overall composition, which matters people have not appreciated, considering the mental subtlety involved, and given that printed copies cannot be produced [economically] to sell for less than about 3 florins each.[30]

The Venetian government proved understanding and Kolb received the exclusive right to sell the print for four years at three ducats a copy.

In Kolb's petition technical innovation and skill—'mental subtlety'— were mixed with economic necessity. Profit and artistic progress went hand in hand, a conjunction which earlier artists would have well understood. In the next chapter we will examine how the balance between these two interests was maintained in the late fourteenth and fifteenth centuries in greater detail.

The Organization of Art

Not all the value of a work of art lay in its material; the virtuosity of its manufacture was also crucial. Certainly by the end of the quattrocento, there was at least one influential group of theorists who were willing to suggest that the sophisticated viewer should appreciate the quality as well as the inherent monetary value of his possessions. Thus the presentation of a set of majolica plates or glass vases could be received with as much rapture as if they had been made in gold and silver; an unusual painting could be as rare as a piece of porphyry.

In a discussion of gift-giving, the late fifteenth-century Neapolitan humanist Giovanni Pontano (1422–1503) argued in just these terms:

sometimes art makes a gift acceptable. There was nothing that Alfonso [the king of Naples] kept with such pleasure as a picture by the painter Giovanni [Jan van Eyck]. There are some who prefer the tiniest little vase of that material which they call porcelain to vases of silver and of gold even though the latter are of higher cost. It does happen occasionally that the excellence of the gift is not judged so much by its cost, as by its beauty, its rarity, and its elegance.[1]

Pontano's examples were both non-Italian rarities: a Flemish painting by Jan van Eyck and the much-prized imported Chinese porcelain. There is, however, considerable evidence to suggest that whatever the object, viewers and patrons were sensitive to artistic virtuosity, in which technical skill and inventiveness were as prized as clever meanings and intellectual ingenuity. But the separation between materials and artistic skill can be exaggerated, for reputations were often based on an ability to organize materials and men as well as on creative design and ingenuity.

In the fourteenth and fifteenth centuries the newest techniques, particularly those associated with ceramic and glass, were often carefully maintained secrets; nonetheless, making works of art was a very public occupation [37]. The modern concept of an individual working alone in a studio for his or her own intellectual satisfaction in the hopes that someone might someday purchase the work was unknown. Most artists worked in accessible surroundings; indeed goldsmiths' guilds usually obligated their members to open their shops directly on to the

De Sphaera manuscript, fo. 11, tempera on parchment, c.1450–60.

This manuscript was originally written and illuminated for Francesco and Bianca Maria Sforza of Milan. An astrological primer, this folio shows the occupations which are under the jurisdiction of the planetary god Mercury; they include painting and sculpture as well as clockmaking and the manufacture of musical instruments.

street to ensure that fraudulent activities, such as substitution of yellow-tin for gold, were not taking place. The public and professional nature of these enterprises ensured that, unlike in later centuries, almost all the artists considered in this book are male. There were exceptions, although these should not be exaggerated: as we have seen, documents show that a number of nuns were trained to provide manuscript illuminations and embroideries; the sculptor Guido Mazzoni (active 1473–1518), renowned for his work in terracotta and *cartapesta*, seems to have also employed his wife and daughter as valued assistants; and one of the daughters of the famed Venetian glass-maker Angelo Barovier specialized in enamel-painting, an area in which we now know other women were employed.[2] The paucity of these examples does not mean that gender is not a consideration in the study of Renaissance art; it merely tells us that images of women, commissions by women, or objects seen by women were almost always produced by men. It means that we need to be attentive to questions of male communities, drawn together by family relationships, business partnerships, and friendship.

Guilds, regulations, and associations

In most Italian cities the activities of artists, like other professional craftsmen, were regulated by guilds or corporations which went under different titles such as *arti* in Tuscany, *paratici* or *università* in the Veneto and Lombardy, and the *Fraglia* in Padua.[3] The importance of these organizations varied from town to town. In Florence guild membership was a condition of government office, and many crafts were subsumed within larger, more powerful associations. Although stonemasons had their own *arte*, the goldsmiths belonged to the influential silk guild, the *Seta* [38], while painters belonged to the guild of doctors and apothecaries, the *Medici e Speziali*. Outside Florence, however, the corporations were less prominent in political affairs and more interested in regulating purely economic activities. The Venetian guild of glass-makers faced strict conditions on their production which were overseen by the government itself. In order to limit output, they were, for example, not allowed to operate their furnaces from August until January and severe penalties were threatened against those who worked abroad or passed on their skills to non-Venetians.

The 1355 statutes of the Sienese painters' guild were less rigid in their conditions.[4] Foreigners only had to pay a fine in order to work in the city, but artists were forbidden to take work away from a fellow painter without the latter's permission, to tempt workers or apprentices away from a colleague's shop, or to substitute low-quality gold, silver, or colours for those promised. Other clauses insisted that painters attend each other's funerals and those of members' close relatives. They were also to ensure that no one cursed or blasphemed and

that holy days were observed. On the annual feast of St Luke, they
were to attend a procession and offer up a wax candle to him as their
patron saint.

Guilds such as those of the Sienese painters or the Venetian glass-
makers were social groups as well as working units and they should not
be compared to modern trade unions. They did not set wages or prices,
nor did they negotiate with employers. Their interests lay in regulating
terms and conditions for entry into the profession, in establishing rules
for the quality of work and its materials, and in defining forms of
assessment and arbitration. There was a consistent need in every town
to control competition and to prevent cheap imports (often those from
a rival town down the road) from driving down local prices and wages.
In Padua, the painters' guild, the *Fraglia*, attempted to monopolize
printmaking by suing merchants who bought and sold woodcuts with-
out paying dues.[5] In nearby Venice, the masons' guild tried to ban the
importation of carved stone in 1456 and in 1457 the city responded to
painters' complaints by seizing carved and gilded wooden altarpieces
illegally imported from Germany. These restrictions were not always
effective. In 1491 the city's local stonemasons famously complained that
they were far outnumbered by Lombards who were both taking away
their jobs and destroying their future by refusing to take on native
apprentices.[6] However, in Genoa the town council actively tried to
encourage artists to immigrate, dropping prohibitions on foreign
painters in their statutes of 1415. When the glass industry weakened in
the late trecento, the Venetians offered tax exemptions to tempt for-
eign workers to Murano. Competition from the pottery works in
Faenza prompted Bologna to offer attractive conditions to Faetine
majolica-workers who moved into the city.[7]

The workshop

The rules and regulations designed to protect jobs tell us just how
mobile artists could be as well as how fiercely each community reacted
to the imagined threat to its prosperity. Nevertheless, any immigrant
could only survive and flourish once he had gained a wider local net-
work of patrons, suppliers, and assistants. When the Florentine sculp-
tor Donatello arrived in Padua in the early 1440s to cast the equestrian
monument to the Venetian *condottiere* Gattamelata [**136**], and to work
on the high altar of the Santo, his assistants were a mixture of col-
leagues from Tuscany who had travelled with him and new figures
drawn from the Paduan community such as the painter and sculptor
Niccolò Pizzolo (1421–53). Donatello's casting was done by local
foundrymen and the assessments and judgements of his work were
carried out by local artists. In his absence money owed to him was col-
lected by a Venetian stonemason, Bartolomeo Bon.[8]

In any city the hub of each artistic association was usually a work-

shop, a site where objects were both made and sold, or a group working together for a common profit. Institutional organizations provided the most formal and long-lived workshops. The cathedrals often had sheds and drawing-rooms in which generations of stonemasons, and other artists, might work both for the church's needs and on subcontracted work for other clients. There were even training schemes. In the late 1390s the Milanese cathedral workshop offered instruction in stone-carving and at his death in 1522, its chief architect and engineer Giovanni Antonio Amadeo (c.1447–1522) left a large sum of money to establish a school of design for his fellow workers.[9]

Workshops were people as well as places. Painters and sculptors might travel to the site where they were to make the object rather than risk the transportation of the finished piece. It could be easier, for example, to paint a large, multi-panelled polyptych directly in the chapel for which it was destined, rather than have to cart the pieces across town. With such fluidity of practice, statistics about the number of artists in any given city are difficult to obtain and notoriously unreliable. Candia, on the Venetian island of Cyprus, which specialized in the export of images of the Madonna had approximately 120 painters for a population of just 15,000. Milan, with a population of almost 100,000 had slightly less: 100. In Florence in 1478 (population 60,000), it has been estimated, based on a contemporary description, that there were about 54 stonemasons' and sculptors' shops, 44 goldsmiths' shops, 84 woodworkers', 40 painters', and 83 silk-manufacturers' shops. In Palermo, in contrast, there was a very small number of painters, approximately 15, the majority of whom were Sicilian in origin with a few from the peninsula and a small number from Spain.[10] These figures may not reflect actual numbers since many artists never achieved independent status, working as assistants or remaining in the service of cathedral and other institutional works. Limited public help and investment were available but only workers with prized specialist skills, such as the new techniques needed for silk-weaving, the creation of gold thread, tapestry-weaving, glass-making, or printing were subsidized by either the civic government or a princely ruler in return for training young men in their trade. At his petition, the intarsia designer and wood-carver Domenico dei Cori was retained by the city of Siena in 1421 to instruct two or three Sienese youths in his craft; the painter Vincenzo Foppa (c.1428–c.1515), seeking a pension for his old age, entered into a similar arrangement with his home town of Brescia in 1489.[11]

It was never easy to establish a successful business or to provide for a prosperous retirement. Capital was needed for premises, tools, and materials and the costs of failure were high. The most important majolica producers in Deruta needed to own forests which provided regular supplies of fuel, kilns, and clay pits as well as workshops.[12] A

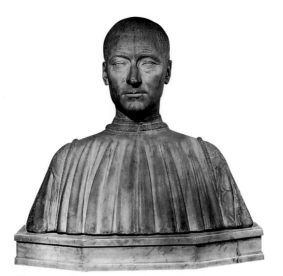

Veronese glass-maker who suffered serious economic problems in 1409 owned two furnaces, thirteen crucibles made of the finest clay from Constantinople, and 40,000 glass objects which he had not yet sold, creating a crisis of liquidity.[13] The inventories of painters and sculptors indicate that they too had to invest in expensive materials, pigments, and marbles, boats for transporting their goods, as well as renting property and buying tools and equipment.

In Florence the average rent of a sculptor's shop, 15 florins, was almost double that of the smaller space needed by a painter. The inventory taken after the death of the Florentine sculptor Benedetto da Maiano (1442–97) itemizes one highly successful operation where profits were ensured by taking on a broad range of work, major and minor, in different materials for clients both at home and abroad. The portrait bust of the wealthy Florentine banker Filippo Strozzi [**39**], signed and dated by the sculptor in 1475, is just one example of his versatility. Benedetto rented at least three workplaces in Florence, one on the ground floor of his house, one where he stored wood and stone, and one for the actual business of marble-carving. In the *Bottega dei Marmi*, 'that is where the marbles are worked', the sculptor's heirs found pieces destined for a royal gateway at Naples, for the shrine of the Santa Casa di Loreto in the Marches, pillars for a tomb for a local dignitary, marble tabernacles, an unfinished stone washbasin, and numerous architectural pieces, such as cornices, architraves, and gutters. There were also several terracotta models for additional work which he had accepted.[14]

A slightly earlier inventory of 1488 for the shop of the equally wide-ranging painter, sculptor, and goldsmith Andrea del Verrocchio shows a similar range of tools but an even broader scope of media and interests. The shop's stock included raw materials such as bronze and stone and models, including one of the cupola of Florence cathedral for

which Verrocchio had provided a bronze ball, along with unfinished commissions. It was furnished with beds, a dining-table, a globe, a lute, and a collection of mainly vernacular literature including Petrarch's *Triumphs* and a work by Ovid and funny short stories by the Florentine writer Franco Sacchetti.[15]

Benedetto, his brother Giuliano (1432–90), and Andrea del Verrocchio all had numerous assistants for as soon as the scale or complexity of a project increased, so did the number of helpers required to complete these multiple tasks. Some of these assistants were associates; others were apprentices. The difference could be important. An apprentice was a youth placed with a master in the expectation of training and supervision. The child, generally aged somewhere between 10 and 13, was sent by his father to live with his teacher and to work for him for a specified period, usually between five and six years. A more experienced adolescent might expect a shorter period of training and receive a wage. But any apprentice would expect to be part of his master's household, eating, sleeping, receiving clothing and medical attention, and learning the skills of his superior. Most guilds were anxious to limit the number of apprentices any one master could take on, both to ensure a high quality of training and to limit the number of artists emerging on to the market. Assistants, employed for specific work on specific projects, were a different matter and will be discussed below.

The painter's shop

Painters were amongst the most mobile of artists, able to work in domestic conditions or to set up their easels or scaffolding on site. There were, of course, some designated painters' workshops in any town and the inventory of the shop of a fifteenth-century painter in Palermo, Gaspare da Pesaro (active 1421–d. 1462), may be quite typical of a modest operation. It included paints, porphyry slabs for grinding pigments, palettes, brushes, prepared wood, and six pairs of eyeglasses. Gaspare da Pesaro, who worked for both the court in Naples and the local Sicilian aristocracy, owned a number of works of art which may have served as examples or inspiration for his own production, an engraved *niello*, and some otherwise unspecified sculpture.[16] The list drawn up at the death of the successful and prolific Sienese artist Neroccio de' Landi (1447–1500) shows a more prosperous figure. Neroccio owned a house, a vineyard, and a share in a kiln which he probably used to fire the terracotta Madonna figures he produced but which he let out to another artisan. His own bedroom, '*la chamera di Neroccio*', was full of cloth, linen, and fine clothing and had a tabernacle with the Virgin and Child on the wall which had a curtain attached to it. There is some indication of financial difficulties in that a number of pieces of linen and jewellery were at the pawnbrokers. His workshop, or *bottega*, contained the expected pieces of porphyry for grinding

In legal documents, an artist might announce his first name, the name of his father, and the place where he was living. There was, however, no systematic formula for naming individuals in fourteenth- and fifteenth-century Italy. An individual was known primarily by a first name and by place of birth or residence. Leonardo da Vinci, for example, merely means 'Leonardo from the town of Vinci'. The name of their father might also be used: Giovanni di Paolo means 'Giovanni, the son of Paolo'. Higher up the social ladder, families might acquire a patronymic, a last name such as de' Medici, which was passed down from generation to generation.

Artists who joined religious orders changed their names when they became professed monks. In documents, Fra Angelico's 'real name' appears in multiple forms. He was Guido di Pietro *dipintore* before he joined the Dominicans. He switched from Guido to Giovanni at that stage, and was known either as Giovanni di Pietro da Mugello (Giovanni, son of Pietro from the Mugello) or as Frate Giovanni de' Frati di San Dominico di Fiesole (Friar Giovanni of the order of San Domenico of Fiesole). He only acquired the name Angelico or 'Angelic' when the Dominican order tried to have him beatified, a process which succeeded in 1984 when the artist was officially renamed Beato Angelico, the 'Blessed Angelic'.

Names were very fluid items even within an artist's lifetime and were often nicknames. Masaccio (a variation on Tommaso) means 'Big Thomas', while his colleague, Masolino (1383-1440/7), was 'little Thomas'. Masaccio's brother was known as '*lo Scheggia*' (1407-80/98) which means 'the splinter'. Some artists changed their names to suggest a connection with another master or to celebrate a particular achievement. The Florentine painter Piero di Cosimo (1462-1521) took his name from his

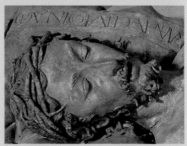

Detail of 9

master Cosimo Rosselli (1439-1507). The Ferrarese painter Bono da Ferrara signed his work now in the National Gallery in London of 1440 as 'Bonus Ferariensus Pisani discipulus' (Bono of Ferrara, the follower of Pisanello); Jacopo Bellini did the same, signing a lost painting of St Michael, 'Jacopo of Venice, the follower of Gentile da Fabriano', while both the Dalmatian artist Giorgio Schiavone (Ciulinovich) (1433/6-1504) and the Emilian painter Marco Zoppo signed their work as 'pupils of Squarcione'.

Artists might acquire nicknames based on a work for which they were particularly renowned. Niccolò dell'Arca, means 'Niccolò, the sculptor of the Arca' of San Domenico in Bologna. Jacopo della Quercia (whose name in the fifteenth century was actually della Guercia—a spelling which was misunderstood by later scholars) was sometimes referred to as Jacopo del Fonte (Jacopo of the Fountain) while Domenico di Niccolò dei Cori (of the Choir) received his nickname from the wooden choir he built in the chapel of Siena's town hall. During his lifetime, Andrea del Castagno (*c*.1421-57) was referred to either as Andrea di Bartolomeo (that is Andrea, son of Bartolomeo), Andrea or Andreino del Castagno (Andrea from the town of Castagno), or as Andrea degli Impiccati (Andrea of the Hanged Men)—a title which he acquired from the paintings of the images of traitors hanging upside down which he provided for the Florentine government after the expulsion of the Albizzi faction in 1433.

colours, a wooden case containing pigments, a painter's palette, seven
gessoed heads, some pieces of ancient statuary, hammers, saws, iron-
mongery, an easel, the unfinished predella to an altarpiece, some
heraldic shields, scaffolding, and 'eight figures, that is painter's
models'. In his study he kept a number of goldsmith's tools and three
gessoed figures, one of which was of Apollo, as well as three gessoed
heads and a foot, two wax hands, and one wax head. Neroccio also
owned a Madonna by Donatello and a figure of St Bernardino by the
Sienese sculptor Lorenzo di Pietro Vecchietta (*c*.1412–80) which he
probably used as the source for his image of this saint produced in
the 1470s [**60**].[17]

Unlike sculptors, those who worked exclusively as painters rarely
needed large numbers of helpers, relying instead on short-term associ-
ations or on a small number of apprentices and assistants who came
and went according to the amount of work available. The conditions
for a painter's apprenticeship were effectively those of a sculptor or a
goldsmith. The case of Francesco Squarcione of Padua, who adopted

many of his apprentices, is an unusual but telling example. The son of a notary, Squarcione had originally worked as a tailor and embroiderer. After travelling in the East and making and collecting drawings, plaster casts, plaquettes, and medals after the antique, he claimed increasing proficiency as a painter [40]. His apprentices were drawn from similar social backgrounds. The most renowned of them, Andrea Mantegna (c.1431–1506), was the son of a tailor, others were the sons of bakers, fishmongers, and shoemakers.

Squarcione's most distinctive apprenticeship contract was drawn up in 1467 with another Paduan painter, Guzone, on behalf of the latter's son. Guzone was looking to improve the boy's prospects by introducing him to the relatively new technique of linear perspective. Since this was a business arrangement, the two artists had taken the paper to a judge in Padua's town hall to ensure that the conditions they had already agreed proved legally binding,

Let it be known and manifest to anyone who reads this paper that I, Guzone the painter, have agreed with master Francesco Squarcione, the painter, that he shall teach my son Francesco, that is that he shall show him the way to make a *piano lineato* or pavement, well drawn in my manner; and to place figures on that pavement here and there in different places, and to place things on it such as chairs, benches, houses; and he is to understand how to do these things on the said pavement. And he must teach him how to foreshorten a man's head by isometry, that is of a perfect square underneath in foreshortening, and to teach the method for making a nude body, measured both from the back and from the front, and to place eyes, nose, and mouth in the head of a man in their correctly measured place and to have him understand all these things item by item as much as it is possible for me [Francesco Squarcione] to do, and as the said Francesco is capable of learning, according to my experience and foundations, and to give him always a paper of examples in hand, one after the other of different figures, to highlight and to correct the said examples and to correct his mistakes as much as I can and as far as he proves capable, as it is said above. This obligation will last for the next four months and if he gives me half a ducat for my salary every month, which makes two ducats in four months and if I have to pay him for work as we make a pact for the said work, and not having work he must pay me and pay me at the beginning of every month . . . and I want the usual gifts, on All Saints' day, a goose or a pair of chickens, on Saint Martin's day, and wine, and on Christmas, 2 lire's worth of lemon or as much of pork and a pair of good pigeons. At Easter he must give a quarter of a young goat. And if you [Guzone] do not wish to be obliged for the feast days you must say so, and if he [the apprentice] damages any of my drawing, Guzone is obliged to pay me for them at my discretion.[18]

The emphasis on food as an exchange for knowledge and training is a reminder of the domestic, personal nature of the relationship between apprentice and master. Such intimacy could turn sour. Thus while in his old age Squarcione boasted to one prospective client that he could

teach 'the true art of perspective and everything necessary to the art of painting . . . I made a man of Andrea Mantegna who stayed with me and I will also do the same to you,' his pupil sued him, claiming that his master 'has not and cannot give anything but promises, but the facts he cannot give because he does not possess them'.[19] Squarcione's own work, which shows a distinctive but relatively unimpressive style of painting, seems to bear out this complaint. None the less, he held positions of considerable influence and respect in Padua and many of his ex-apprentices (including Mantegna himself) continued to identify themselves as his disciples and used his name long after they had left Padua. On the Madonna and Child [**41**] which the Emilian Marco Zoppo (1433–78) painted in the mid-fifteenth century, for example, the artist proudly signed himself as '*discipulus Squarcionis*'.

Competition and collaboration

As an apprentice, Zoppo would have been expected to grind colours, prepare the gessoed background for his master, and learn the skills of preparing plaster for fresco-painting. He would have drawn constantly under his master's supervision and have gradually graduated to more complex work, eventually producing much of a painting himself. At this point his master might consider him an assistant rather than an apprentice and provide him with a salary. There would come a stage, however, when the younger artist would either leave the shop or receive a commission in his own right, forcing him to matriculate in the guild. As the case with Squarcione illustrates, tensions between master and pupil could arise at this particular moment of independence. In any town there was often a great deal of competition for work, and practices such as underbidding, the denigration of rivals, or the stealing of ideas and equipment are well documented. The bitter feelings between Ghiberti and Brunelleschi after the competition for the baptistery doors in 1401 were recorded by both artists. In 1461 the Milanese painter Cristoforo Moretti (documented 1452–85) made it a condition of his work on a stained-glass window for Milan cathedral that his hated rival, Niccolò da Varallo (1420–after 1480) [see **17**], could not participate in the project.[20]

But if they would not work together, Moretti and da Varallo, like Ghiberti and Brunelleschi, did collaborate effectively with other artists. Indeed, it may be precisely because of the unstable competitive nature of the artistic enterprise that artists of every type sought links and associations which would provide a measure of economic stability. These relationships took many forms, from the 'family firm' to short-term associations set up for specific purposes.

Where large-scale investment in property and equipment was involved it is not surprising to find that such enterprises were, like most Italian businesses, staffed by relatives and were considered part of the

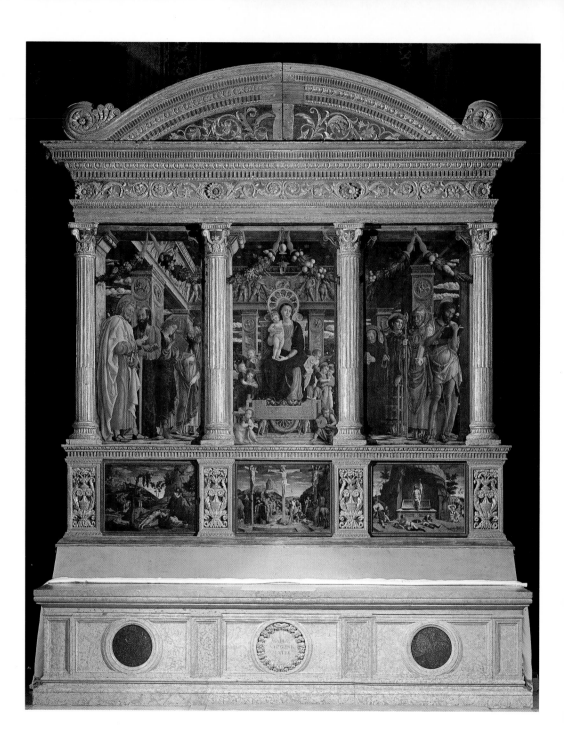

Tomb of Baldassare Cossa,
anti-pope John XXIII, marble
(with gilding and polychromy)
and gilt bronze, 1421–8,
baptistery, Florence.

Baldassare Cossa was elected
pope (John XXIII) by the
Council of Pisa in 1410
and deposed and imprisoned
five years later by another
ecclesiastical council in
Constance. In 1419 Cosimo
de' Medici's father, Giovanni
de Bicci, paid the ransom
which permitted Cossa's
release and return to Florence.
When Cossa died soon after,
his executors included
Giovanni de'
Bicci de Medici and eventually
Cosimo himself who obtained
an agreement in 1421 to erect
the work in the baptistery.

at work in Siena, including Jacopo della Quercia and the goldsmith Giovanni Turini (documented 1394–1427), payments owed to specialist gilders who had provided the gold for his work in Siena, and the 15 florins he had to pay to an expert foundryman, Giovanni di Jacopo degli Strozzi, for several attempts to cast the reliquary of the head of San Rossore made for the church of the Ognissanti in Florence in 1427. While the assessment of Donatello listed debts, the association's profits appear to have been registered, perhaps strategically, in that of Michelozzo, including payments the two men had received for their work on the tombs of Baldassare Cossa [**44**] and Cardinal Brancacci, as well as the works they produced independently of each other in which they had obviously agreed to share the eventual profits.

Given Donatello's crucial importance in the dissemination of a classicizing style and the re-creation of numerous antique forms from the equestrian monument to the small bronze, there have been many attempts to disentangle his relationship with his much less well-known partner. Some art historians have argued that Michelozzo was involved primarily for his business acumen or for his bronze-casting expertise. New evidence for Michelozzo's own finances suggest that the former is unlikely, since he was sued by almost all his creditors, from his butcher to his banker Cosimo de' Medici, for unpaid bills.[28] The efforts to discriminate between the two partners will continue, but such an approach does not seem to be what either the two artists, or their major Florentine patron Cosimo de' Medici (whose influence can be documented behind most of the major commissions in the 1420s), actually intended.

The success with which Donatello and Michelozzo collaborated may explain the long duration of their relationship. By the mid-fifteenth century flexible temporary associations for, or in anticipation of, a single commission were more common. These were not unlike lottery syndicates today, ensuring that all partners profited from one of their member's good fortune. For example, when they heard that the illegitimate brother of the duke of Milan had died in 1473, the Lombard sculptor Giovanni Antonio Amadeo and four other marble-carvers formally agreed that whoever won the job of making the tomb, that person would share the work with his colleagues.[29] Patrons who wanted to see work completed rapidly might even insist on collaboration. One example is that of the Ovetari chapel in the monastic church of the Eremitani in Padua. In his wills of 1442 and 1446, Antonio Ovetari, a prominent local patron, put aside 700 ducats for the decoration of his family's final resting-place. He left only vague instructions, asking that the chapel be frescoed with the lives of Sts James and Christopher (to whom the chapel was dedicated), that it be sealed off with an iron railing, and that the work be completed as quickly as possible. In 1448 his executors (who included the Paduan poet and lawyer

45 Andrea Mantegna, Ansuino da Lorli, and Bono da Ferrara

The Life of St Christopher, fresco, 1448–57, partly destroyed during World War II, Ovetari chapel, church of the Eremitani, Padua.

Francesco Capodilista, then the owner of Giotto's nearby Arena chapel) commissioned two teams of artists to execute the work. One pair was the well-established Venetian painters Giovanni d'Alemagna and his brother-in-law Antonio Vivarini (*c*.1420–76/84). The other was composed of two Paduans who had joined together specifically for the task, the 27-year-old Niccolò Pizzolo, then at work with Donatello on the bronze altar of the Santo, and the adolescent Andrea Mantegna. Each team was given an advance of 50 ducats and the painting, costs, responsibilities, and profits were evenly divided. Yet far from providing evidence for the benefits of collaboration, the Ovetari chapel is a case study of the difficulties of effective group effort. Little had been accomplished by 1449 when Pizzolo and Mantegna were forced to call in an arbiter to decide upon how they were to divide their portion of the work. The neutral party had to identify responsibility, split the pigments and the wood for the scaffolding between the two painters, and

46 Nicolò Pizzolo
St James Speaking with the Demons, detail from the life of St James, fresco, 1448, partly destroyed during World War II, Ovetari chapel, church of the Eremitani, Padua.

even insist that Pizzolo take down a cloth which was blocking his colleague's light. Meanwhile the Venetian team proceeded with the ceiling until 1450 when Giovanni d'Alemagna suddenly died. The patron's wife demanded an accounting of the work she had confidently expected to be complete and was dismayed to discover how little had actually been undertaken. Vivarini finished the vaults but left for Venice soon afterwards and a new group of artists had to be called in. Two, Bono da Ferrara (documented 1441–61) (one of Pisanello's exapprentices) and Ansuino da Forlì (documented 1434–51), signed their contributions to the frescos in the life of St Christopher [45]. Then in 1453 Niccolò Pizzolo was killed in a brawl, leaving Mantegna with sole responsibility for the life of St James [46] on the other side of the chapel wall and for the central image of the Assumption of the Virgin. The frescos were finally completed in 1457. It had taken almost ten years for twelve artists to create the twenty-seven paintings.

Without the extensive documentation behind this commission we would not know how difficult its execution had proved. Much of the Ovetari chapel was destroyed by bombardment in 1944, but photographs taken just before this show how, despite the many arguments and changes of personnel, there was still an attempt to create a very coherent visual style. From the beginning, the artists would have had to co-ordinate scaffolding, plastering, and agree the common elements, particularly the rich surface motifs which were used on all the walls (and also on the altarpiece), such as the putti playing amongst the garlands of leaves and fruit and the centrality of the family coat of arms (undoubtedly a requirement of the patron whose will specified that 'the testator wants his commissioners to put in a high and eminent place within the chapel three or four banners with the noble arms of the Ovetari').[30]

When an expensive commission such as the Ovetari chapel was completed it was quite common for the patron and the artist to put together a group, drawn from representatives chosen either by the former or by both, to assess the total value of the finished work. Once decided, final and part payments might be in cash or in kind. Grain, land, and tax exemptions were all acceptable forms of remuneration. In 1465, for example, the Venetian government agreed to release Squarcione from his taxes in return for a painted map of Padua and its territories.[31] With such funds, artists paid their living expenses and invested in their future, buying interest-bearing shares or properties to rent and agricultural land. The artist responsible for the painted ceiling of the Palazzo Steri in Palermo in the late fourteenth century, Simone de Corleone (documented 1377–80), set up a gardening business while one of the most successful fifteenth-century Palermitan painters, Gaspare da Pesaro, went into sugar-refining and the production of olive oil, rented a mill, and imported and exported merchandise. These

multiple occupations were not unusual. Other Sicilian artists ran taverns. In fourteenth-century Bologna one painter, Cristoforo Biondi, was also the city's official clockmaker, while another, Lippo Dalmasio (1352–1410), also served as a notary.[32]

Such details come from the notarial records of the Palermitan and Bolognese archives; whenever an art historian has chosen to study this kind of source, economic records far outweigh the artistic references. A recently published survey of documents for the important fifteenth-century sculptor and architect Giovanni Antonio Amadeo lists almost 2,000 documents of which only approximately 200 mention works of art. The rest refer to investments, rents, the purchase of clothing, and so forth. This is to be expected from legal documents, but the information should not be ignored. There were few artists who could afford to be isolated from the economic and social realities of their urban environment. There was no organized state social welfare system in the fourteenth and fifteenth centuries and, like most of their contemporaries, artists in the fifteenth century invested efforts in creating networks with patrons as well as with partners in order to ensure a comfortable old age.

Defining Relationships: Artists and Patrons

4

Contracts and conditions

We have been looking at the creation of works of art primarily from the artist's point of view. But how did the purchaser, the patron, ensure that his or her interests were taken into consideration?

There were a number of different ways of obtaining a work of art in this period. Modest items could be purchased quite simply from a diverse range of sources. If a patron was trying to save money, he or she could buy a reconditioned second-hand altarpiece or obtain one of the cheaper varieties sold by shops or itinerant salesmen who moved from city to city. There are late fourteenth-century records in Bologna, for example, of a German peddlar who sold 'certain cards figured and painted with images of saints'.[1] In Padua in 1440 one salesman, operating on behalf of a Flemish trader, was offering 3,500 woodcuts for sale.[2] Engravings, such as the image of St Catherine of Siena produced in Florence [**47**], helped to popularize new figures of devotion while most artists usually had the more traditional Virgin and Child [**48**] readily available for immediate purchase or special order. Specialists in the painting of chests, pennants, banners, and playing-cards also kept stocks which could be personalized by adding the coats of arms of the potential purchaser. These were not necessarily poor-quality offerings; in Florence, the fifteenth-century records of the shop of Bernardo Rosselli indicate that he was happy to sell pictures of the Madonna to purchasers who ranged from the city's wealthiest merchant to its humbler artisans.[3] The buying of glass, majolica, tapestries, or brocade was not dissimilar. Many craftsmen, both in Italy and abroad, kept standard shapes or looms at the ready, able to integrate personalized patterns or coats of arms at short notice.

Alongside the production of works for which there was this reliable demand, most artists hoped to obtain commissions for specially tailored items: profitable shops expected to do both. The range of possible patrons was as wide as the ways of obtaining works of art and included individuals, male and female, of every financial background and status as well as committees operating on behalf of institutions, such as confraternities, cathedrals, and town halls, or court staff who purchased works for a signorial client.

Detail of 50

Most contracts contain conventional legal language about the rights and responsibilities of each party. This document, drawn between a member of the noble Lazzara family and the Paduan painter Pietro Calzetta, concerns the decoration of an entire chapel in the basilica of St Anthony of Padua which was destroyed in the sixteenth century. The contract, however, is of great interest, both because of the specificity of its conditions and the drawing that the notary, himself a renowned humanist, Bartolomeo da San Vito, attached to ensure that the painter understood what was required of him. It was written on 17 October 1466 in the city's town hall:

Let it be manifest to anyone who will read this paper that Mr Bernardo de Lazzaro had contracted with Master Pietro Calzetta, the painter, to paint a chapel in the church of St Anthony which is known as the chapel of the Eucharist. In this chapel he is to fresco the ceiling with four prophets or Evangelists against a blue background with stars in fine gold. All the leaves of marble which are in that chapel [presumably on the architectural elements] should also be painted with fine gold and blue as should the figures of marble and their columns which are carved there. On the façade of the chapel the heraldry with its crest should be placed in gold and blue…

In the said chapel, Master Pietro should make an altarpiece which should rise up the entire wall of the altar up to the vault … In the said altarpiece, Master Pietro is to paint a history similar to that in the design which is on this sheet. This drawing is taken from a design which now belongs to Master Francesco Squarcione and was done by the hand of Niccolò Pizzolo. He is to make it similar to this but to make more things than are in the said design. And he must place the coat of arms of the said Mr Bernardo in relief.

Master Pietro must do all these things written above at his own expense, both of gold and of colours, woodwork and scaffolding, and any other expense which occurs. He must also make a curtain of blue cloth that is of good quality along with the iron needed to cover the said altarpiece. It should be painted with a dead Christ which should be fine.

Master Pietro promises to finish all the work written above by next Easter and promises that all the work will be well made and polished and promises to ensure that the said work will be good, solid, and sufficient for at least twenty-five years and in case of any defect in his work he will be obliged to pay both the damage and the interest on the work and that Mr Bernardo can oblige Mr Galeazzo Musatto who is the guarantor of Master Pietro.

Mr Bernardo de Lazzaro promises to pay 40 ducats to Master Pietro for the said chapel, and for the altarpiece and for the other things needed to adorn the chapel with the condition that the said Mr Bernardo must give him 10 ducats now and when he has finished the altarpiece, he must give him another 10 and when he has finished all the rest of the work he must give him the remainder of the money.

Bartolomeo da san Vito (notary), after sketch by Niccolò Pizzolo, contract for the Lazzara altarpiece showing the Mill of Christ, 1466

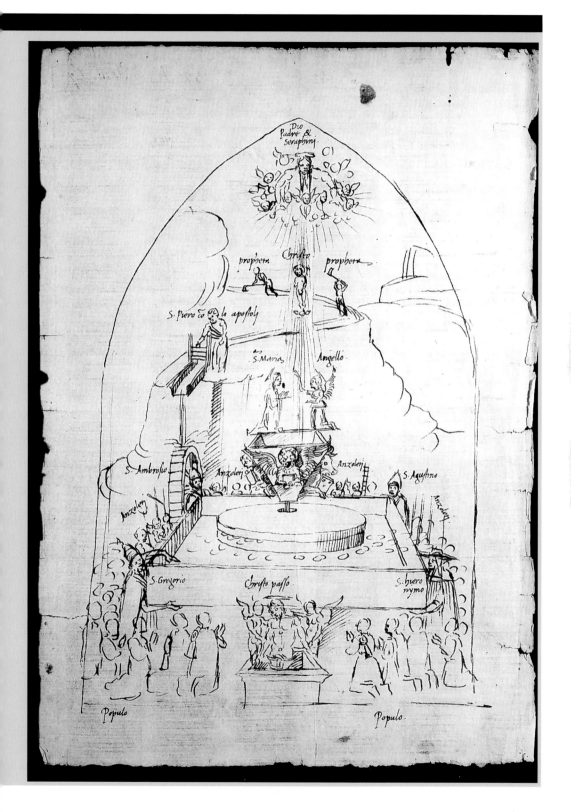

After Catherine of Siena was
canonized in 1461, the
Dominicans encouraged
greater devotion to her cult
and this print, which shows
the saint in the centre and
scenes from her life to the
sides, may have been part
of their campaign.

48 Antonio Rossellino

Madonna and Child,
polyceramed and gilt stucco,
c.1460–79.

Although painted gessoed
reliefs could be found in many
households, they were not
necessarily inexpensive items.
The pictures required close
collaboration between a
carpenter who provided
the frame, the sculptor who
created the mould or relief,
and the painter who coloured
and gilded the finished item.

Each relationship between artist and patron was different but for many purchasers the procedures for obtaining an object such as an altarpiece or chalice were quite conventional with modest variations from city to city. Patrons had to select an artist and discuss the matter relatively informally. The artist drew up plans for the project, often in the form of a sketch or more rarely as a full-scale model, and the two parties then signed a formal agreement, a legal contract. One copy would usually be given to the patron, one to the artist, and one would be placed in the public notaries' records.[4]

These documents, carefully preserved in the various Italian state archives, are often all that remains to indicate the concerns of four-teenth- and fifteenth-century purchasers and providers. Framed with-in a judicial context, they are precious, yet potentially flawed, sources for the study of the history of art. Legally, these contracts could only be drawn up between emancipated men whose fathers had made them independent or by women who were usually represented by a male procurator. Their function was to record measurable obligations and to serve in cases of dispute, not to establish every detail of the expected work of art.

We find, therefore, that the type, quality, and responsibility for materials rather than issues of subject-matter, style, or iconography dominate these documents. Contracts for sculpture were careful to specify the type and quality of stone. Contracts for goldwork made

careful arrangements for the weighing and measuring of the finished
piece. Contracts for painted altarpieces or frescoes usually detailed the
type of ultramarine blue and the amount of gold leaf that the artist was
to use and informed both parties who was responsible for its purchase.
Thus the contract for the apse chapel in Santa Maria Novella drawn up
between Giovanni Tornabuoni and Domenico Ghirlandaio (1449–94)
in 1485 specified that the figures were to be painted with ultramarine,
while the background could be covered in the cheaper azurite or
German blue [**86, 87**]. The frame was often the most expensive part of
a pictorial commission and might, as in the case of Fra Angelico's
Linaiuoli tabernacle, be purchased and evaluated separately [**57**]. A
recent study of Italian contracts drawn up between 1285 and 1537 has
suggested that the cost of the wooden structure accounted for almost
one-fifth of the total price while the expense of gold leaf was approxi-
mately one-third to one-half of the price.[5] It is important to realize,

moreover, that contracts were not exclusively designed for paintings. Any major commission in any material would be subject to similar constraints. Thus the agreement drawn up in 1478 between an embroiderer in Padua (Master Bernardo), a painter (Pietro Calzetta), and the procurators for the Franciscan church of the Santo to provide an orphrey (the long decorative border placed on a chasuble, the main vestment worn by the priest) was very similar to the contract drawn up between the Lazzara family and Calzetta, which is also discussed in this chapter. The concerns were for responsibility for materials (in this case gold and silk thread which Bernardo undertook to provide at his own cost), for the model on which the embroidery was to be based (one drawn by the Paduan painter Pietro Calzetta), for the high quality of the finished product, which was to be 'more rather than less beautiful than the sample given by the said master Bernard to the representatives', and for the total cost of 200 ducats payable in three instalments [**30**].[6]

Patrons were not the only ones who wanted written records. In some cases, the artist wrote them out to ensure that their interests were legally protected. In 1438 the sculptor and architect Bartolomeo Bon wrote down, 'in his own hand', the conditions under which he and his father were willing to undertake the main portal, the *Porta della Carta* [**49**], of the Doge's Palace in Venice. The document, transcribed into the commissioners' account books (the magistrates responsible for the lucrative salt tax which was used to finance public building work), was not a legal notarial record but it still carefully outlined mutual responsibilities. The sum the sculptors were promised was very high, 1,700 ducats, the equivalent to the dowry of a patrician daughter. But much of this would be taken up by the cost of the materials and Bon was particularly concerned to assign responsibility for the choice and transport of the various types of stone required. Its detailed nature makes it worth quoting in full:

I, Zuane Bon, stonecutter from the neighbourhood of San Marciale and my son Bortolamio notify your magnificent lordships, the *provveditori* of the salt tax, of the pacts and agreements which we wish you to observe in regard to us in the name of the illustrious *signoria* of Venice and which we must also observe in regards to you, that is concerning the great door on the lower part of the palace to the side of the church of San Marco. First, on the part of your Magnificent Lordships, you must give and consign the stones for the frame of the said doorway . . . But you do not have to acquire the Ruignio stone for the base of that door; . . . and similarly you do not have to get the marble for the foliage above the vault of that door on which there must be nude putti amongst the said foliage as there should be according to the drawing; and similarly you are not responsible for the marble stones to make the columns which are needed and the figure of St Mark in the form of a lion above, according to the drawing which we have made and which we have given and

consigned into your hands on the understanding that we are obliged to obtain and place our own stones, that is Ruignio and Veronese stone, and that we must make and work the said St Mark in the shape of a lion from our stone of Ruignio. And we have declared that we are obliged to make the entrance with its arches so that it can be closed from within as well as from without, understanding that the said doorway with all its adornments on the side must be the size from the said door of the church of St Mark until the palace, and the said gate with all its adornments must be as high as from the ground to the well on top, and above that there must be worked a figure in our marble in the figure of Justice according to the contents of the said drawing. And if you wish that the figure should be double-sided, that is on the inside and on the outside of the gate, we are content to do it. And also that the said work should be pumiced and polished and finished and joined in the normal way, and in such a way that it is good. And we are obliged to do all that is necessary to put our work into operation. And we are obliged to do this work from now until eighteen months from now. We are also obliged to bring all the things that are needed for this work at our own expense or at our common expense.[7]

The drawing Bon mentioned was the crucial element in determining mutual trust and expectations. It was rarely used as a guide for the sculptor but more normally delivered into the hands of the patron. Contract drawings for public projects might be drawn on the walls of the commissioners' meeting-place or deposited with a notary. This was true of private patrons as well as institutional clients. In 1431, for ex ample, when Giovanni d'Alemagna agreed to paint the tomb of the Paduan lawyer Raffaele Fulgosio for the substantial sum of 50 florins, he said he would do the work, according to a drawing which he had handed over to the deceased's widow, 'as a demonstration of this painting [*pro demonstratione ipsius picture*]'. Similarly, Niccolò Pizzolo

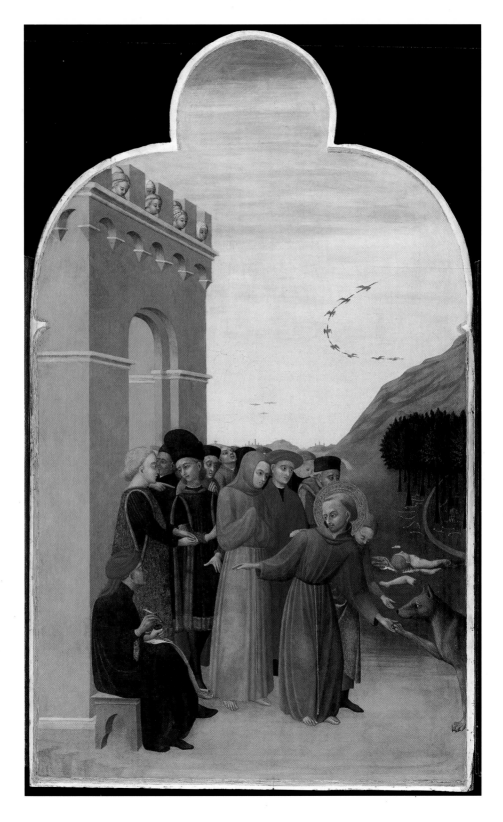

deposited a drawing for the altarpiece of the Ovetari chapel with a notary in 1448.[8]

There were surprisingly very few documented occasions, such as the complaint that Ovetari's widow, Imperatrice, brought against Mantegna in the 1450s, where patrons and artists actively disagreed over the finished product. There were many disputes, however, over the breaching of contracts, above all with regard to the time after which the patron and the artist expected the work to be completed. Despite the penalties, too many artists took on more work than they could reasonably cope with and failed to deliver the goods within the period required. Despite his promises and the bold inscription placed on the architrave, *Opus Bartolomei*, there were still elements missing from the frame of Bartolomeo Bon's *Porta della Carta* in 1468. Niccolò dell'Arca was equally remiss, failing to deliver a number of figures for the Arca di San Domenico in Bologna, a lapse which led in 1494 to the employment of the 19-year-old Florentine sculptor Michelangelo Buonarroti, who provided two of the missing saints and a candelabrum-bearing angel [11].

Legal contracts were never designed to establish a visual format or even the iconography. They were only part of a much more complicated system of communication between patron and artists. At one extreme, we find a small number of patrons complaining that their painters had not provided the promised quality of work. In 1465, for example, the widow of a wealthy Pavian patrician petitioned the duke of Milan, Galeazzo Maria Sforza, to intervene on her behalf as she could see too much diversity in style in the frescoes being painted by three Lombard artists at her behest. The duke wrote immediately to the team, demanding that they appoint one member to harmonize their styles and to obey her instructions.

If we examine the case of a polyptych [50] produced for the friars of Borgo San Sepolcro whose full documentation was discovered by the American historian James Banker in the 1980s, a different version of patronage appears, one where both patron and artist communicated effectively.[9] The evidence begins on 2 August 1426, when the lay body responsible for decorating and repairing the church of San Francesco in the Tuscan town, the *operai*, asked a carpenter to construct a large altarpiece frame following a fourteenth-century polyptych as his model. When completed, the woodwork was given to a local artist, Antonio di Giovanni d'Anghiari, to paint in 1430. He and his young assistant, Piero della Francesca, began work but they were so busy with other commissions that they never produced the promised altarpiece. Seven years later, the Franciscans were exasperated enough to revoke the contract and to reassign the commission to a well-regarded Sienese artist, Stefano di Giovanni di Consalvo da Cortona (better known as Sassetta) (*c.*1392–1450). Because the painting was not being produced

locally, the friars took more care to write down their expectations. For example, they insisted that Sassetta's wooden frame retain the shape of the trecento-style polyptych. None the less, the friars did not offer specific instructions for the work's iconography until 1439, two years after the initial contract had been drawn up. In January of that year, the chapter met to debate the subject-matter and agreed to send two of its members to Siena, 'to order and to compose the images and narratives of the altarpiece as it seems to us and the master [Sassetta] together'. When the two friars returned to Borgo San Sepolcro they informed another chapter meeting of their decisions, showing their colleagues the drawings of the various elements, the *simulacra*, of the 'images and narratives' which Sassetta had produced which were examined along with a written list of subjects which was read out and approved. The two Franciscans planned to give the painter further instructions on this matter and, in all, 116 separate images were required. The scenes eventually selected suggest that some attempt was made by the friars to work with Sassetta in order to individualize the story and give it a special meaning to San Sepolcro itself. The predella scenes included stories from the life of Fra Ranieri Rasini, a local Franciscan *beato* who was buried in the church itself—a figure whose life was obscure enough to require clarification. It was important to ensure accuracy here because the altar itself, erected and funded by the town council in 1402, had been dedicated to Ranieri. In the life of St Francis himself, the episode of the *Wolf of Gubbio*, which had taken place not far from the city, was a rarely illustrated episode from the Saint's legend, showing the pact which Francis brokered between a wolf, who had agreed to stop killing the inhabitants, and the townsfolk who had agreed to feed him at public expense.

Where the imagery was more conventional, the relationship could go to the other extreme with the artist, rather than the patron, making most of the decisions. In 1395, for example, the Florentine painters Niccolò di Pietro Gerini (documented 1370–1415) and his colleague Lorenzo di Niccolò (documented 1371–1420) convinced the Pratese merchant Francesco Datini to commission a large crucifix for the Franciscan church in Florence, Santa Croce. The two painters had already worked extensively for Datini and when they discovered that his representative in Florence, a local Franciscan friar, knew little or nothing of the work's requirements, they asked for complete freedom over the job. All they needed from Datini were the names of the saints he wished to see on the base of the cross and some indication about the coats of arms to be included. The letter of 7 May 1395 began with the proud boast that the crucifix

has been designed so well that, had it been drawn by Giotto, it could not have been bettered. You should not doubt that you are being well served . . . I should now tell you that Fra Giovanni Ducci of Santa Croce, to whom you

have assigned this matter of the crucifix, arrived this morning. Since I thought he knew his business, I listened to him. But whatever was actually required, he said the opposite. And he said so much that had we followed his instructions it would have seemed a thing of arteries and guts [*nerbi*]. Thus we have decided to do it in our own way so that we will not be made fools of. And he marvelled greatly, and said that we must follow his instructions and that he would not shift. We told him that we did not wish to do anything which would make fools of us. Therefore, leave the thinking to us, for we will make something which you will praise . . . Write down and send us the names of the saints whom you wish on the base, first St Francis and then the others as you wish, up to five or six of them.[10]

There has been considerable debate over the level of artistic freedom in the fourteenth and fifteenth centuries with some art historians arguing that the patron's interests were paramount and others seeing the development of the artist's independence. But as the examples shown above indicate, the artist–patron relationship should not be thought of as one of greater or lesser freedom but as a continuum which shifted and alternated from patron to patron and from commission to commission. Few artists could afford to work only according to their own ideas and few patrons had, or even wanted, total control over the finished product; the majority of relationships were somewhere in between these extremes.

Artists and institutions

When artists were employed by institutions the documentation which resulted was often quite different from that generated by individual patronage. The study of major artistic projects has been facilitated by the survival of the registers and account books kept by the bureaucrats who staffed most Italian public organizations. Lay institutional patrons, such as cathedrals, guilds, hospitals, confraternities, were usually composed of a rotating body of appointed or elected members who served short terms of office, one week (in the case of the fourteenth-century cathedral of Milan), or between two months and a year (as in Florence). These were usually known as either an *opera* or a *fabbrica*. The group of laymen, *operai* or *fabbricieri*, were meant to take the fundamental decisions concerning financing, administration, and design. In very large organizations, there might also be permanent salaried staff who were expected to execute such undertakings. Because of their scale and importance, these arrangements were characterized by meetings, argument, public debate, and eventual consensus, providing useful records of the ways in which public patronage functioned in the fourteenth and fifteenth centuries.

Opere could be found in every Italian town of any size. In, amongst others, Pisa, Siena, Orvieto, Bologna, Verona, and Venice, there were active groups in charge of the city's major cathedrals or basilicas. There

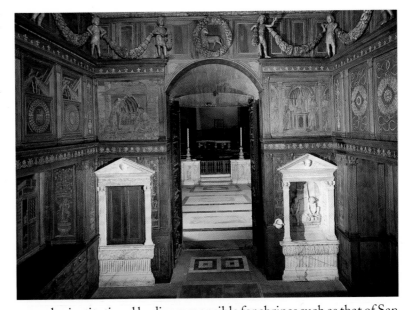

Sacrestia delle Messe,
cathedral of Santa Maria
del Fiore, Florence.
View looking towards
the cathedral crossing.
The Sacristy decorations were
a collaborative effort amongst
an extended family. The
woodworkers responsible
for the intarsia decoration,
Giuliano and Benedetto da
Maiano, were both the sons
and grandsons of important
Florentine carpenters.
Giuliano was married to
the sister of Maso Finiguerra
who, along with the Florentine
painter Alesso Baldovinetti,
provided drawings for these
panels. She was also the niece
of celebrated woodcarver
Manno de' Cori Aretino who
contributed to the work.

were also institutional bodies responsible for shrines such as that of San
Jacopo in Pistoia or hospitals such as the Innocenti in Florence or the
so-called *Ceppo* hospital in Prato. Guilds and confraternities also set up
special committees to oversee artworks. These groups needed to dec-
orate meeting halls and chapels, and were responsible for special sites
such as the shrine of Orsanmichele in Florence, the hospital where
Niccolò dell'Arca's *Lamentation* scene was displayed in Bologna, or the
altar above which Niccolò Varrallo's image of St Eligius was placed in
the cathedral of Milan. They also presented theatrical displays or
played a major part in processions. In Florence the confraternity of the
Magi created pageants in which members of the Medici family took
the part of the Three Kings. Another important Florentine confrater-
nity, attached to the church of Santo Spirito, re-created the mystery of
Christ's ascension to heaven each year, using members drawn from the
painters' community, such as Neri di Bicci (1373–1452), to create
scenery and costumes. In Venice, the major confraternities or *scuole*,
such as the brothers seen parading in Piazza San Marco in Gentile
Bellini's painting of 1495, played a crucial role in the important civic
rituals which punctuated the *Serenissima*'s calendar [**65**].

Each of these organizations depended on either membership fees or
charitable donations from the public and often received some form of
help from their local government as well. Despite their common pur-
poses, there were significant differences in the way these institutions
arranged their affairs. It is worth examining one case in detail, that of
the cathedral of Santa Maria del Fiore [**51**, **52**]. In Florence, where
guild membership was a prerequisite for government office, public
works were often organized by committees set up under the auspices of
the *arti*. The cathedral, which was founded in 1296, was by 1331 under

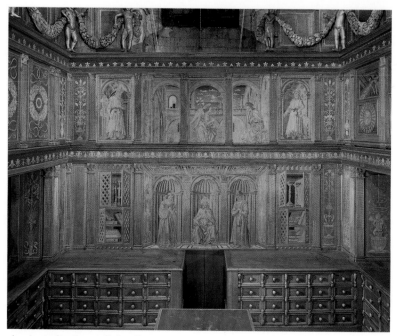

the jurisdiction of the Lana or wool merchants' guild, whose senior consuls appointed members to serve a four- to six-month unsalaried term of office. Because of this arrangement, the priests who served the cathedral of Florence had very little control over the design and decoration of their own church. Thanks to an edict issued by Pope John XXIII in the early quattrocento even the clergy came under the direct control of the Lana guild.

The *opera* of the cathedral faced many problems in the first half of the fifteenth century, the most pressing of which was the construction of the cupola over the central crossing. But another unfinished area which caused concern were the two sacristies where the precious relics and liturgical objects were stored. The story of the decoration of the north sacristy is a useful study of the complexities of institutional projects, the number of individuals involved, and the ways in which decisions were reached between patron and artist.[11]

In 1432 the *operai*, anticipating the actual consecration and use of the church, asked their chief engineer, Filippo Brunelleschi, to start work on the two as-yet undecorated sacristies. A subcommittee consisting of two guild members was set up to supervise the work. At that stage they were thinking of creating marble cupboards, in 'the best and most magnificent shape and form'.[12] Three years later they had settled on more conventional wood. Each expenditure, from salaries to the different types of wood and glues, hinges and locks, and the marble for the wash-basin, the lavabo, was carefully recorded by a notary, indicating that only the first sacristy was completed under Brunelleschi's overall supervision in the late 1430s.

After the provision of a model in 1437, Donatello was awarded the commission for a set of bronze doors for the sacristy. The creation of such detailed drawings and models seems to have been very common in cathedral projects: in 1442, for example, Luca della Robbia gave the *opera* a design for a pulpit in the sacristy while the sculptor Andrea di Lazzaro Cavalcanti (il Buggiano) provided a terracotta model for a lavabo. Through the use of such references, incoming *operai* could check that the versions agreed to by their predecessors were actually being executed.

The agreements reached between the various parties, particularly for major projects like the bronze doors, were also carefully recorded by a notary in the *opera*'s books of deliberations. Like contracts, they stipulated the materials to be used, the time involved, and the method of payment. The records also noted debates such as that carried out in 1443, when the Lana consuls called together various experts to consider design and materials which were to be used in the second sacristy. At this stage, some of the members, like the mathematician Paolo Toscanelli (1397–1482), returned to the suggestion that they be created from marble. Brunelleschi opted for 'marble facing on the wall into which would be set cabinets of coloured, polished marble with flat bronze doors', while Ghiberti wanted mosaic 'on the walls and vaults with white marble cupboards and wooden doors'.[13]

Although they listened carefully to these suggestions, the *operai* did not follow any of the expert advice they were given. Considerations of cost probably meant that the consul in charge merely ordered a large chest from a carpenter. Only in 1463 did yet another committee finally choose a team of wood-workers led by Giuliano da Maiano to finish the intarsia decorations of the second sacristy. To obtain the job, they had had to provide the usual *modello*, a drawing indicating what their work would be like, which the committee retained. They were to receive 4 florins per square *braccia*, a fee which would be lowered to 3 florins if they went beyond their eight-month time-limit. The quality of the work would be judged by the *operai* who were empowered to consult Piero de' Medici if required. To create his intarsia, Giuliano purchased designs from the painter Alesso Baldovinetti (*c*.1425–99) and (using Baldovinetti as an intermediary) from the goldsmith Maso Finiguerra. Two years later, in February 1465, his work on the end wall was completed and of sufficient quality to allow further commissions.

Meanwhile the bronze doors, for which the *operai* had purchased both old pots and pans and raw copper, were the source of some difficulty. By 1445 the guild had accepted that Donatello was unlikely to ever carry out his promised work on the doors and, in 1446, gave the job to the more reliable team of Luca della Robbia, Michelozzo, and the casting expert Maso di Bartolomeo (1406–*c*.1456). They provided a new drawing; a detailed description of the doors they were expected to

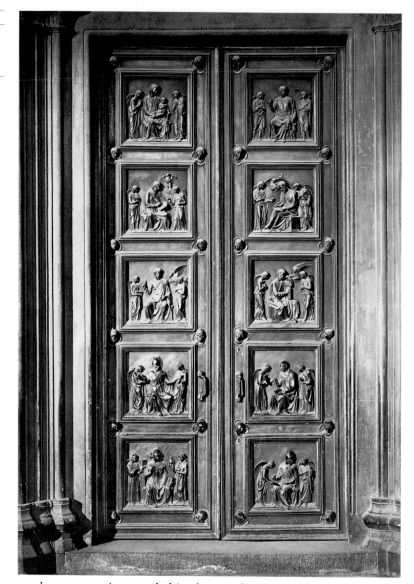

produce was again recorded in the *opera*'s account books. Yet despite these bureaucratic attempts at organization the patrons were unable to enforce their needs. In 1462 the *operai* noted ruefully that Maso was dead, Michelozzo had disappeared (to Chios), and only Luca was left. Della Robbia's doors were finally hung in place in 1475 without the damascene inlay which had originally been promised, a much duller, more conventional bronze sculpture than the commissioners had originally envisaged [**53**].

The sacristy, which involved engineers, sculptors, woodworkers, painters, bronze-casters (not to mention the goldsmiths and embroiderers at work on its contents), provides a miniature example of the cathedral's overall working structure. An extraordinary range of spe-

cialist workers were needed, from plumbers to suppliers of glue to the organ-master who had to give up some of his lead pipes to connect the lavabo to the cathedral well, to create this room. They all needed careful supervision, yet membership of the rotating committee changed hands at least twice a year. Although this was a considerable disadvantage it also meant that over the almost thirty-five years the sacristies were under consideration many different members of the Lana guild would have had the experience of acting as a patron of the arts, taking responsibility for, and ensuring the quality of, one of Florence's most important artistic enterprises.

The artist at court

Records for institutional sponsorship are often dry, and full of economic and legal issues. Like contracts, they lack the informal, personal arrangements which probably characterized the actual interplay between artist and patron. In a signorial society, however, private papers and state papers were one and the same, ensuring that more information survives about the relationship and status enjoyed by artists in the large princely courts like those of Milan or Naples or the small states of the Este in Ferrara, the Montefeltro in Urbino, and the Gonzaga of Mantua. These *signori* (who will be discussed at length in Chapter 8) usually employed a secretariat, including a private secretary who travelled with the lord and to whom letters and memoranda were dictated. The documents produced were then often recopied and stored in the chancellery, along with financial records and the important privileges which the family had either acquired or bestowed on its followers. When considering these letters and records, therefore, it is important to remember that despite their seeming informality, they were actually produced in a very structured manner before being issued.

Although every ruler complained of poverty and tried to avoid paying salaries and promised gifts, the incomes of the largest courts in Italy, which derived from direct and indirect taxes and loans, were often staggering. In the 1470s Duke Galeazzo Maria Sforza spent 5,000 ducats a year on maintaining his hunting-dogs alone, a sum which could equal the annual budget for the cathedral building programme for Milan. The Sforza controlled a large territorial base, and had establishments in each of their major urban and agricultural territories, but even more modest courts had a fairly constant need for ornamentation in one form or another. The term 'court artist' is usually considered to refer to the court painter, but this is a misrepresentation for the type of work produced by such men was much wider. Artists were needed to provide patterns, to decorate palace walls, to design costumes for festivities, and to provide portraits. Goldsmiths, embroiderers, tapestry-weavers, glass-makers, were all employed by

54 Antonio Pisanello

Design with Aragonese devices and motto 'Guarden Les Forces', brown wash, charcoal, and pen, *c*.1450–5.

One of the most important and constant jobs for artists employed by the Italian courts was the provision of textile designs. This pattern illustrates Alfonso of Aragon's French motto and devices.

the more ambitious *signori*, even if they were not necessarily regularly paid. Above all, the Italian lords welcomed the engineer-architects who were needed for large-scale building projects, fortifications, and siege artillery.

There was a tradition of employing a court painter and designer amongst the kings and queens of fourteenth-century Naples who, as rulers of the Anjou country of Provence, modelled their court on that of France. Giotto, for example, was a court artist to King Robert in 1332. In 1355 the Sienese artist Andrea Vanni (*c*.1332–1414) became the 'painter and household familiar' to Queen Giovanna I. The Milanese artist Leonardo da Besozzo (active 1421–58) who had worked for Queen Giovanna II in the 1420s retained his position well into the late 1440s under her disputed heir, Alfonso of Aragon. In 1449 Alfonso employed the painter and medallist Pisanello who had been a *familiaris* in Mantua in 1439 and was working for Leonello d'Este in Ferrara [54]. To entice the artist south, Alfonso asked him to become a member of the royal household with an annual stipend of 400 ducats. Pisanello's letter of appointment suggests that Alfonso had only heard about the artist, rather than necessarily having seen any of his works before the invitation was issued:

Seeing therefore that we had heard, from the reports of many, of the multitude of outstanding and virtually divine qualities of Pisano's matchless art both in painting and in bronze sculpture, we came to admire first and foremost his singular talent and art. But when we had actually seen and recognised these qualities for ourselves we were fired with enthusiasm and affection for him in the belief that this age of ours has been made glorious by one who, as it were, outshines nature herself.[14]

Such hyperbole was quite common in letters of appointment which were drawn up by the humanists working in Alfonso's chancellery. Pisanello did provide a number of medals in honour of the king's imperial aspirations and, probably, offered a design for the triumphal arch being erected on the royal palace. But he did not stay long in Naples, preferring to reside in Rome where he died in 1455 [104].

Pisanello's successor in Mantua, Andrea Mantegna, was a very different case. Unlike the much-travelled Pisanello, Mantegna rarely left the city where he served three generations of rulers from 1461 to his death in 1506. Over these years his salary, like that of most court servants, was somewhat erratic and included tax-concessions, property, a piece of woodland which he received in 1492 as payment for his work for the court and help when he needed to take his son to see a famous doctor in Venice. Mantegna eventually became a count palatine, an aristocratic title which could be purchased from the Holy Roman Emperor and brought the sole privilege of legitimizing bastards.[15] He was not the only artist to achieve this somewhat dubious social recognition. The Venetian artist who worked mainly in the Marches, Carlo Crivelli (1430/5–95?), after working for Prince Ferdinand of Capua, was knighted in 1490, enabling him to sign himself as *milites* in a series of altarpieces produced for towns in the Marches.

Providing such a title was actually an inexpensive reward. Princes were notoriously poor paymasters. Mantegna and Leonardo da Vinci's correspondence with their courtly *signori* rarely concerned abstract intellectual matters; they were primarily letters pleading for some form of compensation for their work. One well-known letter from the Bolognese painter Francesco del Cossa (c.1436–78), concerning his fresco-paintings [55, 56] in the Ferrarese *Schifanoia* Palace, produced for Duke Borso d'Este in the 1470s, has been much discussed in this context:

I recently petitioned your lordship along with the other painters about the payment for the room at Schifanoia, to which your lordship answered that the account was persistent. Illustrious prince, I do not wish to be the one to annoy Pellegrino de Prisciano and others, and so I have made up my mind to turn to your lordship alone, because you may feel, or it may have been said to you, that there are some who can be happy or are overpaid with a wage of ten pennies. And to recall my petition to you, I am Francesco del Cossa, who have made by myself the three wall sections toward the anteroom. And so, illustrious lord, if your lordship wished to give me no more than ten pennies per foot, and even though I would lose forty to fifty ducats, since I have to live by my hands all the time, I would be happy and well set, but since there are other circumstances it makes me feel pain and grief within me. Especially considering that I, when after all I have begun to have a little of a name, should be treated and judged and compared to the sorriest assistant in Ferrara. And that my having studied, and I study all the time, should not at this point have a little more reward, and especially from your lordship, than a

55 Francesco del Cossa and Cosmè Tura

The Month of April, fresco, c.1467–72, Palazzo Schifanoia, Ferrara.

person gets who had avoided such study . . . And because my work proves what I have done, and I have used gold and good colours . . . and I pray you, if your objection should be to say: I don't want to do it for thee because I would have to do it for the others, my lord, your lordship could always say that the appraisals were this way. And if your lordship doesn't want to follow the appraisals, I pray your lordship may wish to give me, if not all that I perhaps would be entitled to, then whatever part you may feel in your grace and kindness, and I will accept it as a gracious gift, and will proclaim it so.

In reply the duke simply noted, 'Let him be content with the fee that was set, for it was set with those chosen for the individual fields.'[16]

Art historians have been fascinated by the middle of this letter where Cossa argues that his work deserves greater reward because of

56 Francesco del Cossa

The Triumph of Minerva
(The Month of March);
c.1467–72, see **54**.

his study and his reputation, but the beginning and ending actually tell us more about what was at stake. This letter is a *supplica*, a typical request for signorial intervention on behalf of a deserving individual who is not being treated fairly by ducal officials. The final note indicates that Cossa, like his colleagues, the Ferarrese painters Cosmè Tura and Ercole de' Roberti (1451/6–96), had agreed a set price for each wall before they began the commission in the late 1460s. As was common, they did not work directly with the duke of Ferrara himself but with his intermediaries, officials such as the noted humanist and grammarian Pellegrino Prisciani (to whom the complex programme for the cycle has often been attributed). When finished, the work was to be appraised to ensure that the painters had delivered the promised quality. At this stage, it was quite common to argue that more materials or figures had been included, requiring a higher price, while the patron would insist that they must accept the sum originally agreed at the commencement of the project. Cossa and his colleagues had already put in a joint petition to the duke. Now Cossa, who worked primarily in Bologna for the urban patriciate of that city, was trying to single himself out from his associates who were more closely connected to the Ferrarese court community. He offered several ways in which Borso could legitimately offer him more money than the others, one by referring to the valuation, the other by pretending that the additional sum was a gift.

Borso d'Este was unimpressed by this approach and Cossa was informed that he had to be content with the arrangement he had originally entered into. This seems to have been the last commission that Cossa was hired to execute for the court, but Tura and Roberti, who understood what was expected of them and how to work through the aristocratic and humanist intermediaries in Ferrara, continued to prosper.

The triumph of fame

There has been a tendency to see the period from 1350 to 1500 as a time of 'the rising status of the artist' or as a transition from craftsman or artisan to artist. Yet Cossa's lament was not so much that his talent had not been appreciated, as that he had not been properly remunerated. In the sixteenth century Giorgio Vasari, anxious to establish the noble status of the arts, diminished the role of the importance of financial reward in his writings. This was an attitude which could already be found in earlier writers such as Filippo Villani who wrote of Giotto in 1381–2, 'he was also, as was proper to a man, very prudent of his reputation, rather than anxious for monetary gain'.[17]

But making works of art remained an economic activity in the fourteenth and fifteenth centuries and the aristocratic superiority of the arts was still an aspiration rather than an actuality in the sixteenth century. If an artist could not sell his work, he could not continue in his chosen profession. Because of this imperative, ambitious figures did not passively wait to be chosen, they marketed themselves, their wares, and their reputation. Thus one of the practices which does differentiate Italian artists from, for example, those of Germany is an early and relatively consistent practice of signing their works. Like wool manufacturers and armourers, goldsmiths used various seals and markers to indicate their responsibility for the quality of the finished product. They were often referred to by name, along with that of the donor, in any accompanying inscriptions. We know, therefore, that Jacopo de Roseto produced the reliquary of the head of St Dominic in Bologna because his signature was prominently inscribed on the piece [19]. On the *Lamentation* ensemble in the same city, Niccolò dell'Arca signed his first name on a banner placed across the pillow on which Christ's head lay, ensuring that anyone looking down at Jesus's tragic figure could not miss the name of its maker [8, 9, 10]. In the late 1490s Michelangelo, who had just finished adding the last pieces to dell'Arca's shrine in San Domenico in Bologna, did the same on the Pietà he had made for a chapel in Saint Peter's, Rome, boldly carving his name across the Virgin Mary's chest [117].

Yet before we pronounce these signatures as some sort of discovery of self-identity we have to remember that such autobiographical inscriptions have a much earlier history. On the pulpit of the duomo in Pisa, for example, Giovanni Pisano (1248–after 1314) left a far from modest description which argued that he was superior to both his father and to his contemporaries and finished, 'Christ have mercy on the man to whom such gifts were given. Amen.'[18]

Giovanni's near contemporary, Giotto di Bondone, signed only two of his paintings (works which art historians now attribute to his workshop) but his name and reputation were preserved thanks to writers such as Dante Alighieri (1265–1321) who included him, along with an

illuminator, in his description of purgatory. Dante intended the rise of Giotto's reputation, which overshadowed that of his master Cimabue, as a symbol of the transience of fame. But by the mid-fourteenth century Giovanni Boccaccio's view of Giotto's achievements, made in a short passage inserted in his popular stories, the *Decameron*, formed the basis for later approaches to the history of art:

And thus he [Giotto] returned to the light that art which had been buried for many centuries under the errors of those who had painted more to delight the eyes of the ignorant than the intellect of the wise.[19]

By the late trecento the Florentine painter's name, if not his style, had become a metaphor for artistic achievement. When his compatriot Niccolò di Pietro Gerini (documented 1370–1415) boasted to his patron Francesco Datini that the designs he had supplied for a crucifix in 1395 'could not have been surpassed by Giotto', he was using a well-worn phrase. Datini, in turn, used the same allusion when complaining about Gerini's bills, arguing that 'I believe that when Giotto was alive he was cheaper'.[20] Several decades later, when the early fifteenth-century Florentine merchant Giovanni Morelli wished to praise his sister's attractions, he too declared that she 'had hands like ivory, so well made that they seemed to have been painted by the hand of Giotto'.[21] By the end of the quattrocento the cathedral of Santa Maria del Fiore had commissioned a bust of Giotto from Benedetto da Maiano, ensuring that his reputation was secured for posterity even if many of his works would disappear or be forgotten.

Giotto's name survived, in part, because of the attention his work was given by contemporary and later writers and chroniclers. By the mid-fourteenth century a number of Italian artists, particularly in Tuscany, seem to have been aware of the need to promote themselves and their memory, either by writing themselves or by encouraging others to write about them. This led to a happy conjunction with the developing humanist genre of rhetorical praise, modelled on that of antiquity where painters and sculptors were often referred to in superlative terms. Over the fourteenth and fifteenth centuries we find, therefore, not so much a change in artistic practice as a change in the type of written evidence with a proliferation of recipe books, theoretical treatises, poetry and prose praises, and biographical sketches. The Roman author Pliny the Elder (AD 23/4–79) provided the model and the information about the artists of Graeco-Roman antiquity. In his multi-volumed work, the *Natural History*, later writers could find and appropriate an extensive series of stories about the importance, social status, and wealth earlier painters and sculptors had enjoyed. Pliny's highest praises were reserved for artists who imitated nature and for patrons who treated their artists with the greatest respect.

To Pliny's concern for the *trompe-l'œil*, a number of later writers

added justifications for the intellectual and mathematical underpinnings of pictorial representations. The dictum used by the Roman poet Horace, 'ut pictura poesis' (poetry is like painting), led to a series of comparisons, known as *paragoni*, between the two arts while others were more interested in the mathematical aspects of geometric perspective. So the humanist Michele Savonarola (*c*.1384–1468) writing in Padua in 1444 could stress,

I hold in no small account our school of painting [*pictorie studium*] which is a singular ornament to our city, for it is connected with the study of letters and the liberal arts more than any of the other [i.e. the mechanical] arts, as it is a branch of perspective, which discourses on the projection of lines, and perspective is a branch of philosophy.[22]

Since the study of mathematics and the proportional harmonics of music were deemed part of the university curriculum, artists who, to use Francesco Cossa's terms, 'studied continuously' were able to argue an equality with graduates such as notaries and doctors. But pride in the painter's profession preceded this mathematical skill. In the late fourteenth century, a Florentine painter working at the Carrara court in Padua, Cennino Cennini (documented only in 1398), wrote what is probably the best-known Renaissance treatise on art today, the *Libro dell'arte*. The earliest surviving copy dates from 1437 and is in the hand of an unknown scribe in the debtors' prisons of Florence, the so-called *stinche*. It was considered to be an act of charity to employ such men to act as copyists but the commissioner of this particular edition is unknown. The information Cennini provided to the aspiring painter included instructions for obtaining materials and creating different designs on wall, on panel, on metal, stone, parchment, and cloth as well as an introduction to glass-painting, mosaic, cosmetics, and bronze-casting. Although the terminology and instructions are those we now associate with craft traditions, many of which are still being used today, the introduction makes no apology for the philosophical status of the painter's profession:

Man [after the fall of Adam and Eve] pursued many useful occupations, differing from each other; and some were, and are, more theoretical than others; they could not all be alike, since theory is more worthy. Close to that, man pursued some related to the one which calls for a basis of that, coupled with skill of hand: and this is an occupation known as painting, which calls for imagination and skill of hand, in order to discover things not seen, hiding themselves under the shadow of natural objects, and to fix them with the hand, presenting to plain sight what does not actually exist. And it justly deserves to be enthroned next to theory, and to be crowned with poetry.[23]

Cennini made it clear that he was writing for fellow practitioners who wished to add lustre to their profession by having a written manual set-

ting out their tasks. There were other fourteenth-century recipe books in circulation, such as treatises on glass-making which were compiled in Florence at about the same time. None of these was meant to replace the apprenticeship system, and only a very small number of manuscripts seem to have circulated at an early stage (Cennino Cennini's was certainly seen and used by Giorgio Vasari in the sixteenth century). Similarly, another Florentine, Lorenzo Ghiberti, believed that, by providing a written account of the history and mathematics which lay behind his profession, he could ensure personal posthumous fame and contribute to the respect in which he and his colleagues were held. Sometime in the late 1440s, Ghiberti put together a series of notes into three so-called *Commentaries*, a humanist term used for history-writing. The first section dealt with antiquity, the second with Ghiberti's own artistic background, and the third with some of the complex theoretical issues which lay behind optical illusion. Much of it was drawn from his reading of ancient authors such as Pliny and the Roman architect Virtruvius, as well as the early medieval comments by Averroes, Avicenna, Roger Bacon, and John Pecham on anatomy and optics, while others were more autobiographical in their approach. Ghiberti has been much criticized for his lack of originality in this work, which only survives in one poor copy; but recent research on Leonardo da Vinci's scientific knowledge has revealed a similar dependence on traditional medieval scientific theory.

In his second commentary, Ghiberti provided a model which Vasari would later follow with considerable modifications in his sixteenth-century *Lives of the Artists*. Ghiberti described how art had been 'resurrected' by Giotto and the Sienese painter Ambrogio Lorenzetti, 'a most perfect master, a man of great genius'. The most perfect sculptors were an otherwise unknown goldsmith, Gusmin, and, of course, Ghiberti himself.[24]

Florentine merchants and aristocrats were unusual in their attention to their *zibaldoni*, or collections of anecdotes, information, and accounts. It is perhaps, therefore, unsurprising that Ghiberti's example as a writer and theorist was followed by two other Florentines, Antonio Averlino (Filarete) and Leonardo da Vinci. Both produced much of their work outside the city, primarily in Milan. The former wrote a treatise on architecture which included a section on the art of drawing, while the latter's extensive collection of notes, drawings, and scattered but important references to theories of optics, painting, and perspective have been the subject of intensive investigation by scholars.

These were the writings of practising artists. One of the most influential writers on the arts of the fifteenth century, Leon Battista Alberti (1404–72), a scholar first and foremost, was in a very different position. The illegitimate son of a Florentine exile, Alberti trained at the University of Bologna. As a cleric in minor orders he was responsi-

ble for producing the many Latin documents which were emitted by the Papacy. This post gave him a regular stipend and a respectable position in intellectual company. He wrote on many subjects, with a prodigious output which included commentaries on mapmaking, ciphers, horses, the family, and architecture, and even a short party-piece written for amusement lamenting the death of his dog. He claimed to have painted himself, and his treatise *De Pictura*, produced in 1435, demonstrates a clear knowledge of the mathematical interests of artists such as Filippo Brunelleschi (to whom the Italian edition *Della pittura* which appeared in 1436 was dedicated). Although to the mathematically literate its outline of Euclidean geometry was actually quite simple, it is unlikely that it was used regularly as a practical manual. That far more copies survive in Latin than in Italian suggest that its real readers were aristocratic patrons such as Gianfrancesco Gonzaga, marquis of Mantua (d. 1444), to whom the first edition was dedicated. Although important in authorizing the visual arts as a subject for distinguished humanist interest, the treatises on paintings, and a shorter one on the proportions of the human body in sculpture, do not seem to have been as popular as his writings on architecture which were borrowed and read by the wealthiest of Italian patrons. Perhaps because of his limited achievement in establishing painting and sculpture as an area of intellectual concern, Alberti did not have an immediate successor in that area. Most humanists were more concerned with the poetics of pictorial praise, a genre already established by Petrarch in the late fourteenth century when he had written sonnets on the portrait of his beloved Laura by the Sienese painter Simone Martini (*c*.1284–1344). In the fifteenth century court artists like Pisanello could expect to accumulate numerous verses in their honour. One example, from the end of the century by a writer in Bologna, illustrates the by-now familiar phrases with which a painter would be exalted. Angelo Salimbeni was writing in the winter of 1478 about the death of Francesco del Cossa, the artist who had resented his treatment by Borso d'Este:

If I believed that my words would not come to other ears I would have said that there has not been such a painter for a good while, although there are many who in this art are worthy, some in one part and some in another, and we see one who knows how to do a head better than anyone else, another who knows how to create a cloth drape better than a nude. But he was the most universal of artists that I have ever seen and he knew more than his art: he gave to his figures such grace according to their function that the eye could find little difference from the truth.[25]

The concept of the need to avoid offending jealous rivals with his praise, the universality of the painter's art, and the skilful illusions created were stock phrases. In his poetry, Salimbeni added a generous

sprinkling of references to Pliny's great ancients such as the sculptor Phidias. In a passage taken from a lengthy work written for a wedding in 1487, Salimbeni turned to the goldsmiths of the fifteenth century:

> But among the goldsmiths I shall mention
> Francia, whom I cannot omit for any reason
> Polygnotus he surpasses with his brush
> and Phidias in his making of sculpture,
> And he acquired so much fame with his burin
> To eclipse even that of Maso Finiguerra,
> And I compare him even to the dead,
> So that those who live would not be envious.[26]

The artist to whom Salimbeni refers in the second line was Francesco Francia (1450–1517) who was used later by Giorgio Vasari as an exemplar of an artist in search of fame. In his life of Francia, Vasari had the Bolognese painter die of shame and despair after viewing a picture by Raphael, realizing that he could never achieve similar greatness, an episode which did not actually take place. The book in which this story appeared, the *Lives of the Artists*, first published in 1555 and considerably revised for republication in 1568, used such anecdotes to authenticate its underlying thesis. Vasari divided the history of art into three periods: taking Boccaccio's notion of Giotto's 'return of art to the light' (the origin of the notion of a medieval 'dark ages'), he based the first third of his volume around this Florentine and his trecento contemporaries; the second wave became the fifteenth-century artists who strove but failed to perfect this vision; the third period was dominated by the pinnacle of perfection Michelangelo Buonarroti.

Vasari's teleological sense of progress and advancement, one which moved away from the medieval past towards the recapture of ancient grandeur in the work of Michelangelo, has had a significant impact on later ideas of the Renaissance. In Vasari's grand scheme the fifteenth century became a period of transition rather than a moment which needed to be considered in its own right. As we have seen, however, those fifteenth-century artists and commentators who wrote about their achievements were unaware that any further development was needed. Whenever they were written, the arguments for the rising status of the artist eventually tell us more about the literary genres in which theorists were working than about the actual experience of artistic production and appreciation. For that information and evidence we need to turn to very different sources, ones which tell us as much about the viewers of art as they do about the artists themselves.

Part II

Audiences for Art

The Sacred Setting

5

Part I of this book asked questions about what an object was made from, how it was made, for whom, and by whom. It finished by asking how literary reputations were created and posthumous fame was guaranteed for a number of Renaissance artists. Part II, which looks particularly at art in sacred settings, asks to what purpose this effort was directed.

To attempt an answer, however partial, we need to know something about the original function and meaning of the works illustrated in this book. For example, where were they located? Who could have seen them and when? How were viewers supposed to behave in front of such objects and how did they actually behave?

These questions, as the many art historians who have embarked on such enterprises will testify, are not easy to answer. Despite our increasing understanding of intellectual ideas and historical events, resiting the works of art in their original context is fraught with difficulties. First, as we have already seen, the traditional notion of art as consisting exclusively of paintings and statuary is unhelpful. Any image belonged to a wider category of goods, one which included liturgical and household furnishings, clothing, embroidery, maps, clocks, scientific, and musical instruments—objects which all contributed to a general sense of a contemporary visual culture.

Secondly, even the very concept of function is difficult. We accept that clothing is worn, viols and lutes are played, and that beds, chairs, goblets, and plates have particular uses. So too, however, did other images, ones whose physical relationship with the viewer has changed dramatically over the years. Paintings, statues, and goldwork were rarely seen in static, unchanging circumstances. While some pictures did hang openly on the walls of churches, homes, and town halls, others were hidden away in chests and cupboards and only shown on very special occasions. Objects, such as the metal plates known as paxes (meaning 'peace' in Latin), which are now kept in untouchable glass-covered museum cases were once held, kissed, and wept over. Paintings and sculptures might be carried in procession, worn in hats, burnt in bonfires of luxury goods, and in some cases, like the last architectural

Linaiuoli tabernacle, tempera
on panel, 1433, (Museo di)
San Marco, Florence: seen
open and shut.

This is another example of
artistic collaboration. The
marble frame was designed
by Lorenzo Ghiberti and
executed by two Florentine
stone-cutters. The wooden
support was made by yet
another artist and Fra Angelico
(who belonged to the same
order as the son of the
procurator of the guild for
whom the tabernacle was
made), painted the figures
and predella scenes below.

model of the church of San Francesco in Rimini which was made of sugar, eaten.

Many religious and secular pictures were hardly visible at all on a regular basis. They were kept covered, either with shutters, or with painted curtains which were only drawn back on specific occasions. Fra Angelico's *Linaiuoli* altarpiece [**57**], now seen in a fixed open position in the Museo di San Marco in Florence, was normally only opened when the guild of linen-drapers, the Linaiuoli, met together in their hall. With the shutters closed, the figures of Sts Peter and Paul standing on a simple rocky ground against a dark, night-time background were visible, their glistening haloes highlighted against the deep inky blue. When opened, the entire image seemed encased in the light of the gold leaf which encircled the Virgin and Child. When the guild eventually installed Fra Angelico's finished tabernacle, they had it fixed into the wall of their meeting-room and ordered stars to be painted on the wall around it.[1] They also ordered a new window to be constructed nearby, which suggests that the ritual of preparing this meeting-room

involved opening a real window to allow real light into the room and then opening the tabernacle to allow the glittering light of heaven into a seemingly dark night-sky.

Such a hypothesis may be an excessive interpretation of sparse documentation but we can begin to see some of the problems which arise in contextualizing a Renaissance object when we take what might seem a simple issue, that of lighting. The experience of being in church at a sunny midday mass was surely very different from being there in the darkening light of a winter's afternoon. The only written information we have concerning Luca della Robbia's Visitation figures from Pistoia [27] comes from a document concerning the donation of an oil-lamp from the widow from a wealthy family. The reflective white surfaces of della Robbia's glazes would have ensured that the play of light against the figures would have been very effective, drawing devotees to the shrine.

Powerful pictures

Alongside the practical questions of the physical conditions in which works were produced and seen, there are even more nebulous assumptions and attitudes which affected contemporary perceptions of imagery. In religious art, the foremost problem was the fact that, according to the Old Testament, a number of forms of figuration were specifically forbidden. The Second Commandment outlawed idols: Exodus 20: 4 clearly stated, 'Thou shalt not make unto thyself any graven image, nor the likeness of anything that is in heaven above nor in the earth below.' This injunction informed Judaic and Islamic prohibitions on the worship of images, and on any attempt to depict the unknowable; that is, the face of God. The Christian religion periodically faced similar bans, above all in the Eastern Orthodox Church where the Byzantine emperors had encouraged fervent iconoclasm (the destruction of religious paintings and statues) from AD 726 to 787 and again in 814 and 843. Although the Latin West did not face such strong divisions and dissent, there were tensions and ambiguities in the Catholic Church's response to religious art. Idolatry was only one issue; the expenditure of wealth on objects rather than on deserving and needy individuals was equally problematic.

In keeping with this attitude the official rules for monastic communities discouraged anything more than a simple crucifix, plain unpainted glass windows, and unvaulted wooden ceilings, although these regulations were rarely observed in practice in Italy's larger Franciscan and Dominican churches. Worshippers in these buildings would have had many more objects and images to consider, from those used in the service itself, such as the liturgical books, the chalice, plate, altarcloths, and the silk embroidered vestments worn by the priest to those on more permanent displays such as frescos, elaborate crucifixes, and

large wall panels or stained glass and mosaics, stone or wooden pulpits, holy water fonts, tabernacles, and statues.

Moralists did not object to the first group of liturgical objects since they had specific, well-defined functions, but only to the lavishness with which they were made. A chalice held the consecrated wine; the patten, the wafer; the pyx, the consecrated host when it was not being used; the altar-cloth and vestments indicated both the status of the wearer and the type of service under way.

There were greater problems with the second category of objects, for the precise function of images, painted or sculpted, proved more elusive. For most Catholics, there was a long-standing definition, traditionally assigned to Pope Gregory I (reigned as Pope 590–604), based on his letter to an iconoclast bishop who had been destroying images:

You brother should have both preserved the images and prohibited the people from adoring them so that those who are ignorant of letters might have the means of gathering a knowledge of history and that people might in no way sin by adoring a picture.[2]

This traditional position of an image as a bible for the illiterate was reiterated in the opening of the Sienese painters' guild statutes of 1355 which told artists that their task was, 'by the Grace of God, the expositions of sacred writ to the ignorant who know not how to read'.[3] But this was only one possible function for religious art. The thirteenth-century *Catholicon* of Johannes Balbus (d. 1298), a compilation of widely accepted traditional beliefs which remained in use throughout the fourteenth and fifteenth centuries and was finally printed in Venice in 1497, shows its other manifestations. As Balbus (who was following earlier writers such as St Thomas Aquinas) explained, images had three functions: to instruct the ignorant and unlettered; to keep the memory alive of the mysteries of the faith and the examples of the saints, and to act as means of exciting devotion.[4] The first function was firmly based on Gregory's admonition that a picture could be used as a teaching aid. Narratives winding around a pulpit, or on the walls of a church nave, illustrated biblical tales and the lives of the saints for public instruction. But while the basic educational purpose was important, many of these images were inscribed in either Latin or Italian which suggests that they also held a value for the literate. The other two functions cited in the *Catholicon*, those of aids to memory and devotion, complicate our understanding of the purposes of pictures. In attracting the viewer's attention, stories or single figures of saints were meant to remind the worshipper of past events and ideas, to encourage a re-examination of one's own life and behaviour, and to prompt an appropriate emotional response.

Behind Pope Gregory I's letter and the *Catholicon's* instructions lay a long-standing concern that viewers might, through ignorance,

misuse these images. There was the danger that prayers were being directed to the actual wood, paint, metal, or marble, rather than to the saint or holy figure being represented. That is, viewers might consider the physical object as divine, rather than using the representation to gain access to a higher spiritual plane. In the thirteenth century St Thomas Aquinas (c.1226–74) was careful to insist that 'Religion does not offer worship to images considered as mere things in themselves, but as images drawing us to God incarnate. Motion to an image does not stop there at the image but goes on to the thing it represents.'[5] In these orthodox terms, which were repeated throughout the fourteenth and fifteenth centuries and reiterated in the sixteenth century, the image, correctly used, was a permeable screen through which communication with heaven was made possible.

Nevertheless, even with careful monitoring, the dangers of idolatrous behaviour did not disappear. The late-fourteenth-century Dominican preacher Giovanni Dominici warned fathers to

beware of frames of gold and silver, lest they [your children] become more idolatrous than faithful, since, if they see more candles lit and more hats removed and more kneeling to figures that are gilded and adorned with precious stones, than to the old smoky ones, they will only learn to revere gold and jewels and not the figures, or rather the truths represented by those figures.[6]

Despite such admonitions, Italian worshippers, like their counterparts throughout Europe, did have very specific expectations of individual objects and places and recognized the importance of an image by the honour which was afforded it. They continued to make valuable offerings and to bring gestures of thanksgiving to the saints, and the figures of saints which had served them well. Since the Church did not always fully control the way viewers behaved before images, we need to explore the ideas and beliefs, official and unofficial, which Christians brought to the objects themselves; above all, their hopes and fears about sin, salvation, and damnation.

Art and the afterlife

In Masaccio's fresco of the Trinity [7] the frail cadaver beneath the fictive altar is inscribed with the words, 'As you are now, so once was I; as I am now, so too will you be.' This standard call, the *memento mori*, encouraged viewers to remember the transience of their earthly existence and the need to prepare for an inevitable death. In his sermons on *The Art of Dying*, delivered in Florence in November 1492 and printed three times over the next four years, the preacher Girolamo Savonarola suggested wearing 'eyeglasses of death [*occhiali della morte*]', to ensure that thoughts of the afterlife coloured everything men and women did and saw on earth. He wanted Florentines to place images of paradise

and hell in their bedrooms so that 'when men enter the chambers of civic councils the "eyeglasses of death" will remind them to speak the truth in their business. The wealthy will see hell if they act dishonestly and women who pamper their body will see that pleasure will lead to damnation.'[7]

Artists, patrons, and viewers would have all agreed with Savonarola that their temporal life could end at any time; yet there were special periods of vulnerability. Records of death in fifteenth-century Milan suggest that the greatest number of deaths occurred in infancy. The majority of deaths were in children under the age of 14; of these, the greatest number were of infants below the age of 4.[8] Having reached late adolescence, however, chances of survival were reasonable and it was not uncommon for men and women to live well into their sixties and seventies. In their absorption in daily troubles and excitements, these mature citizens might be distracted by earthly affairs and forget their spiritual well-being.

This lack of concern could not be permitted since personal salvation and that of family, friends, and neighbours were central issues for both the individual and the community at large. Images of corpses and of the afterlife were only one form of reminder. Examples of appropriate temporal behaviour were also needed for one's future in eternity was determined by behaviour here on earth. Given the range of activities, sexual, financial, emotional, and religious, which were potentially damning, even the most earnest Christians had good reason to be nervous. There were two possible levels of human error. The first were mortal sins which included breaking any of the Ten Commandments or committing one of the Seven Deadly Sins: pride, envy, anger, despair, avarice, gluttony, and lust, whose subsets could be multiplied *ad infinitum*. The sin of pride, for example, included ingratitude, boasting, flattery, hypocrisy, derision, ambition, presumption, curiosity, and disobedience.[9] Some critics, such as the rigorously harsh archbishop of Florence St Antoninus, included excessive ornamentation amongst the mortal sins, condemning women who wore elaborate trains on their cloaks, the tailors who made them, the merchants who sold the cloth knowingly for this purpose, and husbands who permitted the extravagance.[10] A second category of error, the venial sins, was less likely to lead directly to hell. These included acts like eating meat during Lent or having intercourse with one's spouse during a penitential season or on a feast day. But however mundane, such acts needed to be dealt with to ensure that they did not prejudice the Christian's progress towards salvation.

Recognizing that men and women were both born sinful and liable to err, the Western Church had established a number of ways of redeeming original, mortal, and venial sins. According to Catholic doctrine, the seven sacraments (actions established or authorized by

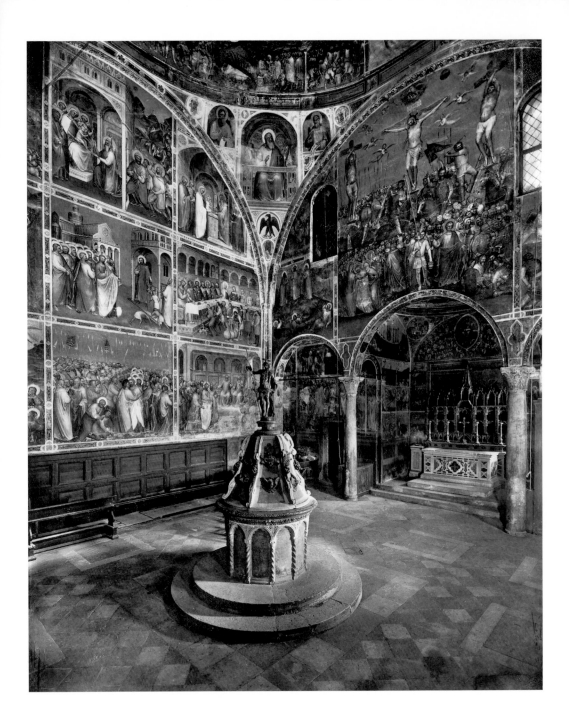

58

Baptistery, Padua. View
of interior with frescos by
Giusto de' Menabuoi of
the life of Christ and Saint
John the Baptist.

Christ during his time on earth) were baptism, confirmation, confession, the Eucharist, extreme unction, ordination, and marriage. The first and most crucial sacrament was baptism which erased the original damnation imposed by God on all humanity and transformed infants into members of the Christian community. The ritual, which involved a priest anointing the child with holy oil (chrism) and water, was so important that it often merited a separate site attached to the cathedral church. Indeed, it was such a crucial step in ensuring salvation that some clerics were even willing to allow laymen and lay-women to baptize children in the absence of a priest if the infant was dying. It was also an important social ritual amongst the élite, with godfathers (*compadri*) expected to look after the child's political, financial, and familial interests.

The attention paid to baptism made the physical site of the baptistery a special place in the city, one free from any factional interest. In Florence, which, like many cities, included St John the Baptist amongst its patron saints, the Romanesque baptistery was a separate building, falsely thought in the quattrocento to have been an ancient temple to Mars in origin. The octagonal building represented the city's claim to a Roman inheritance and its right to the bones of John the Baptist himself. Attempts were made by Florentines such as Filarete to steal this saint's relics from Rome and the burial of the anti-pope John XXIII in the baptistery in Florence [44] was permitted, in part, because of his donation of a portion of John's finger to the city.

In Florence, the saint and his church were thoroughly identified with the municipality. In Padua, in contrast, the frescos in the baptistery attached to the cathedral commemorated a single family, the local *signore* Francesco I da Carrara (1325–93) and his wife Fina Buzzacarina, who funded the elaborate fresco cycle put up by Giusto de' Menabuoi (d. 1393) in the late 1370s [**58**, **59**]. The da Carrara family arms dominated the spandrels of the ceiling and Fina's own very visible patronage of the baptistery (she appears with her patron saints kneeling before the Virgin) was a dramatic indication both of their standing and wealth and of their piety and concern for salvation.[11] The baptistery functioned as the couple's burial site where prayers for their souls were paid for by the sale of Fina's clothing and silverware. It continued, however, to function as the central baptistery of the city and when the Paduan doctor Michele Savonarola wrote a description of the frescos in 1444 he implied that they were normally seen within the context of the ceremony of baptism, encouraging the continued attention of the audience which had gathered for this special moment:

Then Giusto painted the very large space that the Paduans call the Baptistery. For in this place, on a holy day when the Paduan Clergy are assembled, baptism is done and the little children are baptized. And the charming appearance of the figures, composed with great art, is such that for

59 Giusto de Menabuoi

Fina Buzzacarina Presented to the Virgin by St John the Baptist and other saints, fresco, c.1376, detail from the baptistery, Padua.

those who come in, it is disagreeable to leave. It shows the Old and New Testaments, with the greatest richness.[12]

If baptism erased original sin, two other sacraments, confession and extreme unction, cleared the sins of a lifetime. In many Italian cities doctors were legally required to notify a priest of those whom they considered close to death. The patient would then be visited by a cleric and by a notary. The priest, or a friar who had special permission to hear confessions, would encourage a full recital of the patient's outstanding sins, and suggest means by which restitution could be achieved. This put the priest or friar in a strong position to suggest that salvation could be best arranged by a payment either to themselves or to their particular church or order, a practice condemned in ecclesiastical legislation but one which seems to have been widespread.[13]

After a full confession had been heard, the notary would, where necessary, write out a will or make a codicil to an existing document. This was an important step as it gave the dying a final opportunity to repent and to make legal atonement for their sins. A typical will included the request that heirs make restitution for any past misdeeds

or ill-gotten gains that the deceased may have incurred during his or her lifetime, a clause known as the *mala ablata*. The fourteenth-century Strozzi chapel [2, 3] was one example of the result of such a bequest.[14] Aside from dividing up property and goods amongst friends and relatives, testators could also make provision for their burial, for bequests and for endowments which would ensure that prayers would be said in their name, as well as arranging for the commissioning or completion of their chapel or tomb. Although it is not easy to general-ize, wills usually left some money to charity, ranging from donations of food or clothing to the poor and the provision of funds to provide dowries for poor girls to gifts of cash, land, or goods to hospitals, con-fraternities, churches, monasteries, and saints' shrines. In some cities, all testators were forced to make a minimum contribution to the cathe-dral building fund or to the construction of city walls. A small number of benefactors also used the will as their last chance to give precise instructions for the decoration of their tombs or burial chapel. Fina Buzzacarina's will, for example, endowed two priests to provide fu-neral masses and perpetual prayers for her soul and specified that she wanted a tomb constructed 'according to her dignity and con-sidering the conditions of the status and magnificent birth of her lord Francesco da Carrara'.[15] While most were content to leave the issue to executors, a small number such as Bartolomeo Bolognini, one of the wealthiest men in early fifteenth-century Bologna, left extraordinarily precise instructions concerning both the iconography and the quality of the works of art to be created on their behalf[16] [129, 130].

Behind these donations and bequests lay the hope that the prayers which resulted, as well as the good works themselves, would be taken into consideration at the Last Judgement. The Church itself was pri-marily concerned that Catholics might die without making appropri-ate provisions for the afterlife and tried to encourage Christians to confess more regularly, at least once a year. Holy Communion could not be given unless the recipient had confessed and received absolu-tion, so the practice had a very practical impact at Easter when most expected to partake of the host. Preparation for annual confession was needed and the possible sins which needed to be regularly forgiven were so numerous that manuals were written in the early fifteenth cen-tury to instruct both the confessor and the confessee. The archbishop of Florence, St Antoninus (1389–1459), wrote a popular book on con-fession that was eventually printed in thirty-two European cities before 1500. Yet given the possible expense of making restitution and the certain embarrassment, many Catholics were, according to chiding preachers, reluctant to recite their sins regularly, particularly since the private confessional box used today was only brought in in the six-teenth century. Instead of going to the parish priest who saw them on a daily basis, they might turn instead to travelling friars who would move

60 Neroccio di Bartolomeo de' Landi

The Preaching of St Bernardino in the Piazza del Campo and the Liberation of a Madwoman at the funeral of St Bernardino, tempera on panel, c.1470.

from town to town preaching and collecting confessions and the related penitential donations.[17]

For this confession to be effective, that is to genuinely erase sin, the penitent had to do more than make a pious offering; he or she had to be truly contrite. During the season of Lent and the festival of Easter, Catholics were asked to be particularly aware of their sins by preachers who moved across Italy. These itinerants were primarily drawn from two monastic orders founded in the early thirteenth century: the Dominicans, who wore white with a hooded black cape, and the Franciscans, who wore sandles and a brown tunic with a knotted rope belt. There were, as we shall see, fundamental differences between the two organizations which went beyond dress. For example, a Domini-

can monk was often an ordained priest, while the Franciscan friar was not, and the two groups had different attitudes to ownership, property, and poverty. But their essential message on sin and salvation was generally consistent. Sermons would be read, either inside a church or, as the Sano di Pietro (1406–81) and Neroccio de' Landi panels of *St Bernardino Preaching* [**60, 67**] illustrate, in a public square. The paintings, which formed parts of larger altarpieces, show an idealized vision of the attentive, well-behaved audience. The men and women, seated quietly on the ground, are very carefully separated by a cloth barrier. All eyes are focused on the preacher, shown in a temporary wooden pulpit in Siena's main square in front of the town hall, the *Palazzo Pubblico*.

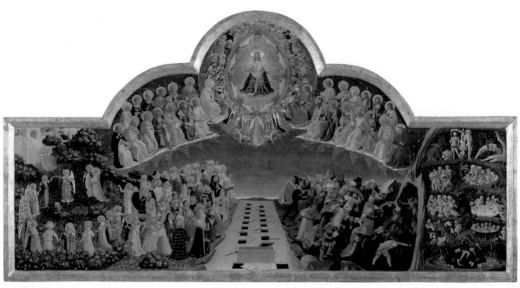

61 Fra Angelico

The Last Judgement, tempera on panel, 1431, (Museo di) San Marco, Florence.

This highly condensed vision of the Last Judgement (it contains over 250 figures) was commissioned by the Camaldolite order for their newly elected abbot, the humanist scholar Ambrogio Traversari. In paradise, the saints who founded the Camaldolites, Benedict and Romualdo, appear in white robes after the Apostles and before the founders of the Dominican and Franciscan orders.

To achieve their goals, the Dominicans and the Franciscans trained their members and provided well-indexed manuals of metaphors and stories designed to appeal directly to diverse listeners. Thus prostitutes could be told the story of the repentant Mary Magdalene (who had once been a prostitute); children could be told of the infant Christ. For his mercantile Florentine audience, the Dominican preacher Giovanni Dominici provided an image of Christ as a 'celestial merchant' buying what was plentiful on earth (sin and repentance) and selling what was scarce (resurrection and paradise).[18] There were some messages which were only intended for a very restricted group of listeners. Savonarola would not, for example, allow women to attend his Sunday sermons when he instructed Florentine citizenry on issues of government policy and organization.

Exhortations to follow the preacher's instructions or the example of the saints were backed up with the clear threat of retribution. At the Last Judgement, a point which, according to the New Testament Book of Revelations, would be announced by apocalyptic signs and the sounds of trumpets, the souls of the dead would be reunited with their bodies. Their souls would be weighed and all would be judged by Christ and consigned to an eternity in either heaven or hell, a scene popular in mortuary chapels. The pious hope of redemption and eternal salvation at this terrible moment of decision can be seen in scenes painted in the late 1350s by Nardo di Cione in the Strozzi chapel in Santa Maria Novella and in Fra Angelico's much more compact version created almost a century later in 1431 [**61**]. Both took their iconography from the Florentine poet Dante Alighieri's vision of eternal damnation and salvation, the *Divine Comedy*, written between 1302 and 1321. On the centre wall of the Strozzi chapel, Christ raises his hand in judgement. To his right, the artists placed paradise with its

hierarchical ranks of saints. To the left appeared a more uncontrolled image of a dark cave with multiple chambers, each inscribed with the tortures which awaited sinners. To the rear of the Strozzi chapel, in a very discreet lower corner, two figures, members of the family, dressed in the undergarments or night-clothes in which they were buried, emerge from their tombs and are clearly destined for paradise [**2**, **3**].

The threat of an immediate descent to hell was only directed at those who had died in mortal sin; that is, without having confessed their worst misdeeds. To bring back someone to life in order to achieve a full confession was a common miracle which saints, or aspiring saints like Catherine of Siena (who resuscitated her mother so that she could make a final confession), often performed. Someone who had died free of sin, or who had completely exonerated himself during his lifetime, might expect a swift passage to paradise. For everyone else, the system was more complex. After death one's fate was not necessarily sealed. By the 1350s traditional Western Catholic belief had divided and layered the afterlife to include an additional, intermediate stage known as purgatory. This concept was developed by theologians during the thirteenth century as a place where the sinful soul was subjected to numerous trials.[19] Although these were dramatic, they were not eternal and the horrors stopped for the weekend. They were remitted on Saturdays because the Virgin had asked for her special day to be thus honoured and on Sundays because of the many masses said on earth in Christ's name.

The purgatorial torments preachers and theologians predicted mirrored those of hell. However, the most painful aspect was not supposed to be the physical torture but the penitents' knowledge of their separation from God and paradise. Nevertheless, provided they had repented and confessed, these souls were not condemned for ever. Good behaviour and charitable donations were taken into consideration. Below the large altarpiece in the Strozzi chapel of 1357, for example, one of the predella panels illustrates St Lawrence saving the sinful soul of King Henry II of Germany because of his donation of a chalice. The cup, which an angel can be seen adding to the scales, outweighed the king's misdeeds, thereby denying the Devil his prey.

Gifts during one's lifetime to the Church and to charity were crucial but help was also available after death. In 1438 the Church Council of Ferrara–Florence made the already-popular practice of assisting souls through purgatory official doctrine. It declared that the pains suffered by friends and relatives caught in this intermediate zone could be alleviated by prayers and masses said on their behalf, and by alms and other works of charity performed in their name.[20] Thus heirs had a serious responsibility to look after the deceased and chapels, altarpieces, or other donations might have to work on behalf of more than just their immediate patron.

This combined sense of obligation towards the dead and fears for one's own salvation meant that memorialization became increasingly important. There were many ways of remembering the dead. Given appropriate financial endowments, masses and prayers could be regularly recited in their names on the anniversaries of their deaths. Sermons in praise of a deceased prince or other important figures might be delivered at the same time. There were more private, but equally important, forms of remembrance. In his diary, the fourteenth-century Florentine Giovanni Morelli provided a vivid written portrait of his older sister Mea's virtues and gave clear directions as to her resting-place in her husband's crypt. The Morelli relatives to whom the text was addressed were asked to go to her grave on the feast of All Souls in order to light candles and to pray for Mea's soul:

I ask every descendant of Pagolo [Giovanni Morelli's father] to go and see the place where she rests at least on the day of the dead, saying a prayer to God for the salvation of her soul, and lighting her sepulchre with a bit of light as is customary for many. For the true light and fruit for her soul is prayer or alms, which God make helpful to her blessed soul, Amen.[21]

Giovanni Morelli had to write out his instructions with care because there was no specific marker to his sister who was interred in her husband's crypt. Some believers, particularly those attached to the discipline of the Franciscan friars, felt that to disappear from earthly memory was appropriate and that any attempt to preserve one's presence on earth denied the superiority of the afterlife. Increasingly, however, research on wills indicates that a considerable body of individuals were anxious to provide a focus which would ensure that one was remembered after death (a topic returned to in Chapter 6).[22]

The relationship between the living and the dead was a reciprocal one. In return for prayers, some of the deceased, above all those who had achieved a certain status in paradise, could intercede for those left behind. Christians could turn to a host of saints with different positions in heaven. As the even ranks of saints and angels in Nardo di Cione's fresco or Fra Angelico's panel of the Last Judgement suggest, paradise was not perceived of as egalitarian, but as a place where strict order and hierarchy were kept. Devotees had to choose their patrons carefully and the worship of a saint who would protect you in your lifetime as well as aiding your case with the Almighty was, in effect, an extension of the *clientelismo* or networking of every-day life.

The most powerful intercessor was the figure closest to Christ, his mother Mary, who was both sympathetic to human needs and able to ask her son for anything. The preacher St Bernardino of Siena provided a succinct and understandable description of this family relationship in a sermon delivered in the town square in Siena in 1427:

God would certainly be sending the most terrible punishments if it weren't for the fact that the Virgin Mary had petitioned her son and her son had spoken to his father at Mary his mother's request. And thanks to this, God's anger has been placated. I don't say he pardons us, no, but he softens the punishment. And Jesus Christ receives the grace of his father and hands it to his mother, and his mother sends it on to us.[23]

Given her crucial position as an intermediary between God and Man, the Virgin's special powers and status were amplified during the fifteenth century, culminating in the acceptance of the doctrines of the Immaculate Conception (meaning that Mary herself had been conceived by her parents without original sin) and of her Assumption (meaning that the Virgin, like Christ and unlike ordinary mortals, had undergone bodily resurrection). By the fifteenth century, particularly in southern Italy, the cult of the Madonna of Purgatory was also well established as were cults of the humble Virgin seated on the ground (the Madonna of Humility), the breast-feeding Virgin, such as that illustrated in the painting by Marco Zoppo (the Madonna Lactans), and the Virgin crowned or enthroned as the Queen of Heaven [40]. The stories and characters associated with Mary had also multiplied and grew more detailed. The Bible provided only limited information about Christ's mother; so the specifics of her parentage, birth, and early life came from apocryphal texts such as the so-called protevangelium of St James, and a book thought to have been written by a late thirteenth-century Franciscan, *The Meditations on the Life of Christ*. This narrative encouraged its readers and listeners to imagine themselves in the Virgin's position and consider her daily life and inner thoughts. Another important source for Marian devotion was *The Golden Legend*, a collection of saints' lives compiled in about 1261 by the archbishop of Genoa, Jacopo da Voragine (1228/30–98). In addition, the visions of the Swedish mystic Bridget which were widely circulated after her death in 1373, proved highly influential. Bridget had had numerous visions of, and conversations with, the Virgin and Christ, and had been granted a privileged view of the Nativity where she saw Mary, dressed in white, kneeling in adoration before her unswaddled infant from whom a supernatural light came forth.

Mary was not the only source of help in heaven. The *Golden Legend* provided the names and tales of hundreds of other saints. In hierarchical terms, Christ and Mary were succeeded by the twelve apostles along with Jesus's most important female follower, Mary Magdalene, supposedly the repentant prostitute mentioned in John 8. Then came the early Christian martyrs, great Church theologians such as Sts Jerome and Augustine, and finally those most closely involved in the foundation of new orders, such as Sts Francis, Dominic, and Thomas Aquinas, and in the daily and civic lives of ordinary men and women,

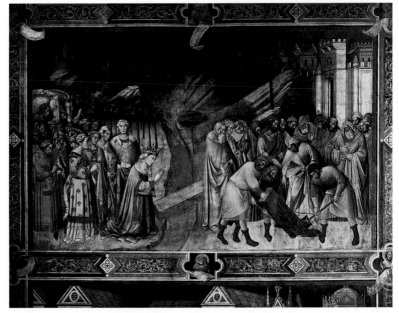

such as Sts Catherine and Bernardino, both of Siena. On a lesser level,
the Church recognized figures of the *beati* or blessed, whose lives were
holy, but whose sanctity had not been confirmed by verifiable miracles.
They were honoured, but their haloes, simple rays rather than a full
circle, were supposed to indicate the lesser nature of their achievement.

In their prayers Catholics could turn to saints after whom they were
named or to whom they had a special devotion. Thus Filippo Strozzi
dedicated his chapel in Santa Maria Novella to St Philip and his four-
teenth-century ancestor Tommaso had put up an altarpiece in honour
of St Thomas Aquinas. There were saints with a reputation for partic-
ular types of efficacy, such as St Margaret, who was believed to aid
women in childbirth, St Christopher, who helped children and trav-
ellers, and St Apollonia, who came to the aid of those with toothache.
Sts Rocco and Sebastian were considered to be effective helpers against
the plague. There were also particular saints' relics or their painted
images which had the reputation of miraculous healing powers. To
obtain help from these sources, some sign of respect or the provision of
a gift was deemed necessary. A vow to make an offering was a binding
obligation which was broken at one's peril. Pilgrimage, a journey
undertaken in anticipation of, or in thanksgiving for, help received was
one powerful form of such homage. It could, however, be commuted
by getting someone else (there seem to have been semi-professional
pilgrims by the fifteenth century) to undertake the voyage or by getting
permission from a bishop or the pope to accept an offering of cash
instead. Once a pilgrim or his or her substitute had arrived at a shrine it
was common practice to make a donation of either wax or some other
valuable and those who held authority over sacred remains could make

large profits, often benefiting the economy of the city or region where the churches and shrines were located.

There was a hierarchy of relics; objects associated with Christ's Passion, and especially his death on the cross, were particularly prized. A very extensive non-biblical legend of the true cross developed, and was again communicated widely through the *Golden Legend*. This connected the seeds from the Tree of Knowledge in the Garden of Eden, which were planted over Adam's grave, with the wood from which Christ's cross had been made, used, and then buried. The fresco cycle by Agnolo Gaddi of 1388–92 [**62**], in the main apse chapel of the church of Santa Croce (the Holy Cross), in Florence, illustrates much of this complex story, showing several episodes in each frame. A vision of the cross inspired the Roman Emperor Constantine's conversion to Christianity in the early fourth century; it was then, according to this legend, rediscovered by his mother Helena, stolen by a Persian ruler, and finally recovered by the Eastern Roman Emperor Heraclius.

Because of this myth, splinters of the true cross needed a Byzantine provenance before they were recognized as valid in the West, boosting the trade in such objects between Constantinople and Europe. In 1369, for example, the grand chancellor of Cyprus, Philippe de Mézières, donated a piece of the true cross which he had received from the Orthodox patriarch of Constantinople to the prominent and powerful Venetian confraternity of the Scuola Grande di San Giovanni Evangelista. In the early quattrocento the main hospital in Siena, Santa Maria della Scala, hoping to improve its position as a pilgrimage site, purchased numerous fragments of saints' remains and a piece of the true cross from the Byzantine court. With the increased communication between Greek Orthodox and Roman Catholic prelates in the 1430s and 1440s and the fall of Constantinople in 1453, the availability of such items increased. Competition could develop between different groups who owned these precious splinters. In Venice, for example, the true cross of San Giovanni Evangelista was challenged in 1463 by Cardinal Bessarion's donation of his personal *stauroteca* (the name for the case in which a piece of the true cross was held) to another confraternity, the flagellant Scuola Grande di Santa Maria della Carità. Bessarion (1403–72) was one of the Greek representatives during the Council of Ferrara–Florence, which had tried to reunite the Orthodox and Roman Catholic Churches. His gift was prompted by the hope of raising Venetian support for a fight against the Ottoman Empire, which had invaded Constantinople (he also gave his library to Venice). The *stauroteca* [**63**], having originally been commissioned by a Byzantine princess, Irene Paleologus, on behalf of the patriarch of Constantinople, had a particularly distinguished provenance. Its eventual arrival in Venice in 1472 was treated as a state occasion. But it was not enough just to own such a relic; to attract pilgrims the object

63

The Stauroteca, or reliquary
of the true cross, of Cardinal
Bessarion.

This case had originally
been commissioned by a
Byzantine princess, Irene
Paleologus, as a gift to the
patriarch of Constantinople.
Bessarion inherited the
cross and then offered to
donate it, along with a rich
collection of Greek
manuscripts, to the
Venetian government in
order to encourage the
signoria to set up a crusade
to drive the Ottomans
from Constantinople.

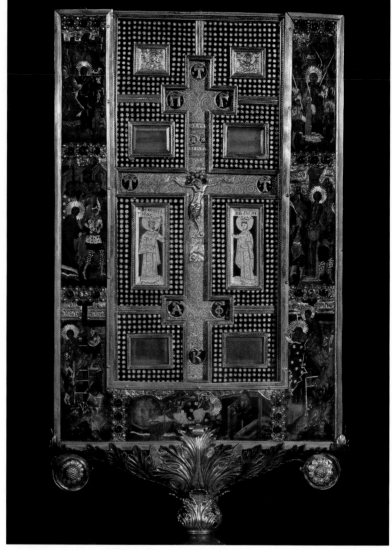

needed an appropriate frame for its display and a form of 'marketing' of
its importance. One of the first things the flagellant confraternity did
in the 1470s was to commission a cover for the *stauroteca* commemorat-
ing the donor, whose earlier ownership validated their relic's import-
ance [**64**].[24]

But despite the best efforts of the Carità, their piece of the true cross
remained inert in comparison to San Giovanni Evangelista's better
established fragment, which continued to work miracles. Initially the
confraternity had wanted to parade their reliquary regularly, 'to magni-
fy and exalt our holy and miraculous and true cross; and to increase the
devotion of it in the heart of Christians'. But in 1458, as the scholar who
has studied the case most extensively put it, 'the strategy of the Scuola
di San Giovanni changed in regard to the display of the cross. The

Cardinal Bessarion Presenting
the Stauroteca to the
Confraternity of the Scuola
Grande di Sante Maria della
Carità, tempera and oil on
panel, *c.*1472.

When the confraternity
finally took possession
of the *stauroteca* in 1472
they commissioned this
cover to commemorate
its provenance.

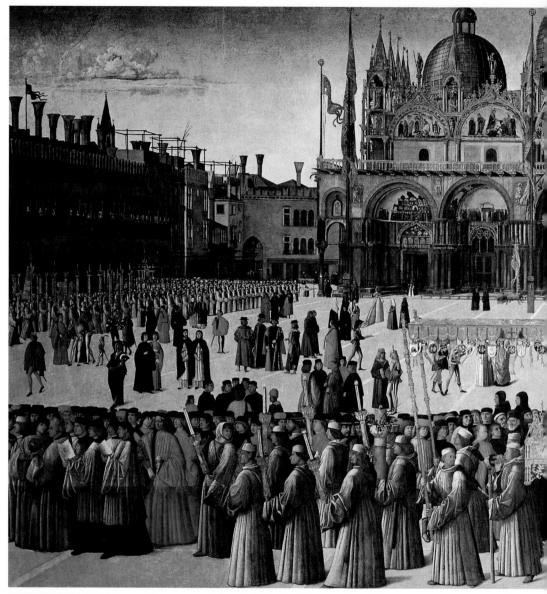

65 Gentile Bellini

Procession of the True Cross
in Piazza San Marco, oil on
canvas, 1496.

officers voted that year to limit its use in public processions "so that the
devotion of the people increases and does not depreciate through the
continuous carrying of it outside the Scuola" '.[25]

A set of paintings done for this confraternity in the 1490s acted as a
substitute for seeing the relic of the true cross itself. If worshippers who
came to the hall of San Giovanni Evangelista could not see the frag-
ment, they could see evidence of its powers and make offerings in its
name. The canvas by Gentile Bellini illustrated in **65** was one of a
series of paintings placed in the confraternity's main hall. It depicts a
miracle which took place during the procession of the relic, illustrating
its powers over both distance and time. It represents the prayer of a

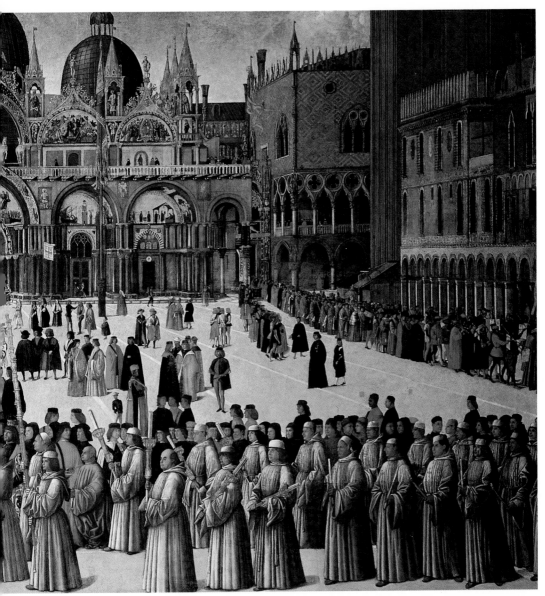

Brescian merchant, Jacopo de' Salis, the figure in red shown kneeling as the procession passed. He asked that his son, whom he had just been informed had broken his skull, would survive this terrible accident, vowing to honour the cross in return. Such was the relic's power that when de' Salis returned home he found the young boy fully recovered and fulfilled his promise. The meaning of the miracle was clear. Physical contact with the sacred object was not needed to bring about supernatural effects, only true belief.

Such healing miracles were worked by contemporary saints as well as by the true cross and other biblical and early Christian objects. Indeed, the performance of miracles during and after one's lifetime

66 Giovanni di Paolo

St Catherine of Siena
Receiving the Stigmata,
tempera on panel, c.1461.

One of a series of predella
panels depicting the life of
St Catherine of Siena, this
scene violated the papal edict
which specifically outlawed
images of the saint's
experience of the stigmata.

was a legal ecclesiastical requirement for the formal process of canonization, established in 1215. In order to be declared holy, a life of spirituality, either through good works or important theological contributions, was required. More than this, however, a sign of God's blessing, miracles, were needed. These had to be verifiable through witnesses, to have occurred both during the saint's lifetime and posthumously, and needed to 'be edifying to the faithful and linked to the person's virtues'. Two examples of Sienese saints, Catherine and Bernardino, will illustrate how such a process was undertaken.

Catherine Benincasa was born in 1347 as the twenty-third child of a Sienese dyer. She began having visions of Christ and exhibiting extreme spiritual behaviour such as fasting and flagellation at the precocious age of 6. Her visions culminated in a mystical marriage with Christ and the reception of the stigmata (the wounds of Christ) which appeared on her hands, feet, and side. Such connections with the spiri-

tual world gave rise to suspicions of heresy but eventually brought her considerable public authority. Before her death in 1380, Catherine considered herself fully responsible for the need to heal the Great Schism in the Church, corresponding with clerics, princes, and prelates. A lengthy inquiry into her life and miracles was undertaken between 1411 and 1416, but Catherine had transgressed so many boundaries of behaviour and expectation that it took almost fifty years before she was canonized, recognition which was assisted by the presence of a Sienese pope in office, Pius II. Even then, the Curia issued a prohibition on images which showed Catherine receiving the stigmata, a stipulation which cult images, like the Florentine engraving depicting the most important moments of her life, clearly ignored [**47**, **66**].[26]

The difficulties surrounding Catherine's canonization contrast sharply with the rapid acceptance of her slightly later Franciscan counterpart Bernardino, who was fully accepted as a saint only six years after his death on 20 May 1444. The city of Siena, where he was born, the town of L'Aquila, where he had died, and the reformed Franciscan order came together to press for his recognition, using paintings and statuary to emphasize their case. His followers had taken care to arrange for a death mask, and these cadaverous features formed the basis for most of the later posthumous portraits. So concerned was one group of patrons, the Sienese confraternity of the Virgin, to achieve an accurate representation that they insisted that their painter Sano di Pietro be prepared to paint and repaint their image of Bernardino until he got it right: 'Said master Sano promises to paint the said Blessed Bernardino according to the pleasure of the above-mentioned commissioners and if they are displeased with it he will be obliged to ruin it and do it over and over so often until the above [commissioners] are well pleased.'[27] In the side panels of the polyptych [**67**] which resulted from this commission, Bernardino was shown holding up two images. One was the crucifix, which he used to encourage meditation on Christ's sacrifice. The other was the initials of Christ, the IHS monogram, whose cult, with his prompting, spread across Italy. Bernardino encountered some resistance from his colleagues, who were concerned about the idolatrous implications of worshipping a painted object.

St Bernardino was fully aware that his fellow Catholics already treated images as powerful objects which could be used to intercede with God. In Florence the images of Madonnas in the churches of Orsanmichele and Santissima Annunziata and in the hills outside the city walls in the town of Impruneta played this role. The local chronicler Matteo Villani (d. 1363) described how the image of Impruneta was used to combat drought in 1354:

The Florentines, fearing to lose the fruits of the land had recourse to divine aid, ordering the saying of prayers and continual processions through the city

and *contado*. Yet the more processions they made the brighter the sky grew, by day and night. Seeing that this was to no avail, the citizens with great devotion and hope had recourse to the aid of Our Lady, and drew out the ancient figure, painted on wood, of our Lady of S. Maria [Impruneta]. And on 9 May 1354 the commune prepared many large candles and called out the parish priests and all the clergy, with the arm of St. Philip the Apostle, and with the venerable head of St. Zanobius, and with many other holy reliques. And almost all the people, men and women and children, with the priors and the whole government of Florence, while the bells of the commune and the churches sounded out in praise of God, went to meet the painting outside the gate of San Pietro Gattolino. And they looked on the painting. . . . It came about that on the day of the procession the sky filled with clouds; the next day remained cloudy . . . The third day it began to drizzle a little, and the fourth to rain in abundance.[28]

Not every powerful image, however, was the work of heaven; there were anxieties about the work of the Devil as well. In 1383 a local chronicler wrote that rumours

67 Sano di Pietro

Altarpiece of St Bernardino, tempera on panel, 1445, originally painted for the chapel of the Compagnia di Sopra in Siena. Reconstruction based on G. Freuler and M. Mallory.

thereby reducing the time they spent in purgatory. Plenary indulgences which allowed an immediate transition to paradise were only issued for special Jubilee occasions such as those which took place in 1350, 1399, and 1450. Pilgrims flocked to Rome from all over Europe to benefit from these special arrangements. Ordinary indulgences, which could be issued by local bishops as well as by cardinals and the pope, released sinners from a more limited portion of their suffering.

The allocation of an indulgence was meant to encourage specific forms of behaviour. It was an incentive to attend sermons, sing or listen to *laude* (songs of praise), attend certain events, visit particular shrines, or make contributions to specific causes. A letter from Rome referring to Lorenzo de' Medici's acquisition of an indulgence for meetings of his favourite confraternity of the Magi in Florence shows how this was achieved and the importance it held:

> The grace [we have obtained] is this: although God for his part is most clement towards whomever congregates in his name, nevertheless his vicars in this world, in order to imitate their Lord and invite one and all to the worship of the divine, concede in response to your intercession, one hundred days of indulgence to those congregated in the *Compagnia de' Magi* at each of its regular meetings. And this Bull had to be obtained from the college of cardinals rather than from the Pope . . . Each cardinal may concede one hundred days of indulgence once a month. And so, if each cardinal gives his twelve 'one hundreds', they sanctify you for the whole year; and never has grace been obtained such as this, that all of them should pay out their whole purse in the same Bull![35]

The metaphor used, of a purse full of spiritual salvation, was an appropriately mercantile symbol of exchange. In return for substantial monetary and political benefits, the College of Cardinals in Rome provided Lorenzo's confraternity with otherwise unobtainable spiritual grace. The ambassador was careful to demonstrate his understanding that indulgences did not replace God's clemency; none the less, this extra help was worth having. Now, thanks to Lorenzo de' Medici's intervention, the men who came to his confraternity meetings had a special incentive to attend: eternal salvation.

Because these benefits could be obtained for both the living and the dead, individuals and organizations embarking on any expensive artistic commission quickly realized that the acquisition and sale of an indulgence was one of the most efficient forms of financing their work. It could be obtained, for example, to build and to maintain churches, hospitals, and shrines. The indulgence given to the hospital of Santa Maria della Vita in Bologna where Niccolo dell'Arca's Lamentation scene was placed was quite explicit about its purpose [8, 9, 10]. A papal bull was issued in 1464 to help repair the buildings and beds and to look after 'the commemoration of Christ's sepulchre with its most beautiful

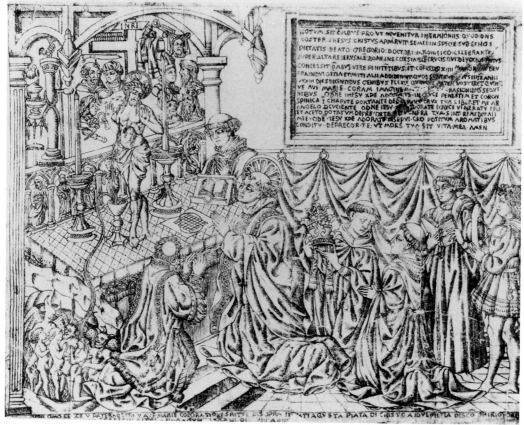

71 Florentine

Mass of St Gregory, engraving, *c*.1460–70.

signs and images whose maintenance the hospital cannot support, but the faithful, if encouraged would do so'.[36] Those who went to the hospital in the evening and confessed to their sins at Christmas, Easter, Pentecost, and the feast day of the local saint, Ranieri, and made some offering towards the hospital's building fund would receive an indulgence of one hundred days in return.

There was also a group of devotional images which were thought, often without papal licence, to bring purgatorial remission. The print illustrating the mass of St Gregory [**71**] has an inscription in Italian which explained that prayers said before it would, for the truly repentant, take as many as 20,000 years off their time in purgatory. Prayers said before paintings of the so-called 'Veronica cloth' or *sudarium*, the napkin on which Christ had wiped his face before the Crucifixion, were supposed to have the same effect.

Indulgences were clearly subject to abuse; in the sixteenth century their misuse was one of the main complaints of Catholic and Protestant reformers alike. But they were never intended to be promises written on pieces of paper or parchment which were sold directly for cash. Although Protestant attempts to reform the Church fall outside the remit of this book's chronology it is important to realize that many

of the ways in which sin was redeemed in an earlier period were specifically condemned or significantly modified in the sixteenth century. This painful process dramatically changed viewers' physical relationship, behaviour, and attitude towards works of art, relics, shrines, and saints. In 1538, a royal decree was issued by King Henry VIII of England which informed his subjects that they were not

to repose their trust or affiance in any other works devised by men's phantasies beside Scripture, as in wandering to pilgrimages, offering of money, candles or tapers to images and relics, or kissing or licking of the same, saying over a number of beads, not understood or minded on, or in such-like superstition.[37]

The denial of the doctrine of purgatory broke the relationship between the living and the dead, limiting the help they could provide for each other. Catholics reiterated their belief in this doctrine but were also concerned to control its worst abuses. In 1563 the Council of Trent responded to criticism by reasserting the traditional function of images which had been promoted by Pope Gregory and St Thomas Aquinas. Paintings and statues were for instruction of the unlettered and meant to move the hearts of men and women, not necessarily to work miracles. But legislating against such beliefs could not prevent viewers from treating images as permeable screens between the powers of heaven and the needs of earth.

Sites of Devotion

6

The purposes art served were dependent on when and where it could be seen. Fourteenth- and fifteenth-century works of religious art were usually created for very precise places, events, and audiences and many of the most important works of art spent much of their time in storage. Thus elaborately woven and embroidered vestments such as the robe (a chasuble) given by Pope Sixtus IV to the Franciscan basilica of the Santo in Padua would have only been seen when a mass appropriate to the pontiff's bequest was being said [**30**]. The reliquaries illustrated in this book, such as the *stauroteca* of Cardinal Bessarion in Venice, or that containing the head of St Dominic in Bologna, were only brought out at specified moments such as feast days. Miracle-working paintings like Bernardo Daddi's (1312/20–after 1348) Madonna and Child in the shrine of Orsanmichele in Florence were kept behind curtains and iron grilles, and revealed while particular ceremonies, such as the performance of songs of praise (*laude*), were under way. To gain some understanding of how meaning was conveyed, therefore, we need to consider the special places and circumstances in which works of art were seen.

Monasteries

Many of Italy's most famous images, such as the frescos of Fra Angelico or the *Last Supper* of Leonardo da Vinci, would have been almost invisible to fifteenth-century viewers. This only changed in the last years of the eighteenth century, when Napoleon Bonaparte conquered much of Italy. Anticlerical and a product of revolutionary secularism, one of his most lasting legacies was the suppression of the peninsula's religious houses and the subsequent sale or transfer of much of their wealth. Cells eventually became army barracks, prisons, or state museums and archives. Although many monasteries have now been returned to the Church, these and later transformations make it particularly difficult to understand the original use of buildings and contents created for these self-enclosed religious communities.

Monks belonged to the earliest male Christian communities who joined together to lead a religious life outside the traditional Church hierarchy. They lived a common life, one governed by specific rules and

Detail of 77

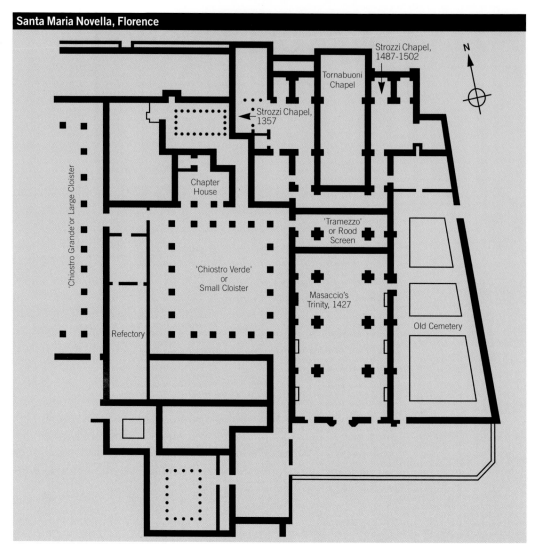

their own careful hierarchy. These groups, which included, amongst others, Carthusians, Cistercians, Camaldolites, Vallombrosans, and Benedictines, were expected to share a simple existence and to dedicate themselves to prayer and contemplation. Their isolation was only exceeded by the hermit orders, the Augustinians and the Hieronymites, who tried to reproduce the existence of the early Christian Fathers who had once lived in the Palestinian and Egyptian deserts.

It took a great deal of property and the assistance of lay brethren (*conversi*), novices, and servants to support this lifestyle and the differences between these orders had distinct architectural consequences. Carthusians, for example, who were expected to keep a cloistered life in private cells, insisted that their numbers be kept small, a maximum of twelve professed monks in any one religious house (in

Christ Carrying the Cross
with Carthusian Monks,
tempera on panel, *c.*1490–5,
executed for the parlatorio of
the certosa in Pavia.

imitation of the Apostles). The image created by Ambrogio da
Fossano (i.e. Bergognone) (active 1481–1522) of Christ Carrying the
Cross [**72**] was designed for the abbot's *parlatorio* of the *certosa* of Pavia,
the parlour where the Carthusian celibates were able to meet relatives
or other friends from the outside world. It would have been a reminder
to all present that the monk's role outside the cloister was not to be
immersed in the mundane activity of day-to-day life, but, as the scroll
which Christ bore emphasized, to 'take up your cross and follow me'.
Requiring as they did individual rooms and an elaborate support sys-
tem, Carthusian monasteries such as that of Pavia were particularly
expensive to maintain and popular recipients of endowments from the
wealthiest of Europe's rulers.

Despite their emphasis on solitude, the Carthusians, like most
monks, followed rules for religious observances which placed emphasis

73 Andrea di Bonaiuti

73 Andrea di Bonaiuti

The Crucifixion and The
Church Militant, frescos,
1366–8, chapter house
(Spanish chapel), Santa Maria
Novella, Florence.

The funds for the decoration of
the Dominican chapter house
were provided by a wealthy
merchant, Buonamico di Lapo
Guidolotti, who arranged for
his burial here dressed in a
Dominican habit. The space
was constructed in the 1350s
as both a funerary chapel and
chapter house and was
decorated with elaborate
didactic images of the benefits
of Dominican teaching.
Buonaiuto eventually received
a house from the order as
recompense for his work.

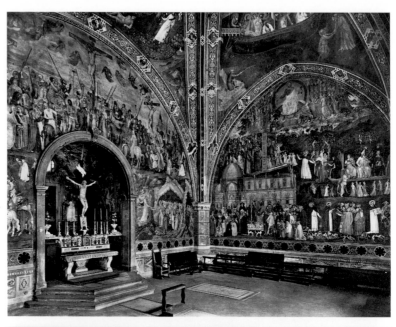

74 Andrea di Bonaiuti

The Triumph of St
Thomas Aquinas, fresco,
1366–8, chapter house
(Spanish chapel), Santa
Maria Novella, Florence.

on an ordered existence of communal prayer with obedience to the
abbot. Under the Benedictine rule, for example, all monks (and nuns)
were responsible for singing and reciting the full liturgy of the seven
canonical hours dedicated to the Virgin, rising in the early hours of the
morning to praise Mary before returning to bed. The demands of these
services, the prayers and masses said on behalf of their benefactors, and
private devotion dominated the traditional monastery and attracted
pious bequests which demanded careful administration and brought
temporal responsibilities. Their wealth, however, attracted the atten-
tion of the Papacy and the income of well-endowed monasteries was

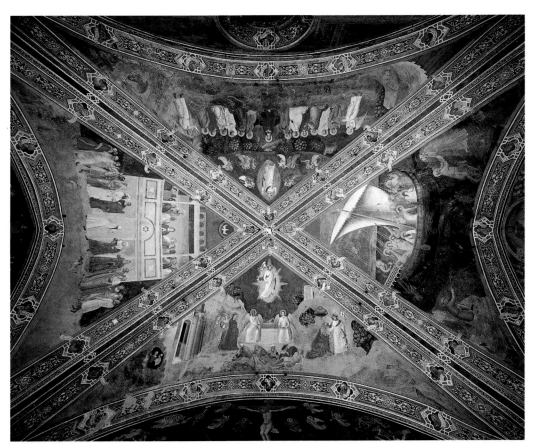

75 Andrea di Bonaiuti

Resurrection, Ascension, Pentecost, and the Calling of St Peter, frescos, 1366–8, chapter house ceiling (Spanish chapel), Santa Maria Novella, Florence.

often given to non-resident cardinals, leaving the monks increasingly unsupervised and poorly rewarded for their physical and spiritual labours. In the fifteenth century the dedication of the traditional monastic orders was often questioned. When the monk and noted Greek scholar Ambrogio Traversari (1356-1439) visited the Camaldolite monasteries of Tuscany in 1421, he found his brothers enjoying the luxury of linen underclothes and declared that 'I believe we monks are the winners in the competition with the seculars for wealth and self-indulgence'.[1] When Cardinal Bessarion conducted an inquiry into conduct of the Orthodox monasteries of the rule of St Basil in southern Italy, he too was disappointed. One abbot explained that he could not give up his concubine, 'because of his affection for the children she had borne him; and furthermore, his doctor advised sex as a useful treatment for gallstones'.[2]

The origins of the friars, or brothers, can be found in an earlier period of dissatisfaction with monastic and clerical behaviour. In contrast to the isolated monastery which emphasized physical separation from the world, the Franciscans (known as the Friars Minor), the Dominicans (known as the Order of Preachers), the Carmelites, and the Augustinians were either established or adapted in the late twelfth

and early thirteenth centuries to reach out to western Europe's growing urban communities. They were founded by charismatic figures such as Sts Dominic (d. 1221) and Francis of Assisi (d. 1226), and approved, sometimes after considerable hesitation, by the Papacy. They were known as mendicants, i.e. beggars, after the fact that they were not supposed to own and administer property but, following the example of Christ's Apostles, to travel, beg, and rely on the charity of the wider secular community.[3] It was this antagonism to temporal wealth and their dedication to a public life of preaching and conversion which was supposed to differentiate the friar from the traditional monk. All friars took vows of poverty, chastity, and obedience. They were not required to act as priests although they could, given special permission, perform duties such as hearing confessions and offering absolution. The Franciscan order positively discouraged its members from taking holy orders for a priest required certain liturgical possessions, such as books, which violated their concept of total apostolic poverty. Yet ironically, from their earliest appearances in the thirteenth century, the friars quickly made inroads into areas where parish priests had previously gained their living such as burials, confessions, and charitable donations. It was popular for laymen and -women to try to be interred in the habit of a monk or a nun, or to sponsor parts of the monastery in return for burial rights. In Florence, for example, the chapter house of Santa Maria Novella served as a tomb for the merchant Buonamico di Lapo Guidalotti as well as a meeting-room for the Dominican friars while the Pazzi family used the chapter house of the Franciscan church of Santa Croce for the same purpose. By the fourteenth century the friars had agreed a compromise whereby the mendicants returned a percentage of all bequests to the parish priest who might have expected to profit from these burials. But the income generated for the Dominicans and Franciscans was still substantial, enabling the construction of some of the largest churches and monastic complexes in Italy.

The Dominicans had few problems with their increasing wealth and importance but many of the followers of St Francis saw a contradiction between their vows of poverty and the vast, elaborately painted churches erected for their use. After many years of disputes and debates the order was eventually formally split in 1517 between those who had encouraged reform, and those who preferred a traditional conventual lifestyle. The doubts and concern about the appropriate behaviour expected of the friars went beyond the mendicants, dividing most orders between the Conventuals (those who believed in a stable convent life) and the Observants (those who claimed to be observing their founder's true values). During the fifteenth century the Observant reform movement, encouraged by charismatic preachers such as Giovanni Dominici of Florence and St Bernardino of Siena, had the support of the Papacy and of Italy's aristocratic élite. But the

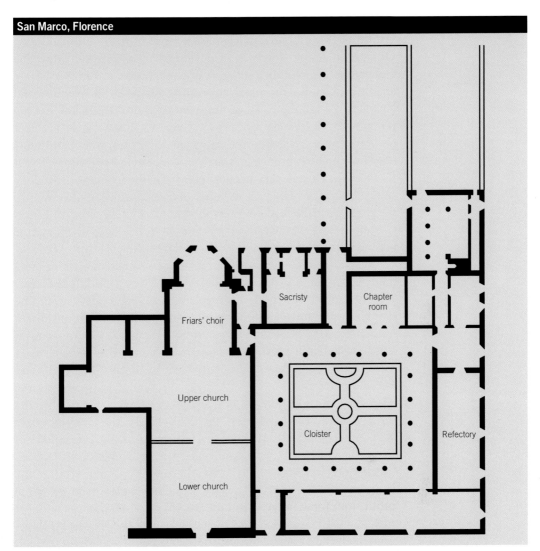

Sacristy

Chapter room

Friars' choir

Upper church

Cloister

Refectory

Lower church

Reconstructed plan after William Hood, *Fra Angelico at San Marco* (Yale University Press, 1993), 3, fig. 5.

Conventuals were also well connected and proved unwilling to give up their traditional rights and rituals. Monastic houses were torn between the two groups, resulting in the fragmentation and proliferation of new foundations in cities across Italy.

In architectural and pictorial terms, however, these changes were of quantity rather than quality. Whatever their affiliation, monks and friars still required kitchens, infirmaries, dormitories or cells, a refectory for common meals, a special room (the chapter house) for meetings, and an apartment for the senior abbot or abbess, as well as a parlour with a grate through which nuns and cloistered monks could speak to the laity. Cloisters and walled gardens provided spaces for movement and provided some of the community's food. The major difference between the two types of monasteries, Conventual and Observant, lay in questions of accessibility to non-members. It would have been prac-

tically impossible for women to enter either type of building but lay-men would have found it much more difficult to enter a fully cloistered Observant house than its Conventual counterpart. Thus the Conventual Dominican monastery of Santa Maria Novella had a large apartment complex for important visiting guests. Popes Martin V and Eugenius IV ran the papal administration from these rooms and the retinues of other distinguished visitors were also housed here. The decoration of this space reflected its particular nature, with Donatello's image of the Florentine lion, the *Marzocco*, serving as the newel-post for the staircase and papal heraldry painted in the rooms and corridors. In the Observant Dominican house of San Marco, founded in 1443, there was permanent accommodation for only one non-friar, its patron Cosimo de' Medici, who could escape from the cares of Florentine politics to the protection of the rules of the cloister.

We can carry the comparison between these two monasteries further. Fresco-painting predominated on both sites, providing appropriate images for instruction, contemplation, and memorialization. The chapter house, for example, was the most public part of the cloister. Activities taking place here ranged from the most devout to the most mundane business affairs. But most importantly, this was the room where the friars gathered on a daily basis to confess their faults and receive admonitions and punishments. In Santa Maria Novella, the frescos painted by Andrea di Bonaiuti (active 1343–d. *c.* 1377) filled the entire wall and ceiling [**73**, **74**, **75**]. On entering, the Dominicans or their visitors, who included men and women brought forward under accusations of heresy, were confronted with a detailed image of the Crucifixion. To their left was a vast and complex didactic scene of the Triumph of St Thomas Aquinas, a picture which required some knowledge of the encyclopaedic ideas of this great Dominican father of the Church. On the other side, they saw the promise of heavenly salvation which the Dominicans were able to provide to heretics through

76 Fra Angelico
Crucifixion, fresco, 1440s, chapter house, Museo di San Marco, Florence.

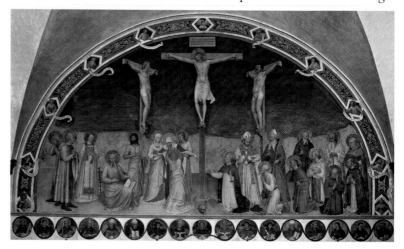

77 Fra Angelico

The Annunciation, fresco, 1440s, north dormitory, Museo di San Marco, Florence.

their teaching. When they raised their heads they were confronted with images of Christ's calling to the Apostles and as they turned to leave, the brothers were reminded of what was expected of them through the images of the preaching of St Peter Martyr (c.1205–52) who was murdered for his faith in the early thirteenth century.

A complete understanding of the trecento frescos of Santa Maria Novella required considerable concentration; the frescos created almost a century later for the chapter house of San Marco were much more spare, but equally demanding. In the bottom frieze, the monastery's resident artist, the Dominican Fra Angelico, painted seventeen saintly members of his order; twenty additional, relatively recent saints were illustrated in the Crucifixion itself [**76**], encouraging the viewer to add himself to the group. As the scholar William Hood has noted, 'Fra Angelico showed the monastic and other saints as they respond to events, *taking place in their minds*.'[4] The interior meditation encouraged by Fra Angelico, like the didactic instructions of Andrea di Bonaiuti, served to prepare the Dominican monk for the tasks which lay before him. Elsewhere in San Marco the response invoked was physical as well as mental. Climbing the stairs to the upper corridors leading to the cells placed the friars in an appropriate position to kneel before the frescoed Annunciation [**77**] at the final step: a greeting and homage to the Virgin Mary before retiring to prayer, study, and contemplation.

Nunneries

For women, contact with the interior of the male monastery would have been rare and potentially scandalous. One scurrilous story about a Florentine abbot relied on the reader believing that a group of young

men would be able to smuggle an attractive girl into the monks' rooms. The party was to pretend to go into the church, 'to look at the paintings', before slipping into the abbot's apartment.[5] Nevertheless, under more decorous circumstances even female founders of monasteries would have had difficulty in visiting the cloisters and sections of the church reserved to the monks. When Ludovico Maria Sforza wished to show Isabella d'Este the choir of the newly completed Carthusian monastery of Pavia in the early 1490s he needed a papal dispensation to permit her entry, one which he obtained over the vociferous objections of the monks themselves.

In compensation, if that is the right word, women had access to the world of the female religious denied to their male counterparts. Recent research on conventual records in Florence and Venice suggests that the fifteenth century saw a dramatic explosion in the number of nuns and nunneries in urban communities.[6] This was partly due to the transfer of once-isolated convents in the countryside to the safety of the town, and by the increasing difficulty of providing young women with adequate dowries for marriages. But religious vocation should not be entirely discounted, even though women's lives in the convent were much more restricted than those of their male counterparts. They were not allowed to travel, to preach, or to teach. In Observant female Franciscan (the Poor Clares) and Dominican convents which enforced a strictly cloistered life (*clausura*), the nuns were not even supposed to receive visitors, a situation which forced them either to obtain a substantial endowment or to rely on either brother houses or a male procurator for support and legal representation. The restrictions on public access to nuns during the quattrocento were often fiercely resisted by well-connected celibates for precisely this reason. In fifteenth-century Messina in Sicily, for example, the nuns insisted that *clausura* was not part of their original vows, arguing that they would not get the 'many legacies and last gifts which were made on men's death-beds by reason of the visitation of many persons'.[7] Yet even when their physical contact with the outside world was limited, nuns whose writings, letters, and opinions were able to circulate were still able to obtain a public reputation. As literate women, they communicated with relatives and with fellow religious and lay members of their cities and abroad. They were able to pass on information, influence decisions taking place in the secular world, and ask for help for their own community. Indeed a small number of highly regarded late fifteenth-century mystics, such as Suor Osanna Andreasi of Mantua and Lucia da Narni of Ferrara, enjoyed substantial political authority, advising their cities' rulers on spiritual and social matters.

The behaviour of the female religious was of concern to every town since their primary task was to provide, through their prayers, salvation for the community as a whole. There were always suspicions about the

true vocation of Italy's nuns and there were concerns about the protection of their chastity. The conduct of women in Venetian nunneries, where reform began in the early fifteenth century, was particularly controversial. Although many of the city's convents were small and poorly endowed, a number were favoured by the highest levels of the urban patriciate who brought both wealth and illustrious connections. Enclosed in these convents, Venetian noblewomen were able to continue to enjoy some of the comforts of their childhood, retaining private apartments, dancing, and other forms of entertainment, and the regular visits of relatives, male and female.

These same women, invisible to the majority of the population, were also responsible for a number of important state rituals. For example, the doge attended mass in the Benedictine convent of San Zaccaria every Easter and was then entertained by the nuns in their cloister. Having been founded in the ninth century by a doge for his sister, this nunnery had a particularly aristocratic history and continued to attract the daughters of Venice's highest nobility. The nuns' long tradition of patronage was continued in the quattrocento in a series of projects, one of which was undertaken in the early 1440s when the abbess Elena Foscari, her prioress Marina Donado, and the housekeepers Cecilia Donado and Agostina Giustinian, all of whom were connected to Venice's most important families, constructed a new choir at a total cost of 1,874 ducats. The choir, which became a separate chapel after the nunnery's further expansion in the mid-fifteenth century, was, under ordinary circumstances, only accessible to the nuns themselves. It contained the body of the father of St John the Baptist, St Zacchariah, a piece of wood from the true cross and a piece of the crown of thorns, the veil of St Agatha, some of the Virgin Mary's clothing, and relics of the early Christian saint Sabina. The nuns also owned the body of St Tarasio (stolen in the eleventh century in a 'holy theft [*sacra furta*]', from a Byzantine monastery near Constantinople) to whom the chapel was actually dedicated. To provide an appropriate setting for these relics, the nuns invited the Florentine painter Andrea del Castagno to fresco the ceiling with images of saints [**78**] and commissioned three monumental altarpieces from Antonio Vivarini and Giovanni d'Alemagna [**79**]. Each altarpiece was inscribed with the name of the nun who had paid for it and the chapel and its furnishings were carefully preserved even after future generations of nuns embarked on campaigns of rebuilding and redecoration.[8]

Soon after he completed the San Tarasio chapel, Andrea del Castagno returned to Florence where he was given the commission for a fresco of the Last Supper by another community of Benedictine women in the refectory of the convent of Sant'Apollonia [**80**]. Although Castagno had an excellent reputation in his home town, the connection suggests that the nuns in Venice had recommended him to

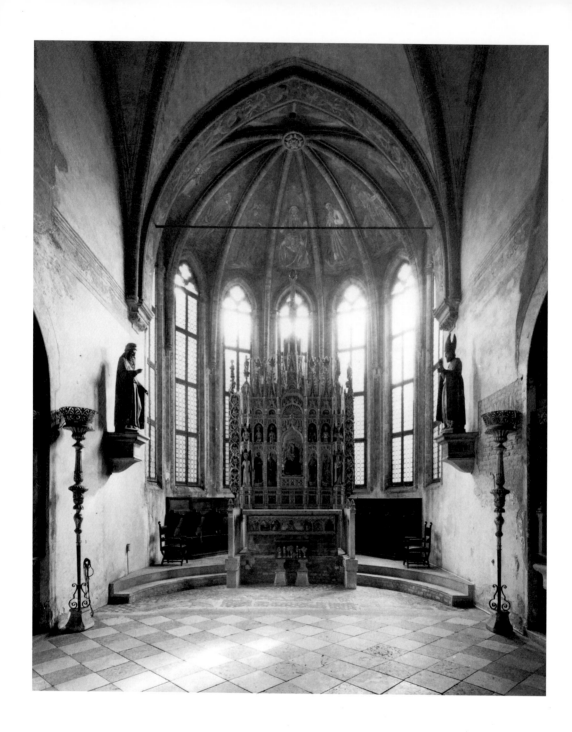

Chapel of San Tarasio, frescos
by Andrea del Castagno,
polyptych by Antonio Vivarini
and Giovanni d'Allemagna,
1442, San Zaccaria, Venice.
Andrea del Castagno and
an otherwise unknown artist,
Francesco da Faenza,
frescoed these vaults of the
reliquary apse of the church
of the Benedictine nuns of San
Zaccaria which is signed and
dated 1442. The abbess and
prioress paid for three
elaborate altarpieces which
were erected in the chapel
the following year.

**79 Antonio Vivarini and
Giovanni d'Alemagna**

Altarpiece of St Sabina,
tempera on panel and
polychromed wood, 1443,
chapel of San Tarasio, San
Zaccaria, Venice.

their sister-nunnery in Florence. or possibly vice versa. The convent of
Sant'Apollonia was an Observant nunnery under direct papal protec-
tion. With the support of Pope Eugenius IV the women were given
exemption from taxation and allowed to raise the funds needed to
expand and rebuild their convent in 1445. As in Venice, the abbess,
Cecilia di Pazzino Donati, had important social and family contacts
while many of her nuns were drawn from Florence's patrician élite.[9]
Castagno's work was undertaken over the summer and autumn of 1447,
a rapid execution of between ten and twelve weeks. In the refectory or
dining-room, the painter created a series of scenes of both the Last
Supper and the events which followed Christ's Crucifixion and
Resurrection on the upper wall. The Last Supper was a traditional
theme for a monastic refectory, one used later in the century by
Leonardo da Vinci in the Dominican refectory of Santa Maria delle
Grazie in Milan; Castagno's earlier version was also set within a fictive
space whose perspective geometry mimicked that of the hall itself as
the painted windows continued the line of the room's actual windows.
At the front of the image, the traitor Judas was thrust forward, remind-
ing the women of the ease with which Christ could be betrayed, while
the Apostles ranged around Christ and the women who mourned his
death in the Crucifixion above provided more appropriate role models.
Along with sexual misdemeanours, monks, friars, and nuns were tradi-
tionally suspected and ridiculed by satirists for their gluttony. The dra-
matic imagery was meant to ensure that the refectory did not become a
social space, much less a place where food was to be enjoyed. Here the

80 Andrea del Castagno
Last Supper, fresco,
1447, refectory,
Sant'Appollonia, Florence.

women would be able to eat a simple repast in silence, listen to religious readings, and consider the food of heaven rather than the sustenance of the flesh.

Cathedrals and churches

Castagno's frescos in the Benedictine nunneries, like Fra Angelico's images for the Observant Dominicans of Florence, were rarely seen by the majority of the civic population. But while laymen and -women needed either special status or permission to enter the monastic buildings themselves, they did have access to the affiliated church, although women (who were often forced to enter through one specific doorway) were forbidden to go into the more restricted parts of the building.

It is difficult to generalize about church buildings in the fourteenth and fifteenth centuries as they varied dramatically in architectural design and scale. In large cities, the main church was the cathedral which contained the bishop's seat. This might be very wealthy and support a special group of priests, the canons, who were originally expected to live a communal life and needed homes nearby. Some, like the cathedral in Pisa, were elaborate complexes which included a separate baptistery and campanile. Other cathedrals, like that of Bologna, were rather minor affairs, neglected in favour of the church dedicated to the city's patron saint, Petronius.

Cathedrals, which were often paid for by city-wide taxes or levies, were supposed to be the focal point for civic life. Memorials and burial sites within the building were usually limited to prominent clerics connected to the church, to the city's rulers, or to figures who had made some substantial civic contribution. In the cathedral of Florence, Santa Maria del Fiore, there are, amongst others, images of Dante, Giotto (erected in 1465), and mercenary soldiers who had served the republic such as the Englishman Sir John Hawkwood.

Monastic and parish churches, in contrast, could act as the centre of local neighbourhood life, and were the prime beneficiaries of requests for burial and memorial masses. These churches, again, could vary dramatically in wealth and importance. Thanks to Medicean influence, their parish church in Florence, San Lorenzo, became a well-endowed and lavishly decorated site. But in the countryside, episcopal visitors noted with dismay the poor quality and condition of the buildings and their priests. Whatever their scale or title, all churches did have some common requirements. They could only be built or dismantled with episcopal or papal permission. They all had to have a high altar with associated relics, and were only sacred once consecrated by a bishop who had blessed the walls with holy water and oil. In addition, churches were expected to have a campanile to call worshippers to mass, and, usually, some form of burial area either inside or outside the building itself. The church also needed a lavabo and sacristy where the priest could wash his hands, change into his robes, and store the church's wealth and essential liturgical furnishings such as the chalice for wine, the plate (known as the patten) for the host, storage containers (pyxes), candlesticks, altarclothes, vestments for the priest, and so forth. Wealthier churches and cathedrals would also have carved choir stalls, pulpits, tabernacles for the host, baptismal fonts, and fonts for holy water as well as paraphernalia such as oil-lamps, incense-burners, and incense-holders.[10]

An important urban church could be a hive of activity as priests and chaplains said mass or shorter services in side chapels, heard confessions, sold votive candles, and counselled their parishioners. Neighbourhood or confraternity meetings took place in local churches while in Naples the king used monastic churches to hold important convocations of his feudal barons. Responsibility for church construction, decoration, and maintenance varied from building to building and town to town. The ecclesiastics themselves were often denied responsibility for the city's most important churches and many organizations and individuals could be involved in their embellishment.

On a day-to-day basis, the neighbourhood or monastic church was usually run either by the abbot and the monastic chapter, or by an elected or appointed parish priest. The religious community involved had to give permission whenever an individual or a family wished to

Andrea di Lazzaro Cavalcanti
(il Buggiano) after designs by
Filippo Brunelleschi, Rucellai
Pulpit, gilt marble, 1443–8,
Santa Maria Novella, Florence.

Adopted at a young age by
Brunelleschi, Cavalcanti
executed many of his adopted
father's sculptural designs.
In 1434 he fled to Naples
with 200 florins and jewels
belonging to Brunelleschi but
was rapidly reconciled and by
the 1440s was again working
closely with the architect.
Brunelleschi was paid for a
wooden model of this pulpit
which Cavalcanti executed on
behalf of the Rucellai family.

place a work of art, erect a chapel, or put up a tomb in its church. But
once this had been granted their involvement of the religious commu-
nity varied. As part of its agreement with a patron, for example, a
monastic chapter or a parish priest would have to decide whether to
retain or to give away its rights of appointment and control over
specific parts of the church. This allowed donors who had provided a
substantial long-term endowment (perhaps by donating a piece of
rental property or land) for a chapel or an altar, or even a part of them,
to appoint their own chaplain and direct services for their personal
needs. This 'privatization' of church space and decoration did give rise
to some concern. For example, the strict Observant Dominican, Fra
Girolamo Savonarola (1452–98), who lived in the Medici foundation
of San Marco in Florence, found it particularly difficult to be sur-
rounded by constant reminders of the family's patronage, preaching in
one sermon of 1496,

Look at all the convents. You will find them all filled with the coats of arms of those who have built them. I lift my head to look above that door, I think there is a crucifix, but there is a coat of arms: further on, lift your head, another coat of arms, and you know they have put coats of arms on the back of vestments, so that when the priest stands at the altar, the arms can be seen well by all the people.[11]

San Marco was extremely unusual in having one single, if very distinguished, patron whose Medicean coats of arms could be found at every turn. Most churches and other sacred sites subdivided patronage as much as possible. Thus one family might have the rights to the altarpiece, another to a chalice or surplice, and yet another to the stained glass.

Increasingly, however, attempts were made by families and individuals to colonize specific parts of churches. In his study of Tuscan wills, for example, Samuel Cohn has found that the wealthy aristocrat Filippo Castellani of the Frescobaldi lineage was willing to give the Augustinians of Santo Spirito in Florence the enormous sum of 1,000 florins in return for burial rights as long as 'no coat of arms other than that of the Frescobaldi were placed on his sepulchre'. Similar sums were offered to the church of San Francesco in Arezzo by a local merchant who wanted to be buried next to the high altar, as long as he was able to paint the friars' choir with frescos celebrating his name-saint Lazarus and to include a central stained-glass window with his coat of arms, 'for his memory and the memory of his ancestors and for their example'.[12]

Under this system, disputes between competing donors were frequent. In Santa Maria Novella in Florence, for example, one family, the Minerbetti, had paid for the pier to which another family, the Rucellai, had attached a pulpit in 1448 [81]. Not unnaturally, the Minerbetti complained, and only retreated when an arbiter appointed by the Dominicans insisted that they would have to donate an equally expensive and beautiful work.[13] With their ambiguous attitude to personal wealth the Franciscans were even more concerned about public memorials to the laity in their churches. In the mid-1440s, for example, the Florentine patrician Castello di Pietro Quaratesi offered to provide a much-needed marble façade for the Franciscan basilica of Santa Croce. But his money was rejected when he insisted on being able to display his family arms on the building. Undeterred, Castello Quaratesi went on to settle his capital of 25,000 florins on an entirely new church and convent for another, more compliant, group of Franciscans, those of San Francesco al Monte at San Salvatore.[14]

To avoid disputes, donors who gave precious objects such as gold chalices often inscribed their gift with admonitions that metal should not be sold or melted down. Others carefully stipulated retributions

which should be taken if their wishes were not followed. The mid-fifteenth-century will of Caterina Poschi, who left 40 florins to the church of Sant'Agostino in San Gimignano for a marble pulpit, insisted that the stone include the Poschi arms; if this obligation were not met, the money was to go to any church listed in her will which would agree to fulfil her conditions. There were, however, some patrons who were willing to disguise their identity in return for spiritual reward. In 1459, for example, a donor was allowed to place a tabernacle in the baptistery in Florence as long as only the official arms of the commune and the guild responsible for the building, the Calimala, were placed on the object.[15] The tomb of Baldassare Cossa, Pope John XXIII, who died in 1419, was particularly controversial because it contravened the decorum of the baptistery space. One of the members of the guild responsible for its decoration, Palla Strozzi, insisted that the tomb could only be erected if it were 'discreet and most honest, and does not occupy the entrance to the church'.[16]

Dividing the church

As these examples suggest, patrons and the public were very concerned about location. There were a number of choices in any church including the nave which was generally open to all, private chapels which were screened off, the choir which was only accessible to those in holy orders, and rooms like the sacristy which again were used primarily by the clergy who were preparing for mass and by those responsible for maintaining the church's stores.

The high altar was normally distinguished from the rest of the church by its central position at the end of the nave and some form of architectural barrier: steps, railings, or an iconostasis, a screen on which images could be displayed. The Dominicans and Franciscans used a large, full-sized rood-screen known as a *tramezzo* or *ponte* (bridge) to divide the transept from the nave, blocking access to chapels in the rear of the church as well as to the high altar. In Santa Maria Novella in Florence, for example, this was almost half-a-bay deep.[17] Such a screen is visible in Carpaccio's early sixteenth-century painting, the *Vision of Saint Omobono*. This image, which illustrates the now-destroyed church of Sant'Antonio di Castello in Venice, shows how altars and chapels were erected against the nave-section of the barrier. When these screens were dismantled throughout Italy in the mid-sixteenth century, monastic churches lost an important focus for lay devotion (see also **68**).

The sites closest to the high altar or to a saint's shrine were the most desirable and the most inaccessible to laymen and -women. In practical terms this meant that donors who sought a prestigious tomb or chapel behind the *tramezzo* might not receive the public prayers and memorialization they craved. It also meant that, to take only one example, at the end of the fifteenth century most visitors, and certainly all female

worshippers, who went to Santa Maria Novella would have been able to see Masaccio's fresco of the Trinity which was sited in the nave, but only the very highest registers of Ghirlandaio's frescos in the choir. Orcagna's and Filippino Lippi's work in the two Strozzi chapels in the transept would have been more or less invisible. The restrictions on vision could work the other way as well. In Santa Chiara in Naples the nuns who prayed for King Robert of Anjou's soul could not see his monumental tomb which faced the laity while the enclosed nuns of San Zaccaria could take little visual pleasure in the elaborate new marble façade they erected in the late quattrocento.

The most public and accessible area in any church was the nave and its associated chapels, any or all of which would have had images of some description. These areas provided a place for private prayer, for attendance at mass, and for preaching. The nave was also a vibrant social space with meetings and religious festivities, and processions and performances—multiple functions which were not always compatible. The early fifteenth-century preacher Girolamo da Siena wrote a little booklet about religious behaviour and included a special section on how men, and above all women, should behave in church, warning that excessive piety was as inappropriate as impiety:

You should enter the church, not like those women who go to find all their tradesmen, neighbours, relatives, and friends in God's house; but go alone, most devoutly in perpetual silence, looking at neither friars, nor priests, nor men or women, and set yourself to prayer. . . . And first satisfy God and, if you have nothing to say from your Book of Hours or from your ordinary devotions, wait, in silence and in fear, for the priest who would hear all your sins, or say mass or the divine office which is to be celebrated or the holy words which are to be preached.

Be attentive during the preaching. Don't judge the preacher, but note and write down in the living tablets of your heart, those elements of [Christian] doctrine which it seems to you that you need to remember most. During mass, stand with great devotion, at the stairs to the altar. And out of reverence, don't press up too close to either the altar, the priest, or to any sacred or consecrated vessel, but remain in fear that it is not so much touching as contaminating, so great is its precious dignity.

And do not imitate those many deeds which different people do, such as the many who run like madmen to see the consecrated host; many, who if they have not come near it, are not happy; many, who after one priest has held the consecrated host in his hand, leave him to go to another who is holding the host higher; others who, during the sermon, leave to go and view the body of Christ; and some who try to touch it all with their hands. Then there are some who beat their breasts with their hands in an inappropriate manner with uncontrolled sighs. Some unwise women, in the middle of the crowd when they are sitting to hear the sermon, stand up and speak. Others hold their hands across their breasts when the priest says the prayer of 'Our Father'. Some write little notes when they sing certain parts of the Gospel.

O these things are for the most foolish souls! You should be composed, and watch, and listen to what you can in the church, not leaving that place where you are accustomed to stand, because the invisible virtue of the sacrament does not consist in bodily vision but in devout mental contemplation.[18]

There is considerable evidence for Girolamo da Siena's concerns and other sources discuss behaviour which goes beyond the excessive behaviour, minor misdeeds, and lack of decorum which he chronicled. The late fifteenth-century diary of the Florentine Luca Landucci (1436–1516) records numerous acts of mischief ranging from practical jokes, such as putting ink in the holy water and letting a horse into the cathedral of Santa Maria del Fiore, to a thief taking advantage of crowds in the baptistery on the feast of St John the Baptist to quietly cut the purses of the wealthy merchants present. The committee responsible for constructing the cathedral of Milan was forced to appoint guards to look after the donations it received in the late fourteenth century and Landucci reported with horror how in 1475 a thief who had hidden himself in the cathedral of Florence after closing-time stole the silver offerings given to an image of the Virgin.[19]

Yet these actions were recorded precisely because they were so shocking. Church attendance was a regular habit and most men and women did know how to act correctly, indeed it was so common that it was rarely remarked upon. Churches were special places which demanded specific forms of behaviour; one of the major functions of church furnishings and decoration was to remind Christians that they were no longer in the street or in their homes and that a precise decorum was expected, particularly at sites such as altars and tombs, and ensembles such as chapels.

The altar

For Catholics the year was organized by variations in worship as well as by seasons and changes in the weather. There was a rhythm which turned on points of the life of Christ such as the Annunciation, his birth, Passion, and Crucifixion. Thus Florentine and Sienese citizens began a new calendar year on the day Christ was conceived, the feast of the Annunciation on 25 March. In every town all work was to stop on high feast days and on Sundays. The statute-books of many towns and guilds insisted that all its parishioners, male and female, attend church on such major feast days and on celebrations in honour of local saints. The proliferation of holidays (i.e. holy days) was a cause of considerable complaint as economic life slowed. But there were few objections to attending mass as frequently as possible since the transformation of bread and wine into the literal body and blood of Christ, a doctrine known as transubstantiation, formed one of the central points of contact with heaven itself.[20]

The drawing by Niccolò Pizzolo which was used for the Lazzara chapel in Padua provides a vivid illustration of how Christ's bodily transformation into the flour which made up the host was visualized. Communicants were meant to believe that the item they were eating was not an allegory or reminder of Christ, but literally Christ himself (see page 105). The altarpiece dedicated to the Body of Christ which a Venetian nun commissioned from the painter Quirizio da Murano, visibly emphasizes the connection between Jesus's wounds and the wafer which he holds before the adoring donor [82].

The prayers which preceded the moment of transubstantiation prepared for the event through confession and absolution, requests on behalf of both the living and the dead, and the binding in peace of the communicants by the kissing of the *pax*. The liturgy then activated the miraculous transformation. Of the seven sacraments, this was the only one which was the exclusive preserve of the consecrated and ordained priest (meaning that friars who had not taken holy orders could not celebrate mass and that nuns needed to employ male priests to carry out their services). By the thirteenth century the ordained priest alone was allowed to drink from the chalice and was often the only figure to partake of the host. Most celebrants were content to watch the ceremony, kneeling and reciting special prayers, many of which were incorporated into their personal Books of Hours, as they gazed at the wafer. As Girolamo da Siena's complaints indicated, viewing the host was the primary motive for attending church, suggesting a frenzy of movement from altar to altar as parishioners tried to get a glimpse of yet another consecrated wafer.

Communion was only offered to the laity after they had made a full confession, a ritual usually carried out at Easter (which legislation made obligatory in fourteenth-century Florence) or during illness. The consecration of the wine and wafer could only take place at a special site, the altar, a table which contained relics and had been consecrated by a bishop. The only formal requirements for this table were a crucifix and candlesticks. The print of the *Mass of St Gregory* shows the essential elements normally used for a mass: two candlesticks, a chalice, a patten for the host (which was placed on a white cloth and covered with another piece of fabric), a stand for the book from which the priest said the service, the missal, and, in the place of the crucifix, Christ himself [71].

Behind the altar was a low retable or altarpiece with images of standing saints while the altar itself was covered with a richly decorated and fringed cloth. There was no requirement for these accessories. A mixture of practical exigencies and the desire to create a visual focus for the audience during mass led to the development of increasingly elaborate embellishments. This was caused, in part, by a change in liturgical procedures. In 1215 the Fourth Lateran council insisted that, instead of

82 Quirizio da Murano

Christ Showing his Wounds
and the Host to a Clarissan
Nun, tempera and oil on panel,
c. 1461–78.

facing the congregation, the priest should turn his back during the prayers which activated the transubstantiation of the host. This meant that there was no need to stand behind the altar table and that an impressive backdrop to the event could prove a useful point for religious contemplation. The multiple fields which polyptychs provided allowed either connected narratives such as Sassetta's *Life of Saint Francis of Assisi* to unfold, or the worship of disconnected saints, as in the Colantonio panels from the church of San Lorenzo in Naples which focused on Francis above and St Jerome below, or a combination of the two whereby the predella panel told stories connected to the saints shown in the main panel above. This versatility meant that the polyptych format survived well into the sixteenth century [**50, 20**].

The monumental multi-panelled altarpiece was not the only focus for devotion. To the later dismay of Protestant reformers, a whole range of objects connected to the Eucharist, from the tabernacle in which the consecrated wafer was stored to the holders in which it was displayed, became increasingly important to church ritual. Often taking the place of the altarpiece, the host and its lavish containers could become the church's liturgical focal point. When the Catholic Council of Trent reversed the communion ritual in the 1560s, the priest returned to the rear of the table. This meant moving or destroying the large multi-tiered paintings on the high altars. The vast majority of Italian panel paintings in museums and private collections today come from altarpieces, such as Giovanni di Paolo's St John the Baptist polyptych or Sassetta's Franciscan panels, which were sold off or cut up when their original purpose was either lost or disregarded.

Tombs

The burial sites in Italian churches had only slightly better treatment than their altarpieces. Sixteenth-century Tridentine reformers and later clerics disapproved of the interment of secular rulers and merchants in important ecclesiastical sites. In Milan, for example, St Carlo Borromeo (1538–64) ordered all the monuments erected to the Sforza removed from the apse of the cathedral, while the tombs from the floor of Santa Maria Novella in Florence were 'tidied away' in the nineteenth century.

To fully appreciate the importance and original proliferation of burial-markers we need to first consider the ambivalence with which lavish tombs were regarded. In Canto XII of the Purgatory section of the *Divine Comedy* written in the early fourteenth century, the Florentine poet Dante Alighieri used the image of tomb slabs to introduce a number of characters guilty of the sin of pride: 'As over the buried dead, that there may be remembrance of them, the pavement tombs bear designs of what they were before, for which tears are often shed there at the prick of memory that spurs only the pitiful.'[21] Such a

scene would have been immediately recognizable to fourteenth-century readers, for tombs and similar memorials could be found in every conceivable spot in the consecrated grounds within and without churches. In their wills, individuals often provided precise instructions as to where they should be buried, and how. The body itself was usually rapidly disposed of, normally within twenty-four hours, and wealthy individuals who travelled extensively usually offered alternative spots for their burial. Soon after the individual had passed away, the body was cleaned, clothed, and laid out, a job which was sometimes undertaken by female relatives. It was then carried openly on a bier—covered in an expensive piece of cloth, the pall—to the point of burial where the office of the dead would be read and the body blessed with holy water and interred in holy ground. The *gisant* on the tomb might illustrate this moment, showing the body lying on the cushions and cloth on which it had been carried through the street. The brocade was eventually given to the priests responsible for the burial, unless it belonged to a confraternity or guild who would reuse it for their next funeral. Such groups would usually promise to provide all their members with an honourable burial, and would take responsibility for dressing the corpse in the appropriate habit, and provide the wax candles, cushions, and the bier that were expected of a funeral procession. In Venice, where citizens might belong to several confraternities or *scuole* who would send representatives, funerals could be very impressive indeed. Some testators would also arrange for paupers to accompany their corpse: the historian John Henderson has discovered one prominent Florentine, Niccolò degli Alberti (d. 1377), who arranged for 500 paupers to attend his funeral.[22]

Funerals were too important to be left to the family alone. Many urban communities, anxious to suppress factional competition and avoid unnecessary expense on ceremonies which would deprive heirs of their estate, made funerals the focus of restrictive sumptuary laws. These limited the number of priests and mourners, the garments which could be worn, the number of torches and candles which could be burnt, and the funeral and memorial meals which could follow. There was often, as we shall see, concern over the expense involved in the tomb itself.[23]

Choosing the spot for interment meant more than selecting a hole in the ground or a piece of marble. Prosperous individuals often created their tombs well before their deaths, arranged for a priest to say mass, and might pay for numerous chaplains to recite prayers for their souls. This was, in part, because burial was only the beginning of the ritual of mourning. Over the next few weeks members of the immediate family, male and female, would be expected to wear special clothing made of expensive brown or black cloth as a sign of their status as grievers, and many wills include provision for mourning garments.

Women were often excluded from the initial funeral. Petrarch, for example, was echoing a common assumption when he wrote that cities should create legislation, 'in order that wailing women should not be permitted to step outside their homes, and if some lamentation is necessary to the grieved, let them do it at home and do not let them disturb the public thoroughfare'.[24] Florentine legislation permitted a female presence but was adamant that only the widow was allowed to let her hair loose in mourning.[25] These rules and regulations should encourage a re-examination of Lamentation scenes such as those by Niccolò dell'Arca, where the controlled grief of the male figures is deliberately contrasted with the feminine lack of restraint [**8**, **9**, **10**].

It was common to arrange a requiem mass a few days after the actual funeral, where again, attempts were made to control women's behaviour. In 1471, for example, Roman statutes forbade female relatives from attending the service in a 'wild or dishevelled state'.[26] The requiem might then, depending on the status and legacy of the deceased, be followed by memorial masses held thirty and ninety days after the time of death, finishing with an anniversary service. The number of masses which were then arranged depended on the endowment which the deceased had provided. Niccolò Acciaiuoli, for example, left an enormous legacy to the Carthusian monastery of San Lorenzo outside Florence at his death in the late 1350s. In return he wanted 1,000 masses to be said for his soul within a year of his death, just under three per day along with prayers for his mother and father and for Queen Giovanna of Naples.[27] In contrast, Antonio Pollaiuolo's will of 1496 was more typical in its still-considerable demands on his legacy. Pollaiuolo asked for a mass on the anniversary of his death, and on the feast of his name-saint, Anthony Abbot, when twelve paupers were to be fed and given alms in perpetuity by his heirs.[28]

If he died in Florence, Pollaiuolo was content to be buried in his father's sepulchre where his bones would be stored for the moment of resurrection. In Fra Angelico's image of the Last Judgement, the figures crawling forth from the ringed slabs are souls which have regained physicality and are emerging from these type of family crypts [**61**]. For this final moment, a proper burial in consecrated ground was crucial but a large piece of marble was not a formal requirement for salvation. Tombs evoked contradictory attitudes; there was the long-standing theme of the tomb as a pointless human investment, which continued to be evoked by preachers, theologians, and writers such as Boccaccio in the fourteenth and fifteenth centuries. In a carefully crafted letter written to a fellow humanist, Poggio Bracciolini, in the early quattrocento, Leonardo Bruni expressed similar thoughts which, he claimed, had been sparked off by seeing the marble carted off to Montepulciano for the tomb of yet another humanist, Bartolomeo Aragazzi (d. 1428/9) (a tomb which was designed by Michelozzo [**83**]):

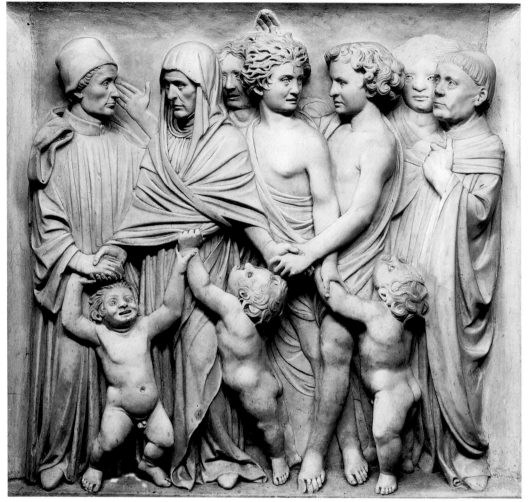

83 Michelozzo di Bartolomeo

Bartolomeo Aragazzi Bidding Farewell, relief from the tomb of Bartolomeo Aragazzi, marble, 1437–8, Duomo, Montepulciano.

The humanist and papal secretary Bartolomeo Aragazzi died in 1429. Work was probably already under way on his monument for in his tax returns of 1427 Michelozzo described the arrangements for payment. In 1437, however, Michelozzo agreed to complete the tomb within six months. This relief of the departure of the soul from worldly ties is based on Roman models.

For in fact no one who was confident of his glory ever thought of having a tomb made for himself. He, content with the fame of his praiseworthy works and the distinction of his name, will think himself quite enough approved by posterity on that account. In what way can a tomb, a dumb thing, help a wise man? And what is more vile than for a tomb to be remembered and a life to be passed over in silence?[29]

But there was another point of view, one expressed very forcibly by the chancellor of the king and queen of Naples, Niccolò Acciaiuoli, in April 1353 when he wrote to a relative supervising the construction of the Carthusian monastery of San Lorenzo in Florence where he expected to be buried, that

I wish my burial chapel to continue to be perfected, and that you should create a home for me there. Nor should you, Jacopo, think that if the work becomes somewhat sumptuous, I will be less pleased. I know that all the other worldly goods which God has given to me will remain for those who follow, and I don't know who they will be. Only this monastery, with all its

adornments, will be mine for all time and it will raise up and make my name enduring in this city. And if, as monsignor the chancellor says, the soul is immortal . . . My soul will rejoice in this.[30]

Acciaiuoli's tomb [84] shows him curved, with his knees crossed, a position associated with knighthood. Painted with the arms of the Anjou dynasty of Naples, his success as a soldier, administrator, and patron of the monastery are both lauded and remembered. He was successful in ensuring that his memory endured in Florence; his portrait was included in a number of cycles, written and painted, of famous men of the past and present. His ideas about the benefits of expenditure on tombs eventually became commonplace statements amongst fifteenth-century Florentines. Thus the merchant Piero del Tovaglia could argue in 1471 that 'If I spend 2,000 florins on my house, my dwelling on earth, then five hundred devoted to my residence in the next life seems to me money well spent.'[31] This aim of memorialization for secular as well as sacred purposes was encapsulated by Giovanni Pontano at the end of the century, who, when writing of the ancient Romans, remarked, 'these sepulchres, which our forefathers wished to make sacred, have the marvellous power of exhorting us to virtue and to glory, especially when they are dedicated to worthy men'.[32]

As Acciaiuoli and Pontano clearly understood, there were always two audiences for tombs. Although heaven did not require an impressive memorial, these marble stones improved one's position on earth, reminding the living of the need to pray for the dead and of the achievements of the deceased. A number of the tombs illustrated in this book were erected by relatives rather than by the deceased him- or herself. The use of a tomb, and the praise of an individual to celebrate the achievements of an entire family, was a common occurrence. After the death of his younger brother in Naples, the Florentine banker Filippo Strozzi supervised the creation of an expensive tomb slab. He explained his decisions to another member of the family in the following manner:

I have seen the design of the stone of that master [in Naples] and have seen how it can be made for 26 ducats. The expense is little but I do not believe it is sufficient for our honour and it would be better to improve it, because the honour is a burden which is attributed to us and not to the dead, and in making it beautiful we honour ourselves.[33]

This sense of familial honour which accrued from a good death and burial monument can be found amongst the élite throughout Italy. Relatives might actually ignore the requests of the deceased for minimal expense in order to celebrate his or her fame more suitably. When the Paduan jurist Raffaello Fulgosio died of the plague in 1427, he asked for a simple tomb, specifically stating in his will that if he were to be

84 Andrea Orcagna (attrib.)

Tomb of Niccolò Acciaiuoli,
*c.*1353, certosa of San
Lorenzo, Florence.

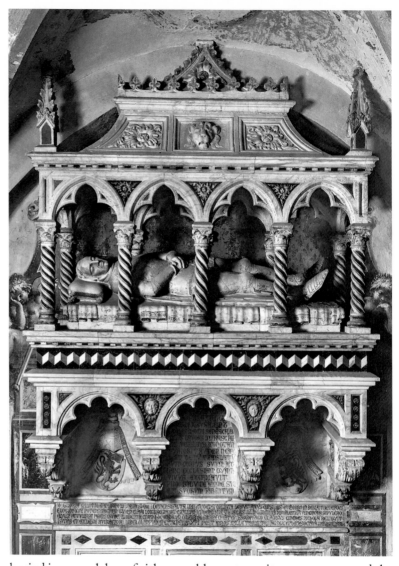

buried in a sepulchre of either marble or stone, it was not to exceed the
height of the altar. His wife Giovanna de' Beccaria, however, had very
different ideas, purchasing an expensive site from the friars of the basil-
ica of Sant'Antonio in Padua and commissioning a young Florentine
then working in Venice, Pietro Lamberti, to provide a lavish monu-
ment to her husband's virtues and interests. The highly detailed con-
tract was very specific about the iconography and about the materials,
Istrian marble or red Veronese stone, to be used in each section.[34]
Likewise, the Florentine chancellor and historian, Leonardi Bruni,
had disapproved of Aragazzi's marble monument, and had asked for a
modest plaque inscribed with his name to mark the site of his earthly
remains. But despite his attitude, he now appears in as lavish a work as
that of his despised humanist rival since the Florentine government

85 Bernardo Rossellino

Tomb of Leonardo Bruni, marble, 1444–6, Santa Croce, Florence.

In his will, the historian and chancellor of Florence Leonardo Bruni asked to be buried in Santa Croce in a simple tomb marked by a marble slab. At his death in March 1444, however, the city of Florence honoured Bruni with a lavish funeral and may have paid for the tomb itself. Bruni's effigy appears wearing a laurel wreath and clasping a copy of his history of Florence. The inscription reads, 'After Leonardo departed from life, history is in mourning and eloquence is dumb, and it is said that the Muses, Greek and Latin alike, cannot restrain their tears.'

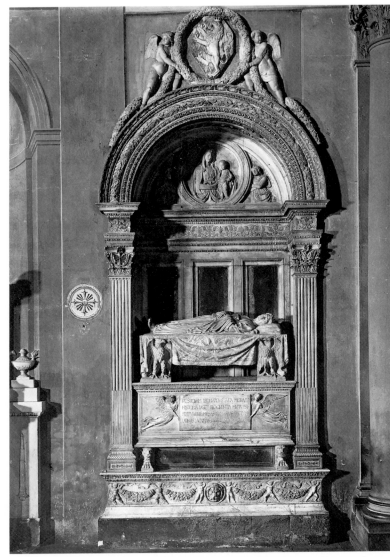

decided to sponsor a state funeral and tomb celebrating his erudition and achievements [**85**].

Lavish funerals, for which exemption from sumptuary laws often had to be sought, were, like lavish tombs, usually the preserve of the public figure, the male head of the family, the *paterfamilias*. Women were normally buried with much less ceremony unless husbands or sons decided to honour a 'good mother'. The Florentine banker Giovanni Tornabuoni was particularly unusual in his attention to the women who had married into his family. He obtained permission from the Dominicans of Santa Maria Novella to bury his daughter-in-law Giovanna Albizzi Tornabuoni, who died in childbirth in 1488, along with his own wife in the choir chapel over which he had recently gained patronal rights. Giovanna was shown in a number of places in

86 Domenico Ghirlandaio

The Life of St John the Baptist, fresco, 1485, left wall, Tornabuoni–Tornaquinci chapel, choir, Santa Maria Novella, Florence.

Members of the Tornabuoni family and their Tornaquinci relations can be observed in the lowest registers in the scenes of the sacrifice of Zaccharias, the meeting between Mary and Elizabeth, and the birth of the Baptist.

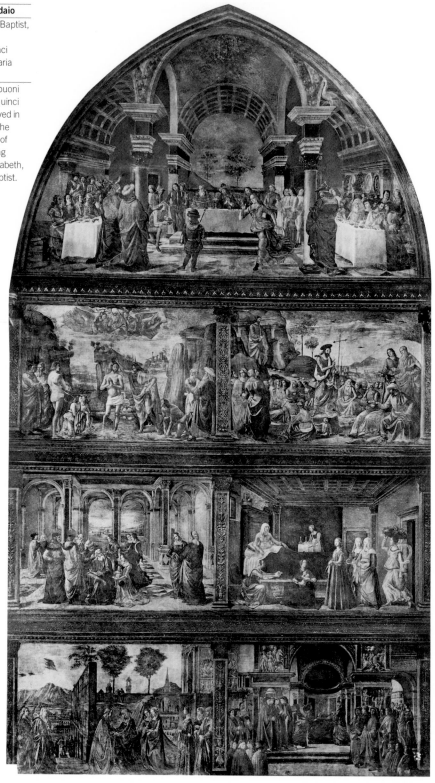

the fresco cycle [**86**, **87**], such as the Birth of the Virgin and the meeting of Mary and Elizabeth. These episodes were on the lower registers of the chapel wall. Invisible to the congregation, but very carefully presented as a modest female to the monastic audience, the mother of Giovanni Tornabuoni's grandson was remembered in the Dominicans' prayers and masses. Indeed, as an extra precaution, the patron even arranged to have portraits of his wife and daughter-in-law embroidered on to the altar-cloth.[35]

Tornabuoni seems to have had a genuine desire to create a memorial to the women of his family; the more expensive and more public fourteenth- and fifteenth-century tombs dedicated to women, such as that of Maria Piccolomini in Naples or Ilaria da Carreto in Lucca [**88**], were usually put up by husbands anxious to stress the aristocratic connections they had gained through marriage (particularly if these women had provided male heirs), or, in a small number of cases, by fathers mourning an unmarried daughter. There was a remarkable uniformity in the portrayal of these secular women. They were usually depicted as young, with slender, symmetrical features, and rich but respectable clothing. The effigy of Bartolomeo Colleoni's daughter Medea, who died in 1470, conformed to this type [**89**].

There is evidence for at least one woman who made provisions for her own, very lavish, tomb memorial. Maria Pereira Camponeschi, who had married a Neapolitan nobleman, belonged to the Aragonese royal family. Her husband, however, found himself on the wrong side of the struggle for the throne of Naples and was imprisoned in the 1480s. After his death, Maria entered a convent in his home town of L'Aquila. Before she left the secular world, she made arrangements in 1488 for her tomb, providing an endowment to the commissioners responsible for a new church containing the body of St Bernardino of Siena. She wanted them to provide a marble monument for herself and her infant daughter, a work in the newest fashion which was eventually finished by the local sculptor Silvestro dell'Aquila (d. 1504) in 1494 [**90**].

Maria Camponeschi was obviously not the only woman to build her own tomb, much less to endow funerary masses. An investigation into late fourteenth-century wills by the historian Samuel Cohn has discovered numerous women who left sometimes quite substantial sums for their own resting-places and those of their relations. In addition, many widows were responsible for the construction of the family tombs and chapels where they would lie with their husbands and children. The case of Fina Buzzacarina's endowment of the baptistery decorations in Padua (see above, p. 141-2) is one case in point but there are other examples of women with more modest means. In 1369, for example, the will of one Domina ('Mistress') Mante, probably the widow of a Florentine notary, left 300 florins and considerable property to pay for and endow a chapel, tomb, and a chaplain 'of mature age, of

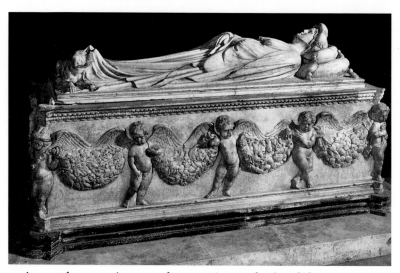

praiseworthy conscience and reputation and who did not possess a benefice from any other church'.[36] This priest was to say, 'continuously and daily, solemn masses perpetually for the praise of God and for the souls of her daughter, her former husband, her kin and herself'.

Chapels and oratories

The tomb into which Domina Mante transferred the bones of her husband and children was often only one part of a larger liturgical ensemble, the chapel where masses were said regularly on behalf of families, individuals, and organizations. Chapels did not always have a funerary purpose nor did they have to be separate architectural sites. They were endowed for any number of reasons. Clerics might wish to expand the range of saints who could be honoured in any single building, or they might wish to raise funds for the church as a whole by selling off the rights to individual parts of the building. The construction of San Lorenzo in Florence during the first half of the fifteenth century was, for example, made possible in part because of the sponsorship of its side chapels. The builders of San Petronio in Bologna also hoped to raise considerable amounts by charging its chapel-holders for the rights of ownership as well as demanding additional sums for the decoration of the chapel and for the provision of an endowment to pay for the priest who would recite the required masses. In return for their investment, the patron and his heirs would usually receive legal authority over the site and the ability to appoint their own cleric. This right, known as the *jus patronatus*, could be held by institutions as well as individuals. Thus while many chapels served as burial sites, others provided special masses for corporate groups such as confraternities or guilds or were erected as memorials to particular events which the patron wished to remember, such as military victories or the birth of a child.

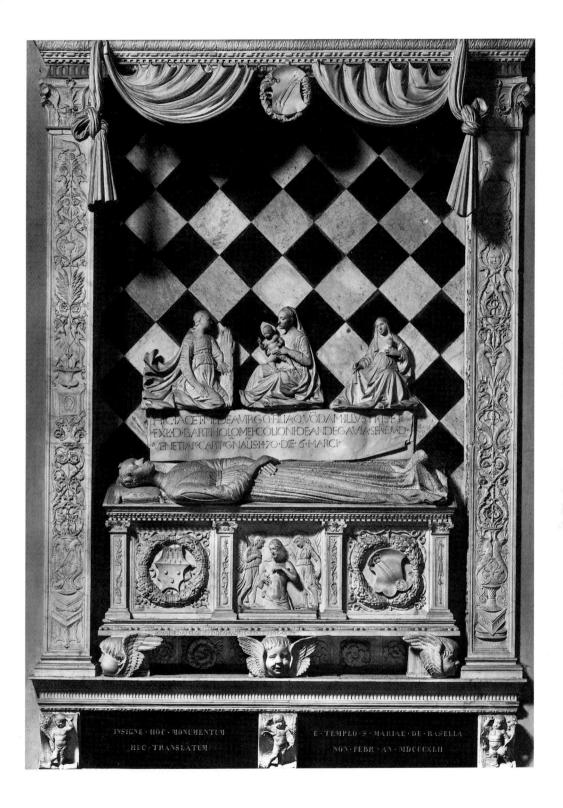

HIC IACET MEDEA VIRGO FILIA QVODAM ILLVSTRIS ET
EXLI D BARTHOLOMEI COLIONI DE ANDEGAVIA SEREBVD
VENETIAR CAPIT GNALIS 1470 DIE 6 MARCI

JOVANES ANTONIVS DE AMADEIS FECIT HOC OPV

INSIGNE · HOC · MONUMENTUM E · TEMPLO · S · MARIAE · DE · BASELLA
HUC · TRANSLATUM NON · FEBR · AN · MDCCCXLII

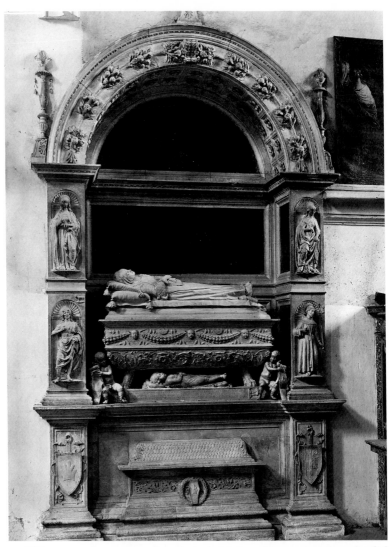

Whatever the reason for their initial endowment, chapels did change in function and might eventually have to serve multiple purposes. The Cavalli chapel in Sant'Anastasia in Verona, for example, is an assemblage of different Cavalli family offerings including a large votive fresco painted by Altichiero [**91**] and the completely unrelated tomb of another member of the dynasty below. Chapels could also move in and out of family control. The decoration of the Brancacci chapel in the Carmine in Florence, founded in the late trecento, was begun in the early 1420s by one of the family's most prestigious members, Felice Brancacci. But what should have been the culminating moment of his success, his marriage to Palla Strozzi's daughter in 1433, proved fatal. The Strozzi were in the ascendancy at the moment of the wedding but only a year later their rivals and eventual successors, the Medici, returned to Florence in triumph. Felice Brancacci was forced

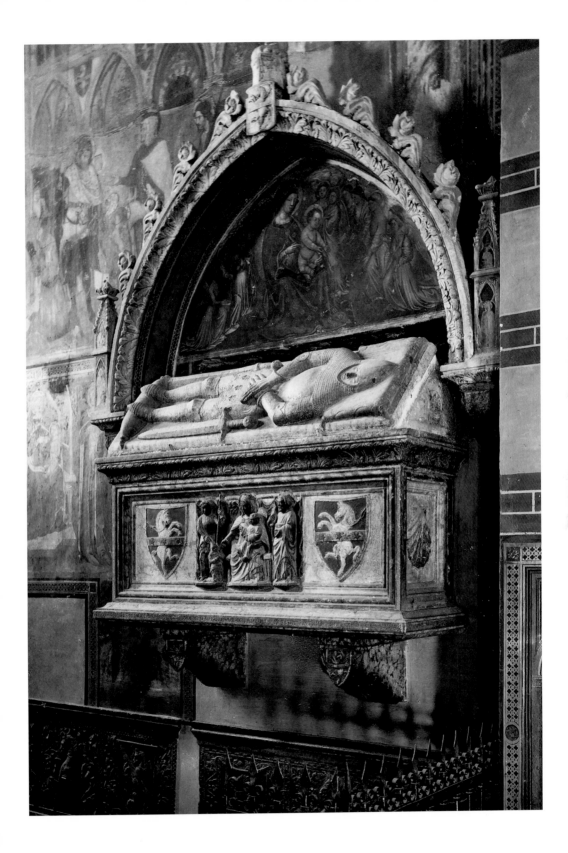

One of Florence's most important patricians, Felice Brancacci, commissioned Masaccio and Masolino to paint the life of St Peter in the early 1420s during the period of his political ascendency. In 1433 Brancacci married the daughter of one of the city's wealthiest and most powerful citizens, Palla Strozzi, then the leader of the anti-Medicean faction. A year later, however, both Brancacci and Strozzi were forced into exile after Cosimo de' Medici's return to the city, incidents which inevitably affected progress on the chapel's decoration. During the second quarter of the quattrocento the Carmelites tried to erase the memory of their politically sensitive patron, cancelling all the portraits of members of the Brancacci family and altering the chapel's dedication.

to leave the city and his family goods were confiscated. The Carmelite monks responsible for the church erased the portraits of these politically embarrassing patrons and eventually arranged for the chapel's completion themselves [**92**, **93**, **94**].[37]

In a period of social change and competition, there was, as we have seen, increasing demand for well-located sites. When, for reasons that are still obscure, the Sassetti family lost their right to the high altar of the church of Santa Maria Novella in Florence in 1488, Francesco Sassetti counselled patience, encouraging his sons to remain on good terms with the Dominicans; he wanted them to try and regain the site 'because it is a sign of our ancient lineage and of the honour of our house'.[38] It was not, however, just the well-to-do patricians who felt the need to purchase and provide for such honour. Samuel Cohn's survey of Tuscan wills includes chapels and altarpieces being offered by notaries, apothecaries, and cobblers as well as by aristocrats. Concerns for salvation and remembrance were clearly not the exclusive preserve of Italy's political and mercantile élite, but the concern of any Christian who hoped for an afterlife in paradise.

Seeing in sequence

Much of this chapter has examined and illustrated the many individual elements that made up larger monastic and church complexes. What has been missing, however, are the smells, sounds, and ephemeral visions which once accompanied the original fourteenth- and fifteenth-century experience of religious worship. Books, such as this, which provide discrete photographs of separate items, can only dimly

reproduce a sense of how objects were originally grouped together, or, more importantly, seen in sequence, one after the other. In Carpaccio's interior view of Sant'Antonio di Castello in Venice, for example, it is clear that the painter meant to stress how worshippers entering the church would have seen the last altarpiece in the nave with its elaborate modern marble surround (which had been painted by Carpaccio himself), after they had passed by two Gothic polyptychs [68]. The novelty of the artist's invention was only understandable in contrast to the work which already existed in the church. However, the painting makes it equally clear that these altarpieces were not isolated works of art. They were part of a plethora of images, some in wax and some in wood, which drew the worshipper towards the monumental rood-screen.

It is unlikely that all Catholics responded in the same way to this choice of objects. Viewers who had a special devotion to one particular item might ignore all else in order to concentrate on a specific painting or sculpture. One fifteenth-century story attributed to the Florentine parish priest Arlotto Mainardi (better known as Piovano Arlotto) (1396–1484) recognized this tendency in the following anecdote:

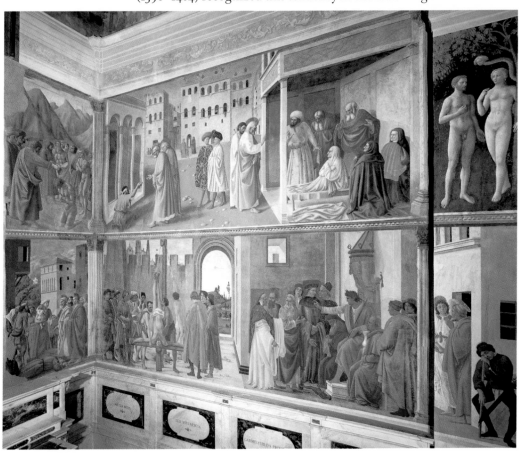

94 Masaccio

Expulsion of Adam and Eve, fresco, 1424–8, the Brancacci chapel, Santa Maria del Carmine, Florence.

One morning Priest Arlotto was walking through the church of Santo Spirito in Florence, and he saw a woman who was heaving deep sighs and saying her prayers devotedly before an image of Saint Nicholas of Tolentino. She had been praying and gesticulating in that manner for perhaps one whole hour and she seemed spellbound.

Priest Arlotto went to her, seized her by the head, and turned her in the direction of an image of the crucified Christ that was nearby; and he said: 'Can't you see, you foolish woman, that you are making a big mistake? Address your prayers to Him who is master and can help you better than his pupil.'[39]

Piovano Arlotto was angered by both the theological error and the mistake in ritual practice. For although worshippers clearly did behave differently, there was an expected decorum to their behaviour in church, one which took into account the multiple sites and images of devotion, but where clerics were insistent that reverence be paid to God and his son Christ first and foremost, and only then to the many other sources of help and inspiration. Christians should have prayed before a crucifix first, and then moved on to the more recent or more local saint.

There were, however, always difficulties in legislating such decorum. As part of the reforms brought about in northern Europe following the Reformation, this multiplicity of intercessors and devotional sites finally disappeared in Protestant churches. In sixteenth-century Italy there were similar campaigns, such as those undertaken by Vasari in the Florentine churches of Santa Maria Novella and Santa Croce, to unify or to simplify the variety and number of places and formats for worship, a process which continued over the succeeding centuries. Rood-screens disappeared, tomb slabs were tidied away, votive offerings were removed or whitewashed over, large polyptychs which had once stood on high altars were moved into sacristies or destroyed, while the wide range and types of altarpieces were often subsumed within later frames or formats. Thus, even on the original sites themselves, the experience of Renaissance viewing is so altered that it can never be physically re-created. None the less, even if our perception is diminished by time, and changing beliefs and practices, it is worth remembering that such sequences of images, with the accompanying music, chanting, smells, and ritual behaviour, once created a unique environment in which to look at works of art, one which is very different from the museums where they often hang today.

Part III

The Art of Government

Creating Authority

7

From the sacred we now move to the secular sphere, a transition which should not be exaggerated. The most public religious sites were the painted or sculpted tabernacles which dotted town walls, street-corners, and country village lanes. Biblical iconography was not confined to churches, nor were prayers and spiritual meditation limited to monks, friars, and nuns. But the question, 'what function did a work of art play in fourteenth- and fifteenth-century Italy?' does evoke a different answer when one examines art commissioned for civic or signorial purposes. For example, each Italian community had its own special saint, a patron who was both the symbol of the city and able to intervene on its behalf. With its sensuous lines and ambiguous iconography, Donatello's bronze statue of the Old Testament hero David [**95**] seems an unlikely image of such political ideology. We now know, however, that when it stood in the Medici palace in Florence it was underscored by the following inscription, originally in Latin, which encouraged viewers to identify with the young warrior and fight against tyrants such as the duke of Milan who were threatening the republic:

> The Victor is whomever defends the fatherland.
> All powerful God crushes the angry enemy.
> Behold, a boy overcame the great tyrant.
> Conquer, O citizens.[1]

These lines, and the statue itself, were designed to suggest that the Medici family were defending rather than usurping their city's prized liberty. Their recent rediscovery is a reminder that Renaissance visions of rulership could be found in many places and in many forms. Religious imagery based on both the Old and New Testaments and on the lives of the saints played a crucial role in establishing civic and signorial identities. A coin, a poem, a religious procession, donations to a church or confraternity, the commissioning of a heraldic shield, a painting, or a statue could all have political overtones. Moreover, for the oligarchical élite, social activities which we might now regard as private family matters, such as friendships or enmities, banquets, funerals, weddings, the entry of a son or daughter into religious orders or the priesthood, gift-giving, and charity all had important public

Detail of 104

David with the Head of
Goliath, bronze, *c.*1420s.
Donato di Niccolò di Betto
Bardi, was the son of a wool-
carder. The first reference
to his activity is not an artistic
one, but records a brawl with
a German in Pistoia in 1401,
which suggests that he may
have begun his career
working with Filippo
Brunelleschi on the silver altar
of San Jacopo under way in
that city. His long-standing
relationship with Cosimo de'
Medici had already developed
by the early 1420s when this
bronze was probably
produced for the first Medici
palace on Via Larga, Florence.

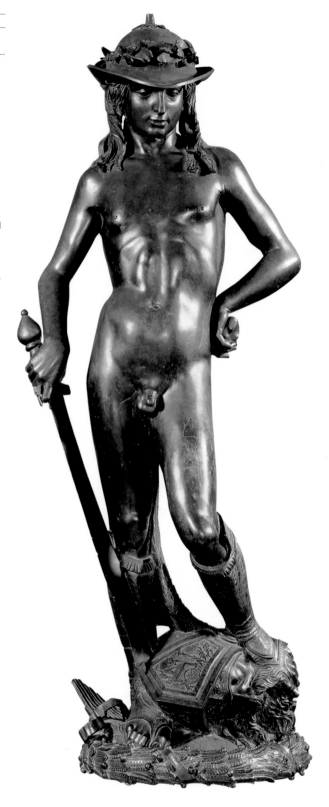

dimensions. Those with whom courtiers or republican clients went to dinner, where they sat, and what they were served, were as closely observed as the paintings and tapestries which were hung on the palace walls.

Ideals and images

The political situation in fourteenth- and fifteenth-century Italy was complex and mutable. During this period artists of every type were intimately involved in the creation of some of the most effective and impressive visions of good and bad government and governors. There were multiple forms of rulership on the peninsula, ranging from king-ship, ecclesiastical control, and communal republicanism to the many small-scale, often illegitimately acquired lordships, known as *signorie*. The extent of choice, and the controversies such choice generated, led to the development and dissemination of philosophical literature concerning the ideal political community. Texts, written in Latin and in the vernacular, in poetry and in prose, were designed to encourage men and women to put aside selfish personal interests in order to work for wider common good and/or to obey their rightful overlord.

This was not a purely academic exercise. Preachers called for appropriate civic behaviour or obedience to princes from the pulpit, while rhetorically sophisticated humanists took up important administrative offices, turning their skills both to the praise of defined modes of behaviour and to the creation of enforcing legislation. But it is important to realize that this language did not reflect the reality of politics; it expressed instead the writer's bias and his readers' or listeners' hopes and aspirations. For a humanist working for a commune or republic, such a form of government was always pious, fair, open, and free; for one working for a *signore*, the ruler was always just, clement, magnani-mous as well as prudent, temperate, charitable, and Catholic. When writing of political antagonists, the language was reversed. For those speaking in the name of the duke of Milan, republics such as Florence were unruly and faction-ridden, governed by the unthinking mob rather than by reason. For the duke's Florentine opponents, the prince was no liberal father to his people; he was a tyrant who held sway through fear and cruelty. Such rhetoric of praise and of blame was well understood by sophisticated fourteenth- and fifteenth-century writers and readers and by image-makers and observers; the continual rivalry between families, cities, and styles of government guaranteed regular employment for those skilled in the creation of both verbal and visual myths, praises, and invectives.

Identifying authority

When considering the Renaissance, museums, collectors, and art historians have tended to value works like monumental sculpture,

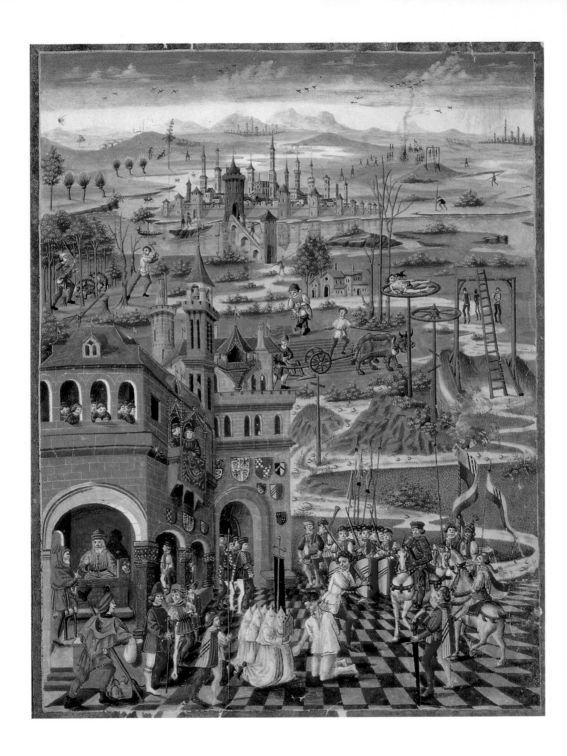

De Sphaera, manuscript, fo. 6,
tempera on parchment,
c.1450–60.

This folio, drawn from the
same manuscript as **37**,
shows occupations under
Saturn which include Justice.
In the foreground an execution
is taking place. White-robed
confraternity members hold
up a panel before the
condemned criminal to ensure
that his last temporal vision is
holy. On the centre of the gate
leading into the city are the
coats of arms of the
Visconti–Sforza , indicating
their jurisdiction over the town.

altarpieces, or illuminated manuscripts as the most influential artefacts of the period. But contemporary remarks suggest that for the majority of citizens simpler and more ubiquitous objects, such as coins, seals, pennants, banners, and coats of arms, acted as the most overt expression of political authority. The mint provided prestigious and much-sought-after employment for goldsmiths, painters, and sculptors while, for even the most prominent of fourteenth- or fifteenth-century artists, one of the most common tasks was effectively the painting of signs. Every important ceremony required special banners, shields, and torches while erecting, white-washing, restoring, and replacing the heraldic symbols which dotted the buildings and dominions of Italy's families, cities, and courts, was practically a full-time job for, like the brand names of major companies today, political and social groups had to be both visible and easily identifiable.

Coats of arms and crests, such as those of the Sforza dukes shown on the gateway in the manuscript in **96**, were designed to indicate ownership, ensuring that there was no doubt over who had control of, or was responsible for, buildings, objects, people, or ceremonies. In the so-called *Tavola Strozzi* [**155**], for example, the shield of the Aragonese king of Naples can be seen flying from every major fortress and gate in the city while the boats in the water bear his insignia and those of his respective captains. The incised background of Filarete's bronze doors of St Peter's was similarly covered with the family heraldry of the patron, Pope Eugenius IV, securing his memory as its sponsor [**114–115**]; purchasers of objects such as the Spanish lustreware jar illustrated in **97** would send drawings of the heraldry and family references which they wanted to display. At a banquet where all the silver, glass, ceramics, and even the clothing of the servants, were covered with such imagery there would be no questioning of the hosts' grandeur, wealth, and status (and no theft of the spoons).

Heraldry was remarkably lax in Italy, and individuals of modest background simply invented their own personal coats of arms. We have already seen the tension caused by the proliferation of armorials in sacred spaces (see p. 183). One story by the Florentine writer Franco Sacchetti (c.1330–1400) had the painter Giotto astounded by the pretensions of a lower-class citizen who had ordered an armorial shield. Obtaining the right to display or include the arms of a more noble or even royal family was, therefore, highly desirable. When Niccolò Acciaiuoli organized the construction of the Certosa of San Lorenzo outside Florence in 1354 he insisted that its interior be painted with the fleurs-de-lis of the royal house of Anjou and that they appear throughout his tomb. Similarly when Piero de' Medici was given the right to incorporate the French lily on his arms in 1465, he placed it in the very centre of his family's traditional coat of arms. Alongside these symbols of dynastic prestige, Italians used personal motifs, now known as

Jar with wing handles,
probably Manises ware,
Valencia, after 1465.

Lustreware such as this
jar was imported from Valencia
in large quantities. The
manufacturer would
have been sent the specific
coat of arms which were
to be included.

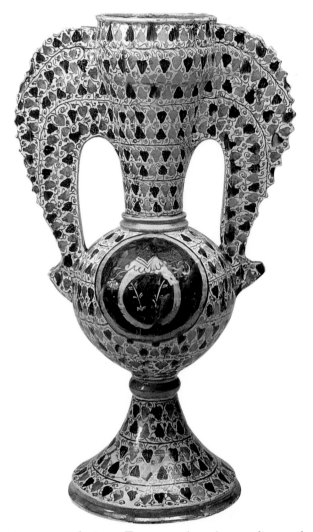

imprese or devices. For example, when a diamond ring and three feathers were added to the Medici arms, Florentine viewers knew that the place or object was related to Piero de' Medici in particular. Thus the diamond forms the keystone of the arch above Piero and his brother Giovanni's tomb in San Lorenzo while the ring and feathers provide the design on the marble surround itself [**13**]. The duke of Ferrara, Borso d'Este, used a wattle-fence, a unicorn, and a diamond ring as personal devices while the Gonzaga of Mantua and other aristocratic rulers gave artists an equally large range of motifs in order to signal their patronage or ownership of objects.

Accustomed to reading abstract heraldry and *imprese* for specific meaning, viewers had little difficulty in identifying other objects, such as animals or patron saints, as symbols of particular governments or families. The Milanese, for example, used the figure of St Ambrose, the Bolognese that of the local bishop St Petronius as representatives of

their cities. The Florentines had several ways of identifying the republic, including the lion associated with the Guelph party (the so-called *Marzocco*), as in the Donatello figure shown in **98**, or the classical figure of Hercules and, as we have already seen, the biblical hero David. In Venice and the Veneto, a winged lion acted as a symbol of that city's patron saint, the Evangelist Mark, while Siena and Rome were represented by sculptures and paintings of their supposed founders, the young infant twins Romulus and Remus, being suckled by the wolf. Neapolitans identified with the Greek goddess Parthenope while the Veronese used the figure of a Roman goddess, the Madonna Verona, for the same purpose, placing her ancient headless statue in their town centre.

The respect which was required for these images was equivalent to the respect called for national flags today. In the rare heavy snowfalls which occurred in Florence, for example, it seems to have been traditional to create civic symbols out of snow such as lions and figures of Hercules or David. During one harsh winter in 1355, someone destroyed the snow-lions which had been created in the city squares. This was not considered a minor prank and the government ordered a judge to begin an immediate investigation into the crime. An attack on the image of the state was equivalent to attacking the state itself. A description of the vandalism which took place in the Veneto after the Venetians lost control of some of the terra firma in the early sixteenth century makes this clear:

98 Donatello

Marzocco, sandstone (pietra di macigno), 1418.
Originally designed as the newel post for the stairs leading up to papal apartments in the monastery of Santa Maria Novella, the Florentine lion cradles the fleur-de-lis of France, a symbol of the city's Guelph allegiance.

All the cities of the Venetian state having rebelled . . . so many St Marks, that is the Venetian symbol, whether gilded, carved in stone, wood, or marble, and so many banners, in silk, gilded on every site, in the city, castle, on fortresses, villas, land, palaces, and, indeed, wherever they were to be found, were taken down . . . and broken and in some places the symbol of the winged lion, which signifies the Evangelist, which is called the St Mark, had its head cut off, in other places its eyes were gouged out, in other areas its wings were cut, and its skin and tail removed and even its testicles cut or gouged away.[2]

The close connection, which we have already seen in religious and allegorical imagery, between the person or concept being painted and the person or concept itself could also be used by governments to punish their enemies. When the criminal was absent he was executed (the pun is intended) in paint. These public images, known as *immagini infamanti*, depicted such unfortunates hanging upside down by one foot. In fourteenth-century Bologna these were painted in the main square, and on bordellos as a symbol of disgrace.[3] Although effective, such imagery was ambiguous, as it potentially shamed the city as well as the individual. In 1396 Milan's city statutes banned depictions on the town hall:

Since certain images are painted on the walls of the Palazzo Nuovo of the commune of Milan, representing false witnesses and corrupt notaries, merchants and money changers, and although they seem to be made for the purpose of confounding and defaming frauds, yet they disgrace and defame not only the authors of the deceits themselves, but also the whole city in the eyes of visitors and foreigners; for when the latter see these images, they imagine and are almost convinced that the majority of citizens can barely be trusted, and are involved in great falsehoods; and so it is decreed that all these pictures be removed, and that no one should be painted in future.[4]

By the mid-fifteenth century, Milan had shifted from illustrating financial shame to illustrating political shame, but the *immagini infamanti* were still in use. In 1458 Francesco Sforza threatened one preacher, Roberto da Lecce, that unless he returned to the city as promised to carry out his religious obligations, 'we will whitewash one side of our great hall and have you painted with your head hanging upside down . . . and [if] you arrive we will have you painted with your head up as a man of worth'.[5] His son, Ludovico Maria Sforza, was still using the formula in the late 1490s, when he placed *immagini infamanti* of his ex-military leader and enemy Gian Giacomo Trivulzio, then working for the French king, throughout Milan. The Florentines, too, continued to use this method of punishment *in absentia* during the quattrocento; Andrea del Castagno got the name *Andrea degli Impiccati*, 'Andrea of the Hanged Men', after painting the losing faction of the Albizzi family and their supporters in July 1440.

It was not enough to make these images highly realistic; inscriptions were also added to in order to fix the name and the crime of the ill-doer in the public eye. In Rome, under the guidance of Pope Pius II, the Curia devised ever more elaborate attacks on a disobedient vassal, the *condottiere* Sigismondo Pandolfo Malatesta (1417–68), which culminated in 1462 with his mock-trial and burning in effigy. It was important, the pope stressed in his memoirs, that the image of Malatesta was recognizable; it had to be made,

so exactly rendering the man's features and dress that it seemed him in person rather than an image. But lest anyone still be misled, an inscription issued from the mouth of the image, reading, 'I am Sigismondo Malatesta, son of Pandolfo, king of traitors, dangerous to God and men, condemned to fire by vote of the holy senate'.[6]

That the Papacy, the Florentine republic, and the Milanese dukes should have all agreed on very similar ways of expressing punishment and suggesting authority shows how cities with very different forms of government could share common assumptions about morality and the use of images. None the less, this is one case where regionality was very important. The same methods expressed different messages to different audiences; the prince did not make the same arguments as the republic.

The virtues of princely rulership

In a signorial dominion the lord was the law and the prince's own portrait could stand for the state itself. There were a few cases where this took place in very public arenas: two bronze statues of the Este lords of Ferrara, now lost, were erected in front of the cathedral in Ferrara in the 1440s, and after 1460 the profiles of ruling members of the Sforza and other prominent rulers were used regularly on coinage. However, these examples are exceptions and individualizing imagery was actually rather rare in public areas. Heraldry which suggested traditional values and family continuity was still preferred.

The personality of the prince himself was normally emphasized or illustrated for a much more carefully defined audience. For example, Gian Galeazzo Visconti, who became the first duke of Milan (after overthrowing and murdering his uncle Bernabò ten years before), commissioned an illuminated page in 1395 showing his ducal investiture [99]. The painter, Anovelo da Imbonate, tried to capture the ceremony as precisely as possible, including crucial details such as the two notaries carefully recording the legal passage of authority. As the frontispiece to the coronation mass used by the clergy of the ancient monastery of Sant'Ambrogio in Milan, the miniature would not have been examined with great frequency. It would have only been used during the investiture of successive dukes of Milan, reminding Gian

99 Anovelo da Imbonate

The Investiture of Gian
Galeazzo Visconti, Ambrosian
Missal, 1395, fo 7ᵛ.

Galeazzo's descendants of the rights of inheritance which he had established and acting as a warning for any priest who attempted to crown a usurper who was not of Visconti descent.

Created almost a century after the Visconti miniature, the painting of Federigo da Montefeltro and his son Guidobaldo [**100**] is not a portrait of an actual moment in time, but a visual exposition of similar values. Wearing the armour in which he made his military reputation and reading a large manuscript, Federigo is shown as both magnificent and wise, the exemplar of arms and of letters. Each element of the picture adds to this argument. The duke's ermine-edged cloak and the sceptre of his papal vicariate refer to the legality with which he held power. He wears the heavy gold and enamelled chain of the chivalric Order of the Ermine; around his calf we find the Order of the Garter, given to Federigo by King Edward IV of England in 1474. The young Guidobaldo acts as a page-boy, carrying the sceptre which he would inherit in due course. Appearing as a virtuous *signore*, one acknowledged by the kings of Europe, there is no hint of the fact that Federigo's accession in 1443 after his half-brother was assassinated was far from straightforward. Although its precise original location is debated, the painting probably hung in the ducal palace in Urbino, an environment where viewers, standing before such a vision of Montefeltro authority, would be unlikely to openly question the message of legitimacy.

Gian Galeazzo Visconti and Federigo da Montefeltro were only two of the many Italian *signori*, and aspiring *signori*, who were able to manipulate philosophical concepts of rulership to their advantage, blending traditional values to suit their particular political problems. Artistic and architectural commissions played an important role in this process, for such patronage expressed the princely virtue of magnificence. This was not a vague concept but a precise idea drawn from the work of the fourth-century BC Athenian philosopher Aristotle, an idea used in the mid-fourteenth century to justify the great palaces of the Visconti rulers. In neo-Aristotelian terms, the prince or wealthy individual had a duty to spend lavishly on appropriately grandiose works of art. As the Neapolitan humanist Giovanni Pontano wrote in 1498,

the magnificent man is made great through great expenditure. Thus the works of the magnificent man consist in illustrious palaces, in churches of excellent manufacture, in theatres, in porticoes, in streets, in sea-ports . . . But since magnificence consists in great expense it is necessary that the size of the object itself be sumptuous, and imposing, otherwise it will not justifiably excite either admiration or praise. And *la imponenza* [impressiveness], in turn, is obtained through ornamentation, the extent and the excellence of the material and the capacity of the work to last for a long time. Without art, in truth, nothing, whether large or small, will merit true praise. Thus if something is tawdry and lacking in ornament, or made in a low-cost

**100 Justus of Ghent
(also attributed to Pedro
Berruguete)**

The Duke of Urbino with
his Son and Heir Guidobaldo,
oil on panel, *c.*1476.

material which will not guarantee longevity, it truly cannot be great, nor should it be held to be so.[7]

It would be easy to supply a lengthy list of works of art commissioned in the Italian courts as samples of such princely magnificence; Pontano's own examples seem to be drawn from his experience of visiting and corresponding with Italy's leading families. This chapter will look at only two of the many possibilities, the courts in Naples and Milan, to consider how the concepts of legitimate rulership and grandiose expenditure went together.

Naples and the Regno

The Kingdom of Naples offers the chance to examine the creation of a myth of dynastic succession and imperial rulership, one modelled both on traditional European styles of royal patronage and on Italy's classical past. Thoroughly entwined with the international aristocracy of east-central and western Europe, its kings and queens were at the apex of the peninsula's secular hierarchy. By marriage and martial conquest, the city of Naples and its territories, the Regno, were successively claimed by the Angevin rulers of Provence, by their Hungarian relatives, the branch of Durazzo, and in the fifteenth century by the Aragonese kings who had, since a major revolt in Sicily in 1282 (the so-called Sicilian Vespers), been overlords of that island. Southern Italy was, therefore, not a territorial state, much less a nation. It was the possession of a crown, often a non-Italian crown, which required an image of rulership which reflected both the institutional nature of kingship (or queenship) and the personal qualities of the incumbent.

As a large and prosperous port city and trading centre, Naples provided the artistic community in the fourteenth- and fifteenth-century with strong links with the Mediterranean cities of Spain, Provence, and the Dalmatian and Albanian coastlines as well as with Flanders, Florence, and Genoa. Its rulers were able to import talent and works of art from considerable distances beginning with the arrival of Giotto and Simone Martini in the early fourteenth century to act as court painters. Tuscany also provided many of the stonemasons who established the Angevin tradition of tomb sculpture, one which emphasized genealogy, visualizing the lines of inheritance which had enabled each successive ruler to reach power.

Because such connections suggested continuity, Neapolitan rulers often referred directly or indirectly to the models provided by previous patrons rather than demanding the latest stylistic innovations. When the last direct male ruler, Robert of Anjou, died in 1342, for example, his wife and niece created the most monumental of the traditional Angevin memorials, a tomb which acted as the rood screen for the convent church of Santa Chiara [101]. Almost a century later, in the early

1420s, the Durazzo rulers of Naples (whose members had murdered the last Angevin queen in order to gain power) insisted on their descent from Robert by directly imitating this tomb. Queen Giovanna II erected her brother King Ladislas's monument as the rood screen of the Augustinian church of San Giovanni a Carbonara outside the city centre [102, 103]. Like the earlier trecento tomb, it is multi-tiered with numerous allegorical figures exalting royal virtues and piety, and portraying saints specifically connected to the Hungarian crown which Ladislas also claimed. The king himself was shown in three ways: as a seated ruler with the orb and sceptre, as a recumbent figure undergoing burial, and as a triumphant equestrian figure brandishing his sword at the congregation below. Giovanna, however, was more reticent, placing her own figure in regal garb to the side of her brother, and using Latin inscriptions to emphasize her fidelity to Ladislas's inheritance.

Although Giovanna and her court invested heavily in the rapid erection of this tomb, it served more as an expression of familial devotion and as a symbol of political standing than as an effective piece of widely seen propaganda. While work was under way, the queen, who was childless and in her fifties, invited Alfonso V, king of Aragon and of Sicily, to come to Naples from Barcelona as her heir-designate. But discovering that the young man was not willing to wait for her death before taking power, she and her circle forced the Catalan group from Naples and appointed Louis III of Anjou of Provence, as the next king. At Giovanna's death in 1435, Naples, by now used to female rulership, welcomed the wife of his heir, King René of Anjou, Isabelle of France, who took control of the city in her husband's name. When the alternative contender, Alfonso of Aragon, conquered the town in 1442 (supposedly climbing through the drains and entering via the city wells), the entire mode of celebratory rulership changed. Alfonso erased references to the French dynasty and asserted his own image as a successor to the imperial regimes of the Holy Roman Emperor Frederick II and even of the Roman Emperor Augustus himself. He carried coins of Augustus in a travelling case and placed busts of the emperors born in Spain, Trajan and Hadrian, on the stairs leading from his courtyard into the palace.

Yet these antique references could not entirely replace the traditional visions of rulership which had already been established by Alfonso's predecessors and rivals. Although it is very different in style, the most impressive memorial to the Aragonese reign, Alfonso's triumphal arch on Castelnuovo [104, 105, 106], has much in common with the tombs of the Angevin and Durazzo kings; a connection which would have been even stronger had the planned equestrian figure for it ever been executed. Here, however, the earlier ideals have been encased in a classical framework. The arch was designed as a permanent record of the triumphal entry which took place in 1443, fixing the moment of recon-

ciliation between the besieger and the besieged. Indeed, both the parade and the intended arch were financed and organized by the city itself.

Originally, the city had agreed to erect a free-standing arch in front of the cathedral in the city centre. But once under way, the location changed and the arch was eventually placed against the main entrance to the newly enlarged fortress, changing both its meaning and its audience. Instead of an offering from a grateful city it became a symbol of the division between the court and its urban surroundings, protecting the king from potential attack. We can see from the contemporary *Tavola Strozzi* how visitors arriving by boat would land at the busy quay leading up to the castle, thus avoiding the city altogether. They would be able to move up through outer gateways painted with

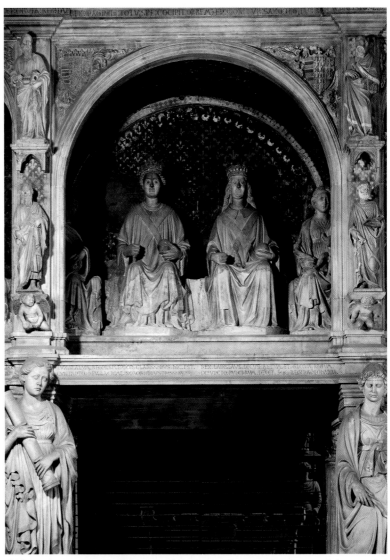

Alfonso's armorials and around to the well-protected rear of the citadel where the marble gateway stood. Walking through the arch, they would have seen marble panels in carved relief, showing armoured knights and fierce hounds—further reminders of the security with which the castle was guarded [**155**].

Alfonso's son Ferrante (1431–94) and his grandson Alfonso II (1448–95) did not complete the arch after his death. Although it has often been surmised that it would have either contained an equestrian figure or a tomb, Ferrante sent his father's body back to their family chapel in Aragon for burial, placed Alfonso's heart in a copper vessel which hung down over the arch, and concentrated on retaining his Italian kingdom. When Ferrante commissioned further work, it was a set of bronze doors for the castle gates [**107**]. These did not suggest a

104 Pisanello (attrib.)

Drawing for the Arch of Alfonso of Aragon, pen and ink, *c.*1449–50.

Arch of Alfonso of Aragon, Istrian marble, c.1450–60s, Castelnuovo, Naples.

Begun in 1445, the arch was still unfinished in 1452. Alfonso's chief supervisor of works was the Majorcan engineer Guillem Sagrera, who employed, amongst others, the sculptor Pere Johan, the Catalan son of a freed Greek slave. Pietro da Milano and Francesco Laurana came (via southern Italy) from the Istrian coast. Still others, such as Isaia da Pisa, were drawn from Rome or, like Pisanello, through court connections. In 1458 four sculptors, Isaia da Pisa, Pietro da Milano, Francesco Laurana, and Paolo Romano signed a contract agreeing 'to carve completely the figures of the triumphal arch of the said Castel Nuovo,' but the work was still unfinished at the King's death.

happy union between ruler and subject but illustrated instead his survival after rebellion and assassination attempts, a very visible reminder, and warning, that the barons who had attacked him were either dead or imprisoned in the castle itself. Art did not have to be charming or cheerful in order to be effective.

Milan and Lombardy

Kingship was rare in the Italian peninsula, and Milan, the second largest city in Italy and the capital of the Western Roman Empire in the fourth century, had a very different legal and political heritage from that of Naples, as well as a significantly different visual culture. An imperial fiefdom, Milan had become an independent commune in the thirteenth century. Lacking a sea-port, its artistic traditions placed greater emphasis on the employment of stonemasons drawn from towns in the nearby Alps and northern lakes. But the loose boundaries between what was defined as France, Germany, and Lombardy ensured regular exchange of artistic traditions and employment.

By the early trecento Milan had come under signorial rulership, with members of the Visconti dynasty contending for positions of

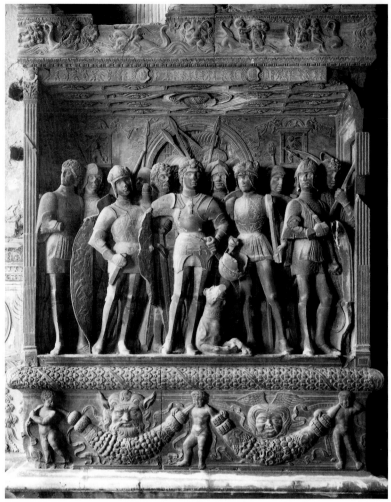

power. In 1354 two young members of the family, Galeazzo II and Bernabò, succeeded to the lordship of Milan, dividing the family's dominions between themselves and embarking on a campaign of territorial expansion. Bernabò, in particular, was an effective military commander and administrator, developing strategies for financing and recruiting mercenary armies. Unlike the Neapolitan kings and queens who illustrated their rights of inheritance in tombs and manuscripts, Bernabò ignored the need for institutional legitimation, developing instead an image of personal virtue and frightening ferocity. His one major surviving commission is a life-size equestrian statue in polychrome marble attributed to the Lombard sculptor Bonino da Campione [**108**].

As we have already seen, the equestrian figure had long-standing connotations of leadership going back to classical antiquity. There had been other secular statues of riders created in the trecento: Bernabò's in-laws, the della Scala family of Verona, used them on their tombs

Gates to the Fortress of
Castelnuovo, bronze, 1474–84,
Palazzo Reale, Naples.

A cannon-ball from the siege
of Naples in 1495 can still be
seen embedded within the
lower left-hand panel.

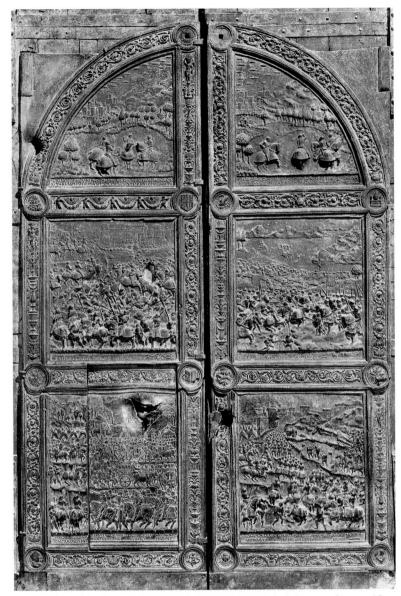

while his uncle, Azzo Visconti, had placed a gilded figure of himself on
the campanile of the cathedral in the 1330s. But the scale and position
of the Milanese figure was unusual. This enormous piece originally
stood directly on the high altar of Bernabò's private chapel in his palace
in Milan, a breach of religious decorum that could only have been
achieved by someone in complete authority. Supported by allegorical
figures of Fortitude and Justice, whose garments were painted with
Bernabò's personal *imprese*, it was once entirely painted and gilded.
After his murder in 1386, the monument was eventually used to sur-
mount his tomb. The statue remained in his palace chapel, but moving
the horse from the high altar to a tomb entirely changed the viewer's

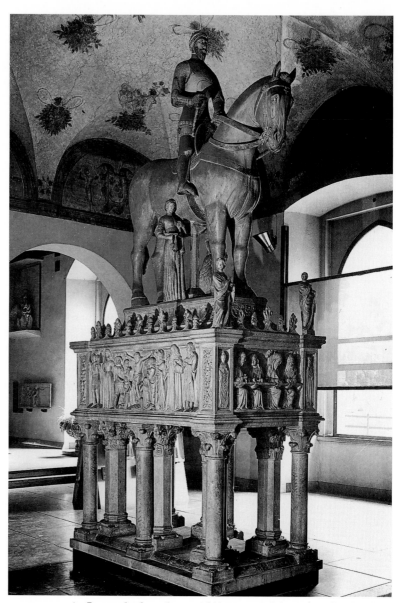

108 Bonino da Campione

Monument and tomb of
Bernabò Visconti,
polychromed marble, *c.*1363.

response to it. Instead of an almost idolatrous celebration of individual achievement, it became a record of past greatness.

The equestrian statue remained an important emblem serving, like the Neapolitan tombs, as a point of reference for later patronage. Just over a century later, another dynasty of Milanese rulers, the Sforza, decided to make their connections with their Visconti predecessors clear in just this fashion, by commissioning a monument to the founder of the family's fortunes, Francesco Sforza. Francesco was the most spectacularly successful of Renaissance *condottieri*. To ensure his loyalty, the third duke of Milan, Gian Galeazzo's son Filippo Maria Visconti, had reluctantly married his illegitimate daughter Bianca

Maria to the soldier. But the would-be duke of Milan had had to besiege his citizens, forcing their surrender in the winter of 1449–50. With the help of Medici funds, Francesco then consolidated his power, enabling his son Galeazzo Maria to have an easy succession on his death in 1466.

Cosimo de' Medici and his sons frequently took advantage of the prestige of Florentine artists to integrate themselves more firmly with Italy's rulers, acting as cultural intermediaries by offering advice on the choice of painter, sculptor, or architect and by sending samples of their work to Italian rulers. It is not surprising, therefore, that soon after Sforza's death, Piero de' Medici promised his widow that he would find a sculptor capable of creating a suitable tomb.

Meanwhile, however, Francesco was buried according to the fashion of his Visconti predecessor. His body was placed in a simple coffin and hung next to the sepulchre of Filippo Maria, a simple but much more effective evocation of legitimate sucession than any elaborate Florentine marble design. Seven years later, however, Duke Galeazzo Maria, concerned by the military threat posed by the Venetian *condottiere* Bartolomeo Colleoni of Bergamo (who was himself planning an equestrian monument to be erected in Venice), decided to revive memories of his father's warrior-like abilities. Like the erection of a tomb, creating a statue of his ancestor would be an effective way both of appearing filial and of reminding viewers of his own standing. Galeazzo Maria clearly had the bronze statue of Gattamelata created by Donatello in Padua and a similar version of Duke Niccolò d'Este, erected by the sculptor Niccolò Baroncelli (active 1434–d. 1453) in Ferrara, in mind when he told his commissioner of ducal works,

Because we wish to have the image of our illustrious lord, our father of well-loved memory, created in bronze on a horse and to place it somewhere on our castle of Milan, either on the drawbridge facing the square or somewhere else where it will look well, we wish you to search throughout our city to find a master who would know how to do such a work and to create it in metal, and if such a master cannot be found in our city . . . to search in Rome, Florence, and all the other cities where an excellent master capable of creating such a work might be found.[8]

But the task was not so simple. Donatello was dead and the goldsmiths of Milan were only interested in creating the appearance of a large bronze by making a wooden core on which they could nail metal sheets. But although the project remained dormant, enquiries clearly had been made in Florence and elsewhere, sparking artists such as Leonardo da Vinci to volunteer their services. In the early 1480s the young Florentine offered, amongst many other services, 'to begin work on the bronze horse, which will bring immortal glory and eternal honour to the happy memory of the Lord, and to the entire house of

109 Leonardo da Vinci

Sketch for the Mould for the
Monument to Francesco
Sforza, Madrid, Bibl. Nac.

Sforza,' conventional words which, none the less, expressed the full purpose of the project [**109**, **110**].

Leonardo, who had trained in the shop of Andrea del Verrocchio, the sculptor eventually responsible for the bronze Colleoni monument, clearly hoped that his potential patron would see the benefits of reviving the piece. The letter was written to Francesco's younger son Ludovico Maria Sforza, known as 'il Moro', who had taken charge after Galeazzo Maria had been assassinated in 1476 by three irate courtiers (he had seduced the sister of one, stolen the lands of another, while the third seems to have genuinely believed in the return of Milan's republican liberty). In theory, Ludovico was the guardian and

regent of the true duke, then still a child. But he was already embarking on a number of projects designed to enhance his own prestige and position within the city. Although Leonardo was already in Milan, 'il Moro' turned back to Lorenzo de' Medici for further advice. Neither man seems to have trusted the Florentine's abilities as a bronze-caster; in July 1489 the Florentine ambassador was open that, 'although he has commissioned this object from Leonardo da Vinci, I do not think he is very confident that he [i.e. Leonardo] knows how to carry it out'.

But Lorenzo de' Medici, who had already recommended Antonio Pollaiuolo to the pope for the bronze tomb of Pope Sixtus IV in Rome, had no further names to pass on. Leonardo began his own campaign to regain the commission, asking humanist friends to compose poems in honour of the statue and its sculptor which were sent on to Ludovico and his advisers. In 1490 he was rewarded for his efforts and work began again. A larger-than-life terracotta model of the horse, without its rider, was exhibited for the wedding of Bianca Maria Sforza to the Emperor Maximilian in 1493 while Leonardo was still trying to work out the logistics of transforming it into bronze. Only a year later, however, Ludovico gave up on the project altogether, passing on the copper destined for the horse to Duke Ercole d'Este of Ferrara to cast a cannon. As the French invasion of Italy began, weapons, rather than images of military virtue, seemed a more effective means of maintaining political authority.

In 1499 the French troops used the terracotta model for target prac-

110 Leonardo da Vinci
Study for the Monument to Francesco Sforza, silverpoint, c.1485–9, Royal Library, Windsor.

Naples

Robert of Anjou, 1309–43
 marries Sancia of Majorca
Giovanna I of Anjou, 1343–81
 marries (1) Andrew of Hungary
 marries (2) Luigi, Prince of Taranto
 marries (3) Otto of Brunswick
Carlo III of Durazzo, 1381–6
Louis II of Anjou, 1386–1400
Ladislas of Durazzo, 1400–14
Giovanna II of Anjou-Durazzo, 1414–35
Alfonso I (Alfonso V of Aragon),
 1396–1458
 King of Aragon, 1416–58
 King of Sicily, 1416–58
 King of Naples, 1442–58
Ferdinand I (Ferrante), c.1431–94
 King of Naples, 1458–94
 marries (1) Isabelle of Clermont,
 d. 1465
 marries (2) Giovanna of Aragon,
 d. 1517
Alfonso II, 1448–95
 King of Naples, 1494–5
 marries Ippolita Maria Sforza, d. 1488
 daughter Isabella (1470–1524) marries
 Gian Galeazzo Maria Sforza in 1490
Federico (brother of Alfonso II) (d. 1504)
 King of Naples, 1496–1501
Ferdinand II (son of Alfonso II) (d. 1496)
 King of Naples, January–February
 1495 and July 1495–October 1496
 marries Giovanna of Aragon

Milan

Archbishop Giovanni Visconti,
 1290–1354
 Lord of Milan (with brother
 Luchino), 1339–49
 Lord of Milan (alone), 1349–54
Matteo II (c.1319–55), Bernabò (1323–85),
 Galeazzo II (d. 1378)
 Joint rulers of Milan from 1354 until
 respective deaths
Gian Galeazzo, 1351–1402
 Lord of Milan, 1378–95
 Duke of Milan, 1395–1402
 marries (1) Isabelle de Valois, d. 1372
 marries (2) Caterina di Bernabò
 Visconti, d. 1404

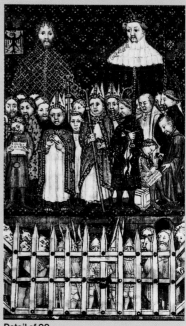

Detail of 99

Giovanni Maria, 1388–1412
 Duke of Milan, 1402–12
 (assassinated)
 marries Antonia da Malatesta
Filippo Maria, 1392–1447
 Duke of Milan, 1412–47
 marries (1) Beatrice della Tenda,
 d. 1418 (accused of adultery and
 beheaded)
 marries (2) Maria di Savoia, d. 1469
 daughter Bianca Maria, d. 1468, born
 to mistress Agnese del Maino,
 marries Francesco Sforza
Francesco I Sforza, 1401–66
 Duke of Milan, 1450–66
Galeazzo Maria, 1444–76
 Duke of Milan, 1466–76
 (assassinated)
 marries Bona di Savoia, d. 1503
Gian Galeazzo Maria, 1469–94
 Duke of Milan, 1476–94
 marries Isabella of Aragon, d. 1524
Ludovico Maria 'il Moro', 1452–1508
 Duke of Bari (1479–1508) and regent
 (1480–94) of the duchy of Milan
 Duke of Milan, 1494–9 marries
 Beatrice d'Este, d. 1497.

tice and Leonardo reworked his ideas in the early sixteenth century to propose an equestrian statue honouring their captain, Gian Giacomo Trivulzio. Yet although it was a failure, the length of time and energy invested in the project reveal how important such images could be in the Italian courts. In a competitive environment, there was pressure to create what one's allies and rivals were able to illustrate: the glory and honour of one's house.

Women in authority

Whether presented as a military leader on horseback or as an anointed ruler, the image of the good ruler was resolutely masculine. But there were moments when such iconography had to be adapted to accommodate female authority. When the last Angevin king of Naples, Robert the Wise, died in 1342, for example, he arranged for the controversial coronation of his granddaughter Giovanna I, indicating that she should then be succeeded by her sister Maria. Giovanna I became queen at the age of 16 under the tutelage of her aunt, Queen Sancia of Majorca, and one of their first acts was to commission the already-mentioned tomb of Robert which illustrated Giovanna's special position. Despite the appearance of Robert's two wives and their numerous children on the sarcophagus, the only figures shown who were still alive in 1342 were Sancia, Giovanna, and her sister, a deliberate exposition of why (despite the fact that Naples followed French Salic law which said women could not inherit the throne) a woman had been permitted to become queen. When the Durazzo queen, Giovanna II, placed herself, dressed in regal robes and carrying the orb and sceptre, next to her brother on his tomb she was offering the same message of legitimate succession. These claims were problematic; although courtiers, poets and artists praised the two queens for their virtues, female rulership was regarded as inherently dangerous and unstable, inviting challenges from pretenders to the throne. Giovanna's three husbands all tried to govern the country in their own name rather than acting as her consort and she was eventually murdered in 1383. Although she died naturally, Giovanna II was also under constant threat from her male associates.

If attitudes towards female rulers were ambivalent, writers and artists were on more secure ground when considering women as powerful spouses or regents. The lady of the court had her own income and entourage and was often able to offer substantial literary and artistic patronage. Scholars are now discovering a remarkable range of élite court women who were responsible for the construction and support of monasteries, nunneries, chapels, altarpieces, manuscripts, and tapestries. For example, Bernabò Visconti's wife Regina della Scala (d. 1384) and their daughter Caterina (d. 1404) (who eventually became duchess of Milan) sponsored or supported numerous churches and chapels including the cathedral of

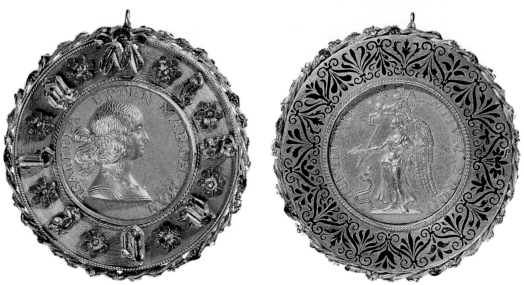

111 Gian Cristoforo Romano
Medal of Isabella d'Este, gold,
diamonds, and enamel, 1498:
(obverse and reverse).

Milan; in 1378 the wife of the lord of Padua, Fina Buzzacarina, bequeathed her silver and clothing to fund the decoration of the baptistery where she and her husband were buried. Even in republican Florence, the wives of the Medici party leaders now appear to have taken a much more active role than was previously assumed.

But in creating a list of names of women who were important four-teenth- and fifteenth-century patrons and figures of authority, we need to consider the conventions and constraints within which such efforts took place. The intention of and responses to female patrons were not the same as those of their male counterparts. Attitudes towards women in general will be considered in more detail in Chapter 9; here it is enough to observe that there was potential conflict between the public exercise and display of power and wealth, and the modesty, silence, and obedience expected from most women. There was, therefore, a precise decorum which governed the behaviour of women in the Italian courts. While *signori* were admired for their virility, strength, and daring, their wives were praised for their piety, learning, virginity or chastity, and their fidelity to fathers, husbands, and children.

Tales of exemplary women, such as those written by Giovanni Boccaccio in the fourteenth century, gave specific cases of acceptable behaviour. By the late fifteenth century such tales had become increas-ingly popular and the genre was used by writers such as the Bolognese Sabadino degli Arienti (*c.*1445–1510), to exalt court ladies or to suggest, in a highly rhetorical fashion, that women were actually superior to men. The models suggested included mythological women such as Amazonian queens, classical figures such as Lucretia (who committed suicide after the disgrace of her rape by the Roman tyrant Tarquin), and Old Testament heroines such as Judith who seduced and killed the Philistine commander Holofernes to save her people. The images of these women were included in painted as well as literary cycles of

heroes and heroines, such as that which survives in the Castello di Manta near Saluzzo [**151**].

These figures from the past provided the frame within which contemporary women were praised or villified. The best-known example of a female court patron was Isabella d'Este, marchioness of Mantua. Determined to be remembered for her chastity and marital fidelity, her private rooms in Mantua included scenes such as the battle between virtue and vice and figures of Roman ladies who had preserved their reputation and their virginity. But while Isabella was very careful to work within the established expectations of female rulership, carrying out the expected pious activities, supporting the canonization of local saints, and promoting churches and monastic institutions, she was unusual for a number of reasons. She began to compete in the very public world of the newly emerging market for antiques, a topic which will be covered in more detail in Chapter 8. Even more unusually for an aristocratic spouse, Isabella began to control her own contemporary and posthumous reputation. She prodded or paid poets and writers to dedicate their works to her, encouraged literary testimonies to her beauty and wisdom, and carefully monitored her visual appearance. She had unflattering drawings and paintings destroyed, and in her middle years arranged to have any new portraits based on images of her younger self. Those of which she approved, such as the medal cast by Gian Cristoforo Romano in 1498 [**111**], were circulated to potential allies and admirers.

With several thousand documents which record her life and the numerous works which she commissioned, Isabella d'Este is at one extreme of the image of female authority. At the other extreme are the many women for whom only the slightest of evidence remains. While references survive for the Italian courts which had a very specific public role which élite women were expected to undertake, the communal governments of Italy refused women such prominence. Women were not expected, and were often forbidden, to enter town halls and when Fra Girolamo Savonarola tried to reinstate a genuine republic in Florence, his first acts included preventing women from taking part in public processions and forbidding their attendance at sermons which touched on matters of state. As we move on to examine the patronage and imagery of the Papacy and the Italian republics, women will only feature in public imagery as allegorical figures, an exclusion which was part of the image of good government itself.

Rome and the Republics

If Italy's princes needed to celebrate their lineage and special prowess, civic governments and the Papacy needed to elevate institutions as well as individuals. Thus while the *signori* searched for their models in the stories and images of Roman emperors and military heroes, communal governments, such as Siena, Florence, and Venice, found their heritage in the Roman Republic.

Rome, however, was not just the centre of Italy's classical past; it was also the bishopric of the successors of St Peter, the popes, and the centre of Western Christendom [**112**]. By the mid-trecento, however, the city had become a symbol of decay, full of monuments which inspired laments about the transience of fortune. Once its walls had held one million inhabitants, by 1400 only 17,000 clustered near the River Tiber. The Coliseum, the Baths of Caracalla, Trajan's Column, the pyramidal tombs thought to be of Romulus and Remus, and the equestrian monument and triumphal arch of the Christian Emperor Constantine stood out amongst the squalor of Rome's abandonment. Artists such as Ghiberti, Donatello, Brunelleschi, and Pisanello carefully observed these ruins; collectors purchased and exchanged coins, medals, and statuary, but little was done to actually preserve the city itself.

During the fourteenth century many of the city's problems stemmed from the transfer of the papal court to Avignon in 1309 and the Great Schism which lasted from 1378 to 1417. There would not be a single head of the Church in Rome until Martin V, a member of the powerful Roman Colonna family, was elected in 1417 and arrived in Rome in 1420; even then his immediate successor, the Venetian Pope Eugenius IV, was forced to leave the city for over a decade in 1433 and still found himself confronting an anti-pope, Felix V, in 1439.

Problems of residency were minor compared to the other threats facing the Papacy during the first half of the fifteenth century. There were serious heretical movements such as the Lollards in England and the Hussites in Bohemia while the College of cardinals, popes, anti-popes, and secular rulers alike convoked councils such as that of Constance (1414–18) and Basle (1431–49) in order to argue for major ecclesiastical reform. To combat these attacks, the Papacy spent much

Detail of 132

112 Taddeo di Bartolo

Map of Rome, fresco, 1413–14, Palazzo Pubblico, Siena.

Designed as part of a commission to depict a series of allegorical virtues, Roman heroes, and gods, these images in the corridor flanking the chapel used by government officials were explicit in their classical references. An inscription, in Italian, made the connection clear, reading in part, 'Take Rome as your example if you want to rule a thousand years, follow the common good, and not selfish ends.'

of the second half of the quattrocento in reasserting its spiritual and temporal authority. Building and embellishment were an important part of this attempt, for the signorial virtue of magnificence was as important for the Church as it had been for Italy's princes. Rituals such as the bestowal of the golden rose on Europe's ruling families and cities were one way of stressing the importance of the Papacy [18]. Improving Rome's physical appearance and ornamenting significant buildings, such as the Vatican, St Peter's, and St John Lateran, were another.

Given the prestige of papal commissions and the opportunities to explore classical ruins, Rome eventually became a ritual destination for artists as well as pilgrims. But initially, artists were loath to stay for lengthy periods of time in this small, impoverished, often disease-ridden town. Although the Papacy could call upon the most renowned of European artists, Rome itself had few painters, sculptors, or gold-smiths of great renown, relying instead on migration to fill its needs. Generations of popes and cardinals invited artists from abroad who were in turn exposed to the city's antiquities and to each other's work. Martin V (Ottone Colonna, reigned 1417–31) asked painters both from the northern courts and from Florence and northern Italy. In 1427 Gentile da Fabriano (active c.1390–d. 1427) and his one-time pupil Pisanello were given the prestigious task of decorating the central nave

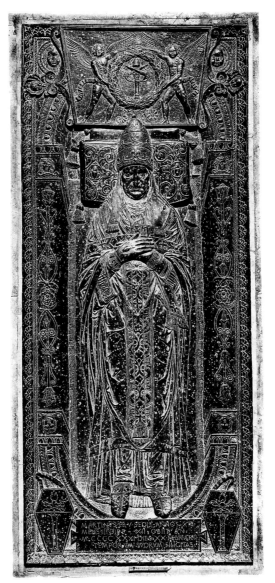

of the St John Lateran with a cycle of scenes from the life of St John the Baptist. In 1428 the Florentine painters Masaccio and Masolino were asked to provide an altarpiece for the Colonna family chapel in the important basilica of Santa Maria Maggiore. Martin V's own bronze tomb was designed and cast in Florence in the mid–1440s before being shipped to the city [113].[1]

The connections between Florence and Rome were crucial to the Medici bank which managed papal finances.[2] In the early part of the century Cosimo de' Medici had supported the anti-pope John XXIII's claim to the papal throne, acted as the executor of his will, and arranged for the erection of his monumental marble and bronze tomb in the Florentine baptistery [44]. When Martin V's successor

**114 Filarete
(Antonio Averlino)**

Doors to the Basilica of St
Peter's, bronze and enamel,
1433–45, Basilica of St
Peter's Rome.

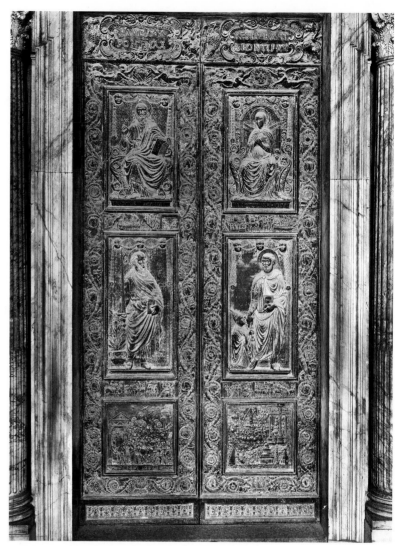

Eugenius IV (Gabriel Condulmer, reigned 1431–47), was forced from
Rome in 1433 he took up residence in Florence for part of his period of
exile. But although the Curia was absent from Rome until 1445, papal
patronage did continue, eventually resulting in Eugenius's most
important commission, the bronze doors for the basilica of St Peter,
which were executed under the supervision of the papal representatives
and the humanists of the Curia who remained in the city.

Plans for the new doors dated back to about 1432, when the Council
of Basle was claiming spiritual superiority over the pontiff. A previ-
ously little-known bronze sculptor (one trained perhaps by Donatello),
Antonio Averlino, il Filarete, was chosen to lead the project [**114, 115**]
and seems to have arrived in Rome in 1433. During this period the city
was governed by the bishop-cardinal Giovanni Vitelleschi, whose own
imperial ambitions were quickly manifested. In 1436, for example, he

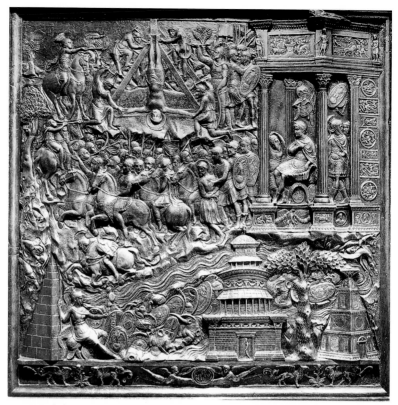

arranged for the Roman senate to erect a marble equestrian statue to himself on the Campidoglio which was inscribed with a plaque comparing him to the city's founder Romulus. Concern for Vitelleschi's plans meant that he was captured and killed in 1440 by the loyal castellan of the papal fortress Antonio Rido (whose portrait was included in the bronze doors). The city was placed under the dominion of another military cardinal, Ludovico Scarampo Mezzarotta, and the pope's own nephew, Pietro Barbo (the future Paul II), both of whom seem to have been highly influential in Filarete's career. Barbo, as we have seen, was already a collector of coins and gems, and several of his pieces were probably used as examples for the classical motifs in the doors. Yet despite the conflict amongst the various supervisors such as Vitelleschi and Pietro Barbo, the overall message of the doors remained the same: Pope Eugenius was the divinely ordained successor to St Peter who had succeeded in uniting the Church.

The courts of cardinals

The commission was typical of papal patronage in that it was accomplished under the supervision of papal relatives and managed both to support the institution of the Church, and, by inscribing the Condulmer arms throughout the panels, to ensure the continuation and prestige of the family name. It was no accident that Pietro Barbo

was able to become pope himself as Paul II. Papal tombs, such as that of Martin V, were also the responsibility of these potential successors, who, like Barbo, were often nephews who had managed to achieve a cardinal's hat with the help of their newly elevated relative.

This promotion gave access to curial power in Rome and the prospect of papal election itself. And as the Papacy grew more secure in Italy, Rome profited out of all proportion from the resulting conglomeration of wealthy households. Cardinals were expected to live in a relatively lavish fashion, supporting a retinue which seems to have numbered, in the case of Cardinal Francesco Gonzaga, between sixty and eighty members, but could go well into the hundreds.[3] Increasingly, Rome became the centre for the display of international wealth and standing, providing numerous opportunities for artists who were called upon to display their virtuosity. In the 1480s, for example, Mantegna argued that he worked in the city in order to enhance his reputation rather than for any monetary profit. The discovery, collection and display of antiquities was also gathering pace within the city, reinforcing relationships between dealers and collectors in and outside Rome. These connections brought contemporary artists capable of imitating the *all'antica* style to their attention. In the mid 1490s, for example, the young Florentine sculptor Michelangelo Buonarroti

Popes and anti-popes

1342–52	Clement VI (Pierre Roger de Beaufort)
1352–62	Innocent VI (Étienne d'Aubert)
1362–70	Urban V (Guillaume de Grimoard)
1370–8	Gregory XI (Pierre Roger de Beaufort)

The Great Schism 1378–1417

	Popes		Anti-popes
1378–89	Urban VI (Bartolomeo Prignano)	1378–94	Clement VII (Robert of Geneva)
1389–1404	Boniface IX (Pietro Tomacelli)	1394–1415	Benedict XIII (Pedro de Luna)
1404–6	Innocent VII (Cosimo de' Migliolati)	1409–10	Alexander V (Pietro Filargo)
1406–15	Gregory XII (Angelo Correr)	1410–15	John XXIII (Baldassare Cossa)

1417–31	Martin V (Oddo Colonna)
1431–47	Eugenius IV (Gabriel Condulmer)
1447–55	Nicholas V (Tommaso Parentucelli)
1455–8	Calixtus III (Alfonso Borgia)
1458–64	Pius II (Aeneas Silvius Piccolomini)
1464–71	Paul II (Pietro Barbo)
1471–84	Sixtus IV (Francesco della Rovere)
1484–92	Innocent VIII (Giovanni Battista Cibo)
1492–1503	Alexander VI (Rodrigo Borgia)

Detail of 30

came to Rome to serve Cardinal Pietro Riario, for whom he created the figure of a drunken Bacchus [**116**] which eventually ended up in the collection of the antiquarian and humanist collector Jacopo Galli. In 1497 the latter acted as Michelangelo's intermediary and guarantor for an important new commission, the Pietà [**117**], which was produced in the basilica of St Peter's for the funerary chapel of the French ambassador, Cardinal Jean de Bilhères de Lagraulas. Given its position in Christendom's most important church the young sculptor could expect his international reputation to increase accordingly, and to ensure that viewers, and potential customers, knew who was responsible for the work, he carefully carved his name into the Virgin's sash.[4]

The Tuscan republics

To the north and west of the Papal States lay the independent cities of Tuscany such as Siena, Pisa, Lucca, Pistoia, and Florence which had claimed communal independence from both papal and imperial control. Like almost every Italian city, these Tuscan republics considered themselves to be the daughter of Rome, the true heir to the ancient republic. They all attempted, in different ways, to prevent any single faction, family, or individual from dominating the city, relying instead on some form of rotating senior magistracy composed of leaders drawn

116 Michelangelo Buonarroti

Bacchus, Carrarese marble, 1496.

Michelangelo's correspondence seems to suggest that the Bacchus was originally begun in 1496 for Cardinal Pietro Riario but was then either rejected or sold soon after it was delivered. In the 1530s it was recorded in the garden of antiquities belonging to one of Michelangelo's friends and sponsors, Jacopo Galli.

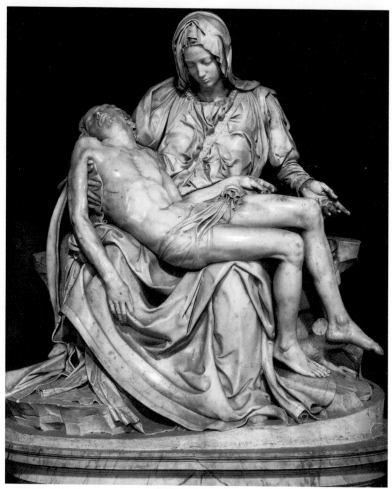

117 Michelangelo Buonarroti
Pietà, Carrarese marble,
1498–1500, basilica of St
Peter's, Rome.
Jacopo Galli acted as the
guarantor for this piece,
promising the French cardinal
Jean de Bilhères de Lagraulas
that his young protegé would
produce 'the most beautiful
work in marble which there is
today in Rome'.

from a small circle of eligible men who served for a short period of time, usually between two and six months. In addition a foreigner, that is someone who was not native to the town, would be invited to act for a year as the town's main judge, the *podestà*.

These systems were not exclusively republican. Naples, Milan, and Mantua, for example, also employed municipal magistracies and a *podestà*. But the rhetoric employed by Italy's republics was often decidedly anti-signorial, encouraging citizens to oppose the rule of a single individual, the tyrant. In the widely adopted language of political theorists such as the early fourteenth-century writer Marsilius of Padua (1275/80–pre-1343), the ideal commune was governed for the common good, not for private benefit. However, this rhetoric, articulated visually as well as verbally, was not easily put into practice. There was a multiplicity of political transitions during the quattrocento and a constant harking-back to earlier periods of good government, so-called golden ages. Thus the greatest innovations were often achieved in the name of a return to the past.

Siena

Quattrocento Siena looked back with nostalgia to a moment of stability lasting from the late thirteenth century to 1355, when the city had been ruled by the magistracy of the Nine, a rotating group of nine men chosen from a small group of eligible citizens. This earlier government had built the town hall, begun the cathedral, supported the hospital, and commissioned artists such as Duccio di Buoninsegna, Simone Martini, and Ambrogio Lorenzetti to create major monuments in a style which appeared, to later eyes, to be distinctly Sienese. When fifteenth-century Sienese artists such as Sassetta, Giovanni di Paolo, Sano di Pietro, and Neroccio de' Landi emphasized limpid clear colours, heavy gilding, and complex narrative traditions, they were deliberately referring to their fourteenth-century heritage rather than to more recent Florentine styles.

The Black Death of 1348, and earlier banking failures, had erased much of the artistic community and caused social disjunctions which resulted in revolts against the Nine in 1355. Threatened by internal disorder and by Florentine expansionism, Siena finally placed itself under the protection of the Visconti duke of Milan from 1399 to 1404. After the death of Gian Galeazzo Visconti and the collapse of his territorial state, Siena returned to its system of a rotating magistracy whose membership was chosen from a small number of eligible families. Concerned by Florentine ambitions, this new government made constant references to the earlier period of stability and prosperity. In 1447, for example, the magistrates commissioned a set of tapestries modelled on the frescos of Good and Bad Government painted in the town hall in 1337–9 by Ambrogio Lorenzetti. The Flemish weaver Jacquet d'Arras (documented 1440–56) was asked to create

three cloths of Arras . . . the said tapestries should be made beautifully, honourably, and ornately as the honour of the town hall requires that they should be an excellent work, as this most noble fantasy deserves . . . the form and design of these cloths should be as follows, the Good Government of the Prince with the prince in the centre. Then they should do that of Peace and then that of War . . . all the faces of the figures of these hangings should be made by the hand of Mr Giachetto and not by others.[5]

The finished pieces, executed at a cost of 3,509 lire, were used in both the meeting-hall and on the external dais where officials sat to observe public ceremonies, evocations of the continuity of Siena's fourteenth-century communal values.

The republican magistrates were not content to imitate, they also adapted the earlier programmes of civic development, taking a decision in 1406 to replace the city's central fountain. This was an initiative which would mark the town's financial stability and its ability to provide the most precious commodity of all, water. Without a nearby river

or lake, Siena relied on underground canals to channel rainwater into the city's wells. Jacopo della Quercia submitted a number of designs which went through considerable discussion and modification. The resulting iconography has been the focus of much controversy but it now appears that the fountain was meant to illustrate a combination of classical figures with civic resonance, such as the mother Rhea Silvia and the foster-mother Acca Larentia of Romulus and Remus, the twins who were believed to have founded the city, as well as having the more conventional figures of allegorical virtues and the Virgin Mary [**118, 119**]. The most impressive aspect of the commission was, however, not its iconography but the investment required to clear and repair the roads which brought the marble and other materials to the town centre and the complex engineering work required to bring water up a slope [**120**].[6] A city which could achieve this, would be able to fight off its greatest enemy, its neighbour, the republic of Florence.

Florence

Despite their historical antagonism, Florence's and Siena's institutions and artistic patronage exemplified similar values. Compared to other Tuscan towns, however, Florence was very unusual in several respects. Its republican government, first established in the late thirteenth century, was restricted to members of its guilds, particularly the seven major guilds or *arti* which regulated businesses such as banking and the cloth, wool, silk, fur, and spice trades. They provided the legislature

119 Jacopo della Quercia
Right Side of a Design for the Fonte Gaia in Siena, pen and ink and sepia wash on vellum on parchment, 1409, Dyce 181, Victoria and Albert Museum, London.

and a rotating magistracy, the *signoria*, composed of eight men and a leader, the *gonfaloniere di giustizia*, who were chosen by lot and served a two-month term of office. The *signoria* in turn redelegated many public responsibilities to the same guilds. Thus care for the baptistery was in the hands of the cloth merchants, the Calimala, while the wool merchants' guild, the Lana, was responsible for the cathedral.

By restricting the political élite to the mercantile patriciate, the Florentines hoped to create a stable community with shared values, but in fact Florentine politics in the trecento were eventually characterized by instability and precariousness. The failures of the city's major bankers, the Bardi and Peruzzi, in the early 1340s and the plague which followed soon after in 1348 only go some way towards explaining this. The instability had already led to a brief flirtation with princely rule when Walter of Brienne, the duke of Athens, ruled for a year between 1342 and 1343. He was expelled after charges of tyranny and, more importantly, after he had attempted to place lower-class artisans on government bodies. His expulsion did not resolve the internal tensions and divisions. During the so-called War of the Eight Saints from 1375–8, which pitted the city against Pope Gregory XI, a traditional system for avoiding time-consuming debate and discussion was used, the *balìa*, whereby full authority for the war was delegated to a small committee of eight men. Even during times of peace, however, the republic's guild-based structure excluded most workers and the so-called revolt of the Ciompi in the summer of 1378 brought fears of

120 Jacopo della Quercia

Fonte Gaia, Campo, Siena, original installed 1419, copy installed 1858.

This photograph shows the almost-ruined fragments of the fountain before it was replaced by a late nineteenth-century copy. The reliefs illustrate the Creation of Adam and the Expulsion from Paradise, the Virgin and Child, and allegorical figures of the theological and cardinal virtues. The free-standing figures of the two women may be further, as yet unidentified, allegories, perhaps Charity, but are more traditionally identified as the mother and foster-mother of Romulus and Remus, the Roman twins who were the mythical founders of the city of Siena.

complete social uprising. As one chronicler remarked, had they succeeded, 'Every good citizen would have been chased out of his home, and the cloth worker would have taken everything he had'.[7]

One of the demands put forward by the Ciompi had been the right of the so-called minor guilds to a place of worship in the church of Orsanmichele, a religious and political site of remarkable importance in fourteenth- and fifteenth-century Florence. Originally the city's central grain market, an open loggia had been constructed in 1337 to provide a shelter for the sale of foodstuffs, storage for supplies against the threat of famine, and an appropriate space for the worship of a shrine which contained a miracle-working image of the Virgin and Child.

Wills and endowments drawn up by Florentines after the Black Death of 1348 had initially made the Laudesi, the confraternity responsible for the shrine of the Virgin of Orsanmichele, one of the wealthiest charitable institutions in the city (money which was, however, confiscated by the government in the 1350s and invested in the public debt).[8] A decade later, the confraternity decided to revitalize the cult and commissioned Andrea di Cione, otherwise known as Orcagna, to create a tabernacle which would set off the miracle-working image from the mundane mercantile environment of the market-place [**121**, **122**]. He and his patrons considered its position and function carefully. We know that confraternity regulations required the picture to be kept covered and during the day the upper part of the shrine was closed off

by metal grates. At dusk, however, as the Laudesi gathered, the grilles were raised to reveal stone sculpture imitating a gold brocade curtain which seemed to be lifted away by music-making angels. Candles would be lit and recent research has suggested that singers were actually located in a small room underneath the shrine itself. Thus as evening fell, the hustle and bustle of the market-place would be replaced by the theatrical spirituality of worshippers hoping to encourage a miracle.

Although this was a religious event, it had considerable civic overtones. The adjacent altar was dedicated to St Anne, one of Florence's patron saints, and in 1339 the government had passed legislation demanding that all the guilds which made up its membership place a tabernacle on the market-hall of Orsanmichele. By the 1370s the city decided that the building's function as a religious shrine had overtaken its economic role. The arches of the open hall were eventually enclosed by large blank curtain-like walls to create a giant shrine for the tabernacle within. At the same time, the pillars which had once contained numerous altarpieces commissioned by the guilds, were replaced with frescos to create a more ordered environment. In 1406, determined to encourage the association between the sacred site and its own status, the *signoria*, which had recently seen the demise of Florence's most feared enemy, Gian Galeazzo Visconti of Milan, passed legislation threatening to confiscate the pillars of any guild which did not erect a statue in either stone or bronze within the next decade.

The unusual contemporaneity of a prestigious public site, multiple patrons, and the necessity of a short time-span, set off a dramatic competition between artists and guilds alike. Each guild kept a record book of their patronage, such as the accounts of the bankers' guild, the Cambio, which supervised Ghiberti's work. Guilds, it must be remembered, were not neutral institutions but composed of ambitious individuals. Thus the committee responsible for the Cambio's statue included two political rivals, the wealthy businessmen Palla Strozzi and Cosimo de' Medici, both of whom contributed much of the money needed to cast the figure of St Matthew in the 1420s [123].

The period which followed the completion of the statues was a particularly difficult time in faction-ridden Florence. The war against Milan began again, dividing the town into two main partisan groups, those (primarily patrician aristocrats) who were essentially for military action and affiliated themselves with the Albizzi and Strozzi families, and those more mercantile in approach, who were more ambivalent about the war and declared an allegiance to the Medici. In 1433 Cosimo de' Medici was forced into exile in Venice but his rivals' seeming triumph was shattered a year later when a newly elected *signoria*, one

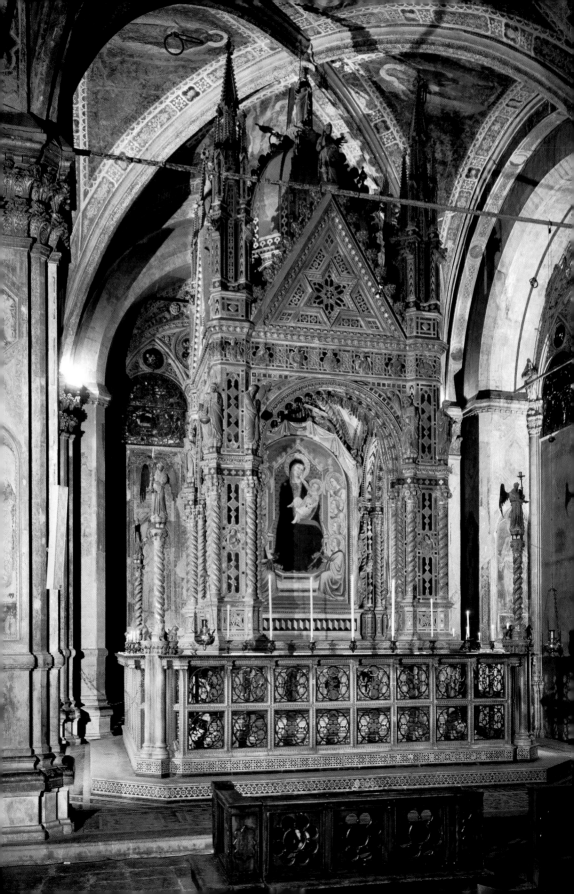

128
Basilica of San Petronio,
Bologna.

in particular, the Bentivoglio, made numerous attempts to dominate the town. For almost half a century members of that family who took control of the government were murdered or assassinated by their political rivals until in 1446 Bologna's ostensibly republican constitution was finally modified with the election and papal recognition of a minor member of the family then resident in Florence, Sante Bentivoglio. He was eventually succeeded in 1462 by Giovanni II Bentivoglio who remained in power until 1506. Although the poets and humanists praised the over-forty-year dominion of Giovanni II and his wife Ginevra Sforza as if they were court rulers, the reality was somewhat different. The Bentivoglio, like the Medici, had to create a delicate balance between the appearance of power and the exercise of discretion. Giovanni II sponsored semi-chivalric activities such as the jousts held in honour of the city's saint in 1470 and major feasts for family weddings which were accompanied by tournaments, games, and mock battles. However, he never became publically involved in the building of San Petronio and Bentivoglio memorials were centred, instead, in the family stronghold, the neighbourhood of San Giacomo, where their palace was located and whose church held the Bentivoglio chapel. Even here, however, the would-be lord of Bologna was careful to work alongside his neighbours, erecting a new portal jointly with his rival Virgilio Malvezzi. In the late 1480s, however, after an attempted

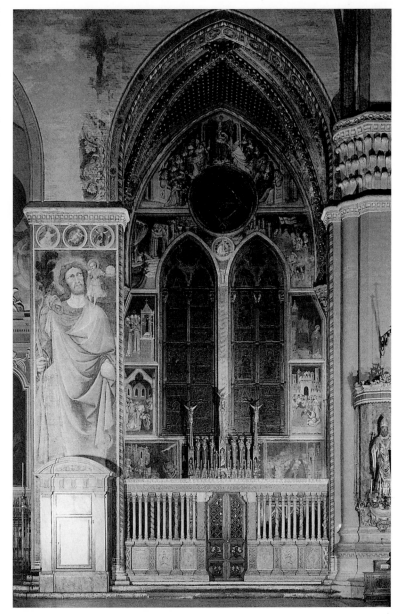

129
View of the interior of
the Basilica of San
Petronio, Bologna,
with Bolognini chapel.

Bartolomeo Bolognini spent
1,750 lire on his chapel
which he purchased in 1400. It
cost him 500 lire to acquire the
space, 400 for its
embellishment, and 850 for
its endowment. He died in
1411 leaving highly specific
instructions as to its
decoration which included
scenes from the lives of the
Magi and of St Petronius, and
images of heaven and hell.

coup by the Malvezzi, Giovanni II decided to commemorate himself,
his wife, and many children by adding four dramatic canvases by
Lorenzo Costa (1460–1535) to their chapel between 1487 and 1490 [**131**,
132].[12] One depicted the couple and their eleven children standing
before the Virgin and Child, the other two showed scenes of the
Triumph of Death and of Fame. A fourth, which is now lost but was
mentioned by a later chronicler, appears to have shown Giovanni II's
ancestors.

Although the overall message of all four canvases concerned the
need to remember the past and present glories of the Bentivoglio fam-

130 Giovanni da Modena
Inferno, 1411, detail from the Bolognini chapel, San Petronio, Bologna.

ily, the paintings were complicated by the presence of inserted images of the pains of earthly life in the Triumph of Fame and of the pleasures of paradise in the Triumph of Death. Thus while praising the Bentivoglio lord, his offspring, and his ancestors, the images also made it clear that Giovanni II was aware of the dangers of vainglory. Bound by the decorum of religious devotion, the paintings suggested both the family's pride in its lineage and its acknowledgement of the Last Judgement. The chapel, it should be remembered, was not a public space nor was it easily accessible. Thus its propaganda value was limited to a small audience of adherents and neighbours. It functioned more as a votive offering to the Virgin, showing the family as honourable and pious believers in her power and authority.

The maritime republics

The great trading empires of Genoa and Venice faced similar problems to their republican counterparts elsewhere but the two cities, locked in battle for much of the second half of the fourteenth century, had dramatically contrasting fates. Although it lost much of its maritime empire to the Ottomans, Venice acquired vast land-based territories; Genoa, deeply divided along family and factional lines, lost control over its immediate territory and its internal politics became enmeshed in struggles between the French monarchy and the expanding Milanese-based dynasties of the Visconti and the Sforza.

Superficially the two cities shared the same mercantile interests and

131 Lorenzo Costa
The Triumph of Fame,
tempera on canvas, 1487–90,
Bentivoglio chapel, San
Giacomo, Bologna.

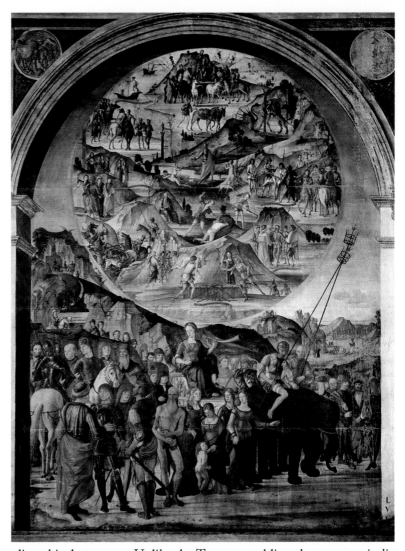

132 Lorenzo Costa
The Triumph of Death,
tempera on canvas, 1487–90,
Bentivoglio chapel, San
Giacomo, Bologna.

oligarchical structure. Unlike the Tuscan republics, there was an individual figurehead, a doge who was elected for life. The Genoese chose their doges from a small number of select families who were grouped in clans known as *alberghi*. Each *albergo* had its own public site, an open loggia, as did groups of foreigners such as the Pisans and the Greeks.[13] There was also an official *signoria* composed of eight magistrates, the *anziani*, but the real stability was provided by the central bank of St George, which controlled the public debt and acted as one of the city's major patrons. In the hall of the bank of St George, a programme celebrating the city's financial benefactors was initiated in the late 1460s showing bankers and other civic notables bearing scrolls reporting their donations. The 1473 figure of Luciano Spinola, for example, commemorated a patrician who had given money to reduce the city's levy on servants, horses, and wine, thereby reducing the tax burden faced by

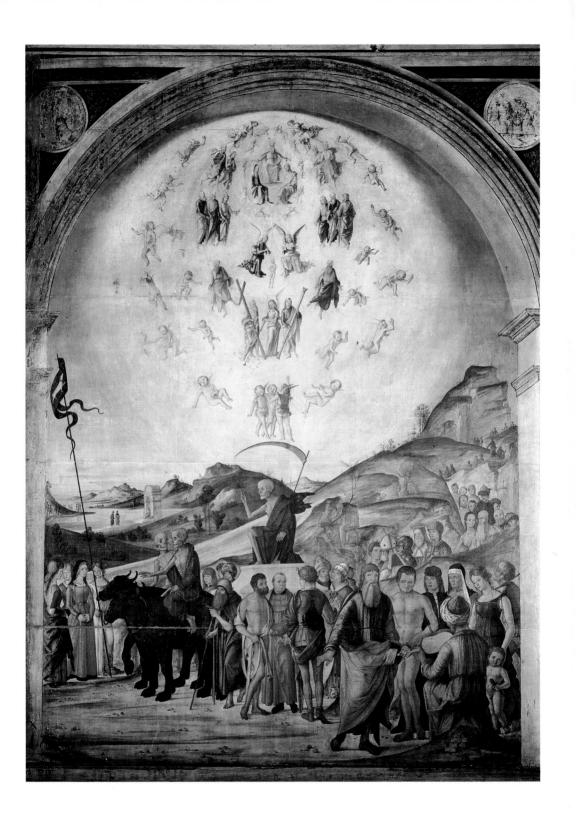

133 Michele d'Aria

Statue of Ambrogio di Negro, marble, 1483–90, Palazzo di San Giorgio, Genoa.

The Genoese bank of San Giorgio honoured the city's greatest financial and civic benefactors. In 1466 they began a tradition which lasted well into the seventeenth century of portraying citizens who had made substantial contributions to the relief of Genoese taxes such as this raffish figure of the commisar of Corsica, Ambrogio di Negro.

his peers. In 1475 a statue was put up by the same sculptor, Michele d'Aria, in honour of Domenico Pastine, a merchant who had relieved the more onerous tax on grain.[14] D'Aria also provided the swaggering figure of Ambrogio di Negro, the commisar of Corsica, who had made contributions towards the relief of Genoese taxes [**133**].

But the celebration of these individual heroes who helped support the financial and military burden of an extensive maritime empire disguised Genoa's difficulties and divisions. As the city degenerated into factional warfare, its failure to maintain its independence against Milan served as a warning to the other major maritime republic in Italy, Venice. The lagoon city's seeming stability and prosperity, which lasted until Napoleon conquered the city in 1797, gave the islands a semi-mythical status throughout Europe. The state was controlled by a small oligarchical élite whose membership had been confined in the late thirteenth century to a restricted number of registered noble families. Members of this aristocracy were eligible to serve on the Great Council, and on its associated legislative and consultative bodies, the senate, the college, and above all, the Dieci (the council of Ten), which managed much of the daily decisions. Below the patriciate were the *cittadini*, who were excluded from the legislature but served as state administrators and in other public capacities, and were responsible for the confraternities, the *scuole*. The majority of the population, the *popolani*, were drawn from native and non-native Venetians alike and had little or no right to participate in government.

In their attempt to avoid the supremacy of a single family or individual, the Venetian patriciate encouraged the city's diverse population to identify with a religious symbol, the Apostle and gospel author St Mark. His body, stolen from Alexandria in the early ninth century, was buried in the doge's chapel, the basilica of San Marco, which was adjacent to the centre of public government, the Palazzo Ducale where the Great Council met and the doge and his family were expected to live. The doge was chosen from a restricted group of families by a complex system of nominations. Often an elderly patrician, his powers were severely circumscribed by both statute and precedent. While he had a crucial ritual function as the centre-point, for example, of Venice's annual ceremonial marriage with the sea, he was not expected to be the focus of individual loyalty. He was not supposed to hold, and indeed was discouraged from holding, active power. Doges who tried to personalize their government found themselves under attack. For example, in 1356 Doge Marin Falier was decapitated on the stairs of the Palazzo Ducale for his personal aggrandizement, Francesco Foscari was deposed in 1457, and in the 1470s the legislature reiterated its ban on personal memorialization, forbidding the profile portraits of its doges on coins.

It was only at the moment of their death that the individual

Venetian doges and patricians could celebrate their achievements on behalf of the state. Like papal tombs, the construction of these monuments were usually *post mortem* family undertakings, designed to illustrate dynastic as well as personal standing and the many memorials to Venice's doges competed with each other in terms of both grandeur and position. Francesco Foscari's tomb, for example, was placed on the wall of the apse of the Frari, the principal Franciscan church in Venice, a site of considerable prestige. One of his successors, Niccolò Tron, who had only served three years as doge from 1470–3 but had managed to create controversy by issuing coinage with his profile portrait, was buried across from Foscari in the apse, in a monument which over-

shadowed previous burial sites [**134**]. His successor, Pietro Mocenigo (1405–76), had an even shorter period of office, dying after just over a year, but his brothers, who had aspired to the dogeship themselves, were prepared to erect an even grander monument in the church of San Giovanni e Paolo [**135**]. Here, instead of showing Mocenigo as a corpse, he appeared triumphant over death just as he had triumphed over his earthly enemies.

Foscari, Tron, Mocenigo, and their relatives were all careful to combine personal imagery with pious intentions. They were both good Christians and examples of good citizenship. Two bronze memorials erected under Venetian auspices, the equestrian statues which honoured the state's faithful *condottieri*, were more problematic in terms of their decorum. All Italian city-states relied, to a greater or lesser degree, on the mercenary system for their armies. By hiring captains, who in turn hired troops, mercantile cities such as Venice could avoid

135 Pietro Lombardo

Tomb of Doge Pietro Mocenigo, Istrian stone and marble, *c.*1476–81, San Giovanni e Paolo, Venice.

The tomb, erected by Mocenigo's heirs, is inscribed 'Ex Hostium Manubiis' (From the spoils of the Enemy) which is meant to suggest that the lavish marble monument was paid for by Mocenigo's military successes which are illustrated on the tomb itself.

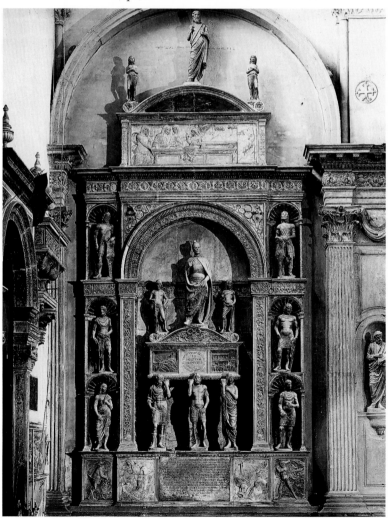

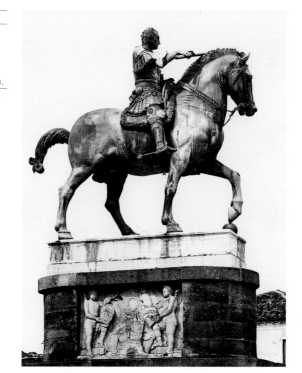

136 Donatello

Equestrian statue of Erasmo de' Narni, il Gattamelata, bronze and marble base, *c*.1445–53, Piazza di San Antonio, Padua. Donatello is first documented at work on the monument to the Paduan *condottiere* Erasmo di Narni in 1447. Disputes over payment seriously affected work and a final settlement was only agreed in 1453 when the sculptor agreed to place the horse on its pedestal by September and that his final payment would amount to 1,650 ducats.

arming their *popolani*, and save funds in times of peace. Governments were wary, however, of the loyalty of these soldiers, suspecting them of trading their services to the highest bidder and of personal ambitions of rulership. Many of the most successful *signori*, from the Este, Gonzaga, Visconti, and Sforza, had begun their careers as military captains and a number, such as Federigo da Montefeltro and Giovanni Bentivoglio, financed their positions as rulers by continuing to lead major armies into battle. Venice, anxious to prevent its military heroes from achieving a prominent political position, yet unable to survive without them, offered its captains land in the terra firma and honours in the senate. They were quick, however, to execute those they suspected of treachery and ambivalent about memorializing their achievements. When one of their most successful captains, the Paduan Erasmo de' Narni (whose nickname Gattamelata means honeycat), died in 1443, his family and executors arranged for his burial in his hometown's most prominent church, the Franciscan basilica of Sant'Antonio. On the square outside this sacred site, a bronze figure on horseback was erected by Donatello [**136**], an achievement designed to imitate the ancient equestrian monuments still visible in Rome and in Pavia. Although the sculptor faced difficulties in getting paid and in having his work evaluated, the monument did not seem to cause any political controversy. But if it were possible to memorialize a Venetian captain in a subject city, erecting an equestrian monument in Venice itself posed a very different problem.

137 Andrea del Verrocchio

Equestrian monument to Bartolomeo Colleoni, bronze and marble, 1496, Campo di San Giovanni e Paolo, Venice. Verrocchio was commissioned by the Venetian government to execute this monumental bronze in April 1480 and arrived to start work in spring 1486. He died in 1488 having only made the clay model, requesting in his will that the statue should be finished by his pupil and collaborator Lorenzo di Credi. In 1490, however, the Venetian senate seems to have given the model to a local sculptor, Alessandro Leopardi, to cast. His signature appears on the completed monument which was finally put in place in March 1496.

Bartolomeo Colleoni, a captain from Bergamo who died in 1475, was a Venetian *condottiere* and a vassal who owned several major fiefs on the border with Milan. At his death, he hoped to pass on this mini-state to his nephews, asking the senate to honour their promises of rights of inheritance and offering them a large sum in cash and the authority to supervise and execute his will. This made the state responsible for his posthumous demand for an equestrian statue which he wanted to be erected in front of the basilica of San Marco itself, the most important ritual space in the republic.

The request caused consternation in a city which eschewed such individualistic memorialization. In 1475 the Milanese ambassador in Venice reported,

Moreover, the *signoria* had argued that they wished to provide the most honourable funeral here in Venice for the captain. But now it seems that the affair is being silenced and put to the dishonour of the said Bartolomeo and they are beginning to speak most sinisterly, saying that he was the greatest usurer and the most avaricious and least liberal man the world has ever had. And some gentlemen have said that his statue should not be placed here in Venice because it would give injury to so many worthy and brave men who have been well deserving of honours from this city, none of whom have ever been shown with such a memorial. And that considering the life of the said Bartolomeo that such a statue, when compared to other famous men, would be derisive to this republic and that if any statue was to be erected it should be placed in Bergamo.[15]

Detail of 49

The multiple arguments against erecting the statue are interesting: Bartolomeo Colleoni provided a poor example of behaviour, it would cause considerable jealousy, and he and his statue belonged not to Venice but to his home town of Bergamo. Despite these concerns, however, Andrea del Verrocchio was eventually called to Venice in the early 1480s to execute the piece [**137**]. A sense of competition between the Venetians and the Milanese *signori* (who had just revived the project for an equestrian monument to Francesco Sforza, see Chapter 7) may have given added impetus to the project, and unlike his former pupil Leonardo da Vinci, Verrocchio and his assistants proved capable of casting the massive piece. But instead of placing the image, as requested, in front of the prestigious site of the basilica of San Marco, the statue was erected towards the north of the city by the hall of the confraternity of San Marco, a ruse which allowed the Ten to fulfil their obligations without offence. In Venice, no matter how wealthy or important the individual, there could be no competitor to the image of the state.

Part IV

Art and the Household

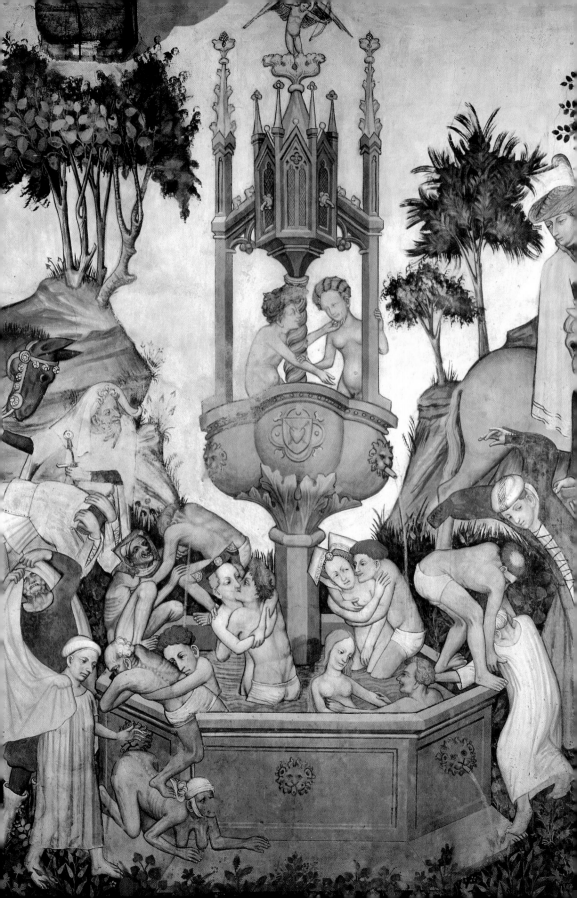

The Domestic Setting

9

Fifteenth-century Italians made a distinction between activities which they carried out for their own pleasure, *cose da piacere*, and work they undertook on behalf of the wider community and government, *cose di stato*. But, like the transition from sacred to secular, the shift from the public to the private domain is difficult to define with precision. Thus although this final chapter is concerned with questions of domestic patronage, it also offers a chance to sum up the broadest problems of the communication of social and moral expectations.

Wealth and social order

One of the major issues in Renaissance studies today is the question of whether or not a change in attitude towards wealth and its display occurred in the late fourteenth century. Was there a move away from the need to give away or hide possessions (for fear of envy, taxation, or damnation) towards the public enjoyment of riches?

This is an important question because art historians generally deal with élites and gaining access to the wider community of owners, patrons, and viewers in the fourteenth and fifteenth centuries is often difficult. None the less if magnificence was the specific preserve of the very wealthy, the careful use of wealth was the concern of all. For example, the late fourteenth-century Florentine moralist Paolo da Certaldo wrote in his *Book of Good Customs*, 'it is a fine and great thing to know how to earn money, but a finer and greater one, to know how to spend it with moderation, and where it is seemly'.[1] Certaldo's assumption that riches were neither good nor bad in themselves was a commonplace reiterated in the fifteenth century by St Bernardino:

> To be rich in itself is not evil, it is only evil to the extent that riches are used badly. In themselves, riches are good, but the problem lies when they are acquired evilly or used evilly . . . Riches which have been well earned and well used are a great grace of God.[2]

For St Bernardino, and other conservative clerics, wealth could only be gained from fair profit or fair exchange, not from the usurious practices of moneylending or the charging of interest, tasks best left to the

Detail of 150

Jewish community. Appropriate expenditure lay in the traditional areas of charity which involved the support of the Church and of the poor. As one late fourteenth-century Florentine put it, in a letter asking for funds to give dowries to poor girls, 'I vow he [the merchant Francesco Datini] will have greater gladness there than from all the walls he has built. Churches are good, and so are holy pictures; but for every once that Christ mentioned them, he spoke a hundred times of the poor.'[3]

In the debate over changing attitudes towards wealth it is usually assumed that such comments illustrate a tension between artistic purchases and charitable donations. But it is important to note that although the writer encouraged the merchant to save his soul by providing dowries, he did not condemn Datini's investment in buildings and sacred images. Christian charity, and expenditure on art and architecture were not contradictory impulses; when handled properly, they were seen as complementary. Indeed, fourteenth- and fifteenth-century patrons who commissioned large private residences or purchased luxury goods, almost always gave money to churches, hospitals, and confraternities. When the businessman Giovanni Rucellai (the third-wealthiest man in mid-fifteenth-century Florence) claimed in a personal note, 'I think I have not given myself as much pleasure in earning money so much as in spending it, above all in the building I have done,' he was referring not only to his lavish new palace, but also to the façade he had provided for the Dominican church of Santa Maria Novella, and the burial chapel he had erected in his local parish church, San Pancrazio. That the display of wealth was not divorced from a display of charity is similarly emphasized in one of Lorenzo de' Medici's notes:

I find we [the Medici family] have spent a large sum of money from 1434 up to 1471, as appears from an account book covering that period. It shows an incredible sum, for it amounts to 663,750 florins spent on buildings, charities and taxes, not counting other expenses . . . This money seems to be well spent and I am very satisfied.[4]

Giovanni Rucellai and Lorenzo de' Medici intended their remarks for posterity; their journals, known as *zibaldoni*, were usually written for, and retained by, future generations. But in our attention to the wealthy it is easily forgotten that there was also a very strong sense of differentiation between different types of poverty. Most fourteenth- and fifteenth-century charities were limited to supporting the deserving or 'shame-faced' poor, the so-called *poveri vergognosi*, rather than to supporting all categories of poor. The elderly, widows and orphans, or the ill were considered particularly appropriate recipients of charity, while other groups were not. Beggars on the street, male vagabonds, and the 'work-shy'—were all condemned by the fifteenth-

century theorist Leon Battista Alberti who wrote in his *Treatise on Architecture* (*De re aedificatoria*):

Some princes in Italy have banned from their cities anyone like that, ragged in clothes and limb, and known as tramps, and forbidden them to go begging from door to door; on arrival they were immediately warned that they would not be allowed to remain in the city out of work for more than three days. For there is no one so handicapped as to be incapable of making some form of contribution to society; even a blind man may be usefully employed in rope making.[5]

In Alberti's ideal world, individuals would accept their status and live their lives accordingly. This concept of social hierarchy was expressed in another, equally complex source for our understanding of contemporary attitudes towards ownership and display. These are the sumptuary laws which were issued by urban magistrates either in civic statutes or as part of a government campaign to control waste and to maintain sexual as well as social distinctions. Unlike humanist treatises, this legislation could be widely publicized and enforced. The sumptuary laws of Florence, Genoa, and Venice, for example, were included in civic statutes, announced by town criers, and supervised by special magistrates. The legislation limited the number of courses served at weddings, and banned or restricted gifts to the bride and groom. It laid down the number of rings a woman could wear (an unmarried girl was permitted to wear more than a married woman) and the detailing of the neckline or the number of buttons or the length of her train; it stipulated the clothing that the prostitute should wear, threatening her with public beatings if these rules were contravened.

The sumptuary laws, examples of which can be found from the thirteenth to the sixteenth centuries, should not be read as legislation which worked, but rather as evidence for the kinds of activities, behaviour, and clothing which elicited confusion and anxiety. In Venice, for example, the Great Council kept trying, despite its obviously limited success, to create a special magistracy to control excess in terms of dress and ritual. To encourage prosecution, it set out boxes where secret denunciations could be placed and encouraged informers by offering them a percentage of the fine. In 1512, however, we still find waiters and cooks being ordered, under threat of imprisonment, to allow Venetian officers to inspect banquets which were under way. The servants were not 'to interfere with our officers . . . [by] throwing bread or oranges at their heads, as certain presumptuous persons have done'.[6]

The moral emphasis enshrined in such legislation was vigorously promoted, particularly in the Italian republics. The Florentine 'officials on women's ornaments', who were appointed to patrol the streets looking for women who had breached the regulations, were

to restrain the barbarous and irrepressible bestiality of women who, not mindful of the weakness of their nature, forgetting that they are subject to their husbands, and transforming their perverse sense into a reprobate and diabolical nature, force their husbands with their honeyed poison to submit to them. These women have forgotten that it is their duty to bear the children sired by their husbands and, like little sacks, to hold the natural seed which their husbands implant in them, so that children will be born. They have also forgotten that it is not in conformity with nature for them to decorate themselves with such expensive ornaments when their men, because of this, avoid the bond of matrimony on account of the unaffordable expenses, and the nature of these men is left unfulfilled. For women were made to replenish this free city and to observe chastity in marriage; they were not made to spend money on silver, gold, clothing and gems.[7]

Compared to this vehemence, art, as we understand it today, was literally not an issue. The possessions which inspired the greatest concern were not paintings or statues, but the far more expensive acquisitions made by men and women such as their clothing and their jewellery as well as the temporary rituals and festivities, such as weddings, which they organized.

Male dignity and female virtues

The phrase used by the Florentine officials, that women were like 'little sacks', was based on their understanding of human biology, one which was quite confused in this period. There were a number of competing theories of human conception and female anatomy on offer in the fifteenth century. The most widely accepted version was based on Aristotle's writings. According to this philosophical system all living creatures were composed of two basic binary opposites: they were either hot or cold, or wet or dry. Men were generally hot and dry; women were normally cold and wet. A human being was created by mixing the hot, active male seed with the cold, passive female menstrual fluid. This contact acted like rennet on milk, coagulating the fluid and initiating the development of a cheese-like foetus which gradually solidified. If there was enough heat available, the more perfect form, a male child would result; too much cold and damp resulted in a less perfect form, the female or 'incomplete male'.[8]

Not every doctor or midwife held to these ideas; but the authority of Aristotle's name was difficult to dislodge and his philosophy had practical consequences. Numerous medical books advised women to eat hot foods before procreation. Because it was believed that, after a woman gave birth, her menstrual fluid was transformed into nourishing milk, she should avoid further intercourse while breast-feeding. This had important theological consequences. For example, it meant that Christ's humanity was confirmed when he suckled from Mary's breasts; an image such as Marco Zoppo's *Madonna Lactans* [**42**]

Female bust, polychromed
marble and painted wax,
c.1470s.

The bust is often considered
to be either Eleanora of
Aragon, who married Ercole
d'Este of Ferrara in 1471 or
perhaps Isabella of Aragon
who married Gian Galeazzo
Maria, duke of Milan in 1490.
It was originally extensively
painted and gilded and the
head-dress was decorated
with wax flowers.

would have reminded fifteenth-century viewers that Christ was made
literally from his mother's blood.

Aristotelian ideas and their later reformulations gave a firm
biological basis to the subordinate and protected position society
expected most well-to-do women to adopt. Behaviour, dress, gestures
were expected to form the outward manifestation of this inner state;
thus the downcast eyes in a figure such as Francesco Laurana's
Aragonese Princess [**138**], the fixed profile and clasped hands of the
Tornabuoni women in Domenico Ghirlandaio's frescos in Santa Maria
Novella, and the demure features of the Virgin in the Pistoia *Visitation*
all conformed to the ideal modest young female. It also meant that
men were expected to exhibit the social virtues associated with adult
masculinity. Wearing robes of office, the Tornabuoni men shown in
the family chapel stand together as a group of social equals, looking
outwards with their hands casually on their hips or conversing amongst
themselves.

The concept of a clearly defined decorum in the iconography of
dress, behaviour, movements, and gestures which related to gender and
social class was promoted by Leon Battista Alberti and by Antonio
Averlino, the latter of whom in his treatise of the 1460s was specific in
his instructions to would-be painters:

Actions, modes, poses and everything should correspond to their nature, age
and quality . . . When you have to do young women [they should have]
honest and moderate actions, with weak poses rather than bold ones . . .
When you have to paint the Virgin Annunciate, she cannot be made so
restrained and chaste that you would not wish to make her more so. [Do not

do] as many who make her rather more lascivious than respectable . . . As I have said, the clothing, pose and features of each one should correspond well to their types.[9]

The laymen and -women shown in the Tornabuoni chapel observe this expected decorum but they could have only been observed by the Dominican monks who gathered in the choir to sing and read the daily services. Similar ideals of male and female behaviour were, however, also illustrated on the objects commissioned for important family rituals such as marriages and births.

The Renaissance concept of the sacrament of marriage was quite specific. In the eyes of the Church, the only requirement for valid matrimony was not a church ceremony but an exchange of vows in the present tense between a consenting couple and the consummation of their union. Thus a wedding could take place anywhere and at any time and although the couple might attend mass after their marriage, it was the secular arrangements, including parental discussions, and the rituals of dowry exchanges and ring-giving (which often took place outside the door of the church), which were crucial to the public nature of the ceremony. Thanks to a computerized investigation into the Florentine tax returns of 1427 we have a substantial number of statistical indicators which add to our understanding of social conventions and expectations of these marriages; urban women married, on average, between the ages of 16 and 18; men were considerably older, between 27 and 30.

For most families, marriage was not an emotional contract; it was designed to create social and economic connections. The money and goods a bride brought to her new household represented her share of her father's wealth and without a dowry there could be no marriage. Poorer girls might work as domestic servants in order to raise the funds themselves, others relied on charity, but most expected their father to provide an appropriate amount. The impact of dowry inflation, particularly in Venice, has been much discussed, and the rising number of young girls destined for a career in the convent may be explained, in part, by familial strategies designed to avoid the burden of excessive dowries. In Florence a specific institution which played a significant role in state finances, the *Monte delle Doti*, was established at the beginning of the fifteenth century in order to enable fathers to raise the required funds. At the birth of a daughter, a Florentine would buy shares which could be redeemed with interest on her marriage.

In many towns the exchange of goods which symbolized the public nature of the wedding was visibly demonstrated by a parade of possessions which passed from the groom to the bride and vice versa. These varied in sumptuousness and scale. The grand dowries and trousseaus of the daughters of the Italian *signori* were usually paid for

by special taxation and provided a symbol of the wealth of their fathers' territories. Private citizens were not encouraged to emulate such extravagance which illustrated political power as well as social status.

In Florence, a portion of the dowry would usually be used to purchase furniture for the couple, often including chests in which the trousseau comprising clothing, cloth, and jewellery could be stored. These painted and gilded chests, now known as cassoni (but originally referred to as *forzieri*), were the standard but not inexpensive product of many workshops. Specializing in motifs taken from classical, romance, or biblical tales, the workshops provided stories, such as the marriage of Solomon and Sheba or the abduction of Helen by Paris, which were meant to be both entertaining and exemplary. Thus the marriage of Solomon and Sheba was not just an excuse to illustrate a wedding ceremony, it was also a reminder of the fact that even the queen of Egypt bowed low before her husband's wisdom and deferred to him. This message had an important civic dimension for the correct relationship between husband and wife was perceived as the very building-block of the state itself. In his treatise *On the Immortality of the Soul*, written in 1482, Marsilio Ficino put forward a very traditional idea, claiming, 'Man alone so abounds in perfection that he rules himself first, which no beasts do, then governs his family, administers the state, rules peoples, and commands the entire world.'[10] In these terms, a man who could not control either himself, his wife, or his household was incapable of wider rulership.

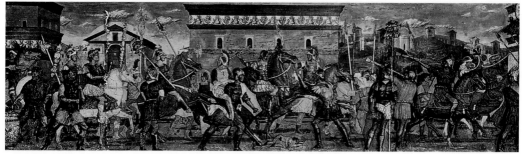

Begun in 1446, the account book of Florence's most prolific cassone-painters, Apollonio di Giovanni (1415–65) and Marco del Buono (1402–89), indicates a wide range of purchasers for chests which had such illustrative tales, ranging from some of the city's most prominent families to a dyer in the wool trade.[11] In this document, the bride's own name was never mentioned; the client was usually her father or another male relative, occasionally her prospective husband, and only in rare instances, another woman such as a married sister. Two relatively well-documented examples, from Florence and Mantua respectively, illustrate the care and expense that went into these objects. The former is a pair of chests in the Courtauld Institute Galleries, London, which were made for the wedding of the Florentine patrician Lorenzo di Matteo Morelli (a relative of the diarist Giovanni Morelli) to Vaggia di Tanai Nerli, the daughter of another well-to-do Florentine, in 1471 [**139**].[12] The young woman brought a large dowry of 2,000 florins and in anticipation of her arrival, the groom spent approximately 100 florins preparing the bedroom where he and his wife would sleep. He purchased a new bed, bed-curtains, chests, and a tabernacle and arranged for the redecoration and updating of earlier works in the house. In commissioning his chests, he bought the framework from a carpenter at a cost of about 21 florins, and then had them painted separately by Jacopo del Sellaio and his partner Biagio d'Antonio at a total cost of approximately 40 florins, a high sum which can probably be explained by the large amount of gold used in the gilding and by the quality of the pigments.

When installed, the chests would have dominated the room in which they stood. Both have high backs as well as painted lids and were decorated both inside and to the rear with reproductions of brocades. The themes on the front were taken from classical history, but from a relatively accessible source, a compilation of stories by the first-century AD Roman author Valerius Maximus, which were still widely available in the quattrocento. Valerius Maximus had usefully organized his tales by the moral virtues they exemplified, permitting writers and artists alike to select appropriate stories which illustrated prudence, wisdom, or any other selected virtue.

The story Morelli chose for one of his two cassoni, the 'School-

141

As 140; detail.

Note the domed building in the rear which may have been based on Leon Battista Alberti's architectural models for churches in Mantua.

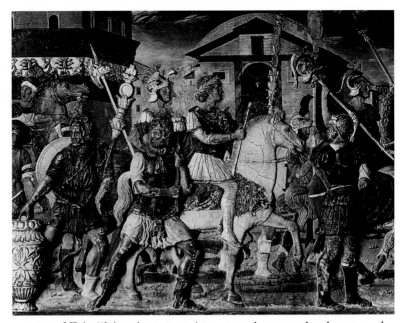

master of Falerii' (a tale concerning a treacherous schoolmaster who betrayed his pupils to the Romans who refused to accept them as hostages), was taken from the section on justice, while the hero shown on the other, Furius Camillus, was an exemplar of moderation and obedience to the state. Both panels were addressed not so much to the bride as to her husband, who was expected, in his new mature married state, to act as these Roman captains had once done, governing his household, and eventually his city, with justice and wisdom.

Morelli's new wife was moving within her own city. Although she was expected to take on new responsibilities she remained within her own community. Amongst the court élites, however, matrimony meant leaving, not just the household where the bride had grown up, but her own city, and even her homeland. When the marquis of Mantua's youngest daughter, Paola Gonzaga, went to Austria to marry the count of Gorizia in 1477, she also took a number of cassoni. Paola, who was only 14 when she married, was neither the patron of these chests nor a particularly willing participant in the marriage negotiations. Her parents had arranged the alliance which reinforced the Gonzaga's already-strong connections to the German-speaking aristocracy (her mother was a member of the Brandenburg family and her sister had married the count of Württemberg) and the chests were only one part of the trousseau which was designed to impress the spouse's future family and servants.[13] Painted and stuccoed, each of the two cassoni contained an episode from the same story, the Justice of Trajan, again by Valerius Maximus [**140**, **141**]. This explained how Emperor Trajan had ordered the execution of his own son who was guilty of having caused the death of a widow's only child. In this case

the message of justice and intercession by a mother was directed to both Paola and to her husband. Like the beseeching widow shown kneeling before Trajan, she was to ask for justice and good government; her husband, in turn, was to heed her righteous requests in order to rule well.

The family

For couples of any rank or standing, the expected outcome of a successful marriage was the creation of a new family. Pregnancy and a successful delivery were expected to follow marriage and the anxiety with which conception was regarded cannot be overestimated. When the merchant Francesco Datini's wife failed to conceive, she received a series of advice including in 1393 one hint from her sister in Florence for a particularly unpleasant smelling cure:

Many women here are with child . . . I went to inquire and found out the remedy they have used: a poultice which they put on their bellies. So I went to the woman and besought her to make me one. She says she will do so gladly, but it must be in winter . . . She has never put it on any woman who did not conceive but she says it stinks so much, that there have been husbands who have thrown it away. So discover from Francesco if he wishes you to get it. The cost is not great. And may God and the Virgin Mary and the blessed St John the Baptist grant you this grace.[14]

Margarita Datini remained barren all her life. For those women who did deliver sons safely, the event was celebrated with considerable gift-giving. In ruling families, the lord's wife might receive greater political authority, an increased allowance, and direct dominion over castles and towns. In patrician families she made do with gifts of cloth, jewellery, land, increased rights of inheritance, and the less valuable but highly visible *deschi da parto* or birth-trays which were particularly popular in Florence [142]. The triumphal scene following a woman's achievement is illustrated in both the Tornabuoni frescos and in a Florentine tray from the first half of the century, now in Berlin. In the latter, the mother watches as her well-swaddled baby (wearing a coral necklace to ward off evil spirits until baptism) is held by a group of mature married women, whose status is denoted by their coiffed or veiled heads. The women who enter from the left appear from their lack of head-dresses and costumes to be unmarried relatives carefully chaperoned by two nuns. This is an exclusively female gathering but only the men, who remain outside, bear gifts.

It is usually assumed that the tray shown in the painting in **142** is a *desco da parto* similar to the one shown in **143**. The husband was not always the patron. The lily-bannered trumpeters suggest that the city could make an offering and in one case we know that a new grandfather ordered a birth-tray for his daughter. But if these gifts were ordered well enough in advance to serve sweets and fruit to a newly delivered mother, patrons were ignoring the risks of childbirth and the chances that the infant might be female. It is, therefore, more likely that this was a commemoration of a birth ordered after the event. The reverse of the trays often depicted the couple's coats of arms or images of fertility, such as putti holding poppy-seed capsules which contained thousands of seeds, or infants urinating gold and silver streams, or in

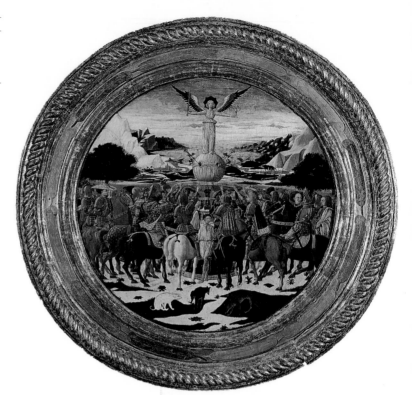

143 Giovanni di ser Giovanni

Called Lo Scheggia, Triumph of Fame, 1449, desco da parto, tempera, silver, and gold on wood.

The frame is decorated with three-coloured feathers, the personal impresa of Piero de' Medici, while the reverse is painted with the Medici and Tornabuoni arms of Lorenzo de' Medici's parents. The painting is attributed to Masaccio's brother, nicknamed 'lo Scheggia' (the splinter).

the case of the Berlin tray a naked boy playing with a dog, all possible harbingers of good luck and hope for the safe delivery of a male child.

The tray-fronts usually had a more decorous theme, one often drawn from Petrarch's Triumphs, a poetic sequence whereby love was conquered by chastity, and then in turn by death, fame, time, and eternity. One unusual example is the *desco da parto* created for Lucrezia Tornabuoni after the birth of the Medici son and heir Lorenzo in 1449 [143]; framed by her husband's feather *impresa*, it shows the Triumph of Fame, a clear aspiration for this young child's future. A more common theme was the Triumph of Love which showed a bound Cupid riding in the centre of a cart surrounded by the examples of men who had been overcome by their love for women. Thus Delilah appears shearing Samson and the philosopher Aristotle is shown either being ridden or being hauled up in a basket by Phyllis (a woman with whom he was apocryphally thought to have been besotted). While the iconography may have brought enjoyment or entertainment to the mother, it also revealed a more ambivalent attitude on the part of her husband. The stories all suggested that inappropriate or excessive love for women was dangerous, capable of emasculating and weakening even great men such as Samson and Aristotle.

Today the many birth-trays and marriage-chests which survive in museums and private collections are often classed as domestic pieces, or as art specifically designed for women. But it is important to

recognize that these were generally pieces which men commissioned, painted, and presented to women, works whose messages were often addressed to the male patron as much as the female recipient. Displayed in the seeming intimacy of the couple's chamber or apartments, these objects announced to privileged visitors that the palace-owner had fulfilled his duty to the city. He was a mature male; and his wife had proved an obedient, fertile mother. Moreover, although we now associate the design of the home with women, it was usually the paterfamilias who took charge of its actual decorations. The wife was expected to govern and care for these possessions but the architecture and furnishings reflected her husband's attitudes and opinions.

Palaces and palace decorations

Cosimo de' Medici's mother's *desco da parto* hung like a trophy in her husband's room, and another was placed in an ante-chamber outside. As with cassoni, they were ordered for very specific ritual moments in a family's life. When placed on permanent display they joined a wider assortment of goods which were either kept in the open or, more normally, stored away in boxes and cupboards. The quality and scale of housing available to Italian citizens and country-dwellers was, as a number of studies have amply illustrated, very diverse.[15] Most men and women rented their accommodation which could be quite small and cramped. In Genoa and Venice, where land was at a premium, homes were particularly narrow and high. In the central parts of Florence or Milan, buildings could rise up to four or five storeys, with a shop or workshop on the ground floor. There are varying estimates of how many people lived in any one dwelling and in what form of social grouping, with ongoing arguments about the increased insistence on privacy and the rise of the nuclear family. Yet there was great flexibility in household organization. A home might hold several generations or brothers for a period of time and then become the residence of only one couple and their children after the grandparents had died and siblings departed. As children married, or widowed sisters or other relatives sought refuge, it might then become an extended family again. In all cases, it was not just blood relations who lived together. Many Italian homes, even those of modest income, had servants, including slaves from eastern Europe and Africa, whose behaviour and emancipation was a constant source of concern.

Much of the experience of living in or visiting such a palace would have depended on one's status and gender. In the princely homes, special servants or guards, known as *uscieri*, controlled entry and access to the household; in more modest dwellings, the owner simply took care to keep rooms locked. Consider, for example, the Medici palace in Florence [**144**, **145**]. Begun in the early 1440s by Michelozzo, it started a fashion for fierce rustication which imitated the architecture of civic

Florence: exterior.

In praising Cosimo de' Medici's architectural patronage, the Augustinian writer Timoteo Maffei gave
this conventional excuse for the magnificence of the Palazzo Medici: 'and in his house he has not thought about what he, Cosimo, wanted but what was consistent with such a great city as Florence in that he thought that if he was not going to look ungrateful it was necessary that he should appear more fully equipped and more distinguished than the other people in the town in the same proportion as he received benefits from it greater than theirs'.

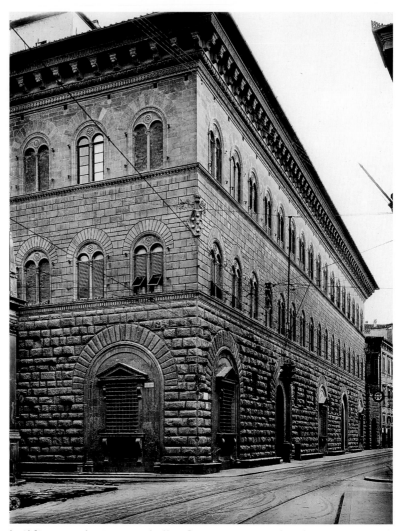

buildings such as town halls. On its exterior façade, the architect included a projecting bench. This gave supporters and petitioners a place to sit while awaiting instructions and entry, or while merely gossiping. A semi-public loggia on the palace's left corner permitted more commercial activities to take place in full view of the neighbourhood while every decorative element on the exterior, from the windows to the rings for tying up horses, was encrusted with the Medici coat of arms.

It is unclear whether entry to the palace was strictly controlled but the transition from the brown dust of the hot street into the cool highly decorated grey of the interior would have made an immediate impact. Donatello's David stood in the centre of the courtyard and relief copies of antique gems and cameos (normally inaccessible to the public in the family's private study) were shown interspersed with Medici coats of arms in the frieze below the windows.[16]

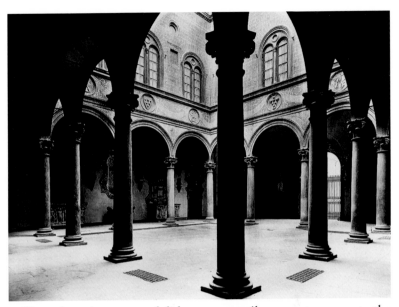

Entry into the courtyard did not necessarily guarantee access to the rest of the house. Beyond the *cortile* lay a door to a large garden, a luxury in this inner-city area, where the sculpture of the two figures of Judith and Holofernes probably stood. The family used the ground-floor apartments which looked on to the garden during the summer months. But Cosimo and his sons often greeted their more important guests in the palace chapel on the first floor or *piano nobile*. Although small, the chapel was richly decorated with frescos [146] by Benozzo Gozzoli (1420–97) and a lavish wooden and gilt ceiling, permitting the Medici to worship in private as princes rather than attending mass alongside their neighbours. The large hall on the *piano nobile*, decorated with canvases depicting scenes of the Labours of Hercules, was also the site of special festivities. But true distinction was only conferred upon guests when they were permitted entry into the private apartments. When the young heir to the duchy of Milan, the 13-year-old Galeazzo Maria Sforza, visited the Medici in 1459, he was impressed with his host's wealth but felt particularly honoured because he had been treated as a member of the family, since he was allowed to stay in the section of the house used by the women.

As this suggests, the experience women had in these homes might be quite different from that of their male counterparts. Although wives shared a bedroom with their husbands in many mercantile households, Leon Battista Alberti, at least, was adamant that women should not be permitted into their husbands' study. In courts such as those of Milan, Mantua, and Ferrara the divisions were much more overt as the ladies lived in separate wings or apartments; in Naples the queen and the wives of important figures such as the duke of Calabria could find themselves unable to leave the rooms they had been assigned without

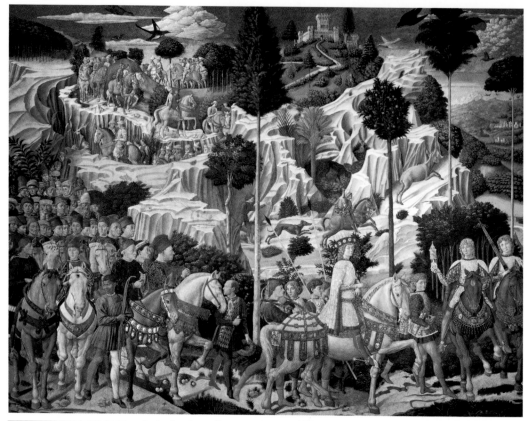

146 Benozzo Gozzoli

Medici Chapel, fresco, 1459, Palazzo Medici, Florence.

The frescos in the Palazzo Medici show the procession of the Three Magi towards the high altar where a painting by Filippo Lippi of the Nativity once stood. Although the last king, a young boy on a white horse, is often said to be Lorenzo himself, the features are non-specific. In the waiting crowd, however, Cosimo (to the left) and Piero de' Medici are clearly depicted with their horses, page-boy, and slave wearing Medici devices and colours. In the rear, the artist Benozzo Gozzoli has identified himself on his hat by picking out his name in gold.

their husband's permission. The lady and her female servants and young children were not expected to cross over into her husband's domain; male courtiers only had limited access to the female quarters. The duke of Milan, for example, refused to allow ambassadors to visit his palace in Pavia on certain days of the week, 'when the ladies are washing their hair'.

In Milan, visitors and courtiers alike complained regularly of the cold, damp, and inconvenience of their rooms. A large, lofty hall might seem grand and comfortable on a hot summer's evening but was much less inviting in midwinter. Given the potential cold and damp of even southern Italy, the most common form of luxury wall decoration in these palaces was the use of fabrics, such as those illustrated in the background to the Berlin *desco da parto* and the Palazzo Davanzati in Florence. Figured tapestries were a more expensive, and consequently more prized, form of decoration. Italian merchants passed orders and instructions on behalf of clients to weavers abroad while maintaining an equally flourishing market in second-hand tapestries. Highly organized and entrepreneurial, Flemish weavers also responded positively to Italian invitations to settle in the south or came in search of special commissions.

An almost-complete set of records for the Este court tapestries

gives a hint of the diversity of possible subject-matter.[17] Throughout the fourteenth and fifteenth centuries the rulers of Ferrara ordered wall-hangings, cushions for benches, and multi-pieced four-poster bed sets from northern weavers and from a team they kept employed in their own palaces. Many of these works simply displayed coats of arms and *imprese* which were drawn by artists in Ferrara and then sent abroad. In 1434, for example, a Lucchese merchant in Bruges arranged for the weaving of twenty-two cushions with Este armorials. The weavers were capable of adapting any design and by the mid-fifteenth century Borso d'Este was insisting that the festoons around his coats of arms be drawn and woven *all'antica*. A number of the Este tapestries had religious subjects and themes were also drawn from chivalric literature, such as the romances of King Arthur and his knights, of Charlemagne and Alexander the Great, or else they illustrated contemporary pastimes like hunting, often including portraits of members of the court. The bed in Niccolò d'Este's 'secret chamber', for example, was draped with a woven wool and silk coverlet which illustrated the lord of Ferrara standing with his favourite courtiers.

Tapestries were especially valued for their portability and relative durability. One Ferrarese set of the 1440s depicting hunting-scenes was used in a number of palaces throughout the Este's dominions and was taken by them to Padua and Venice as well as being lent to other courts and to courtiers for special festivities. The tapestries were still in use in 1528 when they were put on show for a signorial wedding. Unfortunately, out of the many hundreds of pieces woven for the Este court in the fifteenth century, only two can be definitely identified with certainty today. Both are versions of the *Pietà* [**147**] created in 1475-6 by the court weaver Robinetto of France after the cartoons of Cosmè Tura. Woven in wool, silk, silver, and gold, these were not wall-hangings but altar frontals, a sacred purpose which probably explains their survival. Although it was unusual for the local weavers to execute elaborate figured tapestries, Duke Ercole d'Este was pleased enough with the work to ask that they be brought out on a number of occasions, not to be used, but to be admired by his visitors.

The secular versions designed by Tura and woven in Flanders or in Ferrara have not survived. Their themes and styles, however, were imitated in paint and would have been revealed when the tapestries were taken down in the summer. These painted cycles have also suffered and those that remain, such as those in the late fourteenth-century Palazzo Davanzati in Florence, are often heavily repainted and have to be treated with some suspicion (in this case because it was restored by an antiques dealer at the beginning of this century as a showcase for his collection).[18] The room illustrated in **148** was probably originally painted for the 1395 wedding of the earlier owner Tommaso Davizzi whose arms, along with those of his wife Catelana

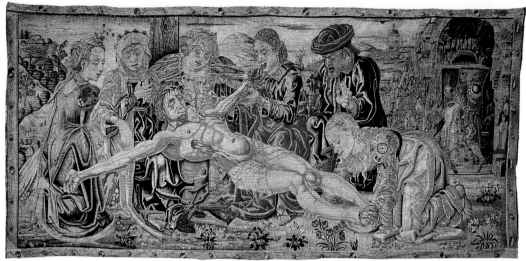

147 Robinetto di Francia
Pietà (based on the designs of Cosmè Tura), tapestry, gold, silver, silk thread, and wool, 1475–6.

degli Alberti, are shown just below the cornice. The scenes are taken, somewhat pedantically, from a popular French chivalric romance known as the *Chastelaine de Vergi*. The poem tells of a Burgundian knight's love for a lady, the Chastelaine (or castle-owner) of Vergi. But when the wife of the duke of Burgundy failed to seduce the young man over a game of chess [**149**] she accused him of rape and demanded revenge. To save himself from death or exile, the knight recounted his affair with the Chastelaine to the duke who passed the news on to his wife. In a complicated denouement, the Chastelaine de Vergi, humiliated at the revelation of her secret, committed suicide, closely followed by her knightly lover. At the end of the tale the duke pulled the sword from the young man's body, beheaded his interfering wife, and departed on a Crusade to the Holy Land.

Although such tales were hardly happy ones, the fashion for chivalric poetry remained strong throughout the fifteenth century, particularly in areas with connections to the French court. In the northern area of Saluzzo, for example, Marquis Tommaso III (ruled 1396–1416) had actually written a sprawling romance, the *Chevalier Errant*, which he arranged to have copied and illuminated in Paris.[19] In the 1420s his illegitimate son Valerano, who acted as regent for the state after Tommaso's death, used the text to decorate the great hall in his palace in Manta. Two very different episodes covered the walls. *The Fountain of Youth* [**150**] depicted the elderly hero rejuvenating himself and his family in order to continue on his quest, creating a burlesque division between the old and the young. On the other side of the fireplace appeared a more dignified procession of characters known as the Nine Worthies [**151**], figures from antiquity, the Old Testament, and history who were the ideal exemplars of chivalric rulership. In Manta, these characters took on the appearance of members of Valerano's own family and were underscored with verses taken from his

father's poetry. The hall, the site of public festivities and feasting, provided both entertainment and education, and above all references which reinforced the new regent's connection to his father, a connection which enabled him to rule despite his illegitimate birth.

Not all secular fresco cycles were taken from tapestries or textual sources. A lengthy programme for the Visconti–Sforza castle in Pavia, drawn up in 1469, indicates the type of courtly decoration which Duke Galeazzo Maria Sforza considered appropriate for his palace. Scenes of the duke and duchess hunting predominated while the ducal audience chamber was painted with an ambassadorial reception. In his wife Bona of Savoy's smaller and more cramped apartments, which she shared with ladies-in-waiting, wet-nurses, and her younger children, the images were less overtly political. Paintings of her own wedding, including scenes of her arrival by boat at the port of Genoa, and her changing from French to Lombard dress, reminded Bona's visitors of her status as a French princess and as Milanese wife while images of signorial pleasures, such as the playing of games and mushroom-hunting, lightened her dining-room.[20]

The ducal rooms in Pavia were destroyed during the sixteenth century. The Camera Picta in Mantua [152], begun in 1465 by Andrea Mantegna and completed in about 1472, is a rare survivor of the type of portrait-based fresco cycle which Galeazzo Maria intended for his palace and which became popular throughout northern Italy in the mid-fifteenth century. Although there has been much scholarly debate over the specific episodes depicted on the walls, the images are less concerned with *what* is shown than with *who* is shown and how. The ceiling, an elaborate *trompe-l'œil* of open space, stucco, and gold mosaic, was the first section to be completed. The illusionism continues on the walls with fictive brocade tapestries (in imitation of

148 Anonymous trecento Florentine

Scenes from the Story of the Chastelaine de Vergi, fresco, 1385, Palazzo Davanzati, Florence.

The palace was originally built for the Davizzi family. This bedroom, much restored, seems to have been painted for the marriage of one of the Davizzi in 1385 with simulated fabric hangings and, in the frieze above, scenes based on the popular chivalric romance of the Chastelaine, de Vergi, who killed herself after her lover revealed their affair.

149

As 148: The Young Knight
Playing Chess with his Lord's
Wife Refuses her Advance.

the more expensive luxury cloth) which appear to be pulled away to reveal scenes of the court [153] over the fireplace, dogs, and horses held patiently by Gonzaga grooms on the near left and on the far left, a meeting between the marquis of Mantua and his sons who formed part of the clergy, including Francesco, the newly created cardinal.

This room served as Ludovico Gonzaga's private bedroom and as an audience chamber. Entry was carefully controlled, ensuring that those who arrived were impressed with both their host, and with themselves. When the Milanese ambassadors visited Mantua in 1471, for example, they were taken to see the still unfinished room as part of the court entertainments. To demonstrate Mantegna's skill in portraiture the two unmarried Gonzaga daughters shown in the fresco appeared in order to compare their likenesses, an exercise which gave the marquis a decorous opportunity to display his daughters in the hopes of arranging a Milanese marriage The room was used again in 1474 to compliment another distinguished visitor, Christian, king of Denmark, whose portrait, along with that of another northern ruler related to the Gonzaga, Emperor Frederick III, was included in the background at the last minute. This shift in portraiture was not accompanied by any special indication of their status, but by now the still-unfinished Camera Picta's reputation was such that the duke of Milan wrote to his ally in fury because he had not been included as well. Although the Sforza ruler had not actually seen the paintings himself, he was well aware of the decoration's growing fame, calling it 'the most beautiful room in the world'.[21]

Furnishings and furniture

The Camera Picta in Mantua was a very small space which would have been dominated by a large bed and its canopy which once hung from a

hook in the ceiling. Such beds, chairs, and boxes were as much a part of public display as frescos, a fact which did not go unremarked by humanist writers. In 1498, in a series of treatises on the social virtues, the Neapolitan court secretary Giovanni Pontano took up the topic 'Splendour'. Here he noted that household goods typically included vases, plates, cloth, beds, and so forth and made a significant differentiation between these objects, writing, 'The vulgar man and the splendid man both use a knife at table. The difference between them is this. The knife of the first is sweaty and has a horn handle; the knife of the other man is shining and has a handle made of some noble material which has been worked with an artist's mastery.'

He then went on to attempt a further definition:

We call objects ornamental if we acquire them as much for use as for embellishment and splendour, such as statues, paintings, tapestries, divans, ivory seats, cloth woven with gems, boxes [astucci] and cases painted in the arabic style, crystal vases and other such things with which one adorns one's house according to the circumstances . . . The sight of these things is pleasant and brings prestige to the owner of the house as long as many [people] are able to frequent the house and admire them. But the ornamental objects, as is required, should be as varied and magnificent as possible and so too they must each be in their appropriate place. There is an object which should be adopted in the hall, another for the bedroom, some are destined for everyday ornaments, others kept for holidays and for solemn feasts.[22]

This text, like any fifteenth-century document, must be used with care. While it may reflect contemporary late fifteenth-century practice, it is still bound up with humanistic rhetoric. Its notions of decorum, variety, and appropriate placement could have been applied to a piece of poetry as well as to household furnishings. It is important, however, to note that Pontano makes no differentiation between what we today regard as the fine arts and the so-called decorative arts. This lack of division can also be discerned in both monetary and other forms of value attached to such objects. For example, when a member of the Florentine Minerbetti family recorded the goods he had been given by his parents for his wedding in 1493, two pieces, a bed and a day-bed, formed the bulk of the gift. They had 'a high back in walnut wood, attached along with chests around all worked in beautiful intarsia' and were valued at 50 florins. In contrast the two marriage-chests he was given only cost 18 florins, while an image of the Virgin, gilded with pure gold, was slightly cheaper at 12 florins and a mirror, encased in gilt gesso, cost 2 florins.[23]

The inventory of the household goods of a modestly wealthy Sienese citizen drawn up in 1450 does not record monetary values but features a four-poster bed with chests placed around its feet as the major element in his camere.[24] These beds were either created with

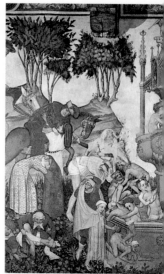

150 Anonymous Piedmontese

Frescos, *The Fountain of Youth*, *c.*1420, Castello di Manta (Saluzzo).

elaborate woodwork or were painted and gilded. The large painted bed in Giovanni di Paolo's *Birth of St John the Baptist* gives some indication of how one might have appeared in the quattrocento. Moreover we now know that Sandro Botticelli's painting of the Primavera as well as a number of the ideal cityscapes associated with the court of Urbino were once part of free-standing or day-beds. Only one of these paintings, the Ideal City [**154**] now in Berlin, is still in its original bed-frame[25] but it has recently been suggested that one of the most important political images of Naples, known as the *Tavola Strozzi*, may have been commissioned by the wealthy Florentine merchant Filippo Strozzi as part of a similarly elaborate high-backed bench, a *lettuccio*, which he gave to the king of Naples in 1473.[26] This bench, worked in intarsia, consisting of 300 pieces, and worth 150 florins, was designed and built by Benedetto da Maiano who was paid by Filippo Strozzi to subcontract either a painting or a design for intarsia work (the documentation is not clear) as part of the ensemble. The view of the Bay of Naples illustrated the return of the triumphant Aragonese fleet (in part financed by the Strozzi bank) after their defeat of the Anjou in 1464 [**155**]. If it was inserted in the upper half of the bench, it would have provided a very direct reminder of the benefits the king had received from his Florentine bankers, one he could meditate upon every time he lay down to rest.

Much of the information concerning objects such as beds and chests comes from a very specific documentary source: inventories. Drawn up for precise purposes, they may tell us more about why the documents were created than what was actually in the home and how it was valued. An inventory created for the purposes of inheritance by someone who knew the family well, or by the owner him- or herself, will probably be more detailed than a record of goods seized by a bailiff

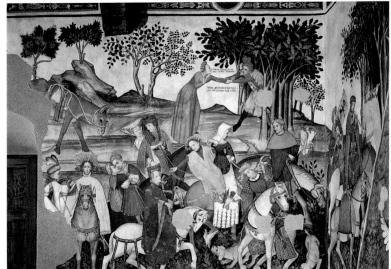

on behalf of the court. But the number and quality of surviving inventories is very important in determining our ability to attempt some recreation of the many varieties of Italian households in the trecento and the quattrocento. Objects could come from many sources and under many circumstances. For example, in dividing the possessions between two Paduan brothers, the notary made it clear that the inlaid Turkish bell and swords, the eight glass mirrors, eight lead nude figures, and other nudes in wood and bronze along with an alabaster head had been acquired by one of the pair during his period of imprisonment in the Ottoman Empire.[27] Not all prized goods were so exotic. One Florentine kept foodstuffs in his bedroom chests, storing flour, bran, vinegar, and oil in sacks and jugs around his bed.[28]

In general, fourteenth- and fifteenth-century inventories suggest that aside from the larger pieces of furniture, lamps, and candelabra, rooms would have still seemed quite bare. The vast majority of possessions were stored rather than displayed. In an inventory of Gonzaga possessions drawn up in 1406, for example, small rooms were furnished with large and expensive beds and usually contained a tabernacle, often 'in a cupboard within the wall' which could be closed. But the vast range of goods placed in one audience chamber was kept locked away in painted chests and cupboards. Hidden from view, there were at least five religious images, two wooden figures of Christ, cushions, lamps, mirrors, combs, scissors, a silver chess set, ivory boxes, Books of Hours, jewels, linen, cloth, and clothing.[29] Viewing these works, therefore, was not just a question of walking into a room and examining what was on the wall. One had to obtain special permission; the process of extracting and exhibiting the objects was part of the ritual of display.

Perhaps the most famous piece of art-historical evidence for palace

furnishings is the Medici palace inventory, in use since it was first transcribed by Aby Warburg in the late nineteenth century.[30] Originally drawn up in 1492 after Lorenzo's death, it was recopied almost twenty years later as evidence for Medici ownership of goods confiscated after Piero went into exile in 1494. It was not written, therefore, to illustrate the works of art in the Medici collection, but as a careful compilation and valuation of the many objects within the palace and the many country villas acquired over three generations. With pieces of spare marble and porphyry stored under the bed and paintings, chests, and coats of arms in the attic, it suggests a method of family accumulation where little was thrown out and much was reused and readapted.

151 Anonymous Piedmontese

The Nine Worthies: Lampeto and Tamaris, fresco, c.1420, Castello di Manta (Saluzzo).

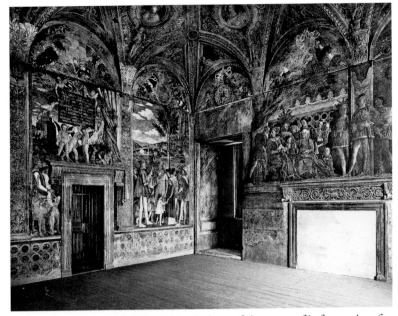

For our purposes it is a particularly useful source of information for how and where works which were not kept locked away were displayed at the end of the quattrocento. It indicates that portrait busts of family members were placed over doorways and that religious and secular paintings could be found on the walls of many rooms. These were often devotional works but also included large canvases such as the Labours of Hercules painted by Antonio Pollaiuolo for the palace's main hall. A number of paintings, such as Paolo Uccello's mid-fifteenth-century battle scenes (now in the National Gallery in London and the Louvre in Paris), were framed high up on the wall in built-in cornices. Expensive tapestries were also on the walls but at the point the inventory was taken, most of the hangings were in the family's many chests. In one cupboard, for example, Chinese porcelain, including a set of blue and white pieces, was carefully set out on seven shelves. The most precious, and most expensive items, such as the engraved stone cups, cameos, medals, mosaics, relics, and a 'unicorn's horn', were stored in specially prepared boxes and bags in the most inaccessible and private of all of the Medici rooms, the studies or *studioli*, small treasuries of rare goods and intellectual endeavour to which we turn for a more detailed exploration of the question of Renaissance accumulation and collecting.

The *studiolo*

Giovanni Pontano argued that ornamental objects only brought their owner prestige if many viewers were given access to the household. This intersection between public reputation and private ownership is at its most acute when considering the study or *studiolo*. Although the

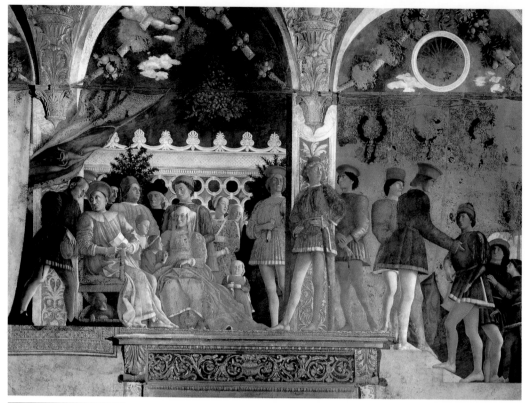

153

As 152; detail of the Court. The frescoed court scene over the fireplace shows the marquis, Ludovico Gonzaga, receiving a letter from his court chancellor. There has been considerable speculation concerning the specific moment represented, but it seems likely that Mantegna intended a general scene rather than one particular event.

room was a very intimate space which could normally hold only a small number of visitors, its contents could provide a wide public reputation. When King Charles VIII of France arrived in Florence in 1494, for example, one of his first acts according to chroniclers was to demand the contents of the Lorenzo's *studiolo*: 'And as soon as the King arrived, he called for the medals, cameos, and porcelain which belonged to Piero, which were things of great value, because Lorenzo his father had taken great delight in them.'[31] In creating his *studiolo* Lorenzo was fostering an image not just of the collector but also of the scholar, a vision exemplified by the paintings of patristic writers such as Sts Jerome and Augustine. The image of Jerome produced in mid-fifteenth-century Naples by Colantonio, for example, presents a simplified version of a contemporary fifteenth-century study area, one appropriate for an ascetic saint. Plain wooden shelves and an attached desk are crowded with scattered books and papers (including one book still in its carrying-bag behind Jerome's head). Glass vases, an hour-glass, an ink-holder, knives and scissors for trimming pens stand on the cluttered desk and shelves along with wooden boxes, the containers for more precious objects [**33**]. In contrast, the image of St Augustine, produced at the beginning of the sixteenth century as part of a series of canvases for the Venetian confraternity of San Giorgio degli Schiavoni [**156**], gives a richer and more detailed impression of a gentleman's

possessions. Here the areas for storage and study are multiplied and the objects increased in number. A musical score stands at the forefront of the picture, scientific and astrological instruments are placed to the rear, while small bronzes and manuscripts are carefully stored on shelves across the wall.

The creation of a special area where objects could be privately stored, examined, and enjoyed seems to be an extension of the multi-tiered desks such as that visible in the room to the rear on Carpaccio's canvas. Although studies became increasingly popular parts of aristocratic households, one wonders whether patrons really considered themselves textual scholars on the model of Jerome and Augustine, or whether they merely wished to suggest learning and erudition through their possessions. A description of Piero de' Medici's use of his study, written by Filarete as part of an attempt to regain Medicean patronage, presents an idealized vision of the patron's behaviour within a *studiolo*, one which emphasized visual pleasure as much as mental stimulation:

He [Piero] has himself carried into a studio . . . when he arrives he looks at his books . . . Sometimes he reads one or the other or has them read . . . Then on another day he runs over all these volumes with his eye for his pleasure, to pass the time and to give recreation to his sight. . . . He has effigies and portraits of all the emperors and noble men who have ever lived made in gold, silver, bronze, jewels, marble, or other materials. They are marvelous things to see. Their dignity is such that only looking at these portraits carved in bronze . . . fills his soul with delight and pleasure in their excellence. These give pleasure in two ways to anyone who understands and enjoys them as he does; first for the excellence of the image represented; secondly for the noble mastery of those ancient angelic spirits who with their sublime intellects [have] made such things as bronze, marble, and such materials acquire such great price. Valuable things such as gold and silver have become even greater through their mastery, for, as it is noted, there is nothing, from gems on, that

154 Central Italian artist

The Ideal City, taken from bedstead or wainscoting, 1480s?

155 Francesco Rosselli (attrib.)

Tavola Strozzi: View of Naples, tempera on panel, c.1473.

This painting shows the triumphant return on 12 July 1465 of the ships serving the king of Naples who fought against his Angevin rival at the Battle of Ischia which had taken place on 7 July. Each galley bears the Aragonese ensign and that of its captain. The artist took meticulous care in depicting the various Neapolitan monuments such as the Castel Nuovo to the left and the details of the ships themselves.

is worth more than gold. They have made it worth more than gold by means of their skill . . . Another day he looks at vases of gold, silver, and other materials made nobly and at great expense and brought from different places. . . . Then another day [he looks] at other noble things that have come from different parts of the world, various strange arms for offense and defense. The observer can only admire such things. In short, worthy and magnanimous man that he is, of many virtues and polite accomplishments, he delights in every worthy and strange thing and does not note the expense.[32]

In Filarete's description, reading plays a very minor part in Piero's enjoyment of his goods. This is perhaps unsurprising since this particular *studiolo*, which was decorated with terracotta roundels in the ceiling, had no natural light and no fireplace. The passage makes it clear that although manuscripts could be studied for their content, they were also looked at rather than read, enjoyed for their visual richness as well as for their intellectual stimulation. Similarly the other objects in Piero's collection, his coins, medals, cameos could be examined as information about the classical past, as exotic curios and as virtuoso pieces of craftsmanship.

Collecting the remains of antiquity or examples of contemporary art was not a new habit. In 1335, for example, a moneylender from Treviso, Olivero Forzetta (1300–73), left a note of the objects he hoped to buy in Venice, a list which included bronzes, medals, classical statues and books, and drawings. None the less, the documentation does increase dramatically during the quattrocento as cardinals,

princes, and wealthy merchants competed, with the assistance of artists, for the limited number of valuable antiquities which were emerging steadily but unsystematically in Rome. A letter written from that city on 31 October 1455 by an illegitimate member of the Medici family, Carlo di Cosimo, to his half-brother Giovanni, discussed the difficulties of secretly shipping an antique figure (one which had been acquired through the help of the sculptor and architect Bernardo Rossellino) (1409–64) out of Rome. He went on to note that he had purchased thirty silver medals from Pisanello's estate on the day of that artist's death. But Pieto Barbo (the future Pope Paul II and a fanatical collector of gems and medals) had already heard about this purchase and forced Carlo to hand over these precious items.[33]

The cultural prestige involved in collecting these rarities was not an exclusively masculine pursuit. By the mid-fifteenth century there were already advisers, often the humanist tutors in aristocratic households or the stationers who offered the manuscripts, who were willing to provide suggestions for the ideal study to both men and women. In 1465, for example, the eldest daughter of the duke of Milan, Ippolita Maria Sforza, created a *studiolo* in Naples after her marriage to the heir to the throne. She did so with the advice of her ex-tutor and secretary Baldo Martorelli who insisted, none the less, that this was Ippolita's own initiative:

At the moment her ladyship is finishing a beautiful *studio* and she has announced that she wishes to study. And she begs Your Illustrious ladyship [her mother, Bianca Maria Visconti] to aid her in adorning it and to send her

156 Carpaccio
St Augustine's Vision of
St Jerome, oil on canvas,
1502, San Giorgio degli
Schiavoni, Venice.

portraits painted on panels of yourself and her father and all her brothers and her sister. And although I too delight in medals and pictures I swear . . . that it was not done at my suggestion—neither the study nor the books nor the pictures.[34]

Martorelli was the precursor of the many scholars who helped the most famous female collector of the late fifteenth century, Ippolita Maria's niece Isabella d'Este, whose unusual status has already been noted. The second daughter of the duke and duchess of Ferrara, Isabella married the marquis of Mantua, Francesco II Gonzaga, in 1490 at the age of 16. Shortly after her arrival she embarked on a course of study and set about creating a set of private rooms which would act as her *studiolo* and as her so-called grotto. Initially, her ambitions were meant to mirror those of her husband. Thus she wrote soon after her marriage: 'I have begun to learn architecture, so that when your Lordship speaks to me of his buildings, I will understand you better.'[35] Gradually, however, the couple set up competing courts and when Isabella acted as regent during her husband's absences in war or imprisonment, she gained increasing independence. The decorum with which her collecting, and indeed her government, was exercised was, therefore, quite problematic. She could not be perceived to be usurping her husband's or her son's roles; but as their regent she could not be seen as weak and subservient. Isabella carefully negotiated these

dangers, hoping to improve her image as a discerning cultured woman with the help of humanist scholars, poets, and artists alike. Although her rooms were private, she did make arrangements to allow visitors to enter in her absence and tried to ensure that her reputation, and that of her collection, was as widespread as possible.

Consecrating the home

It is important to stress that classical texts, coins, medals, and statuary joined, rather than replaced, the traditional religious imagery which could be found in most households. Inventories suggest that bedrooms often contained an image of the Madonna and Child, either a painting or statue which was often kept in a tabernacle or behind a curtain which could be closed when necessary. Crucifixes or simple devotional prints may have also been common. For example in his sermons, Savonarola could assume that his audience would be able to follow his instructions when he stressed, 'as to you who do not know how to read, do you wish me to show you a good book that you do know how to read? Look at the crucifix in your room, that is your book.'[36]

This notion of the home as a place of religious education for women and children, on the model of paintings in churches, took up a theme elaborated by the earlier Dominican preacher and writer Giovanni Dominici who recommended that there should be

Paintings in the house, of holy boys, or young virgins, in which your child when still in swaddling clothes may delight in being like himself, and may be seized upon by the like thing, with actions and signs attractive to infancy. And as I say for paintings, so I say of sculptures.[37]

This statement uses the common assumption that pictures were a means for illiterate children to learn about Christian life and behaviour. But Dominici also expected his youngsters to acquire some literacy and perhaps to eventually own prayer-books which would help in their private devotions, particularly a Book of Hours, a manuscript which has been described as the most popular text of the medieval period. Indeed, children often learned to read from them and the word for a schoolbook, primer, is taken from one of the liturgical moments of prayer known as prime.[38] A Book of Hours typically contained a calendar with the saints' days clearly marked and instructions for calculating when Easter fell. It also had a collection of hymns, prayers, psalms, and short readings which were originally set for the monastic community to recite, but which private citizens could also follow. The manuscript could be varied according to its owner's personal preference and used along with other items such as a rosary, a set of beads which helped the Christian keep track of the cycle of prayers, the paternoster or Lord's Prayer, Ave Maria or Hail Mary, and the Gloria which could be recited over and over again for spiritual comfort. Lorenzo de'

Medici had over twenty-five sets of these beads including a number made from so-called unicorn's horn, crystal, and amber.

In addition to books, rosaries, and crucifixes, many homes contained special images designed to aid prayer. Just as monks in their cells might have a painting which would enhance their ability to contemplate Mary and the saints, so too, laymen and -women were encouraged by preachers and by texts such as the *Meditations on the Life of Christ*, to create a mental imagination where their world and that of Heaven merged. The rise in popularity of the half-length devotional image, such as the *Virgin Annunciate* by Antonello da Messina [157] which seems to directly address the viewer, has been associated with these practices.

Although we know such behaviour was encouraged, contemporary accounts of private domestic devotion are rare. One which does survive is that of Giovanni Morelli, who (as we have seen in the case of his sister, Mea, see Chapter 5) was concerned to leave written memories of his response to the death of relatives. In one section of his *zibaldone*, he described how, on the anniversary of the death of his 9-year-old son Alberto, he used an image of the crucifixion [158] as an aid to remembrance:

Many, many times I had commended the salvation of the soul of my son to the merciful son of God and to his pious mother, Virgin Mary. But [now] disposing my body and all my senses with greater fervor and love, [and] forgetting my own soul and every other personal interest, I knelt with bare knees before the figure of the crucified son of God to which [Alberto] had commended his bodily health during his illness. I was in my nightgown, with nothing on my head, and wore a halter around the neck. Gazing upon Him, I began my prayer by first picturing and looking at my sins . . . And when I considered with what harsh, acerbic and dark torment Jesus Christ [was] crucified, whose figure I gazed upon, had brought [us] back from eternal pain, I could not bear to look upon him with indifferent eyes. Rather, my heart and all my senses heightened to the greatest tenderness through, I believe, a pious gift He gave me, [and] my face was bathed in tears from my eyes.[39]

Morelli went on to describe how he then said psalms and prayers to Christ before asking for help for his son, finishing off with the prayer Hail Mary, while as he wrote, 'gazing continually at the image and figure of the devout Crucified [and] fixing my eyes on his precious wounds'. He then turned his eyes to the figure of Mary on the right, imagining her pain at the loss of her son, and when finally standing up,

took hold of the painting with devotion and kissed it in the same places where, during his illness, my son had sweetly kissed it after he had repeatedly asked that he regain his health. Then after I had put it back in the usual place, and again knelt down, I said the Credo and then the Gospel of St. John. While saying it my eyes were fixed on [John's] figure . . . Holding the

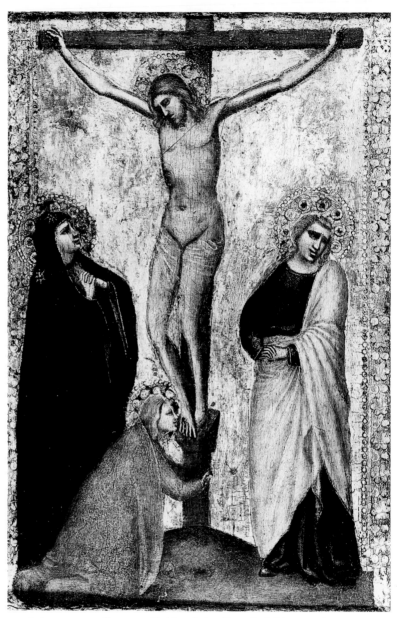

tavola in my arms, I repeatedly kissed the Crucified Christ and the figure of
his mother and of the Evangelist.

Exhausted, he then went to bed.

Although he was in his bedclothes and in his bedroom, Morelli's
actions in weeping, meditating upon, and kissing the scene of the
crucifixion were not spontaneous acts. They took place on the
anniversary of a death, when he needed to create an inner sense of
remorse which would make his penitence and prayers more effective.
He took care to use the very object Alberto had clasped before his

death as a means of communication with both his son and with Christ. The painting was not as an image for visual analysis, but a means to an end.

Although seemingly autobiographical, Morelli's writings were not diaries in the modern sense. They were meant to inspire similar behaviour in his readers, his descendants, who would be expected to emulate his passion and prayers when remembering Alberto and other family members. Given the rarity of such direct descriptions, we cannot assume that all fifteenth-century patrons and viewers behaved in the same way. Yet while Giovanni Morelli's writings show a sensitivity to emotional detail that may have been unusual, it is clear that he did not consider his actions as either bizarre or out of place in a domestic setting.

Just as fifteenth-century churches or town halls can no longer be reconstructed with total accuracy, so too the palace settings and religious observances which Morelli would have recognized have either disappeared or been modified out of all recognition. Today, curators are unlikely to allow modern viewers to emulate Morelli's behaviour in weeping over, and touching and kissing, the paintings in their collections. There are scholars and theorists who would argue, with some justification, that such changing circumstances should forestall any attempt to see works of art from a fourteenth- or fifteenth-century perspective. But as this book draws to a conclusion, I would argue that it is precisely the recognition of our distance from the Renaissance which allows a reconsideration of the different ways works of art were made and used in the past.

Notes

Chapter 1. Introduction

1. T. Verdon and J. Henderson (eds.), *Christianity and the Renaissance: Image and Religious Imagination in the Quattrocento* (Syracuse, NY, 1900), 34 n. 1.

2. J. Larner, *Italy in the Age of Dante and Petrarch, 1216–1380* (London, 1980), 3.

3. J. K. Hyde, *Literacy and its Uses: Studies on late medieval Italy*, ed. D. Waley (Manchester, 1993), 87.

4. Ibid. The information on pilgrimage is taken from ch. 4, 'Navigation of the Eastern Mediterranean in the Fourteenth and Fifteenth Centuries according to Pilgrim's Books'. See also U. Tucci, 'I servizi marittimi veneziani per il pellegrinaggio in Terrasanto nel medioevo', *Studi veneziani*, NS 9 (1985), 43–66.

5. The Italian merchant was working with a partner from the Greek Peloponnese islands. Together they commissioned three painters to make the batch of 700 icons in forty-five days. See N. Chatzidakis, *Da Candia a Venezia: Icone greche in Italia, XV–XVI secolo* (Athens, 1993), 2.

6. See D. Spencer, 'The Discovery of Brancaleon's Paintings', in *Proceedings of the First International Conference on the History of Ethiopian Art* (London, 1989), 53–5.

7. For the Ferrarese chronicle see *Chronicon Estense cum additamentis usque ad annum 1478*, in G. Bertoni and E. P. Vicini (eds.), *Rerum italicarum scriptores* (new edn., Città di Castello, 1908), vol. xv, pt. 3 p. 167; for the Florentine diary see *La cronica domestica di Messer Donato Velluti*, ed. I. del Lungo and G. Volpi (Florence, 1914), 103.

8. The thesis was originally put forward in M. Meiss, *Painting in Florence and Siena after the Black Death: The Arts, Religion and Society in the Mid-Fourteenth Century* (Princeton, 1951). It has been the source of much revisionism since. See the discussion in D. Norman (ed.), *Siena, Florence and Padua: Art, Society and Religion, 1280–1400* (New Haven, 1995), 177–95.

9. S. K. Cohn, *The Cult of Remembrance and the Black Death: Six Renaissance Cities in Central Italy* (Baltimore, 1992), 271–80.

10. R. Weiss, *The Renaissance Discovery of Classical Antiquity* (Oxford, 1969), 37.

11. R. E. Weissman, 'Sacred Eloquence. Humanist Preaching and Lay Piety in Renaissance Florence' in Verdon and Henderson (eds.), *Christianity and the Renaissance*, 266.

Chapter 2. Materials and Methods

1. E. S. Welch, *Art and Authority in Renaissance Milan* (New Haven, 1995), 23–4.

2. M. G. Ciardi Dupré dal Poggetto (ed.), *L'oreficeria nella Firenze del quattrocento* (exhibition catalogue) (Florence, 1977), 35.

3. F. C. Lane and R. C. Müller, *Money and Banking in Medieval and Renaissance Italy* (Baltimore, 1985).

4. G. Pizzi, 'Il reliquario del Capo di San Domenico', and 'Jacopo Roseto, Orafo', *Culta Bononia*, 3 (1971), 3–47 and 202–14.

5. For the Florentine sacristy doors see M. Wackernagel, *The World of the Florentine Renaissance Artist*, trans. A. Luchs (Princeton, 1981), 30 n. 19. For Ghiberti's bronze doors see M. C. M. Ruso, 'Le techniche', in *Lorenzo Ghiberti, 'materia e ragionamenti'* (exhibition catalogue) (Florence, 1978), 576–80, and A. Thomas, 'Workshop Procedures of Fifteenth-Century Florentine Artists', Ph.D. diss., Courtauld Institute of Art, London, 1976. See also the excellent discussion of Donatello's casting techniques and use of assistants in B. A. Bennett and D. E. Wilkins, *Donatello* (Oxford, 1984), 111–21.

6. S. Connell, 'The Employment of Sculptors and Stonemasons in Venice in the Fifteenth Century', Ph.D. diss., Warburg Institute, Univ. of London, 1976 (revised, New York, 1988).

7. C. E. Gilbert, *Italian Art 1400–1500: Sources and Documents* (Englewood Cliffs, NJ, 1980), 107.

8. On the relationship between terracotta

and majolica see J. Pope-Hennessy, *Luca della Robbia* (Oxford, 1980).

9. D. Jacoby, 'Raw Materials for the Glass Industries of Venice and the Terraferma about 1370–about 1460', *Journal of Glass Studies*, 35 (1993), 65–90.

10. R. G. Burnham, 'Medieval Stained Glass Practice in Florence, Italy: The Case of Orsanmichele', *Journal of Glass Studies*, 30 (1988), 77–93.

11. L. Fusco, 'The Use of Sculptural Models by Painters in Fifteenth-Century Italy', *Art Bulletin*, 64 (1982), 175–94.

12. T. Belgrano, *Della vita privata dei Genovesi* (2nd edn., Genoa, 1875), 169.

13. K. Staniland, *Embroiderers* (London, 1991), 52–3.

14. R. Offner and K. Steinweg, *A Critical and Historical Corpus of Florentine Painting: The Fourteenth Century* (Gluckstadt, 1962), sect. 4/1, p. 13.

15. P. Marani, *Leonardo e i leonardeschi a Brera* (Florence, 1987), 11.

16. A. Thomas, *The Painter's Practice in Renaissance Tuscany* (Cambridge, 1995), 157.

17. V. Lazzarini (ed.), *Documenti relativi alla pittura padovana del secolo XV* (Venice, 1908), 41 and 49.

18. Ibid. 193. For contractual clauses concerning materials see Thomas, *Painter's Practice*, and M. O'Malley, 'The Business of Art: Contracts and Payment Documents for Fourteenth and Fifteenth-Century Italian Altarpieces and Frescos', Ph.D. diss., Warburg Institute, Univ. of London, 1994.

19. M. Gregori, A. Paolucci, and C. Acidini Luchinat (eds.), *Maestri e botteghe: Pittura a Firenze alla fine del Quattrocento* (Florence, 1992).

20. P. Bensi, 'Gli arnesi dell'arte: I Gesuati di San Giusto alle mura e la pittura del Rinascimento a Firenze', *Studi di storia delle arti*, 3 (1980), 33–47. On the different pigments specified in contracts see O'Malley, 'Business of Art', 19.

21. D. Bomford, J. Dunkerton, D. Gordon, and A. Roy, *Italian Painting before 1400* (exhibition catalogue) (London, 1989).

22. J. J. G. Alexander, *Medieval Illuminators and their Methods of Work* (New Haven, 1992), 16. See also A. C. de la Mare, 'The Shop of a Florentine Cartolaio in 1426', in B. Maiacchi Biagiarelli and D. E. Rhodes (eds.), *Studi offerti a Roberto Ridolfi* (Florence, 1973), 237–48.

23. See the entry by L. Armstrong in J. J. G. Alexander (ed.), *The Painted Page: Italian Renaissance Book Illumination 1450–1550*

(exhibition catalogue) (London, 1994), 87.

24. W. Hood, *Fra Angelico at San Marco* (New Haven, 1993), 27.

25. Wackernagel, *World of the Florentine Renaissance Artist*, 307.

26. K. Gill, 'Women and Religious Literature in the Vernacular', in E. A. Matter and J. Coakley (eds.), *Creative Women in Medieval and Early Modern Italy: A Religious and Artistic Renaissance* (Philadelphia, 1994), 67–8.

27. Belgrano, *Vita privata dei Genovesi*, 133.

28. D. Landau and P. Parshall, *The Renaissance Print, 1470–1550* (New Haven, 1994), 9.

29. A. M. Hind, *Early Italian Engraving* (London, 1938–48), i. 42–3.

30. D. Chambers and B. Pullen, with J. Fletcher, *Venice: A Documentary History 1450–1630* (Oxford, 1992), 373. On the de' Barbari map see also Landau and Parshall, *Renaissance Print*, 43–6, and J. Schulz, 'Jacopo de' Barbari's *View of Venice*: Map Making, City Views, and Moralized Geography before the Year 1500', *Art Bulletin*, 60 (1978), 425–74.

Chapter 3. The Organization of Art

1. G. Pontano, *I trattati delle virtù sociali*, ed. and trans F. Tateo (Rome, 1965), 260.

2. R. Pane, 'Guido Mazzoni e la pietà di Monteoliveto', *Napoli nobilissima*, 3rd ser. 11 (1972), 49–69 n. 16. For the Barovier family see G. Mariacher, 'Barovier', *Dizionario biografico degli Italiani* (Rome, 1964), 490–2.

3. The differences and terminologies for artists' guild structures are discussed in J. Shell, 'The Scuola di San Luca, or Universitas Pictorum, in Renaissance Milan', *Arte Lombarda*, 104/1 (1993), 78–99.

4. G. Milanesi, *Documenti per la storia dell'arte senese* (Siena, 1854–6), i. 1–56. See also S. A. Fehm, Jr., 'Notes on the Statutes of the Sienese Painters' Guild', *Art Bulletin*, 54 (1972), 198–200.

5. D. Landau and J. Parshall, *The Renaissance Print, 1470–1550* (New Haven, 1994), 8.

6. S. Connell, 'The Employment of Sculptors and Stonemasons in Venice in the Fifteenth Century', Ph.D. diss., Warburg Institute, Univ. of London, 1976 (revised, New York, 1988).

7. F. Alizeri, *Notizie dei professori del disegno in Liguria dalle origine al secolo XVI* (Genoa, 1870), i. 209. For Venetian glassworkers see D. Jacoby, 'Raw Materials for the Glass Industries of Venice and the Terraferma, about 1370–about 1460', *Journal of Glass Studies*, 35 (1993), 65–90, and for conditions of majolica workers, see R. A. Goldthwaite, 'The Economic and Social World of Italian

Renaissance Maiolica', *Renaissance Quarterly*, 42/1 (1989), 1–32.

8. Documentation for Donatello's stay in Padua is published in V. Lazzarini (ed.), *Documenti* (Venice, 1908). See also B. A. Bennett and D. Wilkins, *Donatello* (Oxford, 1984).

9. *Giovanni Antonio Amadeo: Documents*, ed. R. V. Schofield, J. Shell, and G. Sironi (Como, 1989), 18.

10. For Candia see N. Chatzidakis, *Da Candia a Venezia: Icone greche in Italia, XV–XVI secolo* (Athens, 1993), 2. For Milan see J. Shell, 'The Scuola di San Luca, or Universitas Pictorum, in Renaissance Milan', *Arte Lombarda*, 104/1 (1993). For Florence see Y. M. Even, 'Artistic Collaboration in Florentine Workshops: The Quattrocento', Ph.D. diss., Columbia Univ., 1984. For Palermo see G. Bresc-Bautier, *Artistes, patriciens et confréries: Production et consommation de l'œuvre d'art à Palerme et en Sicilie occidentale (1348–1460)* (Rome, 1979).

11. C. E. Gilbert, *Italian Art 1400–1500: Sources and Documents* (Englewood Cliffs, NJ, 1980), 23.

12. R. A. Goldthwaite, 'The Economic and Social World of Italian Renaissance Maiolica', *Renaissance Quarterly*, 42/1 (1989), 8.

13. D. Jacoby, 'Raw Materials for the Glass Industries of Venice and the Terraferma, about 1370–about 1460', *Journal of Glass Studies*, 35 (1993).

14. Gilbert, *Italian Art 1400–1500*, 42–4.

15. D. A. Covi, 'Four New Documents concerning Andrea del Verrocchio', *Art Bulletin*, 48 (1966), 97–103.

16. Bresc-Bautier, *Artistes, patriciens et confréries*.

17. G. Coor, *Neroccio de' Landi, 1447–1500* (Princeton, 1961), 152–9.

18. V. Lazzarini (ed.), *Documenti* (Venice, 1908), 166–7, and Gilbert, *Italian Art 1400–1500*, 34.

19. G. Fiocco, *Mantegna: La Cappella Ovetari nella Chiesa degli Eremitani* (Milan, 1974), 7.

20. C. Pirina and F. Rattè, 'Two Stained Glass Panels from Milan Cathedral in the Rotch Library, Massachusetts Institute of Technology', *Journal of Glass Studies*, 31 (1989), 55–64.

21. S. Connell, *The Employment of Sculptors and Stonemasons in Venice in the Fifteenth Century* (New York, 1988).

22. R. Pallucci, *I Vivarini: Antonio, Bartolomeo and Alvise* (Venice, 1962).

23. Even, 'Artistic Collaboration in Florentine Workshops'.

24. Filarete (Antonio Averlino), *Treatise on Architecture*, ed. and trans. J. R. Spencer

(New Haven, 1965), i. 41.

25. L. Gaia, 'Artigiani e artisti nella società pistoiese del basso medioevo: Spunti per una ricerca', *Artigiani e salariati: Il mondo del lavoro nell'Italia dei secoli XII–XV* (Pistoia, 1984), 225–92.

26. Gilbert, *Italian Art 1400–1500*, 29.

27. B. A. Bennett and D. Wilkins, *Donatello* (Oxford, 1984), 52–3.

28. J. Pope-Hennessy, *Donatello Sculptor* (London, 1993).

29. *Giovanni Antonio Amadeo*, ed. Schofield, Shell, and Sironi, 10–11.

30. The information and documentation on the Ovetari chapel is drawn from K. V. Shaw, 'The Ovetari Chapel: Patronage, Attribution, and Chronology', Ph.D. diss., Univ. of Pennsylvania, 1994.

31. C. L. Joost-Gaugier, 'A View of the Serenissima from Padua: Two Renaissance Territorial Maps', *Studi veneziani*, NS 13 (1987), 291.

32. Bresc-Bautier, *Artistes, patriciens et confréries*, and R. Gibbs, *Tomaso da Modena: Painting in Emilia and the March of Treviso* (Cambridge, 1989), 36.

Chapter 4. Defining Relationships: Artists and Patrons

1. F. Filippini and G. Zucchini, *Miniatori e pittori a Bologna: Documenti dei secoli XIII e XIV* (Florence, 1947), 252.

2. D. Landau and J. Parshall, *The Renaissance Print, 1470–1550* (New Haven, 1994), 8.

3. A. Bernacchioni, 'Le botteghe di pittura: Luoghi, strutture e attività', in M. Gregori, A Paolucci, C. Acidini Luchinat (eds.), *Maestri e Botteghe: Pittura a Firenze alla fine del Quattrocento* (exhibition catalogue) (Florence, 1992), 27.

4. M. O'Malley, 'The Business of Art: Contracts and Payment Documents for Fourteenth and Fifteenth-Century Italian Altarpieces and Frescoes', Ph.D. diss., Warburg Institute, Univ. of London, 1994.

5. Ibid. This division between the cost of the frame and the cost of the rest of the painting is confirmed by P. Humfrey, *The Altarpiece in Renaissance Venice* (New Haven, 1993).

6. K. Staniland, *Embroiderers* (London, 1991), 52–3.

7. The contract was originally published in G. Lorenzi, *Monumenti per servire alla storia del Palazzo Ducale di Venezia* (Venice, 1868), i. 68.

8. V. Lazzarini (ed.), *Documenti* (Venice, 1908), 80, and id., 'Il mausoleo di Raffaello

Fulgosio nella basilica del Santo', *Archivio veneto-tridentino*, 4 (1923), 147–56.

9. J. R. Banker, 'The Program for the Sassetta Altarpiece in the Church of S. Francesco in Borgo S. Sepolcro', *I Tatti Studies: Essays in the Renaissance*, 4 (1991), 11–58.

10. *Ser Lapo Mazzei: Lettere di un notario a un mercante del secolo XIV*, ed. C. Guasti (Florence, 1880), ii. 404–5. See also, R. Piattoli, *Un mercante del Trecento e gli artisti del tempo suo* (Florence, 1930), 93–4.

11. On Florentine cathedral patronage see M. Haines, 'Brunelleschi and Bureaucracy: The Tradition of Public Patronage at the Florentine Cathedral', *I Tatti Studies: Essays in the Renaissance*, 3 (1989), 89–125, and *The 'Sacrestia delle Messe' of the Florentine Cathedral* (Florence, 1983).

12. G. Poggi, *Il Duomo di Firenze: Documenti sulla decorazione della chiesa e del campanile tratti dall'archivio dell'opera*, ed. M. Haines (Florence, 1988), ii. 1.

13. Haines, 'Sacrestia delle Messe', 138.

14. A. Cole, *Virtue and Magnificence: Art of the Italian Renaissance Courts* (London, 1995), 56–7.

15. On Mantegna see most recently, J. Martineau, S. Boorsch, *et al.* (eds.), *Andrea Mantegna* (exhibition catalogue) (London, 1992).

16. Gilbert, *Italian Art 1400–1500*, 9–10.

17. M. Baxandall, *Giotto and the Orators: Humanist Observers of Painting in Italy and the Discovery of Pictorial Composition, 1350–1450* (Oxford, 1986), 68.

18. J. Pope-Hennessy, *An Introduction to Italian Sculpture*, ii. *Italian Gothic Sculpture* (3rd edn., Oxford, 1986), 177–8.

19. Baxandall, *Giotto and the Orators*, 60.

20. I. Origo, *The Merchant of Prato, Francesco di Marco Datini* (rev. edn., London, 1986), 243.

21. R. Trexler, 'In Search of Father: The Experience of Abandonment in the Recollections of Giovanni di Pagolo Morelli', in id., *Dependence in Context in Renaissance Florence* (Binghamton, NY, 1994), 178.

22. R. Lightbown, *Mantegna* (Oxford, 1986), 22.

23. *The Craftsman's Handbook: 'Il libro dell'Arte' by Cennino d'Andrea Cennini*, trans. and ed. D. V. Thompson (New York, 1960), 1–2.

24. L. Ghiberti, *I commentari*, ed. O. Morisani (Naples, 1947). See the discussion in R. Krautheimer, *Lorenzo Ghiberti* (2nd edn., Princeton, 1970).

25. A. Bacchi, *Francesco del Cossa* (Soncino, 1991), 5.

26. Landau and Parshall, *Renaissance Print*, 99.

Chapter 5. The Sacred Setting

1. V. Alce, *Angelicus pictor: Vita, opera e teologia del Beato Angelico* (Bologna, 1993). The payments for the frame and window are documented in D. Cole, 'Fra Angelico: His Role in Quattrocento Painting and Problems of Chronology', Ph.D. diss., Univ. of Virginia, 1977.

2. D. Freedberg, *The Power of Images: Studies in the History and Theory of Response* (Chicago, 1989).

3. G. Milanesi, *Documenti per la storia dell'arte senese* (Siena, 1854–6), i. 1.

4. P. Scaramella, *Le Madonne del Purgatorio: Iconografia e religione in Campania tra rinascimento e controriforma* (Genoa, 1991), 149.

5. Freedberg, *Power of Images*, 87.

6. Ibid. 12.

7. D. Weinstein, 'The Art of Dying Well', in M. Tetel, R. G. Witt, and R. Goffen (eds.), *Life and Death in Fifteenth-Century Florence* (Durham, NC, 1989), 92.

8. G. Albini, 'La mortalità in un grande centro urbano nel' 400: Il caso di Milano', in R. Comba, G. Piccini, and G. Pinto (eds.), *Strutture familiare, epidemie, migrazioni nell'Italia medievale* (Naples, 1984), 117–34.

9. T. N. Tentler, *Sin and Confession on the Eve of the Reformation* (Princeton, 1977), 136.

10. R. De Roover, *San Bernardino di Siena and Sant'Antonino of Florence: The Two Great Economic Thinkers of the Middle Ages* (Boston, 1967).

11. D. Norman (ed.), *Siena, Florence and Padua: Art, Society and Religion, 1280–1400* (New Haven, 1995), i. 21–2. Fina Buzzacarina's will is translated and published in B. G. Kohl and A. A. Smith (eds.), *Major Problems in the History of the Italian Renaissance* (Lexington, DC, 1995), 337–42.

12. C. E. Gilbert, *Italian Art 1400–1500: Sources and Documents* (Englewood Cliffs, NJ, 1980), 209.

13. Tentler, *Sin and Confession*, 71.

14. K. A. Giles, 'The Strozzi Chapel in Santa Maria Novella: Florentine Painting and Patronage, 1340–1355', Ph.D. diss., New York Univ., 1977.

15. Norman (ed.), *Siena, Florence and Padua*, ii. 251.

16. The will is published in L. Frati, 'La cappella Bolognini nella basilica di San Petronio a Bologna', *Arte*, 13 (1910), 214–16. On Bolognini see A. I. Pini, 'Bartolomeo Bolognini', *Dizionario biografico degli italiani* (Rome, 1969), ii. 332–3.

17. Tentler, *Sin and Confession*, 31 and 82.

18. D. R. Lesnick, 'Civic Preaching in the

Early Renaissance: Giovanni Dominici's Florentine Sermons' in T. Verdon and J. Henderson (eds.), *Christianity and the Renaissance: Image and Religious Imagination in the Quattrocento* (Syracuse, NY, 1990), 217.

19. J. Le Goff, *The Birth of Purgatory*, trans. A. Goldhammer (London, 1984).

20. Scaramella, *Madonne del Purgatorio*.

21. R. C. Trexler, *Public Life in Renaissance Florence* (New York, 1980), 180.

22. S. K. Cohn, Jr., *The Cult of Remembrance and the Black Death* (Baltimore, 1992).

23. Scaramella, *Madonne del Purgatorio*, 50.

24. R. Polacco, 'La storia del Reliquiario Bessarione dopo il rinvenimento del verso della croce scomparsa', *Saggi e memorie di storia dell'arte*, 18 (1992), 85–95.

25. P. Fortini Brown, 'Honor and Necessity: The Dynamics of Patronage in the Confraternities of Renaissance Venice', *Studi veneziani*, 14 (1987), 179–212.

26. On St Catherine of Siena see e.g. K. Scott, 'Urban Spaces, Women's Networks and the Lay Apostolate in Siena of Catherine Benincasa', in E. A. Matter and J. Coakley (eds.), *Creative Women in Medieval and Early Modern Italy: A Religious and Artistic Renaissance* (Philadelphia, 1994), 105–19. See also K. Christiansen, L. B. Kanter, and C. B. Strelkhe (eds.), *Painting in Renaissance Siena, 1420–1500* (exhibition catalogue) (New York, 1989).

27. G. Freuler, 'Sienese Quattrocento Painting in the Service of Spiritual Propaganda', in E. Borsook and F. Superbi Gioffredi (eds.), *The Italian Altarpieces 1250–1550: Function and Design* (Oxford, 1994).

28. J. Larner, *Italy in the Age of Dante and Petrarch, 1216–1380* (London, 1980), 247–8.

29. G. Borghezio and M. Vattasso (eds.), *Giovanni di M.o Pedrino, depintore: Cronica del suo tempo* (Rome, 1929), 447.

30. L. B. Alberti, *On the Art of Building in Ten Books*, trans. J. Rykwert, N. Leach, and R. Tavernor (Cambridge, Mass., 1988).

31. Freedberg, *Power of Images*, 229.

32. Ibid. 226. See also G. Masi, 'La ceroplastica in Firenze nei secoli XV–XVI e la famiglia Benintendi', *Rivista d'arte*, 9 (1916), 124–42.

33. L. de la Ville Sur-Yllon, 'Il Bassorilievo della *Morte* a S. Pietro Martire', *Napoli nobilissima*, 1 (1892), 92–3.

34. A. Mottola Molfino and M. Natale (eds.), *Le muse e il principe: Arte di corte nel Rinascimento Padano* (exhibition catalogue) (Modena, 1991), catalogue no. 74.

35. R. Hatfield, 'The Compagnia de' Magi',

Journal of the Warburg and Courtauld Institutes, 33 (1970), 123.

36. J. Beck, 'Niccolò dell'Arca: A Re-Examination', *Art Bulletin*, 47 (1965), 343–4.

37. E. Duffy, *The Stripping of the Altars: Traditional Religion in England c.1400–c.1580* (New Haven, 1992), 407.

Chapter 6. Sites of Devotion

1. D. Hay, *The Church in Italy in the Fifteenth Century* (Cambridge, 1977), 59.

2. Ibid. 59.

3. W. Hood, *Fra Angelico at San Marco* (New Haven, 1993), 18–19.

4. Ibid. 190.

5. L. Martines, *An Italian Renaissance Sextet: Six Tales in Historical Context*, trans. M. Baca (New York, 1994), 77.

6. See V. Primhak, 'Women in Religious Communities: The Benedictine Convents in Venice, 1400–1550', Ph.D. diss., Warburg Institute, Univ. of London, 1991, and R. Trexler, 'Celibacy in the Renaissance: The Nuns of Florence', in *Dependence in Context in Renaissance Florence* (Binghamton, 1994), 343–72. See also G. A. Brucker, 'Monasteries, Friaries and Nunneries in Quattrocento Florence', in T. Verdon and J. Henderson (eds.), *Christianity and the Renaissance: Image and Religious Imagination in the Quattrocento* (Syracuse, NY, 1990), 41–62.

7. Hay, *Church in Italy*, 63.

8. Primhak, 'Women in Religious Communities', and J. R. Spencer, *Andrea del Castagno and his Patrons* (Durham, NC, 1991), 95–102.

9. Spencer, *Andrea del Castagno*, 102–14.

10. The items required for church services, 'liturgical apparatus', are discussed in R. A. Goldthwaite *Wealth and the Demand for Art in Italy, 1300–1600* (Baltimore, 1993), 72–83.

11. C. E. Gilbert, *Italian Art 1400–1500: Sources and Documents* (Englewood Cliffs, NJ, 1980), 258.

12. S. K. Cohn, Jr., *The Cult of Remembrance and the Black Death* (Baltimore, 1992), 145 and 153.

13. M. Wackernagel, *The World of the Florentine Renaissance Artist*, trans. A. Luchs (Princeton, 1981), 42–3.

14. Ibid. 212–13. Further notices for Castello Quaratesi have been discovered by F. W. Kent, 'Individuals and Families as Patrons of Culture in Quattrocento Florence', in A. Brown (ed.), *Language and Images of Renaissance Italy* (Oxford, 1995), 183. For the Rucellai and Poschi pulpits see P. Morselli, 'Corpus of

Tuscan Pulpits', Ph.D. diss., Univ. of Pittsburgh, 1978.

15. Wackernagel, *World of the Florentine Renaissance Artist*, 27.

16. J. Pope-Hennessy, *Donatello Sculptor* (London, 1993), 74.

17. M. B. Hall, *Renovation and Counter-Reformation: Vasari and Duke Cosimo in Santa Maria Novella and Santa Croce, 1565–1577* (New York, 1979), 2.

18. R. Rusconi, *Predicazione e vita religiosa nella società italiana da Carlo Magno alla Controriforma* (Turin, 1981), 176–7.

19. For the Florentine examples see L. Landucci, *Diario fiorentino dal 1450 al 1516*, ed. I. del Badia (Florence, 1883), 46, 153, and 12.

20. J. Bossy, 'The Mass as a Social Institution 1200–1700', *Past and Present*, 100 (1983), 29–61, and M. Rubin, *Corpus Christi: The Eucharist in Late Medieval Culture* (Cambridge, 1991).

21. Dante, *The Divine Comedy: Purgatorio*, trans. and ed. J. D. Sinclair (London, 1971), 155.

22. J. Henderson, *Piety and Charity in Late Medieval Florence* (Oxford, 1994), 161.

23. H. A. Ronan, 'The Tuscan Wall Tomb, 1250–1400', Ph.D. diss., Indiana Univ., Bloomington, 1982.

24. S. Strocchia, 'Death Rites and the Ritual Family', in M. Tetel, R. G. Witt, and R. Goffen (eds.), *Life and Death in Fifteenth-Century Florence* (Durham, NC, 1989), 120–45.

25. Henderson, *Piety and Charity*, 159.

26. Strocchia, 'Death Rites'.

27. G. Leoncini, *La certosa di Firenze nei suoi rapporti con l'architettura certosina* (Salzburg, 1980), 213.

28. M. Cruttwell, *Antonio Pollaiuolo* (London, 1907), 246–55.

29. Gilbert, *Italian Art*, 166.

30. Leoncini, *Certosa di Firenze*, 218.

31. Kent 1995, p. 183.

32. G. Pontano, *I trattati delle virtù sociali*, ed. F. Tateo (Rome, 1965), 249.

33. E. Borsook, 'Ritratto di Filippo Strozzi il Vecchio', in *Palazzo Strozzi: Metà millennio, 1489–1989* (Rome, 1991), 66–7.

34. V. Lazzarini, *Il mausoleo di Raffaello Fulgosio nella basilica del Santo* (Venice, 1923).

35. S. McClure Ross, 'The Redecoration of Santa Maria Novella's Cappella Maggiore', Ph.D. diss., Univ. of California, Berkeley, 1983, 222.

36. Cohn, *Cult of Remembrance*, 133.

37. A. Molho, 'The Brancacci Chapel: Studies in its Iconography and History', *Journal of the Warburg and Courtauld Institutes*, 40 (1977), 50–98.

38. K. A. Giles, 'The Strozzi Chapel in Santa Maria Novella: Florentine Painting and Patronage, 1340–1355', Ph.D. diss., New York Univ., 1977, p. 45. The information given below on the Strozzi chapel is also taken from this dissertation.

39. C. Speroni, *Wit and Wisdom of the Italian Renaissance* (Berkeley and Los Angeles, 1964), 94.

Chapter 7. Creating Authority

1. C. M. Sperling, 'Donatello's Bronze David and the Demands of Medici Politics', *Burlington Magazine*, 134 (1992), 218–24.

2. For Florentine snow-lions see A. Brown, 'City and Citizen: Changing Perceptions in the Fifteenth and Sixteenth Centuries', in A. Molho, K. Raaflaub, and J. Emlem (eds.), *City States in Classical Antiquity and Medieval Italy* (Ann Arbor, 1991), 95. For the Venetian lions see G. Priuli, *I diarii*, in *Rerum Italicarum Scriptores*, new ed., vol. xxiv, pt. 3, fasc. 310 (Città di Castello, 1921), 56. See also L. L. Carroll, 'Machiavelli's Veronese Prostitute: Venetia figurata', in R. Trexler (ed.), *Gender Rhetorics: Postures of Dominance and Submission in History* (Binghamton, NY, 1994), 93–106.

3. G. Masi, 'La pittura infamante nella legislatura e nella vita', in A. Rocco (ed.), *Studi di diritto commerciale in onore di Cesare Vivante* (Rome, 1931), and S. Y. Edgerton, Jr., *Pictures and Punishment: Art and Criminal Prosecution during the Florentine Renaissance* (Ithaca, NY, 1985).

4. D. Freedberg, *The Power of Images: Studies in the History and Theory of Response* (Chicago, 1989), 252–3.

5. Bibliothèque Nationale, Paris, fonds ital. 1588, f. 202: Francesco Sforza to Roberto da Lecce, 5 Dec. 1458.

6. Freedberg, *Power of Images*, 246.

7. G. Pontano, *I trattati delle virtù sociali*, ed. F. Tateo (Rome, 1965), 234–42.

8. L. Fusco and G. Corti, 'Lorenzo de' Medici on the Sforza Monument', *Achademia Leonardi Vinci: Journal of Leonardo Studies and Bibliography of Vinciana*, 5 (1992), 12.

Chapter 8. Rome and the Republics

1. A. Esch, 'La lastra tombale di Martino V ed i registri doganali di Roma', in M. Chiabò, G. d'Alessandro, P. Piacentini, and C. Ranieri (eds.), *Alle origini della nuova Roma di Martino V (1417–1431)* (Rome, 1992), 625–41.

2. G. Holmes, 'How the Medici became the Pope's Bankers', in N. Rubinstein (ed.), *Florentine Studies: Politics and Society in*

Renaissance Florence (London, 1968), 357–80.

3. D. S. Chambers, 'The Housing Problems of Cardinal Francesco Gonzaga', *Journal of the Warburg and Courtauld Institutes*, 39 (1976), 21–58. See also id., *A Renaissance Cardinal and his Worldly Goods: The Will and Inventory of Francesco Gonzaga (1444–1483)* (London, 1992).

4. K. Weil-Garris Brandt, 'Michelangelo's Pietà for the Cappella del Rè di Francia', in W. E. Wallace (ed.), *Michelangelo: Selected Scholarship in English* (Hamden, Conn., 1995), 217–59.

5. S. Borghesi Bichi and L. Banchi, *Nuovi documenti per la storia dell'arte senese* (Siena, 1898), 157–8.

6. A. C. Hanson, *Jacopo della Quercia's Fonte Gaia* (Oxford, 1965). The documentation is published in full in J. Beck, *Jacopo della Quercia* (New York, 1991).

7. G. Brucker, *Florence, 1138–1737* (London, 1984), 134.

8. B. Cassidy, 'The Financing of the Tabernacle of Orsanmichele', *Source Notes in the History of Art*, 8 (1988), and id., 'Orcagna's Tabernacle in Florence: Design and Function', *Zeitschrift für Kunstgeschichte*, 55 (1992), 180–211.

9. D. F. Zervas, *The Parte Guelfa: Brunelleschi and Donatello* (Locust Valley, NY, 1988), and A. Butterfield, 'Verrocchio's Christ and St Thomas: Chronology, Iconography and Political Context', *Burlington Magazine*, 134 (1992), 225–34.

10. B. A. Bennett and D. Wilkins, *Donatello* (Oxford, 1984), 82–5.

11. *La Basilica di San Petronio in Bologna* (Milan, 1986), 15. See also R. d'Amico and R. Grandi (eds.), *Il Tramonto del Medioevo a Bologna: Il cantiere di San Petronio* (Bologna, 1987).

12. C. Volpe, *Il tempio di San Giacomo Maggiore in Bologna: Studi sulla storia e le opere d'arte. Regesto documentario* (Bologna, 1967).

13. L. T. Belgrano, *Della vita privata dei Genovesi* (Genoa, 1875), 39.

14. *La scultura a Genova e in Liguria*, i. *Dalle origini al cinquecento* (Genoa, 1987).

15. Paris, Bibliothèque nationale, fonds ital. 1592, f. 67: Leonardo Botta to Duke Galeazzo Maria Sforza, 17 Nov. 1475.

Chapter 9. The Domestic Setting

1. I. Origo, *The Merchant of Prato: Francesco di Marco Datini* (revd. edn., London, 1986), 257.

2. G. Rinaldi, *L'attività commerciale nel pensiero di San Bernardino da Siena* (Rome, 1959), 22.

3. Origo, *Merchant of Prato*, 282.

4. On Rucellai see F. W. Kent, 'The Making of a Renaissance Patron of the Arts', *Giovanni Rucellai ed il suo Zibaldone*, ii. *A Florentine Patrician and his Palace* (London, 1981), 155–225. For Lorenzo see E. H. Gombrich, 'The Early Medici as Patrons of Arts', *Norm and Form* (3rd edn., London, 1978), 35–57.

5. L. B. Alberti, *On the Art of Building in Ten Books*, trans. J. Rykwert, N. Leach, and R. Tavernor (Cambridge, Mass., 1988), 129.

6. C. Kövesi Killerby, 'Practical Problems in the Enforcement of Italian Sumptuary Laws, 1200–1500', in T. Dean and K. J. P. Lowe (eds.), *Crime, Society and the Law in Renaissance Italy* (Cambridge, 1994), 110.

7. R. Rainey, 'Dressing Down the Dressed-Up: Reproving Feminine Attire in Renaissance Florence', in J. Monfasani and R. G. Musto, *Renaissance Society and Culture: Essays in Honour of Eugene F. Rice, Jr.* (New York, 1991), 232.

8. L. B. Alberti, *On Painting and On Sculpture*, trans. C. Grayson (London, 1972), 74, 80, and Filarete (A. Averlino), *Treatise on Architecture*, ed. and trans. J. R. Spencer (New York, 1965), 306–7.

9. J. Cadden, *Meanings of Sex Difference in the Middle Ages: Medicine, Science, and Culture* (Cambridge, 1993).

10. L. Martines, *Power and Imagination: City-States in Renaissance Italy* (New York, 1979), 216.

11. E. Callman, *Apollonio di Giovanni* (Oxford, 1974).

12. J. K. Lydecker, 'The Domestic Setting of the Arts in Renaissance Florence', Ph.D. diss., Johns Hopkins Univ., Baltimore, 1987.

13. R. Signorini, *Opus hoc tenue: La Camera Dipinta di Andrea Mantegna* (Parma, 1985), 63–4.

14. Origo, *Merchant of Prato*, 162.

15. C. de la Roncière, 'Tuscan Notables on the Eve of the Renaissance', in G. Duby (ed.), *A History of Private Life*, ii. *Revelations of the Medieval World*, trans. A. Goldhammer (Paris, 1988), 159–309.

16. For a reconstruction of the Medici palace in the fifteenth century see W. A. Bulst, 'Uso e transformazione del Palazzo Mediceo fino ai Riccardi', in G. Cherubini and G. Fanelli (eds.), *Il Palazzo Medici Riccardi di Firenze* (Florence, 1990), 98–124. See also F. Caglioti, 'Donatello, i Medici e Gentile de'Becchi: un po' d'ordine intorno alla 'Giuditta (e al'David) di Via Larga', *Prospettiva*, 78 (1995), 22–55.

17. The following material is drawn from N. Forti-Grazzini, *Arazzi a Ferrara* (Milan, 1982).

318 NOTES

18. L. Berti (ed.), *Il museo di Palazzo Davanzati a Firenze* (Florence, 1972).

19. M. L. Meneghetti, 'Il manoscritto Fr. 146 della Bibliothèque Nationale di Parigi, Tommaso di Saluzzo e gli affreschi della Manta', *Romania*, 110 (1989), 511–35, and G. Romano (ed.), *La sala baronale del Castello di Manta* (Milan, 1992).

20. E. S. Welch, 'Galeazzo Maria and the Castello di Pavia, 1469', *Art Bulletin*, 71 (1989), 352–74.

21. Signorini, *Opus hoc tenue*, 111.

22. G. Pontano, *I trattati delle virtù sociali*, ed. F. Tateo (Rome, 1965), 270 and 272.

23. G. Biagi, *Due corredi nuziali fiorentini, 1320–1493, da un libro di ricordanze dei Minerbetti* (Florence, 1899).

24. C. Mazzi, 'Libri e massarizie di Giovanni di Pietro di Fece nel 1450 in Siena', *Bullettino senese di storia patria*, 18 (1911), 150–72; see also id., *La casa di Maestro Bartolo di Tura* (Siena, 1900).

25. R. Krautheimer, 'The Panels in Urbino, Baltimore and Berlin Reconsidered', in H. A. Millon and V. Magnago Lampugnani (eds.), *The Renaissance from Brunelleschi to Michelangelo: The Representation of Architecture* (London, 1994), 233–57.

26. C. da Seta, 'The Urban Structure of Naples: Utopia and Reality', in Millon and Magnago Lampugnani (eds.), *Renaissance from Brunelleschi to Michelangelo*: 370.

27. A. Moschetti, 'Un quadrennio di Pietro Lombardo a Padova (1464–1467) con una appendice sulla data di nascita e di morte di Bartholomeo Bellano', *Bollettino del Museo Civico di Padova*, 16/1–6 (1913), 84–5.

28. De la Roncière, 'Tuscan Notables', 183.

29. Archivio di Stato, Mantua, Archivio Gonzaga, busta 398.

30. M. Spallanzani and G. Gaeta Bertealà (eds.), *Libro d'inventario dei beni di Lorenzo il Magnifico* (Florence, 1992).

31. M. Spallanzani, *Ceramiche orientali a Firenze nel Rinascimento* (Florence, 1978).

32. Filarete, *Treatise on Architecture*, 320.

33. On Forzetta see L. Gargan, *Cultura e arte nel Veneto al tempo del Petrarca* (Padua, 1978). For Giovanni de' Medici see F. Caglioti, 'Bernardino Rossellino a Roma: Stralci del carteggio mediceo (con qualche briciola sul Filarete)', *Prospettiva*, 69 (1991), 49.

34. E. S. Welch, 'Between Milan and Naples. Ippolita Maria Sforza, Duchess of Calabria', in D. Abulafia (ed.), *The French Descent into Renaissance Italy, 1494–1495: Antecedents and Effects* (Aldershot, 1995).

35. *Isabella d'Este: I luoghi del collezionismo* Special edition, *Civiltà mantovana*, ser. 3, 30 (1995), 81. See also S. Ferino Pagden, *'La prima donna del mondo': Isabella d'Este, Fürstin und Mäzenatin der Renaissance* (exhibition catalogue) (Vienna, 1994).

36. P. Scaramella, *Le Madonne del Purgatorio: Iconografia e religione in Campania tra rinascimento e controriforma* (Genoa, 1991), 148.

37. D. Freedberg, *The Power of Images: Studies in the History and Theory of Response* (Chicago, 1989), 4.

38. C. de Hamel, *A History of Illuminated Manuscripts* (Oxford, 1986).

39. R. Trexler, *Public Life in Renaissance Florence* (Ithaca, NY, 1980), 188–93.

List of Illustrations

The publisher would like to thank the following individuals and institutions who have kindly given permission to reproduce the illustrations listed below.

1. Luigi Mussini: *Portrait of Vittorio Emanuele II, King of Italy,* 1888. Oil-painting on canvas. Palazzo Pubblico, Siena/photo Lensini.
2. *Strozzi chapel,* 1354-9. Santa Maria Novella, Florence/Conway Library, Courtauld Institute of Art, University of London.
3. Andrea di Cione (Orcagna): *Strozzi altarpiece,* 1354-7. Tempera on panel. W. 296 cm; central panel, H. 160 cm; side panel, H. 128 cm. Strozzi chapel, Santa Maria Novella, Florence/photo Scala.
4. Filippino Lippi: *Strozzi chapel,* view with tomb by Benedetto da Maiano, 1487-1502. Santa Maria Novella, Florence/Conway Library Courtauld Institute of Art, University of London.
5. Filippino Lippi: *The Expulsion of the Devil by St Philip,* 1487-1502. Fresco. Strozzi chapel, Santa Maria Novella, Florence/photo Scala.
6. Giovanni di Paolo: *Birth of St John the Baptist, c.* 1453. Tempera on poplar panel. 30.5 × 36.5 cm. Trustees of the National Gallery, London.
7. Masaccio: *The Trinity, c.*1427. Fresco. Santa Maria Novella, Florence/photo Scala.
8. Niccolò dell'Arca: *Lamentation over the Body of Christ,* 1463. Painted terracotta. Santa Maria della Vita, Bologna/photo Scala.
9. Niccolò dell'Arca: Detail of the figure of Christ from *Lamentation over the Body of Christ,* 1463. Painted terracotta. Santa Maria della Vita, Bologna/photo Scala.
10. Niccolò dell'Arca: Detail of the figure of the Virgin Mary from *Lamentation over the Body of Christ,* 1463. Painted terracotta. Santa Maria della Vita, Bologna/photo Scala.
11. *Arca di San Domenico,* 1265-1536. Marble, (lid produced by Niccolò dell'Arca, 1469-73). San Domenico, Bologna/photo Mansell Collection, London (Alinari).

12. *Mercury Psychopompos Emerging from the Gate of Hades,* third century AD. Roman sarcophagus. Museo dell'Opera del Duomo, Florence/photo Alinari.
13. Andrea del Verrocchio: *Tomb of Piero and Giovanni de' Medici,* 1469-72. Bronze, porphyry, serpentine, marble, and *pietra serena* surround. H. 540 cm. Old sacristy, San Lorenzo, Florence/photo Scala.
14. Lorenzo Ghiberti: *Gates of Paradise,* 1425-52. Gilt bronze doors. 457 × 251 cm, without frame. Baptistery, Florence/photo Alinari.
15. Lorenzo Ghiberti: detail of the Story of Joseph from the *Gates of Paradise,* 1425-52. Gilt bronze doors. 79.5 × 79.5 cm. Museo dell'Opera del Duomo, Florence/photo Scala.
16. Rinaldo di Giovanni di Ghino and assistants: *Ex-Voto of Anichino Corsi,* 1447. Coral mounted in partly gilded silver. H. 66 × W. of base, 30 cm. Museo dell'Opera del Duomo, Florence/photo Scala.
17. Niccolò da Varallo: *St Eligius is Apprenticed as a Goldsmith,* 1480-6. Stained glass. 115.5 × 61.5 cm. Cathedral, Milan/photo Veneranda Fabbrica del Duomo, Milan.
18. Simone di Giovanni di Giovanni Ghini: *Golden Rose of Pope Pius II,* 1458. Gold and gilt silver with a sapphire tear-drop. H. 69 cm. Palazzo Pubblico, Siena/photo Scala, Florence.
19. Jacopo Roseto: *Reliquary head of St Dominic,* 1383. Silver, gilt-silver, and enamel. San Domenico, Bologna/photo Scala, Florence.
20. *Silver altar of San Jacopo,* 1287-1456. Silver, gilt-silver, enamel, and jewels. San Jacopo, Pistoia/photo Scala, Florence.
21. *Silver Paliotto* for the altar of St John the Baptist, begun 1367. Silver-gilt and enamel. Baptistery, Florence/photo Alinari.
22. Michelozzo di Bartolomeo: Detail of the figure of St John the Baptist, 1452, from the *Silver Paliotto* for the altar of St John the Baptist, begun 1367. Silver-gilt and enamel.

Museo dell'Opera del Duomo, Florence/photo Scala.

23. Maso di Finiguerra: *Pax with Coronation of the Virgin*, 1452. Museo Nazionale del Bargello, Florence/photo Alinari.

24. Filippo Brunelleschi (left) and Lorenzo Ghiberti (right): *Abraham's Sacrifice of Isaac*, 1401. Gilt bronze. 53.3 × 44.5 cm. Museo Nazionale del Bargello, Florence/photo Scala.

25. Maestro Agnolo (Angelo di Nalduccio?): *Annunciation figures*, (Virgin, 1369 and Angel Gabriel, 1370). Painted wood. Virgin, H. 180 cm; Angel, H. 176 cm. Museo Civico Diocesano, Montalcino/photo Alinari.

26. Jacopo della Quercia (with Martino di Bartolomeo): *Annunciation figures*, 1421-6. Painted wood. H. 175 cm. Collegiata, San Gimignano/photo Scala.

27. Luca della Robbia: *The Visitation*, c.1445. Enamelled terracotta. Virgin, H. 184 cm; Elizabeth, 115 × 153 cm. San Giovanni Fuorcivitas, Pistoia/photo Mansell Collection, London (Alinari).

28. Glass plate, mid-fifteenth century. Diameter, 25.6 cm. Castello del Buonconsiglio, Monumenti e Collezioni Provinciali, Trento/ photo Elena Munerati.

29. Giovanni Barovier and Giovanni Maria Obizzo (attrib.): Marriage beaker, enamelled white '*lattimo*' drinking-glass, c.1495-1505. H. 10.2 cm. © The Cleveland Museum of Art, 1996, Purchase from the J. H. Wade Fund (1955.70).

30. Master Bernardo, embroiderer: *Chasuble of Pope Sixtus IV* (based on the designs of Pietro Calzetta), 1477. Museo Antoniano, Padua.

31. Jacopo Bellini: *The Bearing of the Cross*, c.1430-50. Silver-point on prepared parchment. Musée du Louvre (Cabinet des Dessins), Paris/photo Réunion des Musées Nationaux.

p. 67. Masaccio: *Distribution of Goods and the Death of Ananias*, c.1425–8. Fresco. Brancacci chapel, Santa Maria del Carmine, Florence/ photo Scala.

32. Vincenzo Foppa and Lodovico Brea: *Della Rovere altarpiece*, 1490. Tempera on panel and polychromed wood frame. Santa Maria di Castello, Savona/photo Alinari, Florence.

33. Colantonio: *St Jerome in his Study* and *St Francis Giving the Rule to his Followers*, c.1445. Oil and tempera on panel. 120 × 150 cm. Museo di Capodimonte, Naples/photo Alinari (top); Mansell Collection, London (Alinari) (bottom).

34. Strabo: *Geography*, written in Venice or Padua, with illumination attributed to Jacopo or Giovanni Bellini, 1458-9. 37 × 25 cm. Bibliothèque Municipale, Albi (MS 77, fo.

3ᵛ)/photo Alain Noël.

35. Strabo: *Geography*, written in Venice or Padua, with illumination attributed to Jacopo or Giovanni Bellini, 1458-9. 37 × 25 cm. Bibliothèque Municipale, Albi (MS 77, fo. 4ʳ)/photo Alain Noël.

36. Jacopo de' Barbari: *View of Venice*, 1500. Woodcut from six blocks. 139 × 282 cm. Copyright British Museum, London.

37. De Sphaera manuscript, c.1450-60. Tempera on parchment. Biblioteca Estense, Modena (MS Lat 209, fo. 11)/photo Roncaglia.

38. Niccolò da Bologna: Illuminated statutes of the goldsmith's guild of Bologna, *Madonna and Child Enthroned between Saints Petronius and Alle (Eligius)*, 1383. Tempera on parchment, minature on vellum, 35.6 × 21 cm. Rosenwald Collection © 1996 Board of Trustees, The National Gallery of Art, Washington, DC.

39. Benedetto da Maiano: *Portrait of Filippo Strozzi*, 1475. Marble. H. 51.8 × L. 56.7 × W. 30.3 cm. Musée du Louvre, Paris/photo Réunion des Musées Nationaux.

40. Francesco Squarcione: *Virgin and Child*, c.1455. Tempera on wood. 82 × 70 cm; painted area, 80.5 × 65.5 cm. Gemäldegalerie, Staatliches Museen, Berlin, Preussischer Kulturbesitz.

41. Marco Zoppo: *Madonna Lactans* (Wimbourne Madonna), 1478. Tempera on panel. 89.2 × 72.5 cm. Musée du Louvre, Paris/photo Réunion des Musées Nationaux.

42. Andrea Mantegna: *San Zeno altarpiece* for basilica of San Zeno, Verona, 1456. Tempera on panel. Central panel, 212 × 125; left panel, 213 × 134; right panel, 213 × 135 cm. San Zeno, Verona/photo Scala, Florence.

43. Filarete (Antonio Averlino): *Doors of St Peter's*, 1433-45. Bronze. Basilica of St Peter's, Rome/photo Monumenti Musei e Gallerie Pontificie, Vatican City, Rome.

44. Donatello and Michelozzo: *Tomb of Baldassare Cossa, anti-pope John XXIII*, 1421-8. Marble (with gilding and polychromy) and gilt bronze. H. 732 cm; base, W. 234 cm; effigy, L. 213 cm. Baptistery, Florence/photo Scala.

45. Andrea Mantegna, Ansuino da Forli, and Bono da Ferrara: *The Life of St Christopher*, 1448-57. Fresco. Ovetari chapel, church of the Eremitani, Padua/full view from Mantegna: *La Cappella Ovetari della Chiesa degli Eremitani* (2/1978, Silvano Editoriale d'Arte, Milan/ Amilcare Pizzi SpA).

46. Nicolò Pizzolo: *St James Speaking with the Demons*, 1448. Detail from *The Life of St James*, fresco. Ovetari chapel, church of the Eremitani, Padua/photo Mansell Collection, London (Alinari).

p. 105. Bartolomeo da San Vito (notary) after sketch by Niccolò Pizzolo: *Contract for the Lazzara altarpiece Showing the Mill of Christ*, 1466. Pen and ink on paper. The J. Paul Getty Museum, Malibu, CA/photo Christie's, London.

47. Florentine: *St Catherine of Siena*, c.1461-70. Engraving. 249 × 188 cm. Copyright British Museum, London.

48. Antonio Rossellino: *Madonna and Child*, c.1460-79. Polychromed and gilt stucco. 72 × 52 cm. Museo Horne, Florence/photo Scala.

49. Bartolomeo Bon: *Porta della Carta*, 1438-48. Istrian stone with traces of original pigmentation, Veronese and Carrarese marble. Palazzo Ducale, Venice/photo Alinari, Florence.

50. Sassetta: *The Legend of the Wolf of Gubbio*, 1437-40. Tempera on poplar panel. 86.5 × 52 cm. Trustees of the National Gallery, Florence/National Gallery of Art, London.

51. *Sacrestia delle Messe*, cathedral of Santa Maria del Fiore, Florence. Photo Antonio Quattrone.

52. *Sacrestia delle Messe*, cathedral of Santa Maria del Fiore, Florence, view of interior. Photo Antonio Quattrone.

53. Luca della Robbia: *Bronze Doors*, begun 1445-6, completed 1475. Bronze. 410 × 200 cm. Sacrestia delle Messe, cathedral of Santa Maria del Fiore, Florence/Photo Alinari.

54. Antonio Pisanello: Design with Aragonese devices and motto 'Guarden Les Forces', c.1450-5. Brown wash, charcoal, and pen. 21 × 15 cm. Musée du Louvre, Paris/photo Réunion des Musées Nationaux.

55. Francesco del Cossa and Cosmè Tura: *The Month of April*, c.1467-72. Fresco. Palazzo Schifanoia, Ferrara/photo Scala, Florence.

56. Francesco del Cossa: *The Triumph of Minerva (The Month of March)*, c.1467-72. Fresco. Palazzo Schifanoia, Ferrara/photo Scala, Florence.

57. Fra Angelico: *Linaiuoli* tabernacle, 1433. Tempera on panel. Open panels, 260 × 266 cm; closed panels, 260 × 133 cm. Museo di San Marco, Florence/photo Scala.

58. Baptistery, Padua. View of interior with frescos by Giusto de Menabuoi of the life of Christ and Saint John the Baptist. Baptistery, Padua/Photo Alinari, Florence.

59. Giusto de Menabuoi: *Fina Buzzacarina Presented to the Virgin by St John the Baptist*, c.1376. Fresco. Baptistery, Padua/photo Scala, Florence.

60. Neroccio di Bartolomeo de' Landi: *The Preaching of St Bernardino in the Piazza del Campo and the Liberation of a Madwoman at the Funeral of St Bernardino*, c.1470. Tempera on panel. 39 × 78 cm. Museo Civico, Siena/Photo Lensini.

61. Fra Angelico: *The Last Judgement*, 1431. Tempera on panel. 105 × 210 cm. Museo di San Marco, Florence/photo Scala.

62. Agnolo Gaddi: *The Recognition of the Holy Wood by the Queen of Sheba and the Concealment of the Holy Wood*, c.1388-92. Fresco. Santa Croce, Florence/photo Alinari.

63. The *Stauroteca*, or reliquary of the true cross, of Cardinal Bessarion. Galleria dell'Accademia, Venice/photo Scala, Florence.

64. Giovanni or Gentile Bellini (attrib.): *Cardinal Bessarion Presenting the Stauroteca to the Confraternity of the Scuola Grande di Santa Maria della Carità*, c.1472. Tempera and oil on panel. 102.5 × 37 cm. Kunsthistorisches Museum, Vienna.

65. Gentile Bellini: *Procession of the True Cross in Piazza San Marco*, 1496. Oil on canvas. 367 × 745 cm. Galleria dell'Accademia, Venice/photo Scala, Florence.

66. Giovanni di Paolo: *St Catherine of Siena Receiving the Stigmata*, c.1461. Tempera on panel. 27.8 × 20 cm. Metropolitan Museum of Art, New York. Robert Lehman Collection (1975.1.34)/photo Malcolm Varon.

67. Sano di Pietro: *Altarpiece of St Bernardino*, 1445. Tempera on panel. Cathedral (chapter house), Siena/photo Lensini (after Gaudenz Freuler and Michael Mallory).

68. Vittore Carpaccio: *Vision of Prior Ottobon of the 10,000 Christian Martyrs*, c.1515. Oil on canvas. 307 × 205 cm. Galleria dell'Accademia, Venice/photo Scala, Florence.

69. The 'Memoria' of Franceschino da Brignale, 1361. Marble. Museo di Capodimonte, Naples.

70. Antonio Orsini (attrib.): *Ex-Voto of Suor Sara of Ferrara with St Francis*, 1432. Tempera on panel. Musée des Arts Décoratifs, Paris (Sally Jaulmas). All rights reserved.

71. Florentine, *Mass of St Gregory*, c.1460-70. Engraving. c. 194 × 250 cm. Topkapi Seray Museum, Istanbul.

72. Ambrogio da Fossano, Il Bergognone: *Christ Carrying the Cross with Carthusian Monks*, c.1490-5. Tempera on panel. 16.6 × 11.8 cm. Museo Civico, Pavia.

73. Andrea di Bonaiuti: *The Crucifixion and The Church Militant*, 1366-8. Frescos. Chapter house (Spanish chapel), Santa Maria Novella, Florence/photo Alinari.

74. Andrea di Bonaiuti: *The Triumph of St Thomas Aquinas*, 1366-8. Fresco. Chapter house

(Spanish chapel), Santa Maria Novella, Florence/photo Alinari.

75. Andrea di Bonaiuti: *Resurrection, Ascension, Pentecost, and the Calling of St Peter*, 1366-8. Frescos. Chapter house ceiling (Spanish chapel), Santa Maria Novella, Florence/photo Scala.

76. Fra Angelico: *Crucifixion*, 1440s. Fresco. Chapter house, Museo di San Marco, Florence/photo Scala.

77. Fra Angelico: *The Annunciation*, 1440s. Fresco. North dormitory, Museo di San Marco, Florence/photo Scala.

78. Chapel of San Tarasio, frescos by Andrea del Castagno, polyptych by Antonio Vivarini and Giovanni d'Allemagna, 1442. San Zaccaria, Venice/photo Mansell Collection, London (Alinari).

79. Antonio Vivarini and Giovanni d'Alemagna: *Altarpiece of St Sabina*, 1443. Tempera on panel and polychromed wood. Chapel of San Tarasio, San Zaccaria, Venice/photo Osvaldo Böhm.

80. Andrea del Castagno: *Last Supper*, 1447. Fresco. Refectory, Sant'Appollonia, Florence/photo Mansell Collection, London (Alinari).

81. Andrea di Lazzaro Cavalcanti (il Buggiano) after designs by Filippo Brunelleschi: *Rucellai Pulpit*, 1443-8. Gilt marble. Santa Maria Novella, Florence/photo Mansell Collection, London (Alinari).

82. Quirizio da Murano: *Christ Showing his Wounds and the Host to a Clarissan Nun*, c.1461-78. Tempera and oil on panel. 114 × 87 cm. Galleria dell'Accademia, Venice/photo Alinari, Florence.

83. Michelozzo di Bartolomeo: *Bartolomeo Aragazzi Bidding Farewell*, 1437-8. Relief from the tomb of Bartolomeo Aragazzi, marble. Duomo, Montepulciano/photo Alinari, Florence.

84. Andrea Orcagna (attrib.): *Tomb of Niccolò Acciaiuoli*, c.1353. *certosa* of San Lorenzo, Florence/photo Alinari.

85. Bernardo Rossellino: *Tomb of Leonardo Bruni*, 1444-6. Marble. c. H. 610 cm. Santa Croce, Florence/photo Mansell Collection, London (Alinari).

86. Domenico Ghirlandaio: *The Life of St John the Baptist*, 1485. Fresco, left wall. Santa Maria Novella, Florence/photo Alinari.

87. Domenico Ghirlandaio: *The Birth of the Virgin*, 1485. Fresco, detail from right wall. Santa Maria Novella, Florence/photo Scala.

88. Jacopo della Quercia: *Tomb of Ilaria da Carretto*, 1406-8. Carrarese marble, originally in the Franciscan monastery of Lucca. Base, 244 × 88 × 66.5 cm; effigy, 204 × 69 cm.

Cathedral, Lucca/photo Alinari, Florence.

89. Giovanni Antonio Amadeo: *Tomb of Medea Colleoni*, 1472. Marble. Colleoni chapel, Bergamo/photo Mansell Collection, London (Alinari).

90. Silvestro Dell'Aquila: *Tomb monument to Maria Pereira Camponeschi and her daughter Beatrice*, 1494. Marble. San Bernardino, Aquila/photo Alinari, Florence.

91. Altichiero and anonymous Veronese sculptor, Cavalli chapel, c.1375, frescos, and 1390, tomb monument. Basilica of Sant'Anastasia, Verona/photo Alinari.

92. Masaccio, Masolino, and Filippino Lippi: *The Life of St Peter*, 1424-8, completed 1481-2. Fresco, view of the left side. Brancacci chapel, Santa Maria del Carmine, Florence/photo Scala.

93. Masaccio, Masolino, and Filippino Lippi: *The Life of St Peter*, 1424-8, completed 1481-2. Fresco, view of the right side. Brancacci chapel, Santa Maria del Carmine, Florence/ photo Scala.

94. Masaccio *Expulsion of Adam and Eve*, 1424-8. Fresco. Brancacci chapel, Santa Maria del Carmine, Florence/ photo Scala.

95. Donatello: *David with the Head of Goliath*, c.1420s. Bronze. H. 158.2 cm. Museo Nazionale del Bargello, Florence/photo Alinari.

96. *De Sphaera* manuscript, c.1450-60. Tempera on parchment. Biblioteca Estense, Modena (MS Lat 209, fo. 6)/photo Roncaglia.

97. Jar with wing handles, Valencia, after 1465. Tin-glazed earthenware. H. 57 cm. Copyright British Museum, London.

98. Donatello: *Marzocco*, 1418. Sandstone (*pietra di macigno*) with red and white marble inlay. H. 135.5 cm. Museo Nazionale del Bargello, Florence/photo Alinari.

99. Anovelo da Imbonate: *The Investiture of Gian Galeazzo Visconti*, 1395. Ambrosian Missal. Biblioteca Capitolare, Sant'Ambrogio, Milan (MS Lat 6, fo. 7ᵛ)/photo Alinari, Florence.

100. Justus of Ghent (also attributed to Pedro Berruguete): *The Duke of Urbino with his Son and Heir Guidobaldo*, c.1476. Oil on panel. 130 × 75.5 cm. Galleria Nazionale della Marcha, Urbino/photo Alinari, Florence.

101. Giovanni and Pacio da Firenze, *Tomb of Robert of Anjou*, 1343-5. Polychromed marble and glass. Santa Chiara, Naples/photo Mansell Collection, London (Alinari); detail, Alinari.

102. *Tomb of King Ladislas of Naples*, 1420s. Polychromed marble. H. 1800 cm. San Giovanni a Carbonara, Naples/Courtauld Institute of Art, University of London.

103. Detail from *Tomb of King Ladislas of*

Naples, 1420s. Polychromed marble. H. 1800 cm. San Giovanni a Cabonara, Naples/photo Scala, Florence.

104. Pisanello (attrib.): *Drawing for the Arch of Alfonso of Aragon*, c.1449-50. Pen and ink over black chalk and brown wash. 31.1 × 16.2 cm. Museum Boymans Van Beuningen, Rotterdam.

105. *Arch of Alfonso of Aragon*, c.1450-60s. Istrian marble. Castelnuovo, Naples/photo Mansell Collection, London (Alinari).

106. Detail of *Arch of Alfonso of Aragon*, c.1450-60s. Istrian marble. Castelnuovo, Naples/photo Alinari, Florence.

107. Guglielmo lo Monaco: *Gates to the Fortress of Castelnuovo*, 1474-84. Bronze. Palazzo Reale, Naples/photo Alinari, Florence.

108. Bonino da Campione: *Monument and tomb of Bernabò Visconti*, 1363. Polychromed marble. Photo Castello Sforzesco, Milan.

109. Leonardo da Vinci: *Sketch for the Mould for the Monument to Francesco Sforza*. Biblioteca Nacional, Madrid (Cod 8936, II, fo 149r).

110. Leonardo da Vinci: *Study for the Monument to Francesco Sforza*, c. 1485-9. Silver-point. Royal Collection Enterprises Ltd., Windsor © Her Majesty Queen Elizabeth II.

111. Gian Cristoforo Romano, *Medal of Isabella d'Este*, 1498. Gold, diamonds, and enamel, obverse and reverse. Diameter, 6.8 cm. Kunsthistorisches Museum, Vienna.

112. Taddeo di Bartolo: *Map of Rome*, 1413-14. Fresco. Palazzo Pubblico, Siena/photo Lensini.

113. Workshop of Donatello: *Tomb of Martin V*, 1445. Bronze. St John Lateran, Rome/photo Alinari, Florence.

114. Filarete (Antonio Averlino): *Doors to the Basilica of St Peter's*, 1433-45. Bronze and enamel. Basilica of St Peter's, Rome/photo Mansell Collection, London (Alinari).

115. Filarete (Antonio Averlino): Lower panel from the *Doors to the Basilica of St Peter's*, 1433-45. Bronze and enamel. Basilica of St Peter's, Rome/photo Monumenti Musei e Gallerie Pontificie, Vatican City, Rome.

116. Michelangelo Buonarroti: *Bacchus*, 1496. Carrarese marble. H. 203 cm with base. Museo Nazionale del Bargello, Florence/photo Alinari.

117. Michelangelo Buonarroti: *Pietà*, 1498-1500. Carrarese marble. 174 × 195 cm. Basilica of St Peter's, Rome/photo Mansell Collection, London (Alinari).

118. Jacopo della Quercia: Left Side of a *Design for the Fonte Gaia in Siena*, 1409. Pen and ink and sepia wash on vellum. 20 × 21.3 cm.

Metropolitan Museum of Art, New York, Harris Brisbane Dick Fund, 1949 (49.141).

119. Jacopo della Quercia: Right Side of a *Design for the Fonte Gaia in Siena*, 1409. Pen and ink and sepia wash on vellum. 20 × 21.3 cm. Board of Trustees of the Victoria and Albert Museum, London.

120. Jacopo della Quercia: *Fonte Gaia*, 1419. Campo, Siena/photo Mansell Collection, London (Alinari).

121. Interior of the church of Orsanmichele, Florence, with view of Orcagna's tabernacle. Photo Scala.

122. Andrea di Cione (Orcagna): *The Dormition of the Virgin and the Passing of the Girdle to St Thomas*, 1355-66. Marble, polychromed gilt-marble, glass, and bronze. Orsanmichele, Florence/photo Alinari.

123. Lorenzo Ghiberti: *St Matthew*, 1419-23. Bronze. Orsanmichele, Florence/photo Alinari.

124. Sandro Botticelli: *Portrait of a Young Man Holding a Medal of Cosimo the Elder*, c.1474-5. Oil on panel with gessoed medal. 57.5 × 44 cm. Galleria degli Uffizi, Florence/photo Scala.

125. Andrea del Verrocchio: *Christ and the Doubting Thomas*, 1467-83. Bronze. Figures, H. 230 cm. Orsanmichele, Florence/Museo del Opera di Santa Croce, Florence/photo Scala.

126. Donatello: *St Louis of Toulouse* in a replica of the marble tabernacle designed by Michelozzo and Donatello, c.1422-5. Gilt bronze with enamel and glass. Originally for Orsanmichele, Florence. H. 266 cm. Museo dell'Opera di Santa Croce/photo Scala.

127. Donatello: *Judith and Holofernes*, c.1420-30. Gilt bronze. H. 236 cm. Museo Nazionale del Bargello, Florence/photo Scala.

128. Jacopo della Quercia: *Basilica of San Petronio*, Bologna. Photo Alinari, Florence.

129. View of the interior of the Basilica of San Petronio, Bologna, with Bolognini chapel. Fabbriceria di san Petronio/© 1983 Cassa di Risparmio, Bologna/photo Franco Ragazzi (from *La Basilica di San Petronio*, Bologna, Silvana Editoriale, 1981).

130. Giovanni da Modena: *Inferno*, 1411. Detail from the Bolognini chapel, San Petronio, Bologna/photo Scala, Florence.

131. Lorenzo Costa: *The Triumph of Fame*, 1487-90. Tempera on canvas. Bentivoglio chapel, San Giacomo, Bologna/photo Scala, Florence.

132. Lorenzo Costa: *The Triumph of Death*, 1487-90. Tempera on canvas. Bentivoglio chapel, San Giacomo, Bologna/photo Scala, Florence.

133. Michele d'Aria: *Statue of Ambrogio di Negro*, 1483-90. Marble. Palazzo di San Giorgio, Genoa/© Cassa du Risparmio di Genova e Imperia, Genoa.

134. Antonio Rizzo: *Tomb of Niccolò Tron*, begun 1476. Istrian stone and marble (originally painted and gilded). Santa Maria Gloriosa dei Frari, Venice/photo Alinari, Florence.

135. Pietro Lombardo: *Tomb of Doge Pietro Mocenigo*, c.1476-81. Istrian stone and marble. San Giovanni e Paolo, Venice/photo Mansell Collection, London (Alinari).

136. Donatello: *Equestrian statue of Erasmo de' Narni, il Gattamelata*, c.1445-53. Bronze and marble base. Statue, H. 340 cm. Piazza di San Antonio, Padua/photo Alinari, Florence.

137. Andrea del Verrocchio: *Equestrian monument to Bartolomeo Colleoni*, 1496. Bronze and marble. Statue, H. 395 cm. Campo di San Giovanni e Paolo, Venice/photo Alinari, Florence.

138. Francesco Laurana: Female bust, c.1470s. Polychromed marble and painted wax. Kunsthistorisches Museum, Vienna.

139. Jacopo del Sellaio: Morelli-Nerli cassone, 1472. Courtauld Institute Galleries, University of London.

140. Circle of Andrea Mantegna: *The Justice of Trajan*, 1477. Painted wood and stucco. 69 × 210 cm. Museum Rudolfinum, Klagenfurt/ Landesmuseum für Kärnten, Klagenfurt.

141. Circle of Andrea Mantegna: Detail of *The Justice of Trajan*, 1477. Painted wood and stucco. Museum Rudolfinum, Klagenfurt/ Landesmuseum für Kärnten, Klagenfurt.

142. Masaccio (attrib.): *A Birth Scene, desco da parto*, c.1426. Tempera on panel, recto and verso. Diameter including frame, 65 cm; picture surface, 56.5 cm. Gemäldegalerie, Staatliche Museen zu Berlin, Preussischer Kulturbesitz/photo Jörg P. Anders.

143. Giovanni di ser Giovanni, called Lo Scheggia: *Triumph of Fame, desco da parto*, 1449. Tempera, silver and gold on wood. Diameter 62.2 cm (painted area only). The Metropolitan Museum of Art, Purchase, in memory of Sir John Pope-Hennessy: Rogers Fund, The Annenberg Foundation, Drue Heinz Foundation, Annette de la Renta, Mr and Mrs Frank E. Richardson, and The Vincent Astor Foundation Gifts, Wrightsman and Gwynne Andrews Funds, special funds, and Gift of the children of Mrs Harry Payne Whitney, Gift of Mr and Mrs Joshua Logan, and other gifts and bequests, by exchange, 1995. (1995.7).

144. Palazzo Medici, Florence: exterior. Photo Alinari.

145. Palazzo Medici, Florence: courtyard. Photo Alinari.

146. Benozzo Gozzoli: *Medici Chapel*, 1459. Fresco. Palazzo Medici, Florence/photo Scala.

147. Robinetto di Francia (based on the designs of Cosmè Tura): *Pietà*, 1475. Tapestry, gold, silver, silk thread, and wool. 97 × 206 cm. Thyssen-Bornemisza Collection, Lugano.

148. Anonymous trecento Florentine: *Scenes from the Story of the Chastelaine de Vergi*, 1385. Fresco. Palazzo Davanzati, Florence/photo Alinari.

149. Anonymous trecento Florentine: *The Young Knight Playing Chess with his Lord's Wife Refuses her Advance*, 1385. Fresco. Palazzo Davanzati, Florence/photo Scala.

150. Anonymous Piedmontese: *Fountain of Youth*, c.1420. Frescos. Castello di Manta (Saluzzo)/photo Scala, Florence.

151. Anonymous Piedmontese: *The Nine Worthies: Lampeto and Tamaris*, c.1420. Fresco. Castello di Manta (Saluzzo)/photo Scala, Florence.

152. Andrea Mantegna: *Camera Picta* (full view), c.1465-74. Fresco. Room, 808 × 808 cm. Castello di San Giorgio, Mantua/photo Alinari, Florence.

153. Andrea Mantegna: *Camera Picta* (detail of the Court), c.1465-74. Fresco. Castello di San Giorgio, Mantua/photo Scala, Florence.

154. Central Italian artist: *The Ideal City*, 1480s? Taken from bedstead or wainscoting. 124 × 234 cm. Gemäldegalerie, Staatliche Museen zu Berlin, Preussischer Kulturbesitz/photo Jörg P. Anders.

155. Francesco Rosselli (attrib.): *Tavola Strozzi: View of Naples*, c.1473. Tempera on panel. 82 × 240 cm. Museo di Capodimonte, Naples/photo Scala, Florence.

156. Carpaccio: *St Augustine's Vision of St Jerome*, 1502. Oil on canvas. San Giorgio degli Schiavoni, Venice/photo Scala, Florence.

157. Antonello da Messina: *Virgin Annunciate*, c.1474. Oil on panel. Galleria Regionale della Sicilia, Palermo.

158. Allegretto Nuzi: *Crucifixion*, 1365. Tempera on panel. 27 × 17.7 cm. Birmingham Museum of Art, AL. Gift of the Samuel H. Kress Foundation.

The publisher and author apologize for any errors or omissions in the above list. If contacted they will be pleased to rectify these at the earliest opportunity.

Bibliographic Essay

This is not a full bibliography on Italian art and society between 1350-1500. It is designed to suggest further reading, primarily in English, on the topics covered by this book. It is arranged by chapters although obviously some works will be relevant to more than one section.

General

Because this book focuses primarily on the social and historical context in which art was made and used, surveys which take a more traditional biography-based approach provide a necessary complement. The Macmillan *Dictionary of Art* (London, 1996) provides entries on individual artists of the period, while a particularly useful reference work for the material covered by this book is J. R. Hale (ed.), *A Concise Encyclopedia of the Italian Renaissance* (London, 1981). Other well-illustrated surveys include:

F. Hartt, *History of Italian Renaissance Art: Painting, Sculpture, Architecture*, 4th edn., revised by D. Wilkins (London, 1994).

R. J. M. Olson, *Italian Renaissance Sculpture* (London, 1992).

J. Pope-Hennessy, *An Introduction to Italian Sculpture*, i. *Italian Gothic Sculpture*, ii. *Italian Renaissance Sculpture*, 2 vols., 3rd edn. (Oxford, 1986).

J. White, *Art and Architecture in Italy, 1250-1400*, 2nd edn. (London, 1987).

There has been a long-standing emphasis on Renaissance patronage and social history since the nineteenth century although one of the most influential texts, M. Wackernagel, *The World of the Florentine Renaissance Artist: Projects and Patrons, Workshop and Art Market*, trans. A. Luchs (Princeton, 1981) (originally published in German in 1938), has only been available in English relatively recently. Historians and art historians working in this tradition who have added innovative ideas about the relationship between art, language, and visual perception include M. Baxandall, *Painting and Experience in Fifteenth-Century Italy: A Primer in the Social History of Pictorial Style* (2nd edn., Oxford, 1988) and P. Burke, *The Italian Renaissance: Culture and Society in Italy* (rev. edn., Cambridge, 1987): both these works have become classic studies.

Other, more general, considerations of art and patronage include B. Cole, *Italian Art, 1250-1550: The Relation of Renaissance Art to Life and Society* (New York, 1987) and M. Hollingsworth, *Patronage in Renaissance Italy: From 1400 to the Early Sixteenth Century* (London, 1994). Although it concentrates exclusively on painting, J. Dunkerton, S. Foister, D. Gordon, N. Penny, *Giotto to Dürer: Early Renaissance Painting in the National Gallery, London* (New Haven, 1991) is highly recommended. L. Campbell, *Renaissance Portraits: European Portrait-Painting in the 14th, 15th, and 16th Centuries* (New Haven, 1990) offers an excellent overview of European portraiture from the late fourteenth until the sixteenth century. J. Sherman, *Only Connect... Art and the Spectator in the Italian Renaissance* (Princeton, 1992), publishes lectures given in 1988 which explore the relationship between the artist's appreciation of the position and role of the spectator, with particularly relevant material on Donatello.

The most recent, and most controversial, innovations in the field of Renaissance studies have been the economic and social arguments for artistic change developed by historians working with archival documents such as inventories, wills, and contracts. R. A. Goldthwaite, *Wealth and the Demand for Art in Italy, 1300-1600* (Baltimore, 1993), concludes that a great burst of Italian artistic creativity was the result of the peninsula's particular economic strengths and the high level of sophisticated consumer demand from an urban patriciate. S. K. Cohn, Jr., *The Cult of Remembrance and the Black Death: Six Renaissance Cities in Central Italy* (Baltimore, 1992), uses a study of wills to suggest that an increase in artistic output after 1348 was conditioned by changing religious and social expectations. In a series of books and articles, F. W. Kent has re-examined the networks of

family and friendship which, in his terms, defined Renaissance patronage. See, for example, F. W. Kent and P. Simons with J. C. Eade (eds.), *Patronage, Art and Society in Renaissance Italy* (Canberra, 1987) and F. W. Kent, 'Individuals and Families as Patrons of Culture in Quattrocento Florence', in A. Brown (ed.), *Language and Images of Renaissance Italy* (Oxford, 1995), 171–92.

More recently, L. Jardine, *Worldly Goods. A new History of the Renaissance* (London, 1996) and J. Hale, *The Civilization of Europe in the Renaissance* (London, 1993) take a wider European perspective.

Texts and Sources

Two important compilations of Renaissance documents are those of D. S. Chambers, *Patrons and Artists in the Italian Renaissance* (London, 1970) and C. E. Gilbert, *Italian Art 1400–1500: Sources and Documents* (Englewood Cliffs, NJ, 1980). Both historiographic and source material for Renaissance history have been published by B. J. Kohl and A. A. Smith, *Major Problems in the History of the Italian Renaissance* (Lexington, DC, 1995). Two major regional collections, G. Brucker (ed.), *The Society of Renaissance Florence: A Documentary Study* (New York, 1971) and D. Chambers and B. Pullen, with J. Fletcher (eds.), *Venice: A Documentary History 1450–1630* (Oxford, 1992) (with a substantial section on Venetian art) are also very useful. For translations of relevant humanist texts see B. J. Kohl and R. G. Witt, with E. B. Weller (ed. and trans.), *The Earthly Republic: Italian Humanists on Government and Society* (Philadelphia, 1978) and M. L. King and A. Rabil Jr. (ed.), *Her Immaculate Hand: Selected Works by and about the Women Humanists of Quattrocento Italy* (Binghamton, NY, 1983).

Translations of relevant contemporary writings on the visual arts include:
L. B. Alberti, *On the Art of Building in Ten Books*, trans. J. Rykwert, N. Leach, and R. Tavernor (Cambridge, Mass., 1988).
— *On Painting and On Sculpture*, ed. and trans. C. Grayson (London, 1972).
M. Baxandall, 'A Dialogue on Art from the Court of Leonello d'Este', *Journal of the Warburg and Courtauld Institutes*, 26 (1963), 304–26.
A. Cennini, *The Craftsman's Handbook: 'Il libro dell'Arte' by Cennino d'Andrea Cennini*, trans. and ed. D. V. Thompson (New York, 1960).
Filarete (Antonio Averlino), *Treatise on Architecture*, ed. and trans. J. R. Spencer (New York, 1965).
Leonardo on Painting, ed. M. Kemp, trans. M. Kemp and M. Walker (New Haven, 1989).
A. Manetti, *The Life of Brunelleschi*, ed.

H. Saalman and trans. C. Enggass (University Park, Pa., 1970).
G. Vasari, *Lives of the Artists*, trans. G. Bull, 2 vols. (Harmondsworth, 1965 and 1987).

Chapter 1. Introduction

Interpretations of the Renaissance still refer to Jacob Burckhardt, *The Civilisation of the Renaissance in Italy: An Essay*, ed. P. Burke, trans. S. G. C. Middlemore (London, 1990). Although dated, W. K. Ferguson, *The Renaissance in Historical Thought: Five Centuries of Interpretation* (New York, 1970) provides a useful overview of the historiographic changes since Burckhardt, one further advanced by D. Hay, 'Historians and the Renaissance during the last Twenty-Five Years', in A. Chastel *et al.*, *The Renaissance: Essays in Interpretation* (London, 1982), 1–32.

General historical background to the period covered by this volume can be found in the following works:
E. Garin (ed.), *Renaissance Characters*, trans. L. G. Cochrane (Chicago, 1991).
D. Hay and J. Law, *Italy in the Age of the Renaissance 1380–1530* (London, 1989).
J. Larner, *Culture and Society in Italy, 1290–1420* (London, 1971).
— *Italy in the Age of Dante and Petrarch, 1216–1380* (London, 1980).
L. Martines, *Power and Imagination: City-States in Renaissance Italy* (New York, 1979).

For the plague of 1348 see D. Williman (ed.), *The Black Death: The Impact of the Fourteenth-Century Plague* (New York, 1982) and A. G. Carmichael, *Plague and the Poor in Early Renaissance Florence* (Cambridge, 1986).
M. Meiss, *Painting in Florence and Siena after the Black Death: The Arts, Religion and Society in the Mid-Fourteenth Century* (Princeton, 1951) is a text which has generated considerable debate. For pilgrimage and trade see R. S. Lopez and I. W. Raymond, *Medieval Trade in the Mediterranean World* (London, 1955) and I. Origo, *The Merchant of Prato: Francesco di Marco Datini* (revd. edn., London, 1986).
J. A. Levenson (ed.), *Circa 1492: Art in the Age of Exploration* (exhibition catalogue) (Washington, 1991) contains important essays concerning fifteenth-century trade and exploration. For Venetian trade see R. Mackenney, *Tradesmen and Traders: The World of the Guilds in Venice and Europe, c.1250–c.1650* (London, 1987).

A number of new overviews of humanist thought and philosophy are now available.
D. Kelley, *Renaissance Humanism* (Boston, 1991) and J. Kraye (ed.), *The Cambridge Companion to Renaissance Humanism* (Cambridge, 1996) are

highly recommended as is B. P. Copenhaver and C. B. Schmitt, *Renaissance Philosophy* (Oxford, 1992). M. Baxandall, *Giotto and the Orators: Humanist Observers of Painting in Italy and the Discovery of Pictorial Composition, 1350-1450* (2nd edn., Oxford, 1986) specifically deals with the relationship between humanist writing and artistic criticism.

For more specialized areas see:
J. F. D'Amico, *Renaissance Humanism in Papal Rome: Humanists and Churchmen on the Eve of the Reformation* (Baltimore, 1983).
J. H. Bentley, *Politics and Culture in Renaissance Naples* (Princeton, 1987).
A. Grafton and L. Jardine, *From Humanism to the Humanities: Education and the Liberal Arts in Fifteenth- and Sixteenth-Century Europe* (London, 1986).
M. L. King, *Venetian Humanism in an Age of Patrician Dominance* (Princeton, 1986).
N. G. Wilson, *From Byzantium to Italy: Greek Studies in the Italian Renaissance* (Baltimore, 1992).

Chapter 2. Materials and Methods

An excellent introduction to topics covered in this chapter can be found in the series, *Medieval Craftsmen*, published by the British Museum with volumes by J. Cherry, *Goldsmiths* (London, 1992); P. Binski, *Painters* (London, 1991); S. Brown and D. O'Connor, *Glass-Painters* (London, 1991); K. Staniland, *Embroiderers* (London, 1991); and C. De Hamel, *Scribes and Illuminators* (London, 1992).

The English-language literature on specifically Italian materials and techniques is heavily weighted towards painting and sculpture, particularly that of Tuscany.

For work in precious metal, a comprehensive vision of Florentine gold and silverwork is available in M. G. Ciardi Dupré dal Poggetto (ed.), *L'oreficeria nella Firenze del quattrocento* (exhibition catalogue) (Florence, 1977). For mosaic see E. Merkel, 'I mosaici rinascimentali di San Marco', *Arte veneta*, 41 (1987), 20-30. Despite its rather erudite title, D. Jacoby, 'Raw Materials for the Glass Industries of Venice and the Terraferma, about 1370-about 1460', *Journal of Glass Studies*, 35 (1993), 65-90, is a good overview of the means by which glass was made in the fourteenth and fifteenth centuries. Although it is a sixteenth-century text, C. C. Piccolpasso, *The Three Books of the Potter's Art*, ed. and trans. B. Rackham and A. van de Put (London, 1934) provides valuable insights into the traditional techniques of majolica work.

The literature on bronze-casting in fourteenth- and fifteenth-century Italy remains quite specialized with studies focusing on the techniques of individual artists. Much of the information in this book is drawn from J. R. Spencer, 'Filarete's Bronze Doors at St. Peter's: A Cooperative Project with Complications of Chronology and Technique', in W. Stedman Sheard and J. T. Paoletti (eds.), *Collaboration in Italian Renaissance Art* (New Haven, 1978), 33-58; B. Bearzi, 'La tecnica fusoria di Donatello', in *Donatello e il suo tempo* (Florence, 1968), 95-105; and M. C. M. Ruso, 'Le techniche', in *Lorenzo Ghiberti, 'materia e ragionamenti'* (exhibition catalogue) (Florence, 1978), 576-80. See also R. E. Stone, 'Antico and the Development of Bronze Casting in Italy at the End of the Quattrocento', *Metropolitan Museum Journal*, 16 (1981), 87-116.

For carved sculpture in stone and wood see:
C. Klapisch-Zuber, *Les maitres du marbre, Carrare, 1300-1600* (Paris, 1969).
N. Penny, *The Materials of Sculpture* (New Haven, 1993).
P. Rockwell, *The Art of Stoneworking: A Reference Guide* (Cambridge, 1993).
F. Rodolico, *Le pietre delle città d'Italia* (2nd edn., Florence, 1965).
D. Strohm, 'Studies in Quattrocento Tuscan Wooden Sculpture', Ph.D. diss., Princeton Univ., 1979.
Scultura dipinta: Maestri di legname e pittori a Siena, 1250-1450 (exhibition catalogue) (Florence, 1987).

For early techniques of panel painting:
D. Bomford, J. Dunkerton, D. Gordon, and A. Roy, *Italian Painting before 1400* (London, 1989) is highly recommended. E. Borsook, *The Mural Painters of Tuscany: From Cimabue to Andrea del Sarto* (2nd edn., Oxford, 1980), provides a valuable introduction to fresco painting. For drawing, see F. Ames-Lewis, 'Modelbook Drawings and the Florentine Quattrocento Artist', *Art History*, 10 (1987), 1-11, and (with J. Wright), *Drawing in the Italian Renaissance Workshop* (exhibition catalogue) (London, 1983). For designs for embroidery see A. Garzelli, *Il ricamo nell'attività artistica di Pollaiuolo, Botticelli, Bartolomeo di Giovanni* (Florence, 1972), and L. Monnas, 'The Artists and the Weavers: The Design of Woven Silks in Italy, 1350-1550', *Apollo*, 125 (1987), 416-24.

Important recent studies of manuscript and book production include J. J. G. Alexander, *Medieval Illuminators and their Methods of Work* (New Haven, 1992) and id. (ed.), *The Painted Page: Italian Renaissance Book Illumination* (exhibition catalogue) (London, 1994). D. Landau and J. Parshall, *The Renaissance Print, 1470-1550* (New Haven, 1994), provide a highly detailed introduction to the new techniques of

woodcuts, printing, and engraving which were developed in the fifteenth and sixteenth centuries in both northern and southern Europe.

Chapter 3. The Organization of Art

There are a number of good general surveys of the organization of the painter's practice such as B. Cole, *The Renaissance Artist at Work from Pisano to Titian* (London, 1983). Both A. Thomas, *The Painter's Practice in Renaissance Tuscany* (Cambridge, 1995) (with an excellent bibliography) and M. Gregori, A. Paolucci, and C. Acidini Luchinat (eds.), *Maestri e botteghe: Pittura a Firenze alla fine del quattrocento* (exhibition catalogue) (Florence, 1992) bring the field up to date. The painters' corporation of Milan is explained in J. Shell, 'The Scuola di San Luca, or Universitas Pictorum, in Renaissance Milan', *Arte Lombarda*, 104/1 (1993), 78–99.

Detailed studies on the business of painting include:
G. Corti, 'Sul commercio dei quadri a Firenze verso la fine del secolo XIV', *Commentari*, 22 (1971), 84–91.
P. Humfrey, 'The Venetian Altarpiece of the Early Renaissance in the Light of Contemporary Business Practice', *Saggi e memorie di storia dell'arte*, 15 (1986), 65–82.
U. Procacci, 'Di Jacopo di Antonio e delle compagnie di pittori del corso degli Adimari nel XV secolo', *Rivista d'arte*, 35 (1960), 3–70.

There are fewer general works available in English on the economic organization of the other arts. Some important studies are those of S. Connell, *The Employment of Sculptors and Stonemasons in Venice in the Fifteenth Century* (New York, 1988) and R. A. Goldthwaite, 'The Economic and Social World of Italian Renaissance Maiolica', *Renaissance Quarterly*, 42/1 (1989), 1–32.

Artistic collaboration and workshops are specifically considered in the following studies:
J. Beck, 'Jacopo della Quercia and Donatello: Networking in the Quattrocento', *Source Notes in the History of Art*, 6 (1987), 6–15.
Y. M. Even, 'Artistic Collaboration in Florentine Workshops: The Quattrocento', Ph.D. diss., Columbia Univ., 1984.
L. Fusco, 'The Use of Sculptural Models by Painters in Fifteenth-Century Art', *Art Bulletin*, 64 (1982), 175–94.
A. Guidotti, 'Pubblico e privato, committenza e clientela: Botteghe e produzione artistica a Firenze tra XV e XVI secolo', *Richerche storiche*, 16 (1986), 535–50.
H. McNeal Caplow, 'Sculptors' Partnerships in Michelozzo's Florence', *Studies in the*

Renaissance, 21 (1974), 145–73.
A. M. Schulz, *The Sculpture of Bernardo Rossellino and his Workshop* (Princeton, 1977).
W. Stedman Sheard and J. T. Paoletti (eds.), *Collaboration in Italian Renaissance Art* (New Haven, 1978).

For the relationship between painters and carpenters see C. Gilbert, 'Peintres et menuisiers au début de la Renaissance en Italie', *Revue de l'art*, 37 (1977), 9–28, and T. J. Newbery, J. Bisacca, and L. B. Kanter (eds.), *Italian Renaissance Frames* (exhibition catalogue) (New York, 1990).

The information on the Ovetari chapel in Padua is drawn from K. V. Shaw, 'The Ovetari Chapel: Patronage, Attribution and Chronology', Ph.D. diss., Univ. of Pennsylvania, 1994.

Chapter 4: Defining Relationships: Patrons and Artists

The study of contracts and the legal, institutional, and personal relations between artists and patrons has grown increasingly more sophisticated. A. Thomas, *The Painter's Practice in Renaissance Tuscany* (Cambridge, 1995) and M. O'Malley, 'The Business of Art: Contracts and Payment Documents for Fourteenth- and Fifteenth-Century Italian Altarpieces and Frescos', Ph.D. diss., Warburg Institute, Univ. of London, 1994, expand upon the work begun by H. Glasser, 'Artists' Contracts of the Early Renaissance', Ph.D. diss., Columbia Univ., 1965. M. Kemp will shortly be bringing out a synthetic study of Renaissance source-material (Yale University Press). For the moment, the introductory essay in *Giovanni Antonio Amadeo: Documents*, ed. R. V. Schofield, J. Shell, and G. Sironi (Como, 1989) provides a lucid explanation of notarial records. G. Bresc-Bautier, *Artistes, patriciens et confréries: Production et consommation de l'œuvre d'art à Palerme et en Sicilie occidentale (1348–1460)* (Rome, 1979), provides an excellent overview of a usually neglected part of Italy.

Studies of institutional patronage have tended to focus on Florence and Venice. A careful exposition of trecento patronage in the cathedral of Florence is that of L. F. Mustari, 'The Sculptor in the Fourteenth-Century Florence Opera del Duomo', Ph.D. diss., Univ. of Iowa, 1975. The documentary investigations of M. Haines have been particularly influential: see, for example, her 'Brunelleschi and Bureaucracy: The Tradition of Public Patronage at the Florentine Cathedral', *I Tatti Studies*, 3 (1989), 89–125, and *The 'Sacrestia delle Messe' of the Florentine Cathedral* (Florence, 1983), from which the information for this section is drawn.

The work of D. Finiello Zervas, *The Parte Guelfa: Brunelleschi and Donatello* (Locust Valley, NY, 1987) shows how a detailed examination of the identity of the individuals involved in corporate decisions can reveal the complex networks which lay behind commissions such as Donatello's statue of St Louis of Toulouse. The patronage of confraternities is specifically investigated by C. Barr, 'A Renaissance Artist in the Service of a Singing Confraternity', in M. Tetel, R. G. Witt, and R. Goffen (eds.), *Life and Death in Fifteenth-Century Florence* (Durham, NC, 1989), 105-25, and L. Sebregondi, 'Religious Furnishings and Devotional Objects in Renaissance Florentine Confraternities', *Crossing the Boundaries: Christian Piety and the Arts in Italian Medieval and Renaissance Confraternities* (Kalamazoo, Mich., 1991), 141-60. The important work of P. Fortini Brown, in 'Painting and History in Renaissance Venice', *Art History*, 7 (1984), 263-94, and in *Venetian Narrative Painting in the Age of Carpaccio* (New Haven, 1988), has adapted and reconsidered the historical investigations into Venetian *scuole* to provide a new view of the narrative cycles produced for confraternity meeting-halls.

Although there have been numerous monographs on artists who worked for the Italian *signori*, there has been less recent investigation into the role of the artist at court. The translation of a German dissertation written in the 1960s, which was then expanded and updated, M. Warnke, *The Court Artist: On the Ancestry of the Modern Artist*, trans. D. McLintock (Cambridge, 1993), has a useful bibliography. E. S. Welch, 'The Process of Sforza Patronage', *Renaissance Studies*, 3 (1989), 370-86, looks at how art was commissioned at the Sforza court. A. Norris, 'Gian Cristoforo Romano: The Courtier as Medallist', in J. G. Pollard (ed.), *Italian Medals* (Washington, 1987), 131-41, examines the career of one prominent Italian court artist as does S. J. Campbell, '*Pictura* et *Scriptura*: Cosmè Tura and Style as courtly performance', *Art History*, 19 (1996), 267-95.

The current study of fifteenth-century writing on art is reliant on the work of M. Baxandall whose *Giotto and the Orators: Humanist Observers of Painting in Italy and the Discovery of Pictorial Composition 1350-1450* (Oxford, 1971) sums up much of his earlier work. On Vasari see P. L. Rubin, *Giorgio Vasari: Art and History* (New Haven, 1995). Ghiberti's Commentaries have not been fully translated into English. They are published in Italian as *I commentari*, ed. O. Morisani (Naples, 1947).

Chapter 5. The Sacred Setting

Questions about the use of imagery in western Europe have been thoughtfully considered by D. Freedberg, *The Power of Images: Studies in the History and Theory of Response* (Chicago, 1989) on which this chapter is heavily dependent and more specifically for Florence, by R. Trexler, 'Florentine Religious Experience: The Sacred Image', *Studies in the Renaissance*, 19 (1972), 8-14. On devotional wax sculptures see one of the few available studies, G. Masi, 'La ceroplastica in Firenze nei secoli XV-XVI e la famiglia Benintendi', *Rivista d'arte*, 9 (1916), 124-42.

On the fundamentals of Catholic Church organization and belief see the condensed but informative discussion in D. Hay, *The Church in Italy in the Fifteenth Century* (Cambridge, 1977) and J. Bossy, *Christianity in the West, 1400-1700* (Oxford, 1985). R. N. Swanson, *Religion and Devotion in Europe c.1215-c.1515* (Cambridge, 1995) is also very accessible while T. N. Tentler, *Sin and Confession on the Eve of the Reformation* (Princeton, 1977) treats a complex subject with great flair.

A number of the topics covered in Chapters 5 and 6 are discussed in the essays published in T. Verdon and J. Henderson (eds.), *Christianity and the Renaissance: Image and Religious Imagination in the Quattrocento* (Syracuse, NY, 1990) and in M. Tetel, R. G. Witt, and R. Goffen (eds.), *Life and Death in Fifteenth-Century Florence* (Durham, NC, 1989). Although D. Norman (ed.), *Siena, Florence and Padua: Art, Society and Religion, 1280-1400*, 2 vols. (New Haven, 1995) was devised specifically for an Open University course, it contains much material which is relevant here.

The information on St Bernardino of Siena is taken from G. Freuler, 'Sienese Quattrocento Painting in the Service of Spiritual Propaganda', in E. Borsook and F. Superbi Gioffredi (eds.), *The Italian Altarpiece 1250-1550: Function and Design* (Oxford, 1994), 81-118. C. Gilbert, 'The Archbishop on the Painters of Florence', *Art Bulletin*, 41 (1959), 75-87, illustrates how one conservative cleric responded negatively to painters' misinterpretations of spiritual matters. See also id., 'Tuscan observants and Painters in Venice, ca. 1400', in D. Rosand (ed.), *Interpretazioni veneziane: Studi di storia dell'arte in onore di Michelangelo Muraro* (Venice, 1984), 109-20.

Chapter 6. Sites of Devotion

The organization of Italian monasteries and convents is outlined in D. Hay, *The Church in Italy in the Fifteenth Century* (Cambridge, 1977). Specific institutions are covered in detail in W. Hood, *Fra Angelico at San Marco* (New Haven, 1993) and V. Primhak, 'Women in Religious

Communities: The Benedictine Convents in Venice, 1400–1550', Ph.D. diss., Warburg Institute, Univ. of London, 1991. For Florence see R. Trexler, 'Celibacy in the Renaissance: The Nuns of Florence', in *Dependence in Context in Renaissance Florence* (Binghamton, NY, 1994), 343–72, and G. A. Brucker, 'Monasteries, Friaries and Nunneries in Quattrocento Florence' in T. Verdon and J. Henderson (eds.), *Christianity and the Renaissance: Image and Religious Imagination in the Quattrocento* (Syracuse, NY, 1900), 41–62.

The rood screen and monastic church architecture are discussed by M. B. Hall, *Renovation and Counter-Reformation: Vasari and Duke Cosimo in Santa Maria Novella and Santa Croce, 1565–1577* (New York, 1979). Although they deal primarily with English material, J. Bossy, 'The Mass as a Social Institution, 1200–1700', *Past and Present*, 100 (1983), 29–61, and M. Rubin, *Corpus Christi: The Eucharist in Late Medieval Culture* (Cambridge, 1991) provide an excellent introduction to the importance of the Eucharist. C. W. Bynum, *Holy Feast and Holy Fast: The Religious Significance of Food to Medieval Women* (Berkeley and Los Angeles, 1987) considers the topic from a feminist perspective.

The altarpiece has proved to be one of the most popular subjects for discussion in recent years. See P. Humfrey, *The Altarpiece in Renaissance Venice* (New Haven, 1993). Proceedings of two conferences on the topic have been recently published: P. Humfrey and M. Kemp (eds.), *The Altarpiece in the Renaissance* (Cambridge, 1990) and E. Borsook and F. Superbi Gioffredi (eds.), *The Italian Altarpieces 1250–1550: Function and Design* (Oxford, 1994). H. van Os, *Sienese Altarpieces, 1215–1460: Form, Content, Design* (2 vols.), Groningen, 1984 and 1990) investigates a variety of Sienese polyptychs.

Italian tombs and chapels have also been the subject of detailed investigation, particularly in S. K. Cohn, Jr., *The Cult of Remembrance and the Black Death: Six Renaissance Cities in Central Italy* (Baltimore, 1992). See also:

H. A. Ronan, 'The Tuscan Wall Tomb, 1250–1400', Ph.D. diss., Indiana Univ., Bloomington, 1982.
S. Strocchia, 'Death Rites and the Ritual Family', in M. Tetel, R. G. Witt, and R. Goffen (eds.), *Life and Death in Fifteenth-Century Florence* (Durham, NC, 1989), 120–45.
— 'Remembering the Family: Women, Kin and Commemorative Masses in Renaissance Florence', *Renaissance Quarterly*, 43 (1990), 635–55.

— *Death and Ritual in Renaissance Florence* (Baltimore, 1992).
W. J. Wegener, 'Mortuary Chapels of Renaissance Condottieri', Ph.D. diss., Princeton Univ., 1989.

For the fourteenth-century Strozzi chapel in Santa Maria Novella, Florence studies include K. A. Giles, 'The Strozzi Chapel in Santa Maria Novella: Florentine Painting and Patronage, 1340–1355', Ph.D. diss., New York Univ., 1977. The fifteenth-century Strozzi chapel has been examined by G. Corti, 'Notes on the Financial Accounts of the Strozzi Chapel', *Burlington Magazine*, 112 (1970), 746, and D. Friedman, 'The Burial Chapel of Filippo Strozzi in Santa Maria Novella in Florence', *Arte*, 9 (1970), 109–31. For the same building see also S. McClure Ross, 'The Redecoration of Santa Maria Novella's Cappella Maggiore', Ph.D. diss., Univ. of California, Berkeley, 1983. For the Brancacci chapel see A. Molho, 'The Brancacci Chapel: Studies in its Iconography and History', *Journal of the Warburg and Courtauld Institutes*, 40 (1977), 50–98, and U. Baldini and O. Casazza, *The Brancacci Chapel Frescoes* (London, 1992).

For tombs and chapels outside Florence see D. Pincus, 'The Tomb of Doge Niccolò Tron and Venetian Renaissance Ruler Imagery', in M. Barasch and L. Freeman Sandler (eds.), *Art the Ape of Nature: Studies in Honour of H. W. Janson* (New York, 1981), 127–50, and R. Munman, *Sienese Renaissance Tomb Monuments* (Philadelphia, 1993).

For Padua see, in particular, M. Plant, 'Portraits and Politics in late Trecento Padua: Altichiero's Frescoes in the S. Felice Chapel, S. Antonio', *Art Bulletin*, 63 (1981), 406–25, and 'Patronage in the Circle of the Carrara Family: Padua 1337–1405', in F. W. Kent and P. Simons (with J. C. Eade) (eds.), *Patronage, Art and Society in Renaissance Italy* (Canberra, 1987), 177–99. H. Saalman, 'Carrara Burials in the Baptistery of Padua', *Art Bulletin*, 69 (1987), 376–94, discusses the location of the da Carrara family tombs.

Chapter 7. Creating Authority

For a general introduction to political theory and rhetoric see N. Rubinstein, 'Political Theories in the Renaissance', in A. Chastel *et al.*, *The Renaissance: Essays in Interpretation* (London, 1982), 153–200, and J. Hankins, 'Humanism and the Origins of Modern Political Thought', in J. Kraye (ed.), *The Cambridge Companion to Renaissance Humanism* (Cambridge, 1996), 118–41. See also the collection of conference papers in C. M. Rosenberg (ed.), *Art and Politics in Late Medieval and Early Renaissance Italy, 1250–1500* (Notre

Dame, Ind., 1990) and the individual essays in R. Starn and L. Partridge, *Arts of Power: Three Halls of State in Italy, 1300-1600* (Berkeley and Los Angeles, 1992).

For the use of religious imagery for civic purposes see A. Vauchez, 'Patronage des saints et religion civique dans l'Italie communale à la fin du moyen âge', in V. Moleta (ed.), *Patronage and Public in the Trecento* (Florence, 1986), 59–80, and E. S. Welch, *Art and Authority in Renaissance Milan* (New Haven, 1995). On heraldry, see K. Lippincott, 'The Genesis and Significance of the Italian Impresa', in S. Anglo (ed.), *Chivalry in the Renaissance* (Woodbridge, 1990), 49–76. For *immagini infamanti* see S. Y. Edgerton, Jr., *Pictures and Punishment: Art and Criminal Prosecution during the Florentine Renaissance* (Ithaca, NY, 1984).

The literature on signorial patronage is primarily based around individual dynasties or courts. A. Cole, *Virtue and Magnificence: Art of the Italian Renaissance Courts* (London, 1995) is a well-illustrated introduction to the issues involved while J. Law, 'The Renaissance Prince', in E. Garin (ed.), *Renaissance Characters*, trans. L. G. Cochrane (Chicago, 1991), 1–21, summarizes the historical consensus. For specialized studies see the essays in S. Anglo (ed.), *Chivalry in the Renaissance* (Woodbridge, 1990) and the sections which follow.

Naples
There are limited studies in English on late Angevin art and politics. G. Galasso, *Il Regno di Napoli: Il mezzogiorno angioino e aragonese (1266–1494)* (Turin, 1992) is, therefore, the most comprehensive survey, while F. Bologna, *I pittori alla corte angioina di Napoli, 1266-1414* (Rome, 1969), provides good illustrations. The works of Professor A. F. C. Ryder have made the study of Alfonso of Aragon much more accessible to an English-speaking audience than that of any other Neapolitan ruler: his *The Kingdom of Naples under Alfonso the Magnanimous* (Oxford, 1976) and *Alfonso the Magnanimous, King of Aragon, Naples, and Sicily, 1396-1458* (Oxford, 1990) are indispensable. G. L. Hersey, *The Aragonese Arch at Naples, 1443-1475* (New Haven, 1973) remains the fundamental study of Alfonso's major commission while M. A. Skoglund, 'In Search of the Art Commissioned and Collected by Alfonso I of Naples, Notably Painting', Ph.D. diss., Univ. of Missouri, Columbia, 1989, has useful general information. See also J. Woods-Marsden, 'Art and Political Identity in Fifteenth-Century Naples: Pisanello, Cristoforo di Geremia and King Alfonso's Imperial Fantasies', in C. M. Rosenberg (ed.), *Art and Politics in Late Medieval and Early Renaissance Italy, 1250-1500* (Notre Dame, Ind., 1990), 11–37.

Milan
For a general survey see C. A. Ady, *A History of Milan under the Sforza* (London, 1907). For works which consider the political implications of the art of Sforza Milan see:

L. Giordano, 'L'autolegittimazione di una dinastia: Gli Sforza e la politica dell'immagine', *Artes*, 1 (1993), 1–27.
G. Lubkin, *A Renaissance Court: Milan under Galeazzo Maria Sforza* (Berkeley and Los Angeles, 1994).
E. S. Welch, 'Galeazzo Maria and the Castello di Pavia, 1469', *Art Bulletin*, 71 (1989).
— 'The Process of Sforza Patronage', *Renaissance Studies*, 3 (1987), 370–86.
— *Art and Authority in Renaissance Milan* (New Haven, 1995).

Urbino
C. Clough, 'Federigo da Montefeltro's Patronage of the Arts, 1468-1482', *Journal of the Warburg and Courtauld Institutes*, 36 (1973), 129–44, repr. in *The Duchy of Urbino in the Renaissance* (London, 1981).
C. M. Rosenberg, 'The Double Portrait of Federico and Guidobaldo da Montefeltro: Power, Wisdom and Dynasty', in G. Cerboni Baiardi and G. Chittolini (eds.), *Federico di Montefeltro i. Lo stato, le arti, la cultura* (Rome, 1986), 213–22.

Ferrara
C. M. Rosenberg, 'Art in Ferrara during the Reign of Borso d'Este (1450–1471): A Study in Court Patronage', Ph.D. diss., Univ. of Michigan, 1977.
— 'Some New Documents concerning Donatello's Unexecuted Monument to Borso d'Este in Modena', *Mitteilungen des Kunsthistorisches Institut in Florenz*, 17 (1973), 149–52.
W. Gundersheimer, *Ferrara: The Style of a Renaissance Despotism* (Princeton, 1973).
— 'The Patronage of Ercole I d'Este', *Journal of Medieval and Renaissance Studies*, 6 (1976), 1–19.
A. Mottola Molfini and M. Natale (eds.), *Le muse e il principe: Arte di corte nel rinascimento padano* (exhibition catalogue) (Modena, 1991).
R. Varese (ed.), *Atalante di Schifanoia* (Modena, 1989).

On women as rulers and patrons see 'Women, Learning and Power: Eleanor of Aragon and the Court of Ferrara', in P. H. Labalme (ed.), *Beyond their Sex: Learned Women of the European Past* (New York, 1980), 57–93, and E. S. Welch, 'Women as Patrons and Clients in the Italian Courts', in L. Panizza (ed.), *Women, Culture*

and Society in Renaissance Italy (Manchester University Press, 1997).

For Isabella d'Este see C. M. Brown, ' "Lo insaciabile desiderio nostro de cose antique": New Documents for Isabella d'Este's Collection of Antiquities', in C. H. Clough (ed.), *Cultural Aspects of the Renaissance: Essays in Honour of Paul Oskar Kristeller* (Manchester, 1976), 324–53, and (with A. Lorenzoni) 'The Grotta of Isabella d'Este', *Gazette des Beaux-Arts*, 89 (1977), 155–71, and 90 (1978), 72–82. The surviving items of Isabella's *studiolo* are lavishly illustrated in S. Ferino-Pagden (ed.), '*La prima donna del mondo*': *Isabella d'Este, Fürstin und Mäzenatin der Renaissance* (exhibition catalogue) (Vienna, 1994). R. San Juan, 'The Court Ladies' Dilemma: Isabella d'Este and Art Collecting in the Renaissance', *Oxford Art Journal*, 14 (1991), 67–78, synthesizes much of the known material and offers a more gendered approach to the marchioness of Mantua. *Isabella d'Este: I luoghi del collezionismo*, special edition, *Civiltà mantovana*, ser. 3, 30 (1995) republishes the inventory of Isabella's *studiolo*.

Chapter 8. Rome and the Republics

The theme of republicanism has been much discussed: see Q. Skinner, *The Foundations of Modern Political Thought* (2 vols., Cambridge, 1978). For one overview, based primarily on Florentine material, see A. Brown, 'City and Citizen: Changing Perceptions in the Fifteenth and Sixteenth Centuries', in A. Molho, K. Raaflaub, and J. Emlen (eds.), *City States in Classical Antiquity and Medieval Italy: Athens and Rome, Florence and Venice* (Stuttgart, 1991), 93–111.

On the reuse of the antique see P. P. Bober and R. Rubinstein, *Renaissance Artists and Antique Sculpture: A Handbook of Sources* (London, 1986) and the classic study of R. Weiss, *The Renaissance Discovery of Classical Antiquity* (2nd edn., Oxford, 1988). The only current synthetic study of Renaissance Rome which considers the quattrocento is that of C. Stinger, *The Renaissance in Rome* (Bloomington, Ind., 1985). Individual studies of important papal patrons include P. Partner, *The Papal State under Martin V* (London, 1958) and C. W. Westfall, *In This Most Perfect Paradise: Alberti, Nicholas V and the Invention of Conscious Urban Planning in Rome, 1447–1455* (University Park, Pa., 1974). See also the collection of essays in P. A. Ramsey (ed.), *Rome in the Renaissance: The City and the Myth* (Medieval and Renaissance Texts and Studies, 18; Binghamton, NY, 1982). For Michelangelo's Pietà, see K. Weil-Garris Brandt, 'Michelangelo's Pietà for the Cappella del Rè di Francia', in W. E. Wallace (ed.), *Michelangelo: Selected Scholarship*

in English (New York, 1995), 217–59.

Like those of the Italian courts, most studies of Italy's republics focus on a single city with an increasing trend towards small-scale documentary investigations: micro-history.

Siena

J. Beck, *Jacopo della Quercia* (New York, 1991). K. Christiansen, L. B. Kanter, and C. B. Strehlke (eds.), *Painting in Renaissance Siena, 1420–1500* (exhibition catalogue) (New York, 1988). A. C. Hanson, *Jacopo della Quercia's Fonte Gaia* (Oxford, 1965). J. Hook, *Siena: A City and its History* (London, 1979). A. Rutigliano, *Lorenzetti's Golden Mean: The Riformatori of Siena, 1368–1385* (New York, 1991).

Florence

The study of Florentine history and art history has dominated Anglo-Saxon scholarship since the mid-twentieth century. Very readable introductions are G. Brucker, *Renaissance Florence* (repr. Berkeley and Los Angeles, 1983) and *The Civic World of Early Renaissance Florence* (Princeton, 1977). A very different approach, drawn from an anthropological and sociological perspective, is the work of R. Trexler, *Public Life in Renaissance Florence* (Ithaca, NY, 1980) and the study on the records of the magistracy responsible for policing Florentine morals, M. J. Rocke, 'Male Homosexuality and its Regulation in Late Medieval Florence', Ph.D. diss., Binghamton, 1989 (to be published shortly by Oxford University Press).

A number of now classic studies have defined the Medici's rise to power in the second quarter of the fifteenth century, particularly N. Rubinstein, *The Government of Florence under the Medici (1434 to 1494)* (Oxford, 1966) and D. Kent, *The Rise of the Medici: Faction in Florence, 1426–1434* (Oxford, 1978). See also:

A. Brown, 'The Humanist Portrait of Cosimo de' Medici', *Journal of the Warburg and Courtauld Institutes*, 24 (1961), 186–221. A. D. Fraser Jenkins, 'Cosimo de' Medici's Patronage of Architecture and the Theory of Magnificence', *Journal of the Warburg and Courtauld Institutes*, 33 (1970), 162–70. E. H. Gombrich, 'The Early Medici as Patrons of Art', in id., *Norm and Form* (London, 1966), 35–57. G. Holmes, 'How the Medici became the Pope's Bankers', in N. Rubinstein (ed.), *Florentine Studies: Politics and Society in Renaissance Florence* (London, 1968), 357–80. R. De Roover, *The Rise and Decline of the Medici Bank* (Cambridge, Mass., 1963).

C. M. Sperling, 'Donatello's Bronze David and the Demands of Medici Politics', *Burlington Magazine*, 134 (1992), 218–24.

Anniversaries of the deaths of respective Medici sparked conferences whose proceedings have now been published, such as F. Ames-Lewis (ed.), *Cosimo 'il Vecchio' de' Medici, 1389–1464* (Oxford, 1992) and A. Beyer and B. Boucher (eds.), *Piero de' Medici, 'il Gottoso' (1416–1469): Art in the Service of the Medici* (Berlin, 1993).

The 500th anniversary of the death of Lorenzo de' Medici prompted no fewer than eleven official publications and a number of conference proceedings. The conference papers, primarily in English, in G. C. Garfagnini (ed.), *Lorenzo il Magnifico e il suo tempo* (Florence, 1992), M. Mallet and N. Mann (eds.), *Lorenzo de' Medici: Culture and Politics* (London, 1996), and the lavishly illustrated F. Cardini (ed.), *Lorenzo il Magnifico* (Rome, 1992) summarize the current consensus on this much-mythologized figure.

For work on non-Medicean artistic patronage in Florence:

F. W. Kent, 'The Making of a Renaissance Patron of the Arts', *Giovanni Rucellai ed il suo Zibaldone*, ii. *A Florentine Patrician and his Palace* (London, 1981), 155–225.
— 'Individuals and Families as Patrons of Culture in Quattrocento Florence', in A. Brown (ed.), *Language and Images of Renaissance Italy* (Oxford, 1995), 171–92.
J. R. Spencer, *Andrea del Castagno and his Patrons* (Durham, NC, 1991).
R. M. Steinberg, *Fra Girolamo Savonarola: Florentine Art and Renaissance Historiography* (Athens, Ohio, 1977).

Bologna
C. M. Ady, *The Bentivoglio of Bologna: A Study in Despotism* (London, 1937).
B. Basile (ed.), *Bentivolorum Magnificentia: Principe e cultura a Bologna nel Rinascimento* (Rome, 1984).
B. W. Dodsworth, *The Arca di San Domenico* (New York, 1995).
I. B. Supino, *La scultura in Bologna nel secolo XV* (Bologna, 1910).
N. Terpstra, *Lay Confraternities and Civic Religion in Renaissance Bologna* (Cambridge, 1995).

Genoa
L. T. Belgrano, *Della vita privata dei Genovesi* (Genoa, 1875).
J. Heers, *Gênes au XVᵉ siècle: Activité économique et problèmes sociaux* (Paris, 1961).
La scultura a Genova e in Liguria, i. *Dalle origini al Cinquecento* (Genoa, 1987).

Venice
See P. Humfrey, *The Altarpiece in Renaissance Venice* (New Haven, 1993); P. Fortini Brown, 'Painting and History in Renaissance Venice', *Art History*, 7 (1984), 263–94; id., *Venetian Narrative Painting in the Age of Carpaccio* (New Haven, 1988); id., 'The Self-Definition of the Venetian Republic', in A. Molho, K. Raaflaub, and J. Emlen (eds.), *City-States in Classical Antiquity and Medieval Italy: Athens and Rome, Florence and Venice* (Stuttgart, 1991), 511–48. See also:

D. S. Chambers, *The Imperial Age of Venice, 1380–1580* (London, 1970).
J. R. Hale (ed.), *Renaissance Venice* (London, 1973).
N. Huse and W. Wolters, *The Art of Renaissance Venice: Architecture, Sculpture and Painting, 1460–1590*, trans. E. Jephcott (Chicago, 1990).
F. Lane, *Venice: A Maritime Republic* (Baltimore, 1973).
D. Pincus, *The Arco Foscari: The Building of a Triumphal Gateway in Fifteenth-Century Venice* (New York, 1976).
B. Pullan, *Rich and Poor in Renaissance Venice: The Social Institutions of a Catholic State* (Oxford, 1971) (a classic study).
D. Romano, *Patricians and Popolani: The Social Foundations of the Venetian Renaissance State* (Baltimore, 1987).
G. Ruggiero, *Violence in Early Renaissance Venice* (New Brunswick, NJ, 1980).

For Venetian *condottieri* such as Gattamelata and Bartolomeo Colleoni see M. E. Mallet and J. R. Hale, *The Military Organization of a Renaissance State: Venice c.1400 to 1617* (Cambridge, 1984).

Chapter 9. The Domestic Setting

On mendicant attitudes towards wealth see H. Baron, 'Franciscan Poverty and Civic Wealth as Factors in the Rise of Humanistic Thought', *Speculum*, 13 (1938), 18–25; G. Rinaldi, *L'attività commerciale nel pensiero di San Bernardino da Siena* (Rome, 1959); and R. de Roover, *San Bernardino of Siena and Sant'Antonio of Florence: The two Great Economic Thinkers of the Middle Ages* (Boston, 1967). Much of the primary material quoted on magnificence is drawn from G. Pontano, *I trattati delle virtù sociali*, ed. and trans. F. Tateo (Rome, 1965).

One of the most important movements in Renaissance studies has been the introduction, often controversial, of issues relating to gender studies. A good survey from a European perspective is M. L. King, *Women of the Renaissance* (Chicago, 1991). J. Cadden, *Meanings of Sex Difference in the Middle Ages:*

Medicine, Science and Culture (Cambridge, 1993) gives a clear explanation of medieval and renaissance concepts of the male and the female. D. Herlihy and C. Klapisch-Zuber, *Tuscans and their Families: A Study of the Florentine catasto of 1427* (New Haven, 1985) provide the statistical information most commonly used by historians in their discussion of the family. Important historical studies include:

C. W. Bynum, *Fragmentation and Redemption: Essays on Gender and the Human Body in Medieval Religion* (New York, 1991).
S. Chojnacki, 'Patrician Women in Early Renaissance Venice', *Studies in the Renaissance*, 21 (1974), 176-203.
S. Cohn, *Women in the Streets. Sex and Power in the Italian Renaissance* (Baltimore, 1996).
C. Klapisch-Zuber, *Women, Family and Ritual in Renaissance Italy*, trans. L. Cochrane (Chicago, 1985).
T. Kuehn, *Law, Family and Women: Towards a Legal Anthropology in Renaissance Italy* (Chicago, 1991).
E. Rosenthal, 'The Position of Women in Renaissance Florence: Neither Autonomy nor Subjection', in P. Denley and C. Elam (eds.), *Florence and Italy: Renaissance Studies in Honour of Nicolai Rubinstein* (London, 1988), 369-81.
R. C. Trexler, *Power and Dependence in Renaissance Florence*, ii. *Women in Renaissance Florence* (Binghamton, NY, 1993).

For an example of how this material has been used by art historians see P. Simons, 'Women in Frames: The Gaze, the Eye, the Profile in Renaissance Portraiture', in N. Broude and M. D. Garrard (eds.), *The Expanding Discourse: Feminism and Art History* (New York, 1992), 39-58. The proceedings of the conference published in L. Panizza (ed.), *Culture, Society and Women in Renaissance Italy* (Manchester, 1997) add to our understanding of gender and the visual arts. See also E. A. Matter and J. Coakley (eds.), *Creative Women in Medieval and Early Modern Italy: A Religious and Artistic Renaissance* (Philadelphia, 1994).
The notion of decorum is extensively discussed in the essays in F. Ames-Lewis and A. Bednarek (eds.), *Decorum in Renaissance Narrative Art* (London, 1992). For sumptuary laws see R. Rainey, 'Dressing Down the Dressed-Up: Reproving Feminine Attire in Renaissance Florence', in J. Monfasani and R. G. Musto (eds.), *Renaissance Society and Culture: Essays in Honor of Eugene F. Rice, Jr.* (New York, 1991), 217-37. See also D. Owen Hughes, 'Sumptuary Law and Social Relations in Renaissance Italy', in J. Bossy (ed.), *Disputes*

and Settlements: Law and Human Relations in the West (Cambridge 1983), 69-100, and C. Kövesi Killerby, 'Practical Problems in the Enforcement of Italian Sumptuary Laws, 1200-1500', in T. Dean and K. J. P. Lowe (eds.), *Crime, Society and the Law in Renaissance Italy* (Cambridge, 1994), 99-120.
On palace construction, decoration, and furnishings see the comprehensive studies of R. Goldthwaite, *The Building of Renaissance Florence: An Economic and Social History* (Baltimore, 1980); J. K. Lydecker, 'The Domestic Setting of the Arts in Renaissance Florence', Ph.D. diss., Johns Hopkins University, Baltimore, 1987; P. Thornton, *The Italian Renaissance Interior, 1400-1600* (London, 1991), particularly recommended for its clear exposition, extensive illustrations, and bibliography.
An inventory of known secular frescos in fourteenth- and fifteenth-century Italy is appended to R. Shepherd, 'Giovanni Sabadino degli Arienti, Ercole I d'Este and the Decoration of the Italian Renaissance Court', *Renaissance Studies*, 9 (1995), 18-57. C. M. Rosenberg, 'Courtly Decorations and the Decorum of Interior Space', in G. Papagno and A. Quondam (eds.), *La corte e lo spazio: Ferrara estense* (Rome, 1982), ii. 529-44, looks at a suite of rooms in the Palazzo Schifanoia in Ferrara.
For cassone panels and *deschi da parto* see E. Callman, *Apollonio di Giovanni* (Oxford, 1974) and 'Apollonio di Giovanni and Painting for the Early Renaissance Room', *Antichità viva*, 27 (1988), 5-18. J. Pope-Hennessy and K. Christiansen, *Secular Painting in 15th-Century Tuscany: Birth Trays, Cassone Panels and Portraits* (New York, 1980) is a short, well-illustrated discussion of works in the Metropolitan Museum of Art, New York.
For collecting, and *studioli* and their contents, see D. Thornton, 'The Study Room in Renaissance Italy with Particular Reference to Venice, c.1560-1620', Ph.D. diss., Warburg Institute, Univ. of London, 1995 (soon to be revised and published by Yale University Press). See also W. Liebenwein, *Studiolo: Storia e tipologia di uno spazio culturale* (Modena, 1988).
On medals see S. Scher (ed.), *The Currency of Fame: Portrait Medals of the Renaissance* (exhibition catalogue) (New York, 1994). For devotional Books of Hours see, C. De Hamel, *A History of Illuminated Manuscripts* (Oxford, 1986). The translation of Giovanni Morelli's *ricordanze* is taken from R. Trexler, 'In Search of Father: The Experience of Abandonment in the Recollections of Giovanni di Pagolo Morelli', in id., *Dependence in Context in Renaissance Florence* (Binghamton, NY, 1994).

	1350	1354	1358	1362	1366
Political/ Religious	● 1348 Black Death ● 1350 Archbishop Giovanni Visconti of Milan purchases Bologna; first papal Jubilee ● 1351 Cangrande II della Scala becomes *signore* of Verona	● 1355 Popular revolts against the government of Siena; execution of Doge Marino Falier for attempting to undermine republican government of Venice; Francesco il Vecchio da Carrara deposes his uncle and becomes sole lord of Padua		● 1362–3 Second major wave of plague in Italy	
Cultural/Art	● 1350s Foundation of *certosa* of San Lorenzo outside Florence by Niccolò Acciaiuoli ● 1350–74 Active period of Giovanni Boccaccio: writes *Decameron* (1353) and *Genealogy of the Gods* (*Genealogia deorum gentilium*) (1360) ● 1353–61 Francesco Petrarca in service of Archbishop Giovanni Visconti, *signore of* Milan	● 1354–7 Andrea di Cione (Orcagna) at work on altarpiece in Strozzi chapel, Santa Maria Novella, Florence ● 1355 Andrea Vanni becomes court painter to Queen Giovanna I of Naples	● *c.*1360–3 Bonino da Campione, equestrian statue of Bernarbò Visconti, Milan	● 1365–7 Guariento paints frescos in hall of the Great Council, Venice	● 1366–8 Andrea di Bonaiuti paints frescos in chapter house, Santa Maria Novella, Florence

1370

1374

1378

1382

1386

1390

● 1375–1406 Coluccio Salutati, humanist writer, chancellor of Florence
● 1375–8 War of Eight Saints between Florence and Papacy
● 1376 Bolognese patriciate declare the city a republic
● 1377 End of Avignon Papacy with return of Pope Gregory XI to Rome from Avignon

● 1378 Beginning of Great Schism with election of anti-pope Clement VII; Revolt of the Ciompi in Florence; war between Venice and Verona
● 1378–81 War of Chioggia between Venice and Genoa
● 1380 Death of St Catherine of Siena
● 1381 Excommunication and murder of Giovanna I of Anjou

● 1384 Florence takes control of Arezzo
● 1385–6 Deposition and murder of Bernabò Visconti by nephew, Gian Galeazzo Visconti of Milan

● 1387–8 Visconti conquests of Verona and Padua; exile of Francesco il Vecchio da Carrara from Padua

● 1390 Francesco II restores da Carrara rule in Padua

● 1373 First public lectures on Dante in Florence given by Boccaccio

● 1374 Death of Francesco Petrarca in Arquà;
● 1375 Death of Giovanni Boccaccio
● 1376 Giusto de' Menabuoi at work on frescos in baptistery, Padua
● 1379 Death of Orcagna

● 1385–95 Agnolo Gaddi paints the cycle of the true cross in choir of Santa Croce, Florence

● 1386 Foundation of cathedral of Milan
● 1388 Foundation of church of San Petronio, Bologna

	1394	1398	1402	1406	1410
Political/ Religious		● 1399 The Bianchi movement: penitential processions in major north Italian cities; Pisa and Siena accept rulership of Gian Galeazzo Visconti ● 1400 Perugia, Spoleto, and Assisi accept rulership of Gian Galeazzo Visconti	● 1402 Gian Galeazzo Visconti captures Bologna and besieges Florence; his death temporarily ends Milanese military threat ● 1404 Ladislas of Durazzo, king of Naples, controls Rome ● 1405 Venetian conquest of Padua and Verona	● 1406 Florence captures Pisa. ● 1409 Council of Pisa attempts to end schism but creates third anti-pope ● Ladislas conquers Cortona, threatening Florence	● 1412 Assassination of Giovanni Maria Visconti of Milan
Cultural/Art	● 1396 Foundation of *certosa* of Pavia by Gian Galeazzo Visconti ● 1397–1400 Manuel Chrysoloras professor of Greek in Florence ● 1397 Birth of mathematician and astronomer Paolo dal Pozzo Toscanelli	● 1400 Coluccio Salutati, *On Tyranny* (*De Tyranno*) ● 1401 Leonardo Bruni, *Panegyric of the City of Florence* – 1401 Competition for Florentine baptistery north doors; commission awarded to Lorenzo Ghiberti in 1403 and work completed in 1424	● 1404 Birth of Leon Battista Alberti	● 1406 Florentine *signoria* threatens to confiscate tabernacles belonging to any guild not erecting a statue at the church of Orsanmichele within ten years ● 1406–9 Translation of Ptolomy's *Geography* from Greek into Latin ● 1408–19 Jacopo della Quercia works on the Fonte Gaia, in the Campo, Siena	● *c.*1411 Bolognini chapel, San Petronio, Bologna

● 1414 Death of Ladislas, king of Naples, and succession of Giovanna II
● 1414–18 Council of Constance attempts to end schism
● 1417 Great Schism ends with election of Pope Martin V

● 1420 Martin V returns to Rome

● 1422 First Ottoman siege of Constantinople
● 1425 Alliance between Venice and Florence against Milan; establishment of Monte delle Doti to provide dowries for Florentine girls

● 1427 Historian and writer Leonardo Bruni becomes chancellor of Florence; Florentine Catasto: census of all citizens for taxation purposes
● 1428 Venetian conquest of Brescia and Bergamo

● 1431 Opening of the Council of Basle
● 1431–3 War between Milan and Venice

● 1432 Venice executes *condottiere* Francesco Carmagnolo for treason in war against Milan
● 1433 Expulsion of Cosimo de' Medici from Florence and exile in Venice

● 1414–18 Poggio Bracciolini rediscovers lost Cicero and Quintilian manuscripts in abbeys of Cluny and St Gall

● 1418 Public competition for designs for the cupola of Florence cathedral
● 1420s Reconstruction work begins on façade of Palazzo Ducale, Venice; Pisanello and Gentile da Fabriano at work on frescos in the Great Hall
● 1420–6 Guillaume Du Fay, French singer and composer, in service of Malatesta rulers of Pesaro; joins papal choir in 1428
● 1421 Della Quercia, Annunciation, Collegiata, San Gimignano

● 1423 Vittorino da Feltre establishes school on humanist principles, La Ca' Giocosa, at Gonzaga court in Mantua
● 1424–7 Donatello and Michelozzo, tomb of Pope John XXIII in baptistery, Florence
● 1425–52 Ghiberti at work on 'Gates of Paradise' in baptistery, Florence
● *c.*1425–8 Masolino/Masaccio at work on frescos of the lives of Sts Peter and Paul, in Brancacci chapel, Florence

● *c.*1426–8 Donatello sculpts St Louis of Toulouse in Orsanmichele, Florence
● 1427 Death of Gentile da Fabriano in Rome
● 1428 Death of Masaccio in Rome
● 1429 Francesco Filelfo appointed to chair in Florence *studio*

● 1431 Humanist and Greek scholar Ambrogio Traversari elected general of Camaldolite order

● *c.*1433 Fra Angelico, Linaiuoli triptych, San Marco, Florence

Timeline

	1434	1436	1438	1440	1442
Political/ Religious	● 1434 Return of Cosimo de' Medici to Florence and exile of anti-Medici faction ● 1435–41 War between Milan and Venice		● 1438–9 Opening of Council of Ferrara–Florence designed to unify Eastern Orthodox and Western Latin Churches ● 1439 Council of Basle deposes Eugenius IV and elects Felix V as pope		● 1442 Conquest of Naples by Alfonso of Aragon against Anjou rival
Cultural/Art	● 1434 Alfonso of Aragon founds University of Catania ● 1435 Leon Battista Alberti, On Painting (De pictura); Italian translation Della pittura written ● 1436 and dedicated to Filippo Brunelleschi	● 1437 Earliest surviving copy of Cennino Cennini, Libro dell'arte (probably written c.1390s) ● Brunelleschi's cupola of cathedral of Santa Maria del Fiore, Florence completed ● 1437–44 Sassetta, high altar of San Francesco for Borgo San Sepolcro	● 1438 Professional singers first hired to form choir in cathedral and baptistery in Florence – 1438 Bartolomeo Bon, Porta della Carta, Palazzo Ducale, Venice ● 1439 Guillaume Du Fay composes Nuper rosarum flores for consecration of cathedral of Florence by Pope Eugenius IV ● 1440s Colantonio at work in Naples; credited with early use of Flemish techniques of oil-painting	● 1440 Leonardo Bruni translates Aristotle's Politics from Greek into Latin; Lorenzo Valla proves that the Donation of Constantine (basis for Pope's temporal power) is a forgery ● 1441 Pisanello begins to produce medals for Italian rulers and humanists – Luca della Robbia using new technique of tin-glazed terracotta	● 1442–3 Andrea del Castagno in Venice ● 1443 Donatello arrives in Padua to work on Gattamelata and high altar of the church of Sant'Antonio

● 1444 Death of St Bernardino of Siena (canonized 1450); Federigo da Montefeltro becomes *signore* of Urbino

● 1446 Florentine *signoria* orders all Jews (except moneylenders) to wear yellow badges; Venice signs peace treaty with Mehmed II
● 1447 Sante Bentivoglio becomes *signore* of Bologna; death of Filippo Maria Visconti of Milan: Milanese institute Ambrosian republic

● 1449 Resignation of last anti-pope Felix V

● 1450 Francesco Sforza besieges Milan and forces the city's surrender; Jubilee in Rome under Nicholas V, where Ponte Sant'Angelo collapses, killing hundreds of pilgrims

● 1453 Capture of Constantinople by the Ottoman Turks; Nicholas V declares crusade (Sept.); conspiracy of Stefano Porcari against Nicholas V and attempt to re-establish Roman civic independence fails

● 1454 Peace of Lodi established between Milan, Naples, Florence, Venice, and the Papacy

● 1444 Death and state funeral of Leonardo Bruni
– 1444 Michelozzo begins work on Palazzo Medici, Florence
● 1444–6 Flavio Biondo writes *Rome Restored* (*Roma instaurata*): description of the antiquities of Rome
● 1445 Filarete, bronze doors, basilica of St Peter's, Rome
– *c.*1445 Della Robbia, Visitation, San Giovanni Fuorcivitas, Pistoia
● 1445–50 Fra Angelico in Rome

● 1446 Death of Brunelleschi
● 1447 Sienese government commissions tapestries modelled on Ambrogio Lorenzetti's frescos, *Good and Bad Government*
● *c.*1447–55 Ghiberti at work on *Commentaries*

● 1449 Pisanello called to court of Naples

● 1450s Angelo Barovier credited with improved techniques which permit manufacture of glass-crystal
● 1450 Death of Sassetta

● 1452 Alberti, *On Architecture* (*De re aedificatoria*)
● 1452–8 Greek scholars at court of Naples: George of Trebizond (1452–5), Theodore Gaza (1455–8)
● 1453 Cardinal Nicholas of Cusa dedicates treatise on mathematics, *De mathematicus complementis*, to Pope Nicholas V
● 1453–4 Piero della Francesca at work on Cycle of the True Cross in San Francesco, Arezzo

● 1455 Death of Pisanello in Rome
● 1455 Death of Fra Angelico; death of Ghiberti

	1456	1458	1460	1462	1464
Political/ Religious	● 1457 Deposition of Doge Francesco Foscari, Venice ● 1456–8 Ottoman Turks conquer Athens		● 1461 Louis XI becomes king of France	● 1462 First public bank, Monte di Pietà, established in Perugia; King Ferrante of Naples defeats rebel barons and Jean d'Anjou at Battle of Troia (29 Aug.), securing Aragonese claims to Naples ● 1463 Louis XI cedes Genoa to duke of Milan	● 1464–79 Ottoman conquest of Negroponte and territories in Albania threatens Venetian trade in eastern Mediterranean
Cultural/Art	● c.1456 Gutenberg Bible printed in Germany ● 1456–9 Andrea Mantegna at work on altarpiece in San Zeno, Verona	● 1459 First documented presence of singer and composer Josquin des Prez in choir of Milan cathedral – 1459 Mantegna, frescos, Ovetari chapel, Padua – Benozzo Gozzoli, Adoration of the Magi, Medici chapel, Palazzo Medici, Florence – Pope Pius II renames his birthplace of Corsignano near Siena, Pienza, and begins its reconstruction along Albertian principles	● c.1460–4 Filarete writes Treatise on Architecture (Trattato di architettura) in Milan ● 1460 Coins with profile heads of Sforza rulers introduced in Milan ● 1461 Mantegna becomes court painter in Mantua	● 1463–9 Marsilio Ficino translates Plato's dialogues from Greek into Latin	● 1465 First printing-press established in Italy at Subiaco near Rome ● c.1465–72 Mantegna works on the Camera Picta, Castello di San Giorgio, Mantua ● 1466 Death of Donatello

● 1466 Attempted overthrow of Medici regime in Florence by rival faction led by Luca Pitti

● 1468 'Conspiracy' of humanist Pomponio Leto against Pope Paul II
● 1469 Marriage of Ferdinand of Aragon and Isabella of Castile (eventually leading to unification of Spain)

● 1472 Sack of Volterra by Florence

● 1476 Assassination of Duke Galeazzo Maria Sforza of Milan

● 1478–80 Pazzi conspiracy against the Medici, death of Giuliano de' Medici; war declared by Papacy and Naples against Florence

● 1468 Cardinal Giovanni Bessarion bequeathes library of Greek manuscripts to republic of Venice
● c.1468–71 Francesco Cossa, Cosmé Tura, and Ercole de' Roberti, at work in Palazzo Schifanoia, Ferrara
● 1469 Birth of Niccolò Machiavelli

● 1472 Reform of University of Pisa under patronage of Lorenzo de' Medici
● 1472 Andrea del Verroccio, Medici tomb, San Lorenzo, Florence – Death of Alberti
● 1472–6 Creation of the *studiolo* of Federigo da Montefeltro
● 1472–92 Johannes Tinctoris, Flemish composer, at court of Naples
● 1473 Josquin des Prez leaves Milan cathedral for Sforza court; establishment of major court chapels in Milan, Ferrara, Naples, and Rome prompts immigration of Flemish and French singers and composers; Pliny the Elder, *Natural History* (*Historia naturalis*) translated from Latin into Italian
● 1473 Work begins on façade of *certosa* of Pavia

● 1475 Birth of Michelangelo

● c.1479–88 Andrea del Verrocchio, Colleoni monument, Venice
● 1479 Gentile Bellini goes to Constantinople to work as a court portraitist for Sultan Mehmet II, returning to Venice in 1481

	1480	1482	1484	1486	1488
Political/ Religious	● 1480 Ludovico Maria Sforza becomes regent in Milan ● 1480–1 Otranto in southern Italy held by Ottoman Turks ● 1481 Death of Sultan Mehmed II	● 1482–4 War of Ferrara; alliance between Pope Sixtus IV and Venice against Naples, Florence, Milan, and Ferrara; war ends with Peace of Bagnolo (7 Aug. 1484) ● 1483 Death of King Louis XI of France and succession of Charles d'Anjou as Charles VIII	● 1485–6 Barons' War in Regno in southern Italy threatens Aragonese kings of Naples		
Cultural/Art	● 1480s Piero della Francesca, *On the perspective of painting*, dedicated to Federigo da Montefeltro of Urbino ● 1480 Lorenzo de' Medici appoints Angelo Poliziano to chair of Greek and Latin in Florence *studio* ● 1481 Cristoforo Landino publishes influential commentary on Dante's *Comedy* – 1481 Sandro Botticelli and engraver Baccio Baldini illustrate Cristoforo Landino's *Commentaries* on Dante's *Comedy* ● 1481–3 Frescos in Sistine Chapel painted by Botticelli, Ghirlandaio, and others	● 1482 Death of Giovanni di Paolo in Siena ● 1483 Matteo Maria Boiardo, count of Scandiano, publishes Italian romance epic *Orlando innamorato* – c.1483 Andrea del Verrocchio, Christ and St Thomas, in Orsanmichele, Florence – Leonardo da Vinci in Milan; signs contract for the *Virgin of the Rocks*		● c.1485–90 Ghirlandaio at work on Tornabuoni chapel, Santa Maria Novella, Florence ● 1486 First printed Latin edition of Vitruvius's *Treatise on Architecture* ● 1487–90 Lorenzo Costa at work on Bentivoglio chapel, San Giacomo Maggiore, Bologna ● 1487–1502 Filippino Lippi at work on Strozzi chapel, in Santa Maria Novella, Florence	● 1488 Silvestro d'Aquila sculpts tomb of Maria Pereira Camponeschi, in San Bernardino, L'Aquila ● 1489 Vincenzo Foppa hired by the city of Brescia to provide instruction in painting and architecture

1490	1492	1494	1496	1498	1500

● 1491–8 Girolamo Savonarola preaches against luxury and encourages bonfires of 'vanities' and paintings in Florence

● 1492 Expulsion of Moors from Granada and Jews from Spain and Sicily; Christopher Columbus lands in the West Indies
● 1493 Pope Alexander III divides New World between Spanish and Portuguese crowns

● 1494 Invasion of Italy by Charles VIII of France; expulsion of Piero de' Medici and establishment of less oligarchic republican regime in Florence
● 1495 First reported cases of syphilis, mal francese, in Naples; French troops defeated at Battle of Fornovo (6 July); expulsion of Jews from Florence

● 1498 Girolamo Savonarola burnt in Florence; death of Charles VIII and succession of Louis d'Orleans as Louis XII
● 1499 Invasion of Italy by Louis XII of France and conquest of Milan
● 1499–1500 Cesare Borgia, nephew of Pope Alexander VI, begins campaign to recapture Papal States

● 1500 Treaty of Granada divides Kingdom of Naples between France and Spain; King Louis XII is ruler of Milan

● 1490 Aldus Manutius establishes printing-press in Venice
● 1491–2 Isabella d'Este begins work on her studiolo and grotta in Castel San Giorgio, Mantua

● 1492 Giovanni Pico della Mirandola dedicates Neoplatonic On being and the One (De ente et uno) to Angelo Poliziano; Franchino Gaffurio, The Theory of Music followed by The Practice of Music (1496)
– 1492 Death of Piero della Francesca

● 1494 Mathematician Luca Pacioli publishes treatise on arithmetic, geometry, and porportions in Venice; enters Sforza service in 1497
– 1494 Death of Niccolò dell'Arca; Michelangelo called in to complete figures on Arca di San Domenico, Bologna
– 1494 death of Ghirlandaio
● 1495 Donatello's sculptures of Judith and Holofernes and of David moved from Palazzo Medici to the Palazzo Vecchio, following fall of the Medici

● c.1496 Gentile Bellini, Finding of the True Cross
● 1496–7 Mantegna provides paintings for Isabella d'Este's studiolo
● 1497–1500 Jacopo de' Barbari, panoramic view of Venice
● c.1497 Leonardo da Vinci, Last Supper, Santa Maria delle Grazie, Milan
● 1497–9 Michelangelo, Pietà, basilica of St Peter's, Rome

● 1498 Giovanni Pontano, On Splendour (De splendore) and On Magnificence (De magnificentia)

Index

This list represents the most significant collections of artworks relevant to the text of this book.

Museums and Galleries: Europe

Austria
Vienna
Kunsthistorisches Museum
Maria-Theresien-Platz
1010 Vienna
www.arc.de/khm
Renaissance holdings include a remarkable collection of armour, sculpture, and paintings.

France
Paris
Musée du Louvre
75058 Paris, Cedex 01
www.louvre.fr
A major collection, with works by Pisanello, Mantegna, and Leonardo.

Germany
With the reunification of Germany, the country's art museums are undergoing major change. Renaissance paintings from East and West Berlin are now in:

Gemäldegalerie
Staatliche Museen zu Berlin
Kultur forum
Berlin Tiergarten
www.smb.spk-berlin.de

Italy
Bergamo
Accademia Carrara
Piazza G. Carrara 82/a
Includes works by Mantegna, Bellini, and Carpaccio, and a series of playing cards painted for the Visconti of Milan by Bonifacio Bembo in the 1440s.

Bologna
- Museo Civico dell'Medioevo e del Rinascimento
 Palazzo Ghislardi-Fava
 Via Manzoni 4
 Includes medieval and renaissance sculpture and a wide range of domestic and sacred objects from Emilia-Romagna area.

- Pinacoteca Nazionale
 Via delle Belle Arti 56
 The major collection of paintings from the Emilia-Romagna.

Ferrara
Pinacoteca Nazionale
Corso Ercole d'Este 21
Includes works by Cosmé Tura, Francesco del Cossa, and Ercole de' Roberti.

Florence
- Galleria degli Uffizi
 Via della Ninna 5
 50122 Florence
 www.it/uffizi
 The major paintings collection in Florence with a remarkable range of fifteenth-century works from Tuscany and other regions of Italy.

- Museo Nazionale del Bargello
 Via del Proconsolo 4
 Florence's major collection of sculpture and decorative arts; includes important fourteenth- and fifteenth-century paintings.

- Museo di San Marco
 Piazza San Marco 1
 Small museum housing works executed by Fra Angelico for the Dominican monastery of San Marco in Florence.

- Palazzo Davanzati
 Via di Porta Rosa 9
 Museum dedicated to the domestic arts, with fourteenth-century wall paintings.

- Horne Foundation, Via dei Benci;
 The Stibbert Museum, Via Stibbert 26;
 Museo Bardini; Piazza de' Mozzi
 Three museums housing wide-ranging collections dating back to the late-nineteenth–early-twentieth century, including paintings, armour, textiles, and statuary.

Milan
- Fondazione Bagatti Valsecchi
 Via Gesu 5
 www.museo.bagattivalsecchi.org
 Late nineteenth-century collection including major northern Italian sculptures and Lombard paintings.

- Pinacoteca di Brera
 Via Brera 28
 Major collection of Lombard paintings; includes works by Venetian artists such as Giovanni Bellini.

- Civiche raccolte d'arte del Castello Sforzesco
 Castello Sforzesco
 Includes an important collection of Lombard paintings, decorative arts, and musical instruments, as well as a series of detached fifteenth- and sixteenth-century frescos.

- Museo Poldi Pezzoli
 Via Manzoni 12
 Small but important collection of textiles, Lombard paintings, and works by Florentine artists.

Naples
Museo di Capodimonte
www.capodimonte.com
Major collection, recently restored, with an exemplary display of fifteenth-century southern Italian paintings.

Perugia
Galleria Nazionale di Umbria
Palazzo dei Priori
Corso Vannucci 1
The Umbrian region's major collection of paintings.

Rome
Musei Vaticani
Viale Vaticano 00165
00120 Citta del Vaticano
www.christusrex.org/www1/vaticano/o-musei.html
Wide-ranging collection of antiquities and paintings housed in the Vatican palace.

Siena
Pinacoteca Nazionale
Via S. Pietro 29
National collection of Sienese art, with works by Sassetta, Giovanni di Paolo, and Matteo di Giovanni.

Turin
Galleria Sabauda
Via Accademia delle Scienze 6
National collection of Piedmontese art.

Urbino
Galleria Nazionale delle Marche
Piazza Duca Federico 3
Houses the surviving remnants of the Montefeltro collection, including Piero della Francesca's double portrait of Federigo da Montefeltro and his wife, Battista Sforza.

Venice
- Galleria dell'Accademia
 Dorsoduro 1060
 Campo di Carità
 Major museum of Venetian painting, including canvases by Vittore Carpaccio and works by Jacopo and Giovanni Bellini, Andrea Mantegna, and the Vivarini.

- Museo Civico Correr
 Piazza San Marco 52

Verona
Museo Castelvecchio
Corso Castelvecchio 2

Spain
Madrid
Museo del Prado
Paseo del Prado s/n 28014
www.museoprado.mcu.es
Includes works by Taddeo Gaddi, an Annunciation by Fra Angelico and narrative panels by Botticelli.

United Kingdom
Cambridge
Fitzwilliam Museum
Trumpington Street
Cambridge
www.fitzmuseum.ca.ac.uk

London
- The Courtauld Gallery
 Somerset House
 The Strand
 www.courtauld.ac.uk
 Includes a small but select group of fifteenth-century works.

- The National Gallery of Art
 Trafalgar Square
 www.nationalgallery.org
 Major collection of paintings including
 works by Masaccio, Gentile da
 Fabriano, Sassetta, Paolo Uccello,
 Piero della Francesca, and Antonello
 da Messina.

- Victoria and Albert Museum
 Cromwell Road
 South Kensington
 www.vam.ac.uk
 Major collection containing works by
 Donatello and Benedetto da Maiono, as
 well as maiolica, Venetian glassware,
 and textiles.

- The British Museum
 Great Russell Street
 London
 www.british-museum.ac.uk
 Includes a major collection of coins
 and medals, metalwork, and maiolica
 from fifteenth-century Italy.

Edinburgh
National Gallery of Scotland
The Mound
Includes small but high-quality collection
of fourteenth- and fifteenth-century
works.

Glasgow
The Burrell Collection
Pollock Country Park
www.clydevalley.com/glasgow/burrell.
html
Decorative arts and painting.

Oxford
Ashmolean Museum of Art and
 Archaeology
Beaumont Street
Oxford
www.ashmol.ox.ac.uk
Includes cassone panels, maiolica, and
small bronzes.

Museums and Galleries: USA

Baltimore, MD
The Walters Art Gallery
600 North Charles Street
Baltimore, Maryland 21201
www.thewalters.org

Boston, MA
- Boston Museum of Fine Arts
 465 Huntington Avenue
 Boston, MA 02115
 www.mfa.org

Cambridge, MA
- The Fogg Art Museum
 The Harvard University Art Museums
 32 Quincy Street
 Cambridge, MA 02138
 www.artmuseumsharvard.edu
 A small collection with a number of
 fourteenth- and fifteenth-century works.

Chicago, IL
The Art Institute of Chicago
111 South Michigan Avenue
Chicago, Illinois 60603
www.artic.edu
Contains works by Giovanni di Paolo,
drawings, and the Alschot Gallery of
Renaissance jewellery.

Detroit, MI
Detroit Institute of Arts
5200 Woodward Avenue
Detroit
Michigan 48202
www.dia.org
Holds works by Carlo Crivelli, Pollaiuolo,
and Giovanni di Paolo.

Los Angeles, CA
J. Paul Getty Museum
1200 Getty Center Drive
Los Angeles
California 90049
www.getty.edu
Newly designed museum with works by
Vittore Carpaccio. Also holds contract
drawing by Bartolomeo di San Vito for the
'Mill of Christ'.

New York City, NY
- The Metropolitan Museum of Art
 100 Fifth Avenue
 10028-0198
 www.metmuseum.org
 Substantial collection divided between
 the main paintings and the Lehman
 collection of paintings and decorative arts.

- The Frick Collection
 1 East 70th Street
 New York City
 New York 10021-4967
 www.frick.org
 Private collection including Piero della
 Francesca's *St John the Evangelist*.

- The Pierpont Morgan Library
 29 E. 36th Street
 New York City
 New York 10016
 www.morganlibrary.org
 Collection of drawings, books, and
 manuscripts in a Renaissance-style villa.

Philadelphia, PA
Philadelphia Museum of Art
26th Street and Benjamin Franklin
 Parkway
Philadelphia, PA 19130
www.pma.libertynet.org
Includes good collection of Lombard and
Sienese art.

Washington, DC
The National Gallery of Art
www.nga.gov
Substantial holdings, including paintings
by Domenico Veneziano and Leonardo.

Websites

Useful search engines and sites with links
- *www.vos.ucsb.edu/shuttle/art.html*
 Search engine for the humanities.

- *www.citd.scar.utoronto.ca/crrs/database*
 The University of Toronto's centre for
 Renaissance and Reformation studies.

Websites with link pages
- *www.comune.firenze.it/english//arte.htm*
 Information about, and links to, Florentine
 museums.

- *www.paris.org/Musees/Paris art museums*
 Information about, and links to, museums
 in Paris.

Sites for illustrations
- *www.ncsa.uiuc.edu/SDG/Experimental/*
 vatican.exhibit/exhibit/Main_Hall.html
 Offers a virtual tour of the Vatican library.

- *www.thais.it*
 Illustrations of Italian sculpture mainly
 from Italian museums and galleries.

- *www.christusrex.org*
 Catholic site with images of items from
 the Vatican collections in Rome.

- *www.greatbuilding.com*
 Illustrations of architectural monuments.

- *www.televisual.it/uffizi*
 Contains downloadable images from the
 Uffizi collection in Florence.

Research and documentary resources
- *www.wsu.edu:8001/~dee/reninres.htm*
 Internet resources for Renaissance
 studies.

- *www.haverford.edu*
 Medieval feminist index containing
 sources and links for the study of
 European women in the fourteenth and
 fifteenth centuries.

- *www.orb.rhodes.edu*
 Online reference book for medieval and
 Renaissance studies.

- *www.fordham.edu/haball/sbook*
 Online source book for medieval and
 Renaissance studies.